THE A. W. MELLON LECTURES IN THE FINE ARTS
DELIVERED AT THE NATIONAL GALLERY OF ART, WASHINGTON, D. C.

BOLLINGEN SERIES XXXV · 20

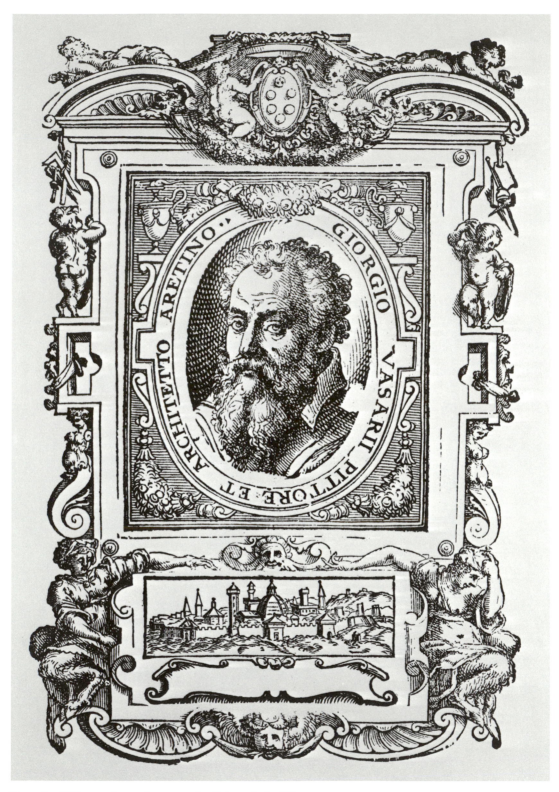

Portrait of VASARI from the second edition of the *Vite*

T. S. R. Boase

GIORGIO VASARI

The Man and the Book

THE A. W. MELLON LECTURES IN THE FINE ARTS, 1971

THE NATIONAL GALLERY OF ART, WASHINGTON, D. C.

BOLLINGEN SERIES XXXV · 20 / PRINCETON UNIVERSITY PRESS

This is the twentieth volume of the A. W. Mellon Lectures
in the Fine Arts, which are delivered annually
at the National Gallery of Art, Washington.
The volumes of lectures constitute Number XXXV
in Bollingen Series, sponsored by Bollingen Foundation

Library of Congress Cataloging in Publication data
will be found on the last printed page of this book.

Designed by Mahlon Lovett
Type set by Princeton University Press
Clothbound editions of Princeton University Press books
are printed on acid-free paper, and binding materials are
chosen for strength and durability.
Printed in the United States of America by
Meriden Gravure Company

To DAVID and MARY CRAWFORD
in gratitude for a long friendship

Contents

List of Illustrations

Photographic Sources

Alinari, Florence–Art Reference Bureau: 1, 5, 6, 8, 9, 13, 14, 15, 16, 18, 20, 23, 24, 26, 27, 29, 34, 35, 39, 42, 45, 47, 48, 49, 50, 54, 56, 59, 61, 63, 66, 68, 69, 72, 73, 75, 81, 83, 85, 87, 88, 90, 95, 96, 97, 98, 99, 100, 103, 104, 105, 115, 116, 117, 121, 125, 130, 133, 134, 135, 138, 141, 143, 146, 147, 148, 149, 151, 154, 157, 158, 162, 167, 169, 170, 172, 176, 177, 178, 186, 191, 197, 203, 204, 205, 207, 210, 211, 212, 213, 216, 220, 227

Anderson (Alinari, Florence)–Art Reference Bureau: 4, 46, 57, 86, 94, 106, 153, 155, 156, 159, 160, 161, 182, 190, 195, 221, 222, 223, 224

Archives Photographiques, Paris: 128

Ashmolean Museum, Oxford: 76, 196

Author: 60, 108, 113, 119, 171

British Museum, London: 24, 124

Brogi (Alinari, Florence)–Art Reference Bureau: 7, 84, 114, 132, 206

Christ Church, Oxford: 43

Christie's, London, photo A. C. Cooper Ltd.: 217

A. C. Cooper Ltd., London: 127

Courtauld Institute, London: 21, 30, 31, 37, 38, 40, 41, 44, 62, 74, 118, 139 (courtesy of Mr. M. Hirst), 140, 142, 144, 179, 201

Dumbarton Oaks Center for Byzantine Studies, Washington, D.C.: 55

Fogg Art Museum, Harvard University, Cambridge, Mass.: 166

Gabinetto Fotografico Nazionale, Rome: 32, 67, 70, 101, 163, 168, 174, 175, 180, 181, 183, 184, 185, 187, 188, 189, 192, 193, 194

Isabella Stewart Gardner Museum, Boston: 19

Gesellschaft, Berlin: 89

Hanfstaengl, Munich: 152

Lippi, Poppi, Tuscany: 64

Metropolitan Museum of Art, New York: 77 (Purchase, Fletcher Fund, 1920)

National Gallery, London: 11, 51, 58, 78, 92, 93, 131, 136, 164

National Gallery of Art, Washington, D.C.: 52

Pierpont Morgan Library, New York: 200

Princeton University, Princeton, N.J., Library: 30, 126; Marquand Library: Frontispiece

Réunion des Musées Nationaux, Paris: 17, 22, 79, 91, 129

Soprintendenza alle Gallerie (Gabinetto Fotografico), Florence: 2, 8, 12, 28, 33, 65, 82, 102, 107, 109, 110, 111, 112, 120a and b, 122, 137, 165, 173, 198, 199, 202, 208, 209, 214, 215, 225, 226

Unknown: 10, 36, 53, 71, 145, 150

Vatican, Archivio Fotografico: 218, 219

Victoria and Albert Museum, London: 3, 123

Villani, Bologna: 80

Abbreviations

AB	*Art Bulletin*
BM	*Burlington Magazine*
Frey ɪ, ɪɪ, ɪɪɪ	K. Frey, *Der literarische Nachlass Giorgio Vasaris*, Munich, ɪ, 1923, ɪɪ, 1930; ɪɪɪ, H. W. Frey, *Neue Briefe von Giorgio Vasari*, Munich, 1940
JWCI	*Journal of the Warburg and Courtauld Institutes*
Maclehose, Technique	*Vasari on Technique, being the Introduction to the Three Arts of Design*, ed. G. B. Brown, trs. L. S. Maclehose, London, 1907; reprint by Dover Publications, New York, 1960
M	*Le opere di Giorgio Vasari*, ed. G. Milanesi, 9 vols., Florence, 1878–85
MKIF	*Mitteilungen des Kunsthistorischen Institutes in Florenz*
Vite (*Lives*)	Giorgio Vasari, *Le vite de' più eccellenti pittori, scultori, et architettori*
ZfK	*Zeitschrift für Kunstgeschichte*

To avoid constant repetition, references are not given in the notes to Frey and Milanesi, where the date and recipient of the letters and the *Vita* in question are indicated in the text. Both works have excellent indexes. Where not otherwise specified, information about Vasari comes from his "Descrizione dell' opere di Giorgio Vasari," *M*, ᴠɪɪ, pp. 649–713.

Measurements:
Vasari gives his measurements in *braccia* $= 58.4$ cm
palmi $= 32.8$ cm

Preface

THE basis of this book is six lectures which I had the honor to give at the National Gallery of Art in Washington in February and March 1971. This series of lectures, which has had an alarming distinction of tenure, was created by the A. W. Mellon Foundation, to which I am most grateful for the privilege of being one of their lecturers, and of, over a period of six weeks, working in and coming to know with some intimacy the National Gallery. The staff of that great institution could not have been more welcoming and helpful, and my audiences encouraged me with their regular attendance and many comments afterwards.

Six lectures are hardly sufficient for the great wealth of material about Vasari, and the book includes several sections which could not be delivered verbally. Even at this length, I have had to be highly selective in my account of this much documented man. Anyone who deals with Giorgio Vasari must be aware that his name pervades all writings on the artists of the Renaissance, and that inevitably there must be lacunae in the author's knowledge, some passage in a monograph, some new point in an article. I am here concerned with his own views, but these necessarily involve some assessment of their accuracy, and on this there is a constant flow of comment. After long acceptance of his authority, there was by the mid-nineteenth century steady criticism of his facts. Sir Francis Palgrave writing in the *Quarterly Review* in 1840 could state that "errors, inaccuracies, mistakes and false judgments, are the continual subject of fault finding," while at the same time he admitted that without him we would know as little of Renaissance artists as we do of medieval. By 1876 Ruskin, who had said hard things of Vasari, concluded that "after a while, I find he is right, usually." The great mentor of art-historical studies in our own time, Erwin Panofsky, could write in 1965, discussing the early *Lives*, "in spite of these inaccuracies, Vasari was, as so often, right in principle." As I have been tracing his name through periodical literature, the tendency seems more and more to endorse his views rather than to confute them.

I have followed Vasari's own practice of sometimes using his final name, sometimes his first, Giorgio. This breaks the monotony of constant reference, and for the same reason I have been inconsistent in quoting the *Vite* or the *Lives*.

My debts are too numerous, and some now of too long standing, for acknowledgment. My thoughts have grown in conversation and many friends have contributed to them. The Courtauld and the Warburg Institutes have been my constant resource, and at the former Dr. John Shearman and Mr. Michael Hirst have been very patient with my questioning, and have seldom failed to produce the answer. The Harvard Center for Italian Renaissance Studies at I Tatti has been constantly hospitable and inspiring, and the British School at Rome has frequently aided my access to Roman buildings.

London, 1973 T.S.R. BOASE

Publishers' Note

The author's death in 1974 has meant that this book, which he prepared for publication, has had to be seen through press without him. We are greatly indebted to Sir Anthony Blunt and to Mr. and Mrs. Michael Hirst for their generous help and advice in the course of its production.

GIORGIO VASARI
The Man and the Book

I. The Man

Giorgio Vasari was not a profound or original thinker. The main theses of his book, *Le vite de' più eccellenti pittori, scultori, et architettori*, were taken from earlier writers or the current ideas of the time, though as he worked over them in his long labors he modified and reinterpreted, giving them qualifications which were personal to himself. In the planning of his work he had few precedents. Never before had a history of the arts been attempted on this scale, nor had biographies been handled with such anecdotal intimacy: and as a writer he had many gifts, not least in that highly stylized age that he wrote without too many literary pretensions, "in the way," he himself put it, "that seemed most natural and easy." He had a thoroughly professional knowledge of the arts, a great interest in human nature and gossip about it, and endless industry. The book that emerged fixed for some three hundred years the general views of Europe about the art of the Renaissance, and some of its influence still lingers about us today. His grading of artistic achievements formed a canon that was long unquestioned, and any artist who escaped his notice has had a retarded progress in finding appreciation. Much read when it first appeared, spiced as it was with some contemporary malice, its great length has no doubt debarred a later public from a complete knowledge of it. But it has been a constant quarry of information, used by every scholar, and there have been very many, of that period; and those who have never opened it, or never even heard of it, have been touched by its pervasive authority, so that something of Vasari lies behind any print of Michelangelo's *Adam* or version of the *Sistine Madonna* distorted in stained glass or on a church banner. There are few men of his time about whom we are so well informed. He wrote of himself; his notebook and carefully kept accounts have come down to us; and his vast correspondence, almost a life's work in itself, has largely survived. The two houses he inhabited still stand, much as he left them. He is immensely knowable.

He was born on 30 July 1511 in Arezzo, a town that for a hundred and fifty years had been under Florentine domination, a provincial place with stronger local feeling than its activities and achievements entirely justified. Giorgio Vasari's great-grandfather, Lazzaro, had

moved there from Cortona between 1450 and 1458, and died there in
1468.[1] He is described in a tax return at Cortona as a saddler, and his
great-grandson admits that his particular skill lay in painting small
figures on the caparisons of horses. Painters, however, in those days
turned their hands to many tasks: Girolamo Genga and Timoteo Viti,
more established names, are recorded as painting horse trappings,[2]
and even Francesco Francia had "greatly increased his fame" by dec-
orating a saddlecloth for the Duke of Urbino with scenes of a forest
fire, "a frightening and truly beautiful thing." Giorgio claims that his
ancestor, a friend of Piero della Francesca, was a distinguished painter,
and recent researches have substantiated the claims. Thanks to a
reference in Lazzaro's *Vita* to work done in the church of the Servites
at Perugia, it has recently been possible to assign to him some frag-
ments of frescoes there, a *Crucifixion* and scenes from the life of St.
Catherine. These were painted about 1455 and show Lazzaro to have
been much influenced by Piero della Francesca, and to have been able,
as his great-grandson claims, to express emotions, tears, laughter, fear,
with some ability.[3] Hitherto his only known work had been the faded
fresco of *St. Vincent Ferrer* [1] in the Aretine church of S. Domenico,
an attribution that Giorgio said was vouched for by "old family rec-
ords" and the Vasari arms on the painting. Giorgio must be allowed
to speak for himself. "Great indeed is the pleasure of those who find
that one of their forebears . . . has been singular and famous in some
art, and men who find in history such honorable mention of past mem-
bers of their family have a stimulus to *virtù* and a curb to restrain them
from any deeds unworthy of such repute." *Virtù* is an all-important
and untranslatable word, meaning a man's true exercise of his gifts.
It comes very often from Vasari's pen. Whatever Lazzaro's merit, his
son Giorgio was a potter, *vasaio*, hence the family name. He revived
the old methods of making red and black Etruscan ware vases, for
which Arezzo had been famous, and he found outside the town, buried
some five feet deep, an Etruscan kiln, with four vases intact, which he
presented to Lorenzo de' Medici when the latter visited Arezzo, "the
beginning of the service that we have always held with that most
fortunate house." One of the potter's sisters married Egidio Signorelli,
and their son was Luca, the celebrated painter. Of this Giorgio's
numerous offspring, one son Antonio married Maddalena dei Tacci
[2], whose family had some position in the town. Their eldest son was
another Giorgio, who was to bring fame to the name Vasari. It is
characteristic of him, as we shall find all too often, that the dates he

[1] A. del Vita, *Vasari*, III, 1930, pp. 51–75.
[2] *M*, IV, p. 498.
[3] F. Santi in *Bollettino d'Arte*, IV, 1961, pp. 315–22.

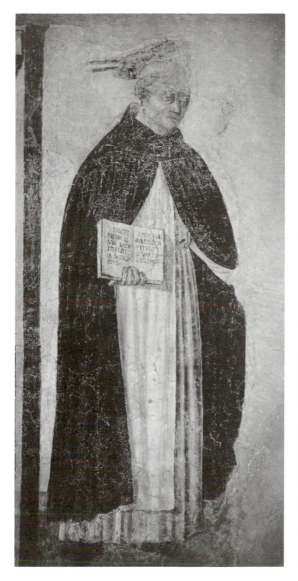

1. Lazzaro Vasari, *St. Vincent Ferrer*. Arezzo, S. Domenico

"Kneeling before the saint he painted himself and his son Giorgio, who had accidentally wounded himself in the face with a knife." There is no trace now of these figures in the damaged lower area of the fresco.

2. Vasari, Portraits of his parents, from the family shrine now in the Badia of SS. Fiore e Lucilla, Arezzo, painted in 1563

His father had died in 1527 as a comparatively young man, his mother as an old lady in 1558 so that Vasari remembered them very differently.

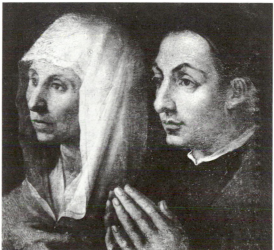

gives for the deaths of Lazzaro and his son are far out from those inscribed in the burial records of the town.

Antonio carried on his father's trade, "a poor citizen and artisan" his son calls him, and the numerous family with which his wife with annual regularity provided him must have strained his resources.[4] Writing of Luca della Robbia, Vasari later made a comment that has a backward-looking autobiographical tinge: "No one ever becomes excellent in any exercise, who did not begin as a child to bear heat and frost and hunger and thirst and all other hardships." But Arezzo was a small, democratic community where everyone knew everyone.

[4] Frey I, pp. 1, 30.

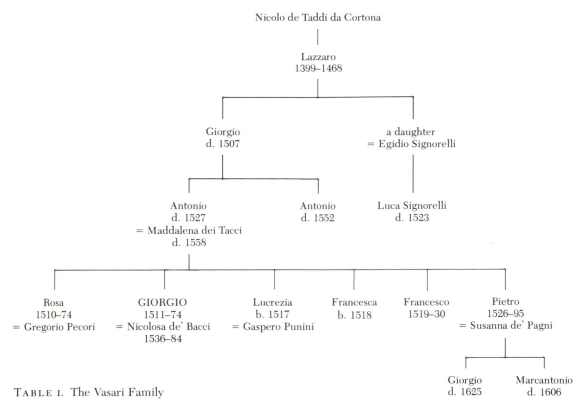

Nicolo de Taddi da Cortona
|
Lazzaro
1399–1468

Giorgio
d. 1507

a daughter
= Egidio Signorelli

Antonio
d. 1527
= Maddalena dei Tacci
d. 1558

Antonio
d. 1552

Luca Signorelli
d. 1523

Rosa
1510–74
= Gregorio Pecori

GIORGIO
1511–74
= Nicolosa de' Bacci
1536–84

Lucrezia
b. 1517
= Gaspero Punini

Francesca
b. 1518

Francesco
1519–30

Pietro
1526–95
= Susanna de' Pagni

Giorgio
d. 1625

Marcantonio
d. 1606

TABLE I. The Vasari Family

The young Montaguti, local feudatories, particularly Count Federico, were acquainted with Giorgio, "like a most dear brother,"[5] and he received instruction in Latin from the town's most learned man, Giovanni Pollastra, humanist and playwright. He was, too, always drawing. Writing of Giuliano da Maiano he gratefully reflects on the wisdom of fathers who allow free course to their sons' natural gifts. He also found help from the French glass painter, Guillaume de Marcillat, who had been employed in Cortona [3] by Cardinal Passerini and who in 1520 came to Arezzo to design windows for the cathedral and to fresco its ceiling. Marcillat had worked with Raphael in the Vatican Stanze, and his splendid and still extant Aretine windows are works in the High Renaissance manner, examples for Giorgio of the art of his time.[6] When in 1520 Luca Signorelli, his father's cousin, came to Arezzo to supervise the setting up of one of his altarpieces [4], he

[5] Frey I, pp. 79, 102.
[6] Donati, "Dell'attività di Guglielmo de Marcillat nel Palazzo Vaticiano," *Rendiconti della Pontificia Accademia Romana di Archeologia*, xxv–xxvi, 1949–51, pp. 267–76. Marcillat and his assistants were employed by Cardinal Passerini on the windows of the recently completed church of the Madonna del Calcinaio in Cortona. Signorelli was also working for him on a fresco of the *Baptism* in his new villa, Il Palazzone, outside Cortona. Windows and fresco are still extant. Another of Marcillat's windows, from the cathedral of Cremona, is in the Victoria and Albert Museum.

stayed with his Vasari kinsfolk. It was an occasion "fixed in eternity in my mind." The altarpiece itself was carried in procession from Cortona to Arezzo by members of the confraternity that had commissioned it. It is not one of Signorelli's happiest works, but it must at the time have made a deep impression on Giorgio, and he was always to be prone to similar overcrowding of his figures. The town was *in festa*. Giorgio was not at his best, being afflicted by severe nosebleeding; but Signorelli took much interest in him and urged his father to

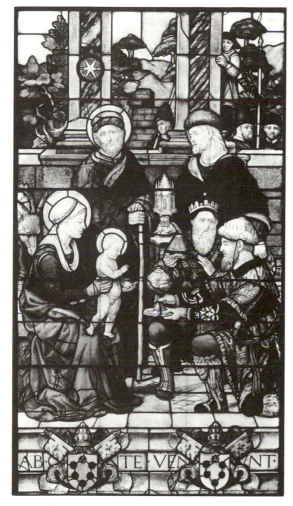

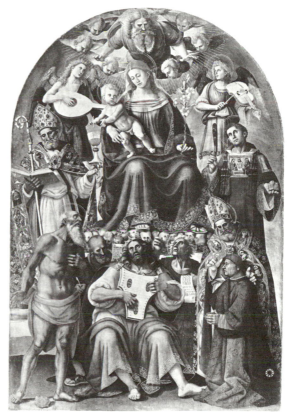

4. Signorelli, *The Virgin in Glory*. Arezzo, Pinacoteca

"Messer Niccolò Gamurrini portrayed from the life is kneeling before the Virgin, presented by St. Nicholas . . . and Luca, old as he was, wished to come to put it in position, and partly to see old friends and his relatives."

3. Guillaume de Marcillat, *Adoration of the Magi*, window from Cortona cathedral. London, Victoria and Albert Museum

"Silvio, cardinal of Cortona, had him make in the Pieve of Cortona the window of the *cappella maggiore*, in which he made a *Nativity* and an *Adoration of the Magi*."

let him learn to draw in every way. "Learn, little kinsman," he said
to him.[7]

It was not an exhortation that Giorgio ever needed, but it was in
fact his Latin not his drawing that won him his first advancement.
When in May 1524 Cardinal Silvio Passerini passed through Arezzo
on his way to Florence, Antonio Vasari presented his son to him.
Giorgio duly recited long passages from the Aeneid, and the cardinal
was sufficiently impressed to urge Antonio to send his son to Florence.
Despite financial difficulties, he agreed to do so. Giorgio in a later
letter admitted that the greater part of the family resources was spent
on him.[8] He was now a boy of thirteen, though with his usual dis-
regard for dates he describes himself as nine, and no doubt liked to
think of himself as an infant prodigy. With the cardinal's patronage
he was, however, soon established in Florence, and was put to con-
tinue his studies with the two young Medici, Ippolito and Alessandro,
boys much of his age, no doubt in the hope that this clever fellow-
student might be a stimulus to them.

Vasari's career is so closely linked with the family of the Medici
that the course of their history must briefly be recalled. In November
1494, Piero, son of Lorenzo the Magnificent, had been ignominiously
driven out of Florence, and after various governmental experiments
Piero Soderini in 1502 was appointed gonfalonier for life. For ten diffi-
cult years, much occupied with the Pisan war but years that saw Leo-
nardo and Michelangelo at work in the city, he directed Florentine
policies. Then in 1512 Pope Julius II, urged on by Lorenzo's son,
Cardinal Giovanni, sent a force against the city, which occupied Prato
with a horrible massacre. Florence, reacting to this piece of terrorism,
admitted the papal troops and Soderini fled to Siena. Within a few
months Julius II was dead and the Medici cardinal became pope as
Leo X. Piero de' Medici had died in 1503, and Pope Leo chose his
son Lorenzo to take over the rule of the city, in preference to the
pope's brother Giuliano. The latter died in 1516, Lorenzo in 1519.
Their tombs in S. Lorenzo are of far more moment than anything in
their lives. Lorenzo left an infant daughter, Caterina, who was to
achieve in France a sinister reputation as Catherine de Médicis, and
an illegitimate son, Alessandro; Giuliano also had a bastard son, Ippo-
lito. The two boys were brought up in Rome till another Medici pope,
Clement VII, himself a bastard son of the elder Giuliano, the Mag-
nificent's brother, sent them to Florence in 1524, with the young
Giorgio as their companion. Moved about as pawns in a political
game, the two lads had a sorry upbringing. Pontormo's portrait of the
young Alessandro [5] is a psychological study of uncertain and bewil-
dered youth. The son of a serving woman, he was bred in uneasiness,

[7] *M*, III, p. 693. [8] Frey I, p. 1.

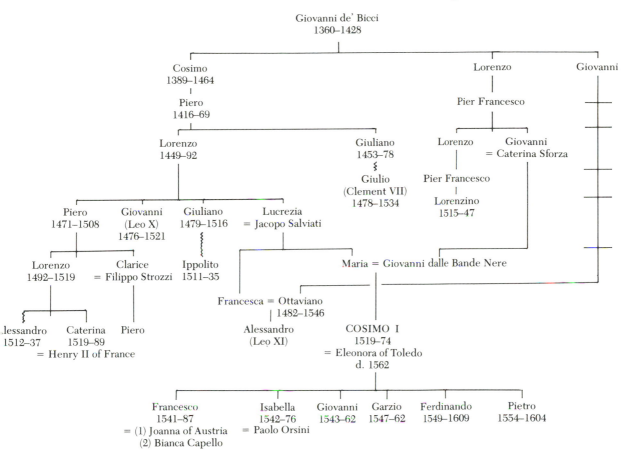

TABLE II. The Medici Family

and his enemies spread rumors, all ill-founded, about him, that Pope Clement was his real father and that his mother was a mulatto from whom he had his thick lips.[9]

Giorgio had many memories of this period. He shared not only in the lessons given by the humanist, Pierio Valeriano, but also in some of the young princes' amusements. He recalls how fine were the sets that Andrea del Sarto and Bastiano da Sangallo made for Machiavelli's *Mandragola*, and how much the Medici boys enjoyed that entertaining but not very edifying piece.[10] These sets would have had a particular interest for Giorgio, for he was now studying painting under Andrea del Sarto. When he came years later to write the *Vite*, he suggests that he studied for a time under Michelangelo but that Michelangelo was called to Rome and decided that his pupil should go to

[9] For Alessandro see G. Spini in *Dizionario biografico degli italiani*, Rome, 1968, pp. 231–33. [10] *M*, VI, p. 437.

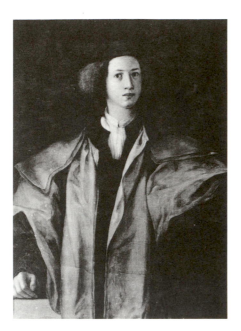

5. Pontormo, *Alessandro de' Medici*. Lucca, Pinacoteca

Painted in 1524 when Alessandro was twelve years old; commissioned by Ottaviano de' Medici. The scarlet of his gown is all important in the composition of the portrait.

Andrea's *bottega*. There seems some wishful thinking here in Giorgio's recollections. Michelangelo was briefly in Rome in December 1523, but returned to Florence and was working there till 1529. Involved in the funerary chapel at S. Lorenzo and harassed about the tomb of Julius II, it is unlikely that he had time for an unknown boy, and distant admiration was probably the only contact that Vasari had as yet with the man who was to dominate his thoughts. For his master, Andrea, though criticizing his lack of ambition and a certain feckless-ness in money matters, he seems to have had considerable liking, but for his wife, Lucrezia, "who had respect for no one, imperiously utter-ing her commands," his feelings were very different. He had his revenge. The first edition of the *Vite* has an account of Andrea, against the advice of his friends, marrying a widow much below him in rank, and becoming jealous and poor as a result of her conduct and extrava-gances, till on his deathbed she deserted him. Much of this is omitted or toned down in the second edition; Lucrezia was, as Vasari admits, still alive, not dying till 1570, and she or her relatives, who were by no means as lowly as Giorgio suggests, may have protested. But the tale stuck, and Browning's poem finally immortalized the view of Lucrezia that had been first elaborated in the angry chatter of her husband's *garzoni*.

Giorgio also worked for a time with Baccio Bandinelli, the sculptor; there was clearly something about this passionate, bullying man that young Vasari liked; he was years afterwards to deal with some of his unfinished works in the Palazzo Vecchio: "I have always held his

works in respect, and have sought to finish them, so that they should not be wasted, and to do them honor"; but he admits that "his villainous language lost him all goodwill and obscured his talent." What with Lucrezia's nagging and Bandinelli's abuse, it cannot have been an altogether easy pupilage.

He was fortunate in his lodging. He had been placed, presumably through the cardinal-legate's influence, in the house, close to the Ponte Vecchio, of a knight of Rhodes, Niccolò Vespucci, from whom he must have heard talk of his kinsman, Amerigo, "who navigated the Indies." Vasari had a drawing of him by Leonardo da Vinci, but otherwise shows little awareness of the man whose name was to be given to a new continent.[11] Of more interest to him was Niccolò's friendship with Jacopo Pontormo, who, on his friend's recommendation, was painting a *Deposition* [6] in the Capponi chapel of S. Felicita, while Giorgio was resident in the Vespucci household.[12] It was a new form of art, this Florentine Mannerism, with its flowing lines and bright, unshaded colors, and one that puzzled him, but he had something to learn from it, and it was now that he formed a close friendship, lasting into their old age, with Pontormo's favorite and devoted pupil, Agnolo di Mariano, known as Bronzino; "and he has been and is," Vasari wrote forty-three years later, "the sweetest and most courteous friend . . . liberal and lovable in all his doings."

There was another friend, of a more difficult temperament, but a man for whom he had an enduring affection, Francesco de' Rossi, later known from one of his early patrons as Salviati. Francesco, or Cecchino as he was usually called, was working with the painter Bugiardini, an amiable but not very accomplished man, and Giorgio, better placed, used secretly to bring some of Andrea's drawings for Francesco to see. The two boys took part in a famous episode that occurred in 1527, in the first stirrings against the Medici, as news came that the imperial forces were marching on Rome.[13] Some of the republican party seized the Palazzo Vecchio, only to be besieged in it by the forces of the Duke of Urbino, the general of the anti-imperial league. During the attack on the Palazzo, the defenders hurled down a bench which hit the raised arm of Michelangelo's *David* at the entrance gate, breaking it into three pieces. There the broken fragments lay for three days, till the two lads went out and collected them, carrying them back to Francesco's father's house, where for some time they remained; then in 1543 Duke Cosimo had them riveted back in position. While Vasari was carrying out this work of salvage, within

[11] *M*, III, p. 255.

[12] I. L. Zupnick, "Pontormo's Early Style," *AB*, XLVIII, 1965, pp. 345–53.

[13] *M*, VII, p. 8.

6. Pontormo, *Deposition*. Florence, S. Felicita
 "Thinking of new things, he painted it without shadows and with clear colors, so that it is hardly possible to distinguish the half-lights from the half-shadows. . . . His earlier manner was much better."

the Palazzo Francesco Guicciardini was persuading the rebels to submit, a strange propinquity of two of the great names in Italian literature.

With the news that the imperial troops had seized Rome and that the pope was besieged in Castel S. Angelo, the Florentine republicans finally gained control, and Cardinal Passerini and the two young Medici had to leave the city. Their departure deprived Giorgio of his protectors, and his association with them might now mean danger and certainly discredit. He returned to Arezzo, to find the town plague-ridden, this recurrent terror of the times, and his father died of the pestilence on 24 August 1527. Giorgio was left as the head of the family with his mother, two brothers (the younger, Pietro, an infant), and three sisters in his charge, a heavy responsibility for a boy of sixteen. "I must study hard," he wrote to Vespucci, "to provide dowries for my three sisters." His uncle Don Antonio, a priest, was his main support; "my father lives again in him," Giorgio wrote. But the obligation was his own and he at once started to earn some money by touring the surrounding villages and painting saints in the churches, where religious rather than aesthetic motives were the main cause of the demand; and also by restoring some paintings in Aretine churches, learning much by doing so.[14]

[14] Frey I, p. 30. How Vasari's father and uncle both came to be called Antonio is not clear. Possibly the uncle took the name Antonio in religion.

In Arezzo, as throughout Italy, news was now circulating of the terrors of the Sack of Rome, when on 6 May 1527 the imperial troops led by the Constable de Bourbon had forced their way into the city, and avenged the death of their leader by a brutal pillage. "God for the castigation of that city and the abasement of the pride of the dwellers in Rome permitted that Bourbon came with his army, and the whole city was put to sack by fire and sword, in which ruin many men of genius suffered ill." The horror of these days ended an era, and the men who passed through them could never return to former, easier ways. The Sack is a recurrent theme throughout the *Vite*. "In truth," wrote Erasmus, "this was rather the fall of a world than of a city."[15]

Refugees passed through Arezzo, amongst them the Aretine painter, Giovanni Antonio Lappoli, who was taken in by his uncle, Giovanni Pollastra, Vasari's former tutor. Lappoli had been tortured by the Spaniards, lost his belongings and escaped only in a shirt. Giovanni Battista Rosso, who had been equally ill treated by the German troops, was at Borgo S. Sepolcro, and then came to Arezzo, where Pollastra provided him with a scheme for a fresco of the Virgin releasing Adam and Eve, a work not carried beyond the cartoon [7], but certainly known in that form to Giorgio, who later used the iconography of it

[15] *M*, VII, p. 499; "Nimirum orbis hoc excidium erat verius quam urbis," *Opus Epistolarum Erasmi*, ed. P. S. Allen, Oxford, 1947, VII, p. 510.

7. Copy after Rosso, cartoon, *Allegory of the Immaculate Conception*. Florence, Uffizi

Of the four cartoons designed on the instructions of Giovanni Pollastra, one, the *Throne of Solomon*, is in Bayonne, and another, the *Allegory*, is known in this copy.

for one of his most famous pictures [20]. He was studying Rosso's drawings, and obtaining some of them, as eagerly as he was collecting the stories brought back from Rome.

Rosso's departure from Arezzo had left the unfortunate Lappoli liable for 300 crowns, as he had stood guarantee for Rosso's completion of the work, and it was largely due to Vasari that a committee of Aretine painters assessed the work already done as worth that amount.[16] Prices and contracts were already something of a speciality with Giorgio, whose own affairs were conducted in a highly businesslike method. From the year of his father's death he began to keep a *Libro delle ricordanze*, a record of all his paintings and the prices received for them, "to the honor of the Divine Majesty, and to the

[16] E. A. Carroll in *AB*, XLIX, 1967, pp. 297–304; K. Kusenberg, "Autour de Rosso," *Gazette des Beaux-Arts*, LXXV, 1933, pp. 159–72. Lappoli's *Immaculate Conception* now in the Museo Civico at Montepulciano made some use, very reasonably, of the cartoon.

8. Vasari, *Siege of Florence*. Florence, Palazzo Vecchio, Sala di Clemente VII

Vasari in his *Ragionamenti* gives a long account of how he chose his viewpoint and worked out his measurements. He particularly points out the fortifications designed by Michelangelo, and explained to Prince Francesco where the various captains of the besieging forces had their posts.

use and furthering of myself and all my house and the salvation of our souls." He kept it faithfully up to his death, and it remains a source book such as few other artists have left us.

In April 1529 he was back in Florence, called there by Francesco Salviati, who had nearly died of the plague. Events, however, were moving with great rapidity. The pope, Clement VII, had come to terms with the emperor, Charles V, and their joint forces laid siege to Florence in the autumn of 1529 [8]. The disaster of the French expedition to Naples, in which the Florentines had participated, and the expulsion of the French from Genoa, left Florence, France's ally, an exposed and vulnerable enemy whom the emperor could not neglect. The Florentines, often mocked as only tradesmen, showed themselves ready to endure anything in defense of liberty, a concept very variously interpreted but certainly anti-Medicean. Outside the ring of the walls they destroyed houses and even churches, so as not to give cover to the enemy. Time after time they raided far into the

besieger's camp, but the Perugian exile, Baglioni, to whom the defense had been entrusted, was playing his own hand, hoping for restoration to his native city. There were divisions within the walls, and contacts with Florentines in the papal–imperial forces. Hunger and plague took their toll, and in August 1530, after nine months' siege, the city surrendered. Some vengeance was taken. The Otto di Pratica led by Baccio Valori executed several republicans, till they were stayed by the pope, anxious for a peaceful Medicean restoration. The young Alessandro de' Medici arrived at Florence on 5 July 1531 and on imperial instructions was recognized as head of the state.[17]

Vasari, with his Medici links, had little sympathy with the republicans and their desperate resistance, and he was not a courageous character. Moreover Arezzo had declared for the papal–imperial forces, and driven the Florentine republican garrison from the citadel. "I hate war," Giorgio wrote, "as the priests hate the *decime*, for it deprives us of the chance of working."[18] He betook himself during the siege to Pisa, his first visit to a city that was to provide him with many problems, and from there, making a long detour through the mountains to avoid the area of fighting, he went to Bologna, where the emperor had arrived to make his formal peace with Pope Clement. On 24 February 1530, his birthday, Charles V was crowned by Clement VII in S. Petronio, a strange rapprochement after the brutalities of the Sack of Rome. Giorgio saw the coronation festivities, and years later when he came to depict the scene on the walls of the Palazzo Vecchio [9], remembered, or appeared to remember, infinite details about the ordering of events and the personalities involved. In his notebook, his *Zibaldone* (medley), he had a summary of the description of the coronation given by Paolo Giovio in his *Historiarum sui temporis* and no doubt this assisted him. The *Ricordanze*, however, shows no commission obtained in Bologna, and in March he was back

[17] C. C. Bailey, *War and Society in Renaissance Florence*, Toronto, 1961, pp. 284–315.
[18] Frey I, p. 347.

9. Vasari, *Coronation of Charles V by Clement VII* (24 February 1530, in S. Petronio, Bologna). Florence, Palazzo Vecchio, Sala di Clemente VII
Vasari details the names of a large number of the participants. In the bottom left-hand corner is a group of portraits including Duke Alessandro, and below him Francesco's maternal grandfather, Pedro of Toledo, Viceroy of Naples. The Gothic S. Petronio is shown with classical columns and Ionic capitals. In the foreground German soldiery roast a bull.

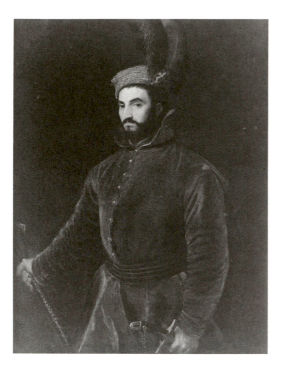

10. Titian, *Cardinal Ippolito de' Medici in Hungarian Dress.* Florence, Pitti Palace
Created cardinal in 1529, when Clement designated Alessandro as ruler in Florence, Ippolito was always ready to lay aside ecclesiastical state to lead a contingent against the Turks in Hungary (1534) or drive the pirate Barbarossa from the Campagna (1535).

at Arezzo, seeing to the needs of his family and awaiting what opportunities the Medicean restoration might provide. Ippolito de' Medici, now a most secularly minded cardinal [10, 11], passed through Arezzo and arranged for Giorgio, on a recommendation from Niccolò Vespucci, to come and work for him in Rome. "To his most blessed memory I recognize myself as much indebted, for my beginnings, such as they were, had their origins from him."[19] In Rome Giorgio found Salviati, and there was some embarrassment between the friends, as it was clear that Giorgio was displacing Cecchino in the cardinal's favor. Their friendship, however, survived this test, and they busied themselves copying everything, both antique and modern, spending long days in the Vatican when the pope was absent, "with nothing to eat but a morsel of bread, and almost benumbed with cold." It was an arduous life, and Rome of those days was notoriously unhealthy and malarious, particularly in the heat of summer. Giorgio and his servant, Giambattista Cungi, both fell desperately ill, but he managed, carried in a litter, to be brought to Arezzo and his mother's care. Giorgio describes the pathetic grief of his family and their fear that they might lose him, their main support. Fortunately a doctor in Arezzo, Baccio Rontini, cared for him, and "next to God restored him to life and health."[20]

[19] *M*, IV, p. 361.

[20] Frey I, pp. 11, 79.

11. Girolamo da Carpi (attributed to), *Cardinal Ippolito de' Medici and Mario Bracci.* London, National Gallery

The cardinal holds a paper identifying him as Vice-Chancellor, which he was created in July 1532. He seems more at home in his Hungarian dress than in his ecclesiastical robes. The attribution to Girolamo da Carpi must be considered doubtful, for Vasari knew him well, and surely would have mentioned a portrait of Ippolito, had he painted one.

In Rome he had been painting highly worldly themes for the cardinal, "a lecherous satyr gloating over a naked Venus" and suchlike subjects. These paintings, "gay and ridiculous" he called them, brought him into a new price category. For a *Venus and Three Graces* the cardinal paid him twenty scudi, the standard gold coin that was replacing the florin and the ducat. Two years earlier in Arezzo his total earnings for the year had amounted to seventeen scudi. He wrote a long letter about it all to Ottaviano, of the younger branch of the Medici, who had shown him much kindness and was to be one of his most understanding patrons. Ottaviano had remained in Florence during the siege, and had been imprisoned. Now in his early fifties he was a respected figure in Medicean circles, and in 1533, on the death of his first wife, had married Francesca Salviati, aunt of the young Cosimo de' Medici: "Madonna Baccia," Vasari wrote, "has been a mother to me."[21] There were other new friends, in particular Paolo Giovio, the well-known litterateur, much Giorgio's senior, whose lively letters, full of gossip and witticisms, were to be a constant part of Vasari's ever increasing correspondence.

In Arezzo his family affairs had been well cared for by his uncle, Antonio, but one of his brothers, aged twelve, had died of the plague in the army besieging Florence. In November 1532 he returned to

[21] Frey I, p. 8.

19

Florence, bringing with him to show to Duke Alessandro a painting of the *Entombment* that the cardinal, testing him out on a more serious subject, had commissioned [12]. Alessandro hung it in his room and when more than thirty years later Vasari wrote of it, it was hanging in that of Francesco, son and heir of Duke Cosimo. It still survives and shows the elongated bodies, muscular emphasis and closely posed grouping that were long to be characteristic of his work.[22] Ottaviano commissioned from him a portrait of Duke Alessandro, a work over which Vasari naturally took great pains, and which he filled with allegorical references to ducal rule [13]. "I near went out of my mind" in getting the "burnishing of the armor bright and correct." He asked Pontormo to come and advise him; the older painter told him he would never achieve the sheen of the real armor but that, if he put it away, his own painting would seem much better than he thought.[23] It was a

[22] A. Baldini in *Rivista d'Arte*, xxviii, 1952, pp. 195–97.
[23] *M* vii, p. 657.

12. Vasari, *Entombment*. Arezzo, Casa Vasari

"I made in a picture of three *braccia* a dead Christ carried by Nicodemus, Joseph and others to the sepulcher, which, when completed, Duke Alessandro had as a good and happy beginning of my labors."

Opposite

13. Vasari, *Duke Alessandro de' Medici*. Florence, Palazzo Riccardi

"I made a painting of Duke Alessandro from the life, with new inventions, and a chair of prisoners bound together and other fantasies."

lesson in the limits of naturalism. Pontormo was himself painting Alessandro, for the second time. Vasari shows him armed and heroic, Pontormo black-gowned with a paper in his hand, withdrawn and enigmatic. Bronzino's portrait, a weak, unreliable but arresting face, is the most convincing rendering of this strange, unfulfilled and now corrupted character. Vasari also painted an imaginary portrait of Lorenzo the Magnificent, and one of Alessandro's sister Caterina, the future Queen of France, a lively girl, who, in Vasari's absence, blackened the face of the portrait, "and would have put black on mine if I had not hurried away." An opportunity of another kind came when Alessandro employed him to finish in the Medici palace some scenes from the life of Julius Caesar begun by Giovanni da Udine. It was his first attempt at decorative work. The duke gave him two scudi a month and board and lodging for himself and his servant, Giambattista Cungi, while he was working on them.[24]

"Meanwhile the cardinal, in whom was the sum of all my hopes, died." It is thus, with a reflection on the vanity of earthly hopes, that Vasari writes of the death of his patron. Ippolito died at Itri on 10 August 1535. He had become the leader of the exiled Florentines, and men such as Baccio Valori, who after the siege had condemned the defenders of the city but had now changed parties, and the Strozzi family, themselves half Medici on their mother's side, were urging him to oust his cousin. There were rumors that his sudden death was due to poison administered by some emissary of Alessandro. Vasari must have heard the current talk, but Alessandro was now his protector, and he would not retail any scandal of him. He refers only to "certain calumnies," and the emperor, after going into the accusations, exonerated Alessandro, agreed to visit Florence, and to give him as wife his natural daughter Margherita.

These events meant much employment for the artists in Florence. Triumphal arches had to be erected for the emperor's entry. Vasari was entrusted with some of the work but ran into trouble with the twenty men under him, possibly unused to the pressure of work he expected from them. They refused to continue with him, encouraged by the jealousy of the Florentines for this young Aretine. "I am small of stature and as yet have no beard," was Vasari's explanation. He had hurriedly to summon to his assistance Cristofano Gherardi, Raffaellino del Colle, with both of whom he had made friends in Borgo S. Sepolcro in 1528, and his kinsman, Stefano Veltroni. They were to be the basis of Vasari's workshop. He had also in Florence a good friend, whom he had commended to Duke Alessandro and Don Ottaviano,

[24] In the *Opere* Vasari gives his salary as six scudi per month, in the *Ricordanze* two scudi. The latter, being a contemporary entry, is certainly right. In the *Opere* he gives his age at this time (1534) as eighteen, when in fact he was twenty-three.

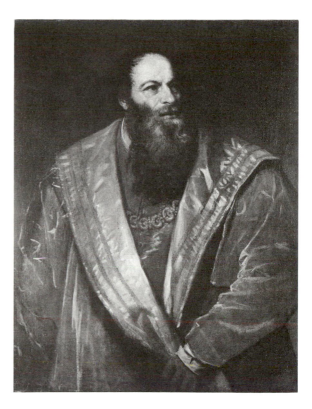

14. Titian, *Pietro Aretino*. Florence, Pitti Palace
Given by Aretino to Cosimo de' Medici in 1545.
Aretino himself criticized the brush work of the
picture, broadly painted as though, in his opinion,
Titian had not given sufficient time to the work.

Niccolò called Tribolo, an older man, but one with whom he was to
have constant cooperation. The work was carried through successfully
and the duke was much pleased with it, rewarding Vasari munificently.
Then the decorations had to be refurbished for the duke's marriage
with Margherita.

Vasari wrote by request long accounts of it all to his fellow citizen,
Pietro Aretino [14], in Venice, the scurrilous, lively protagonist of
Italian journalism. Vasari remembered as a child visiting his house in
Arezzo, a very much humbler place than his present Venetian estab-
lishment, but Pietro was little in his home town in Vasari's youth and
their contacts, given the disparity in years, cannot have been frequent.
There could be no greater contrast than that between the full-blooded,
foul-mouthed "Messer Pietro mio" and the cautious, correct and
businesslike Giorgio.[25] Pietro, however, always welcomed news, and
Vasari was very ready to provide it. The complex iconography of these
apparati, part allegory, part political comment, fascinated both of
them.

These splendors and employments were not to last. On 5 January
1537 the duke was murdered by his kinsman, Lorenzino, known con-
temptuously as Lorenzaccio, a worthless, debauched and unbalanced
young man. "So many swords, arms, hired soldiers, guards, citadels,"

[25] *Lettere sull'arte di Pietro Aretino*, III, pp. 499–515.

Giorgio wrote to his uncle, "could not protect him against one sword and two villainous traitors." On Giorgio the event left a permanent mark. "Worldly hopes, fortunes, favors, trust in princes and the rewards of many labors vanished in a breath." He determined, and Ottaviano encouraged him in doing so, "never to follow courts again, for he had lost his first master, Ippolito, and then Duke Alessandro."[26] In the turmoil following the assassination, he withdrew to Arezzo and when Cosimo, the youthful son of the great condottiere general, Giovanni dalle Bande Nere and of Maria Salviati, was established in the dukedom he seems to have made no effort to return to Florence.

The change-over at Florence, managed by the historian Francesco Guicciardini, politically a somewhat ambiguous character, had been smoothly carried out. Cosimo [15], only in his nineteenth year, soon showed a determination and a sense of government that took his supporters by surprise. Brought up by his careful and pious mother in uneasy and sometimes poverty-stricken circumstances, this young man, whose resolute features recalled those of his hard-fighting father, was quickly to be reckoned with. When the exiles attempted an attack on the city, financed, against his better judgment, by the wealthy banker, Filippo Strozzi, Cosimo defeated them at Montemurlo [16].

[26] Frey I, p. 76; *M*, VII, p. 660.

15. *Cosimo I*. Florence, Palazzo Riccardi

Once attributed to Pontormo, this is now held to be a later work from the Vasari school. It must, however, be based on some earlier version. There is a Pontormo drawing, and there may have been a finished painting from it. The short-cut hair is a new fashion. Earlier Ippolito de' Medici had, according to Scipione Amminato, cut Cosimo's hair with the remark "this is no time for long hair (*da usare la zazzera*)."

Opposite

16. Vasari, *Victory of Montemurlo*. Florence, Palazzo Vecchio, Sala di Cosimo I

In this work, based on a Roman triumph, the head of Cosimo is closely related to that in Fig. 15. The prisoners are, in the front row, Baccio Valori and his son, the old Filippo Strozzi, and Antonio Francesco degli Albizzi. "The young lord (*signorotto*) of Montaguto" is one of the officers presenting them. In the group behind Cosimo are Ottaviano de' Medici, Bishop Ricasoli and Sforza Almeni, all men whom Vasari knew well.

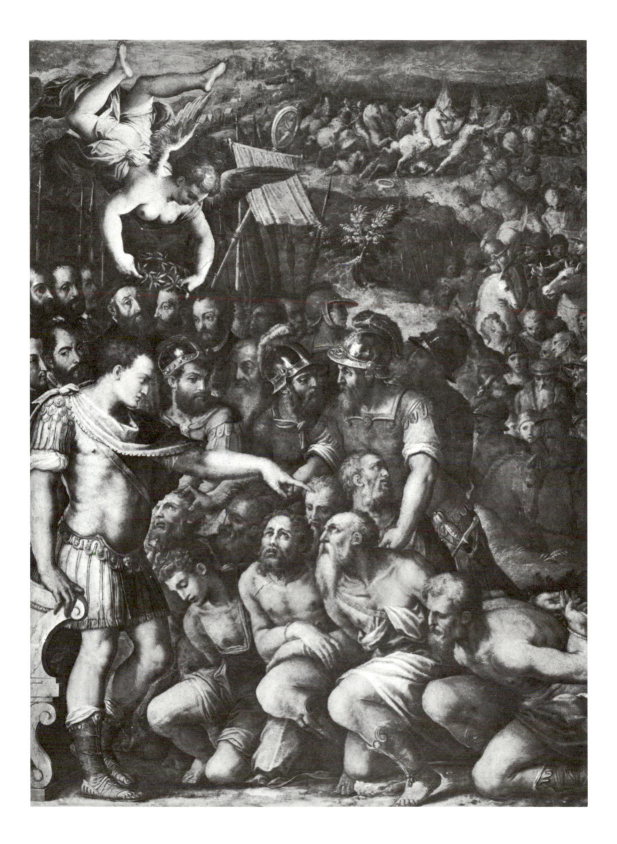

Executions followed, amongst them that of the turncoat, Baccio Valori; and Filippo Strozzi, after a year's imprisonment in the Fortezza da Basso, was found dead, leaving a moving letter invoking vengeance. His son Pietro had escaped and later was again to disturb Florentine affairs. Cosimo, having sought unsuccessfully the hand of Alessandro's widow, Margherita, who would gladly have stayed in Florence, married in 1539 Eleonora, daughter of the Spanish viceroy of Naples, Pedro of Toledo.[27]

All these doings Giorgio heard of from a distance. Shaken and disillusioned he remained in his home town. Here, on the profits made at the time of the emperor's entry into Florence, he had provided dowries for one of his sisters to marry, and for another—to whose dowry Vasari added a painting of the *Annunciation*—to become a nun in an Aretine convent. In one of his letters at the time he writes that love of his family has made him realize more and more the claims of servitude in courts, where men "are taken from you by poison or dagger when most you need them." He was painting a *Deposition* (now much damaged in SS. Annunziata, Arezzo) and finding peace of mind in meditating on the sufferings of the Savior. He was busied also in the chapel of the Company of St. Roch, whose work for the plague-stricken must have had a very personal meaning for him.[28]

The comforts of religion, which were, particularly in his disillusioned state, more than conventionally real to him, had other sources. Bernardetto Minerbetti became bishop of Arezzo in 1537, and soon took great interest in the painter. Of all Giorgio's correspondents he is the most critical and outspoken. He reveals himself in his letters as a man of high principle and integrity, and few better understood the young man and his problems. Another friend was Miniato Pitti of the prominent Florentine family, a monk of the Olivetan order, who had been one of his early patrons in Arezzo, commissioning a work from him in 1530. "A rare connoisseur of cosmography and of many sciences, particularly of painting," Vasari calls him.[29] It was a lifelong friendship, and through Miniato Vasari became the chosen painter of the Olivetan order throughout Italy, and known to all its leading figures. Miniato was a very different man from the bishop. Cheerful, good-natured, with robust common sense, his letters are full of anecdote, humor and consideration for others, and generally contain messages to Giorgio's assistants. The Olivetani had a house in Arezzo and were in 1547 to build larger accommodation amid the ruins of the Roman amphitheater. Vasari, who thought of Christianity as having been a great destroyer of antiquity, can hardly have approved. But

[27] L. Simeoni, *Storia politica d'Italia: Le Signorie*, Milan, 1950, ii, pp. 1018–64. For Cosimo see C. Booth, *Cosimo I, Duke of Florence*.

[28] Frey i, pp. 79, 86; B. F. Davidson in *AB*, xxxvi, 1954, pp. 228–29.

[29] Barocchi, *Michelangelo*, i, p. 23.

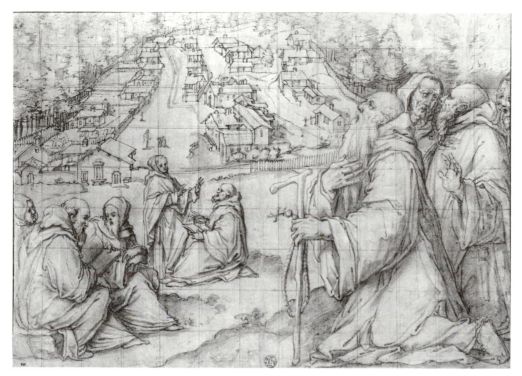

17. Vasari, *The Hermitage at Camaldoli*. Paris, Louvre, Cabinet des Dessins

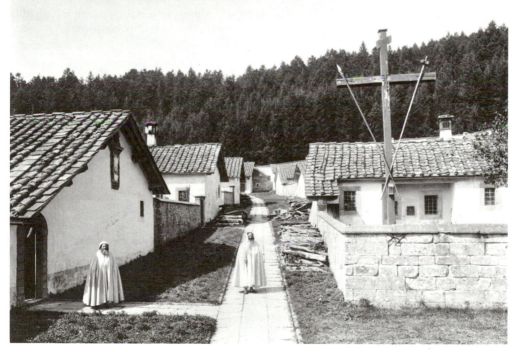

18. The Hermitage, Camaldoli
It is still a very peaceful spot, little changed since Vasari's time.

now it was another order with which he was to be associated, the Camaldoline monks, who in the hills of the Casentino had just completed a new church and wanted paintings for it. Giovanni Pollastra recommended Vasari to them, and for the next four years, 1537 to 1540, he spent part of the summer there, in the quiet of this Apennine height, soothed by the piety around him, admiring these monks who rose at early hours in the cold mountain air, allowing neither age nor infirmity to hinder their prayers [17, 18]. "Quivi il silentio stà con quella muta loquela sua"[30]—Here silence stays with its mute speech.

There was much in the monastic life that fascinated him and he constantly refers to its problems. He well knew that there could be much discord in monasteries, and that some entered them "out of cowardice and to avoid fending for themselves." But for the pious monk or friar who devoted himself also to creative work, the Camaldoline Lorenzo, the Dominican Fra Angelico or the Servite friar Giovanni Agnolo Montorsoli he had the greatest admiration, and did not hold it against the last that he had tried the Camaldoline order and found it too severe a test.

In this haven of peace his work matured. His *Nativity*, "una notte alluminata," was one of his most admired and much copied works. Here too he met a new friend, Bindo Altoviti, "my most cordial Messer Bindo" as he was to call him.[31] Altoviti had come to Camaldoli to arrange about large-sized tree trunks for the work on St. Peter's. An older man, the friend of Raphael who had painted him, he was a link with the great days of Rome before the Sack, and in his Roman palace, where he was frequently to stay, Giorgio must have found answers to many questions about Raphael and his followers. Altoviti was a wealthy and influential banker [19]. He was also strongly opposed to Cosimo de' Medici, this cold, calculating young man now firmly established in Florence, and had financed the Strozzi in their rising against him. In 1540, however, Cosimo was prepared to negotiate with Altoviti, and, taking the opportunity of these relaxed relations, the latter commissioned Vasari to paint an altarpiece for his family chapel in SS. Apostoli in Florence. The subject was the doctrine of the Immaculate Conception, which was shortly to receive renewed affirmation by the Council of Trent, and had had a long history of debate. Vasari not surprisingly found the subject intricate, and he and Altoviti consulted various learned men, but, whatever the advice given, the bound

[30] Frey i, p. 90.

[31] Frey i, p. 348; see C. Belloni, *Un banchiere del rinascimento, Bindo Altoviti*, Rome, 1935; and A. Stella in *Dizionario biografico degli italiani*, 1970. For the Raphael portrait, often attributed to Giulio Romano, see F. R. Shapley, *Paintings from the Samuel H. Kress Collection, Italian Schools*, London, 1966, p. 105, and L. Dussler, *Raphael: A Critical Catalogue of his Pictures, Wall-paintings and Tapestries*, London, 1971, p. 66.

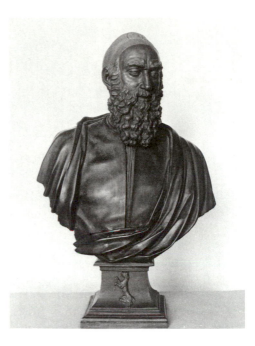

19. Benvenuto Cellini, *Bindo Altoviti*. Boston, Isabella Stewart Gardner Museum

This represents Altoviti at the age at which Vasari knew him. The bust, so Cellini tells us, was much praised by Michelangelo. It was in the Palazzo Altoviti in Rome (badly lit, Cellini complains) and must have been well known to Vasari.

figures of Adam and Eve and the serpent twisted round the tree go back to the scheme worked out in 1528 for Rosso by Pollastra [7]. Vasari realized the importance of this work for his reputation in Florence, and in order to have good working conditions he bought a house in Arezzo "in the best air of that city," and also arranged the marriage of his third sister. In the opinion of contemporaries, the *Allegory of the Immaculate Conception* [20] was one of his finest works. Vasari made a small replica for Altoviti and a larger version for Lucca, and other artists copied it.

Meanwhile he was briefly in Florence and back in Rome, where he continued to draw, this time architecture and sculpture and above all *grotteschi*, the old Roman decorations found in excavations, that had already been so great an inspiration to Raphael. Then it was Bologna, where Miniato Pitti had secured him a commission to decorate the refectory in the Olivetan convent of S. Michele in Bosco. On a hill overlooking the city this house had suffered much in recent wars and had been rebuilt between 1517 and 1523.[32] In this task, Vasari put to use his study of the *grotteschi* in a frieze along the walls, where ovals with scenes of the Apocalypse and rectangles with views of Olivetan monasteries are set in arabesques. His assistants were Giambattista Cungi, "who has served me faithfully for seven years," Cristofano Gherardi, and Stefano Veltroni, Giorgio's cousin. The last had been working with Vasari at Camaldoli, and all were tried collaborators. Gherardi had recently been banished from Florence. Some conspirators against Cosimo had approached him, and, though he had not

[32] A. Roule, S. *Michele in Bosco*, Bologna, 1963.

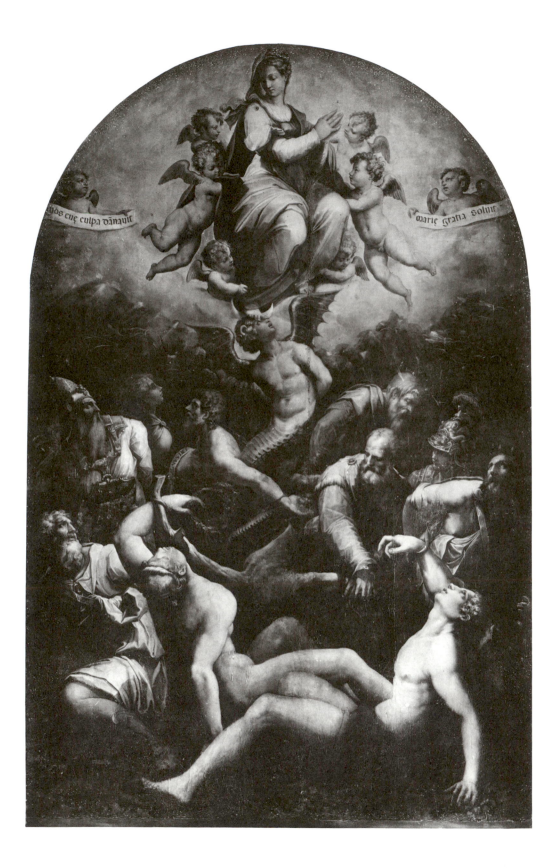

joined them, he had not delated them to the authorities, "as he should have done," Giorgio wrote in his *Vita*. But such political imbroglios did not affect Vasari's appreciation of his workmanship, and the decorations of the refectory certainly owe much to Gherardi's inventiveness. Vasari gives an appealing account of the team at work: how they all painted in competition on the frieze and Giorgio offered a pair of scarlet shoes to the one who should do best; how Cristofano piled up stools and chairs, and even pots and pans to stand on, and one day his haphazard erection collapsed and he had to be let blood and bandaged; how he was always allowing the bandages to slip and might have bled to death one night if Stefano had not discovered his plight. Vasari himself painted three large canvases for the walls, *The Feast of St. Gregory* [21], *Christ in the House of Martha and Mary*, and *Abraham and the Three Angels*, of which the second remains in the refectory. In the *St. Gregory* (Pinacoteca, Bologna) he gave the saint the features of Clement VII and showed behind him, leaning on his chair, Duke Alessandro, "in memory of the benefits and favors that I have received from him, and for having been what he was." The third painting, last heard of in Milan, has now disappeared.

On 1 December 1541 he was in Venice, having stopped en route at Bologna, Parma, Modena, Mantua and Verona. Aretino had summoned him to make designs for his new play that was being performed by the Sempiterni, one of the Compagnie della Calza, clubs of well-to-do young Venetians. It was an undistinguished piece about a Roman courtesan. Vasari brought three of his assistants, Bastiano Flori, Cristofano Gherardi and Giambattista Cungi, of whom the last two came by sea and were driven by a storm on to the Dalmatian coast. The designs received general applause despite the fact that much in them was based on Florentine and Roman fashions and was new to Venice. Other commissions were offered him, and in the Corner-Spinelli Palace he painted a ceiling; the scheme, with its illusionist perspective, was to have considerable influence in Venice, where Titian undertook at S. Spirito in Isola a ceiling originally offered to Vasari.[33] Giorgio,

[33] J. Schulz in *BM*, cⅢ, 1961, pp. 500–11; and see the same author's *Venetian Painted Ceilings of the Renaissance*. The Titian ceiling is now in the Salute.

20. Vasari, *Allegory of the Immaculate Conception*. Florence, SS. Apostoli

"Up till then, I had never done a work with more love and labor than this one." Adam and Eve and the prophets are bound to the Tree of Knowledge; above them is the serpent, on whose head the Virgin places her foot: QUOS EVAE CULPA DAMNAVIT, MARIAE GRATIA SOLVIT.

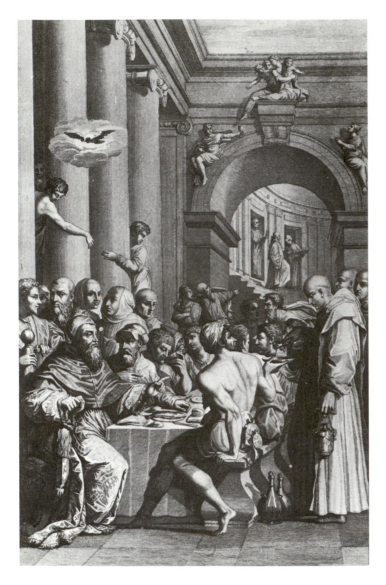

21. Vasari, *Feast of St. Gregory*
Engraving after painting in the Pinacoteca at Bologna. Drawn by Napoleone Angiolini (1799–1864), Professor of Fine Art in Bologna, and engraved by G. Tomba (1786–1841), this is an example of the repute Vasari still held as a painter in the early nineteenth century, before the long decline of his popularity set in.

however, was anxious to return to Tuscany, not without some complaints from sharp-tongued Aretino. He had undoubtedly met Titian and Sansovino, both intimates of Aretino, and also Michele Sanmicheli. Francesco Leoni, the Florentine banker with whom Vasari lodged in Venice, was a close friend of the Aretine coterie. Giorgio purchased for Ottaviano de' Medici a painting by Schiavone, but "the finest painting in Venice" seemed to him one done two years earlier by Francesco Salviati in the palace of the Patriarch Grimani.[34]

[34] M. Hirst in *ZfK*, xxvi, 1963, pp. 146–65.

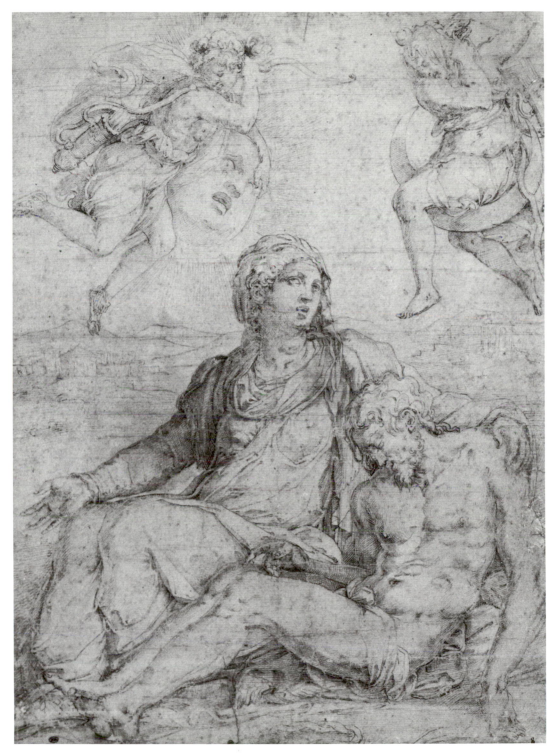

22. Vasari, *Pietà*. Paris, Louvre, Cabinet des Dessins

33

The experience in wall and ceiling decoration was now used by
Giorgio in painting his own new house in Arezzo [109]. Soon, how-
ever, he was in Rome, summoned there by Bindo Altoviti, who gave
him rooms in his Palazzo and commissioned a *Pietà* from him, a strange
work, known to us by a drawing for it in the Louvre [22]. Above
the mourning Virgin, Phoebus and Diana obscure the sun and moon,
a pagan intervention into the Christian tragedy, and one borrowed
from Rosso. Altoviti's favor secured Vasari another patron, Cardinal
Alessandro Farnese. He requires some introduction for much will be
heard of him. His father was Pier Luigi, the son of Paul III, born dur-
ing his cardinalate and in 1545 created Duke of Parma, only, very
understandably, to be assassinated two years later. Alessandro's two
brothers, Orazio and Ottavio, married respectively Diane, natural
daughter of Henri II, and Margherita, natural daughter of Charles V
and widow of Alessandro de' Medici. Titian's family group of the
pope, cardinal and Ottavio [23] is a most convincing representation
of this extraordinary and on the whole repellent family. Alessandro,
outliving his brothers till 1589, was at least a great patron of the arts.
For him Vasari painted an *Allegory of Justice*, admired at the time
when these symbolic intricacies were much in vogue, but today prob-
ably one of the least pleasing of his works [24].

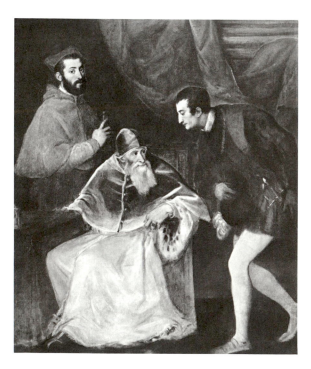

23. Titian, *Paul III with his Grandsons, Cardinal
Alessandro and Ottavio Farnese*. Naples, Capodi-
monte

Painted during Titian's visit to Rome in 1546,
Vasari tells us it gave great satisfaction to the
sitters.

Opposite

24. Vasari, *Justice*. Naples, Capodimonte

Justice has one arm round an ostrich, carrying
the Twelve Tables; with the other arm she crowns
Truth presented to her by Time: Corruption, Ig-
norance, Cruelty, Fear, Treachery, Envy and Mal-
ice lie at her feet, bound by chains to her girdle.
It is a singularly bizarre piece, but was much to
the taste of the times.

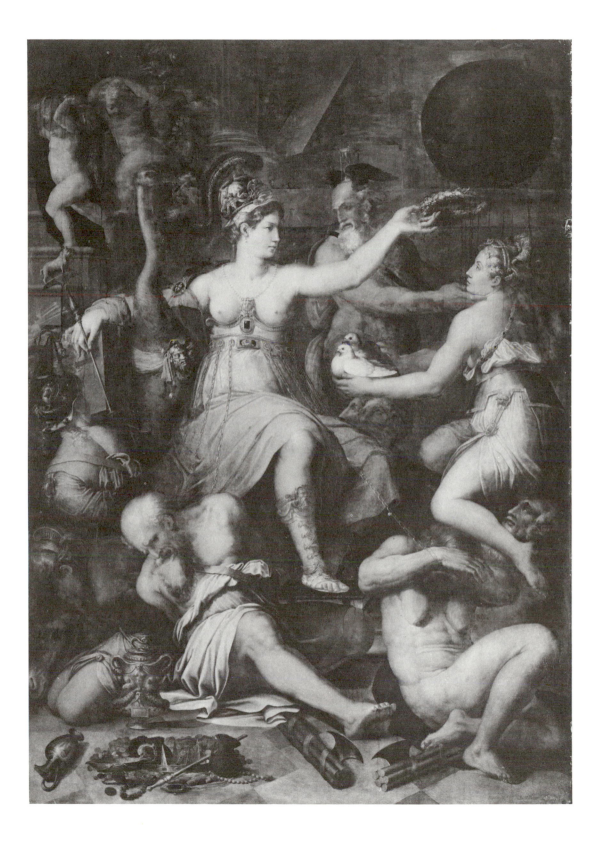

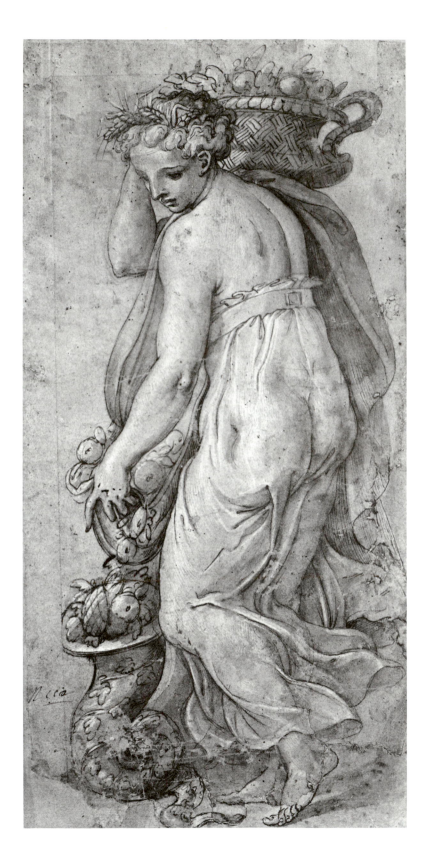

Vasari was next in Naples, commissioned by the monks of Monteoliveto, the order that employed him so much, to paint their refectory, a task for which he felt some reluctance when he found it was a vaulted room, low and badly lit, "d'architettura antica," "old-fashioned and clumsy." It was only at the urgent request of his close friends, Miniato Pitti and Ippolito of Milan, both at that time visitors of the order, that he agreed to proceed with it. He had the ceiling remade with stucco and on it painted Faith, Religion and Eternity, surrounded by the Virtues, "so as to show to the monks eating in the refectory the perfection of life required of them." Round the allegories [25] in the roof are grotesque decorations, and on the walls were biblical scenes, in particular on the end wall a *Feast in the House of Simon the Pharisee*, divided into three parts, of which the wings are genre scenes of the servants and a well-stocked sideboard. The ceiling survives, despite war damage to the church. Vasari is probably right in his claim that he brought the modern style to Naples. Certainly he was much in demand and began to work on the refectory of the Augustinian monks at S. Giovanni a Carbonara. The viceroy, Pedro of Toledo, Cosimo I's father-in-law, also commissioned him to fresco a chapel, but this pressure of business led to a quarrel between the viceroy and the Augustinians, ending in a riot in which some of Vasari's workmen were involved. With his usual caution, "not caring to remain in Naples," he returned to Rome.

With enlarged experience from the Neapolitan work, Vasari now received one of his greatest commissions, the frescoing of the great hall in the Palazzo della Cancelleria [26, 27]. "The room is more than 100 palms long, with a height and breadth of fifty," and the cardinal was anxious for its rapid completion. The subjects were taken from the life of the Farnese pope, Paul III (1534–49), and included many portraits of Vasari's friends, with inscriptions composed by Paolo Giovio. One of these claims that the work was completed in a hundred days. "It would have been better," Giorgio admits, "to have toiled for a hundred months, and not have had to depend so largely on the work of apprentices." The frescoes are Vasari at his most grandiloquent, and it is well to accept the exuberance of the decorative effect without lingering

25. Vasari, *Abundance*. London, British Museum
 This beautiful drawing was for one of the figures on the ceiling of the refectory of Monteoliveto at Naples. The painted figure is still in position, and its heavier treatment shows the hand of an assistant.

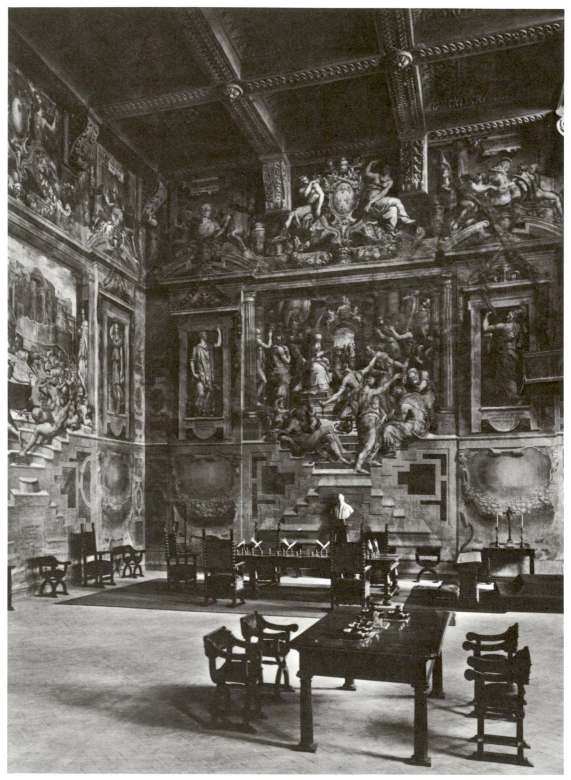

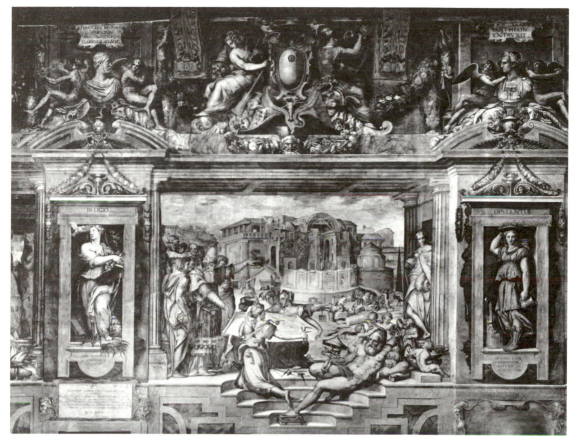

27. Vasari, *Pope Paul III and the Building of St. Peter's.* Rome, Palazzo della Cancelleria, Sala dei Cento Giorni

Painting, Sculpture and Architecture kneel before the pope displaying a plan; in the background St. Peter's, with its apse and crossing still waiting completion.

Opposite

26. Rome, Palazzo della Cancelleria, Sala dei Cento Giorni

"The cardinal decided that it must be done with the greatest possible speed, to be ready by a fixed date." There is a large *storia* on each end wall, and two on the side wall opposite the windows. From some of the scenes depicted, painted steps seem to lead down into the room, and the niches are in feigned perspective, creating an illusion of openings into further space. Whatever the clumsiness of some of the detail, it is an impressive decorative scheme.

over the details and individual figures, with their derivative poses and lack of meditated invention.[35]

It was about this time, however, that Vasari undertook a work of far greater importance. The genesis of the *Vite* must wait for later discussion, but now till the publication of the first edition in 1550, Vasari was busied with an immense commitment of research and compilation. One can only wonder at his energy and application, for his writing hardly seems to have held up his painting. It was during this period in Rome that Vasari came to know Michelangelo well and to do much *servitù* for him, probably acting as a general factotum for any odd jobs. There is no doubt that Michelangelo depended on him, and found his devoted service often useful, but there is at times a note of irony in his letters to his "dear Messer Giorgio," and the latter's idolization of him must often have been tedious. "If," Michelangelo once wrote, "I deserved but one of the many praises you give me, I would have done something and paid some small part of the debt I owe you."[36] For Vasari, the most immediate result of this friendship was Michelangelo's insistence that he should turn to architecture. "I might never have done this, but for his encouragement." He was now in his late thirties, with no previous architectural training. Despite all his activities, he was to become a very competent practitioner, "un architetto molto adoperato."

For the moment, however, he was concerned with a more personal matter. Cardinal Gianmaria del Monte had been talking seriously to him about matrimony. "He persuaded me with such good reasons that I resolved to do something, which hitherto I had not wished to do, that is to take a wife." Wives do not figure very prominently in the *Vite*. If few receive such unfavorable notice as Andrea's wife Lucrezia, they are as a whole regarded as a hindrance. He wrote of Franciabigio: "He liked to live in peace, and never took a wife, quoting the trite proverb, 'Who has a wife, has pain and grief.'" Wives are usually considered an encumbrance that prevents artists moving to new centers for their work. Many of the artists were, in fact, unmarried. Some of the main rewards that went to them, particularly in Rome, required the holding of a celibate office, notably the post of Frate del Piombo, which entailed somewhat nominal work in charge of the leaden seals for papal bulls and had an annual revenue of 800 crowns. Vasari in his

[35] A. A. Ronchini, "Vasari e la corte del Cardinal Farnese," *Vasari*, II, 1928–29, pp. 273–84. For the subjects of the frescoes see the letter of Antonfrancesco Doni, 1547, in G. Bottari and S. Ticozzi, *Raccolta di lettere*, Milan, 1822, v, no. 37. For the traditional comment made by Michelangelo when told of the completion of the work in a hundred days, "E si vede" ("So it appears"), see Barocchi, *Michelangelo*, IV, p. 2092.

[36] Frey I, p. 305.

youth had thought of this as one of the goals of his ambition, but it had for some time been held by Sebastiano del Piombo, and on his death in 1547 it had been given to Guglielmo della Porta. Vasari may well have decided that this prize was not for him, and sagely reflected that this assured means had made both Fra Sebastiano and Fra Guglielmo very idle.

Other considerations prompted matrimony. His mother, whom he had brought with him to Rome, was now elderly, and there was his new house in Arezzo that required someone to look after it. It was all approached in a cold-blooded, deliberate manner, and at first there was clearly no particular lady in view. There was, too, a good deal of chaffing from his friends. Paolo Giovio wrote that Cardinal Farnese had laughed much when he heard that Giorgio wished to take a wife, and Giovio added on his own "Don't buy a cat in a sack. . . . remember Andrea del Sarto. . . . Roman wives make cuckolds, Aretine wives have small dowries, the Florentine merchant class is best. . . . I suppose you can say you are marrying to avoid sin and the French disease." There seem few grounds for Giovio's suggestion. Vasari's comments on those who allow loose living to interfere with work are so constant that they must be genuine. "He did no little harm to his art," he wrote of Girolamo da Carpi, "by spending too much time on amorous pleasures and playing the lute." When Don Ippolito, general of the Olivetans since 1546, wrote to say how glad he was that Giorgio had brought his mother to Rome, it was because she would keep an eye on his consumption of Cretan malmsey, not on any sexual lapses.[37]

The eventual choice fell on Niccolosa Bacci, the daughter of well-to-do Aretine apothecaries, whose Palazzo still survives and who had in the previous century financed Piero della Francesca's frescoes in S. Francesco. She seems to have been suggested by Pietro Aretino, and Vasari set about some hard bargaining over the dowry. His new friend, Vincenzo Borghini, acted for him and advised him not to hold out for 1000 florins, but to accept 800. The two were married in January 1550, and in February Vasari was back in Rome, where Cardinal del Monte had been elected pope as Julius III. Cosina, as his wife is always called, was left in Arezzo. It was not a romantic match, and it was childless. Bishop Minerbetti of Arezzo was worried over Vasari's long absences, and wrote rebuking him, saying that he cared more for gain than progeny. It does not, however, seem to have been a failure, and there will be more said later about Cosina and her part in Vasari's life. She figures as one of the muses in a painting in his Arezzo

[37] Pecchiai (*Le vite*, ɪ, p. xix, n. 9) appears to think that Don Ippolito's letters (Frey ɪ, pp. 207, 216) refer to wenching not drinking, but I cannot agree with this interpretation of *malvasia Candiotta* (Candian malmsey).

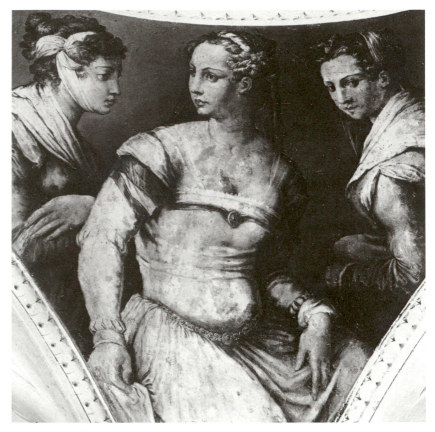

28. Vasari, *Three Muses* (detail). Arezzo, Casa Vasari
The central figure is a portrait of his wife, Cosina, painted very shortly after their marriage in 1550.

house [28]. He had also painted, as he tells us, "as it were jestingly, a wife who in one hand holds a rake, showing that she has raked up all she could from her father's house, and in the other a lighted torch, showing that wherever she goes she brings the fire that destroys and consumes." It is to be hoped that Cosina thought the joke amusing. But if 1550 saw this step in his personal affairs, it also saw an event of far more lasting consequence, the publication of the first edition of the *Lives*.

II. The Book

In his autobiography Vasari gives a celebrated and much quoted account of the genesis of the *Vite*. At a gathering one evening, when the group of literary men round Cardinal Farnese came to talk with him while he dined, the discussion turned on the paintings of illustrious men collected by Paolo Giovio [29], the bishop of Nocera, and on the eulogies, elegant Latin epitaphs, that he had published on them. Giovio, at this time a man of about sixty, a survivor of the great days of Rome before the Sack, could speak with accepted authority, and he suggested the need for a treatise upon famous artists from Cimabue to the present time. The cardinal turned to Giorgio asking if this would not be a fine work, to which he replied that it would indeed be excellent, but that Giovio would need "someone of the profession" to help him over technical details. They all then urged that Vasari should be such an assistant, but when later he took Giovio some of his notes, the latter insisted that he, Giorgio, should himself undertake the work. The others of this group of friends, Molza, Caro and Tolomei, made the same plea, and so Vasari agreed to undertake it. "My account," Giovio said to him, "would more resemble a treatise such as that of Pliny." This is the only hint that Vasari gives of one essential and all-important result of this change of authorship. Giovio, who could lament that the plays of Plautus and Terence, once a school of Latin style, had been replaced by comedies in Italian,[1] would have written in Latin. Vasari, though as a boy he had had training in Latin, could not have competed with the humanists. Like his fellow Tuscan historians, Machiavelli and Guicciardini, he used the vernacular, and thereby was available to readers ever growing in numbers with the progress of printing.

Characteristically Vasari leaves us in some doubt as to the date of this meeting. His description of it may well be a literary set piece, summarizing a more gradual process. "At this time," he writes, following the account of his visit to Naples from November 1544 to September 1545, and his frescoing of the hall of the Palazzo della Cancelleria, the "hundred days" which began in March 1546. On the other hand,

[1] G. Tiraboschi, *Storia della letteratura italiana*, 9 vols., Florence, 1805–12, VII, Pt. IV, p. 1698.

29. Francesco da Sangallo, Memorial to Paolo Giovio in the cloisters of S. Lorenzo, Florence

The statue is signed and dated 1560, eight years after Giovio's death, but seems a lively and convincing representation of the man.

in the discussion about the *Vite* he twice mentions the poet, Francesco Maria Molza, who had died in February 1544, "slain," as he himself says in his moving deathbed poem, "before his day by wasting sickness."[2] Molza was a much talked of man. His attack on Lorenzino de' Medici for mutilating some ancient statues in Rome was said to have provoked the hubristic passion in which the latter murdered his cousin, Alessandro. It is impossible that Vasari could have included the name of this somewhat notorious friend if he had in fact been two years dead, so that the gathering at the cardinal's dinner must be placed in the year 1543, before the month of July when Vasari left for Lucca and then Florence.

[2] J. A. Symonds, *The Renaissance in Italy: The Revival of Learning*, London, 1915, p. 356, and *Italian Literature*, London, 1909, Pt. II, pp. 195–203. F. Baiocchi, "Sulle poesie Latine di Francesco M. Molza," *Annali della R. Scuola Normale Superiore di Pisa: Filosofia e Filologia*, XVIII, 1905, p. 172. Baiocchi assumes a lapse of memory on Vasari's part: it seems much more probable that Vasari's "at this time" is a very generalized statement.

Seven years, from 1543 till the publication of the first edition, was a short enough period for the completion of the work, carried out as it was along with regular commissions for paintings. As Giovio said in a letter to Giorgio, "You are a gallant man and are wont to achieve what you promise."[3] Vasari acted with his usual despatch. He soon had notes on the project ready for Giovio, and the discussion in Rome must have brought to a head something that he had long had in mind. Many lesser books have been brought to birth in similar ways. "Ten years' work," he called it in a letter of 1550 to Duke Cosimo. At Bologna in 1539 he had "wanted to see the famous paintings of the city" before starting work in S. Michele in Bosco. In 1541, on his journey to Venice, "in a few days I succeeded in seeing the works of Correggio in Parma and Modena, those of Giulio Romano in Mantua, and the antiquities of Verona," a town he thought "by site, customs and other details" very like Florence.[4] On his return he went by Ferrara, where he was hospitably received by Benvenuto Garofalo. That indeed during these visits he was busy taking notes is shown by the detailed accuracy with which he describes works in these towns, an accuracy that is stressed by the brief references that are all he can give to works not personally known to him. Padua on this occasion he did not visit, rather surprisingly, and of the Arena chapel he merely states that Giotto painted there "una Gloria mondana," presumably the *Last Judgment*, and he does not enlarge on this in the second edition. It seems likely that he never saw Giotto's greatest work. Meanwhile in Florence he was questioning those who had known the artists of the quattrocento, looking at their tombs, noting inscriptions and reading earlier accounts of them. His strong Tuscan bias was stated from the first. In the prefatory letter to Duke Cosimo he writes that the men who had resuscitated the arts, bringing them to that "degree of beauty and majesty where they are today," were almost all Tuscans, members of the Medici state and much indebted to the patronage of the family. It was a point of view that was to be frequently repeated.

Giovio had continued to encourage him with the work. "Write, brother mine, write . . . you will be more joyful, more famous and more rich by this fine work, than if you had painted the chapel of Michelangelo, which is perishing with saltpeter and cracks." By 8 July 1547 Vasari reported that the work was finished, and in October he took the whole manuscript to Rimini, where Don Gianmatteo Faetani, prior of the convent of Vasari's faithful friends, the Olivetans, had undertaken to have a fair copy made. One would like to know more

[3] Frey I, p. 134.
[4] *M*, v, p. 274.

of this literary relationship, for Faetani was a strange and passionate character, who ended on the scaffold at Gubbio for killing a brother abbot.[5] Vasari remained in Rimini till May of the following year, painting in the Olivetan church of S. Maria di Scolca outside the town, and also at the order's church in nearby Ravenna, presumably in part return for the work on his manuscript, though he received also, after some dispute, a payment of 300 scudi for expenses.[6] Meanwhile sections of his book, possibly scripts made available as the fair copy progressed, were circulating amongst his friends. Annibale Caro, one of the original begetters of the work at the cardinal's dinner, wrote him a very discerning letter on his style, which was "a punto come il parlare," exactly as spoken, and this was how it ought to be in such a book. He asked him to change a very few passages where words had been transposed "for elegance" but which jarred with the general effect.[7]

Giorgio himself was obviously much exercised about his literary qualifications.[8] In the concluding section, "To the Artificers and the Readers," in the first edition he goes into a long explanation of how he has written as a painter, without considering whether the language is Florentine or Tuscan, and using terms "scattered throughout the work" that would be understood by artists, even if not in general use. He has not bothered himself about orthography, wondering whether a Z is better than a T, or whether one can write without an H. Kind friends have been through it all, trying to make it as consistent as possible, and at any rate teaching Tuscan is not the aim of the work. In the second edition this passage is approached with more confidence. The problem of orthography is not mentioned, nor the cares of his friends in correcting the text. "I have left ornate and long periods, the nice choice of words and the other ornaments of learned speech and writing to those who are not, as I am, more used to handle a brush than a pen. . . . I have done what I know how to do, accept it willingly, and do not ask from me what I do not and cannot know, satisfying yourselves with my goodwill, which is and will be always, to help and please others." These final words of the lengthy book do not entirely represent the facts. Vasari was no stranger to the literary formulas of the time, the carefully cultivated rhetoric that was being imposed upon the vernacular. He often, particularly in the moralizing introductions, indulges in long, intricate passages, where sense and sound

[5] A. Tosi, "Giorgio Vasari a Rimini," *Vasari*, xii, 1941, pp. 43–49. For Faetani's possible influence on the style of the *Vite* see Scoti-Bertinelli, *Vasari scrittore*, pp. 207–09.

[6] Frey i, p. 219.

[7] Frey i, p. 210.

[8] Scoti-Bertinelli, *Vasari scrittore*; C. Naselli in *Studi Vasariani*, pp. 116–28; Rouchette, *La Renaissance*, pp. 409–33.

form an elaborate pattern. Throughout rhythm is practiced, frequently at the expense of making two epithets serve the meaning of one. Giorgio was in fact a master of several styles: pompous official language, used for communications with Medici princes and some more formal passages of the *Vite*; a professional command of technical terms; and everyday colloquialisms and humorous slang which he sometimes employed in letters to intimate friends ("your *Fiorentinuccio*" Miniato Pitti called it),[9] and which only rather distantly are echoed in the anecdotal sections of the *Lives*. Much of what he writes can stylistically be very pedestrian, not surprisingly given the circumstances of its composition, "the fatigues, the toils, the expense that this work has cost me," but he could coin memorable and sometimes moving phrases, when he allowed more personal feelings for a moment to intervene in the pressure of organizing his material. "Those that have tried what a thing it is to write, will hold me excused."

Pietro Aretino's name was always good for publicity and Giorgio wrote to him asking for some verses to append to the work, but Pietro replied that he was so busy with an edition of his own letters that he could hardly get any sleep, and could not take on any more work. There was much discussion about the title, which seems in the end to have been decided by Giorgio. In September 1549 another name appears, Vincenzo Borghini, who was to play such a large part in the preparation of the second edition. Vasari sent him the index of the work. This in itself requires some comment. For a book of this period the index is unusually full, divided into four parts: the chapters of the introduction, the actual *Lives*, other artists mentioned, and places where there are works of art described. Whether this arrangement is due to Borghini or not, he was from now on to be Giorgio's main consultant. He was a Florentine, four years younger than Vasari, "a man most notable not only for his nobleness, goodness and learning, but also for his love and understanding of the arts."[10] He had been consecrated priest in 1541 by Bishop Minerbetti of Arezzo, and it may well have been through him that he had met Giorgio. In 1551 he was appointed by Cosimo prior of the hospital of the Innocents in Florence, that familiar building with its della Robbia children, but he resided much outside Florence at the Augustinian convent of Le Campora or at the Villa Poppiano in the Val di Pesa with the fortunate result that there was much correspondence between the two of them. The printer was a Fleming, Laurens Lenaerts van der Beke, known in Florence as Lorenzo Torrentino, and ducal typographer there since 1547. Giorgio was well aware how "useful" was the invention of "Giovanni Guittemberg," and how books increased a man's fame, because

[9] Frey I, p. 164. [10] *M*, I, p. 25.

they could easily circulate.[11] Two other Florentine friends, Cosimo Bartoli and Pierfrancesco Giambullari, undertook to see it through the press. Perhaps almost too many people were concerned, for all these efforts did not avoid an occasional lacuna where a word had never been filled in, or certain fairly obvious misprints. There was some delay, owing apparently to a dispute in the printer's office, but in May 1550 the book had appeared [30].[12]

Unfortunately we do not know how many copies were printed, and the size of editions of the time has not been fully explored. When in 1563 an inventory was taken of the Torrentino printing office, the stock is only described as "A good number of printed books." It is clear, however, that the book was received with considerable enthusiasm. To Giorgio himself one of the most welcome tributes must have been a sonnet from Michelangelo.

> With pencil and with palette hitherto
>> You made your art high Nature's paragon;
>> Nay more, from Nature her own prize you won,
>> Making what she made fair more fair to view.
> Now that your learnèd hand with labour new
>> Of pen and ink a worthier work hath done,
>> What erst you lacked, what still remained her own,
>> The power of giving life, is gained for you.
> If men in any age with Nature vied
>> In beauteous workmanship, they had to yield
>> When to the fated end years brought their name.
> You, reilluming memories that died,
>> In spite of Time and Nature have revealed
>> For them and for yourself eternal fame.[13]

[11] *M*, II, p. 540.

[12] G. Hoogewerff, "L'editore del Vasari: Lorenzo Torrentino," *Studi Vasariani*, pp. 93–104; for a discussion of sizes of editions at the time, see E. Armstrong, *Robert Estienne*, Cambridge, 1954, p. 38.

[13] J. A. Symonds, *The Sonnets of Michael Angelo Buonarroti*, London, 1878, p. 12: there are other translations, but this, despite its Tennysonian overtones, seems to me to come nearest to the feeling of the original. Symonds's translation of *stile* as pencil is anachronistic. For another translation see C. Gilbert, *Complete Poems and Selected Letters of Michelangelo*, New York, 1963.

30. Title page of the first edition of Vasari's *Lives*
 The words "in lingua Toscana" do not figure in the title page of the second edition [37]. The use of the vernacular was by then more generally established.

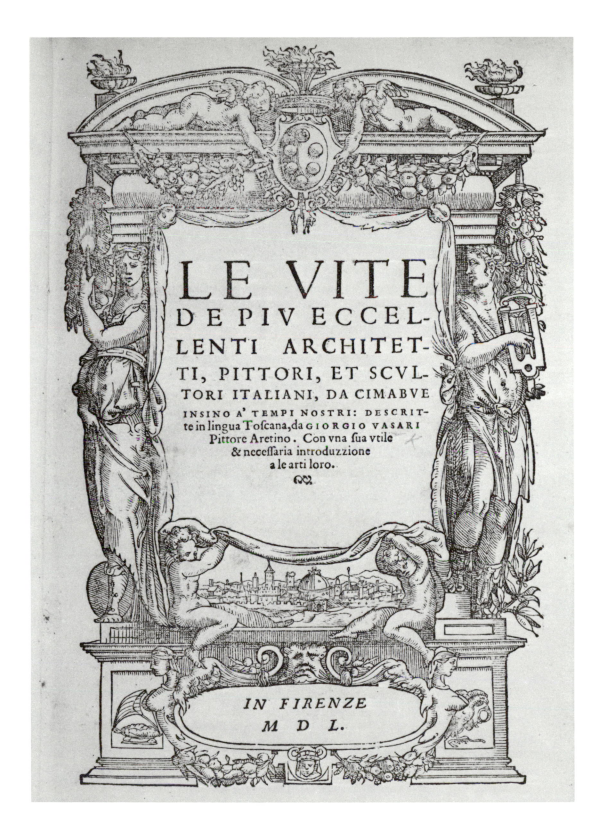

LE VITE

DE PIV ECCELLENTI ARCHITETTI, PITTORI, ET SCVLTORI ITALIANI, DA CIMABVE

INSINO A' TEMPI NOSTRI: DESCRITte in lingua Toſcana, da GIORGIO VASARI
Pittore Aretino. Con vna ſua vtile
& neceſſaria introduzzione
a le arti loro.

IN FIRENZE
M D L.

"The fine book of the famous painters will certainly make you immortal," wrote Giovio. "These works you did in Naples, under that tyranny of fat and greasy *fritture*" (Giovio always writes about food) "in the end will be cheated (*cacoboldole*), consumed by saltpeter and woodworms, but that villain time cannot consume what you have written."

In his preface to the second book Vasari sets out his view of the historian's duty. The true historian is he who knows that history is "the mirror of human life," not a dry chronicle of facts, and who indicates "the judgments, counsels, courses and handling of men" that are the causes "of fortunate and unfortunate acts." His book is about people, and how their doings furthered or hindered the progress of the arts. What these arts were he defines in a technical introduction where his impressive expertise is shown to great advantage and which remains the most complete statement of Renaissance methods, a handbook for his time and now for restorers today. He tells us in the preface that he follows schools rather than chronology, but later asserts that he is following a chronological order, and this is actually the framework of the book. The arts resemble nature and have their birth, growth, age and death. It is an analogy that gives him a certain uneasiness. The arts may, from the high achievement they have reached, decay again: if "which God forbid" this should come about, then at least in this book there will be some memorial of past greatness. But if there is death, there is also rebirth, *renascità*, renaissance.[14]

Chronology, in the remoter periods, involved him in difficulties. He arrived, how is often far from clear, at datings of artists that are now demonstrably wrong, such as his belief that Cavallini and Duccio were younger than Giotto, or that Masaccio lived till 1443. Someone or something must have led him to such conclusions, but he had a poor head for dates, accuracy in which was then little regarded, and even in dealing with his own life he makes contradictory statements about them. Many people, Titian for instance, were equally uncertain of their own exact age. He was not even consistent in his ordering of the *Lives*, and explains that he has put Nanni di Banco before Donatello, because though younger, as Vasari probably wrongly thought, he died much before him. And when it comes to medieval history he is random to a degree. Popes and emperors are wildly confused, and none of his advisers seemed aware of these mistakes. Innocent IV becomes a friend of Manfred, Benedict XI appears as Benedict IX, and Gregory XI, "who returned to Italy after the papacy had been so long in France," a subject Vasari was later to paint in the Sala Regia, undergoes the same numerical transposition.

[14] The famous term appears in the preface, *M*, I, p. 243.

The form adopted by him involved other considerations. Each life was a short tale, illustrating some facet of human nature: thus Simone Martini through his friendship with Petrarch typifies those whose fame is preserved by writers; Uccello is an example of immoderate devotion to one branch of his art, perspective; Leonardo da Vinci is the greatly endowed genius who through a certain fickleness sets himself to learn many things, and, once begun, abandons them. This is the method of the Italian *novella*, of which Boccaccio was the great exemplar. Franco Sacchetti's *novelle* were still unprinted, though circulating in manuscript, when Vasari's first edition appeared, but Borghini drew his attention to them for the second edition and the stories about artists that they contained. His knowledge of the work of Bandello presents something of a problem: Bandello's *novelle* were not published till 1554 in Lucca, but in the *Life* of Filippo Lippi Vasari's account of the friar escaping from a window by making a rope of his bedclothes corresponds verbally with a passage from Bandello's *novella* LVIII. It is possible, even though Bandello was then in France, that the *novelle* were available in manuscript; or Bandello may have taken the passage, for his printed work, from the *Vite*; or more likely they both had some common source. What other *novelle* Vasari knew are nowhere mentioned; almost certainly they included those of his friend Molza, probably those of Grazzini and of Agnolo Firenzuola, but most writers tried their hand at them and they are the popular side of Renaissance literature. Vasari could hardly escape their influence.

The *novelle* inspired the setting; for the matter he had other sources.[15] "According to Lorenzo Ghiberti" is a common phrase in the earlier lives, and Vasari knew and used, sometimes simply paraphrasing, Ghiberti's *Commentaries*, of which Giorgio's invaluable friend, Cosimo Bartoli, had a manuscript. He had, however, no great opinion of them, and in the second edition, with the confidence of his own success, complains that Ghiberti wrote much too briefly of earlier artists, so as to bring out his (Ghiberti's) work the more strongly. Much as he admired the creator of the doors that were "the finest masterpiece of the world whether amongst the ancients or moderns," Vasari could not forgive Ghiberti's opposition to his great hero, Brunelleschi, in the disputes within the Opera del Duomo. He knew, however, some of the Ghiberti family, particularly his great-grandson Vittorio, and from him he had access to various family papers. He remembered seeing the furnace which Ghiberti had used for casting the Baptistery doors. Ridolfo Ghirlandaio showed him his father's papers, which included some accounts now lost of trecento artists.[16]

[15] Kallab, *Vasaristudien*, is the essential account of the sources: see also Murray, *Index of Attributions*.
[16] *M*, I, p. 452.

Chronicles were another source, particularly Villani's, and Cristofano Landino's commentary on Dante, either directly or in the use made of it in the *Libro di Antonio Billi*, another work much consulted by Vasari. For his account of Brunelleschi he borrowed from the anonymous biography formerly attributed to Antonio Manetti, and nowhere else did he have so exhaustive a study on which to base his own judgments. From other chronicles he borrowed here and there, Villani, Leonardo Bruni, Giambullari, Guicciardini, Platina, the *Commentaries* of Pius II, the *Life of Nicholas V*, the writings of Paolo Giovio. He searched also through inventories and records of churches, monasteries and guilds. He copied inscriptions, not always accurately, and on his travels consulted, though it must have been rapidly, any manuscripts or books to which his attention was drawn, such as the letter from Girolamo Compagnuola to Leonico Tomeo about the arts in Padua, or Torello Saraino's book on the antiquities of Verona, which Giovanni Francesco Caroto had sent him along with a portrait of Don Cipriano, master-general of the Olivetani, needed by Vasari for work in S. Michele in Bosco. And all the time he was acquiring verbal information from "those who had known them." What he did not consult, and no doubt they were much less accessible then than now, were the Florentine state records, particularly the tax returns or *catasti*, from which has come so much information about the date of death and the life span of the artists. In the great flood of 1557 the papers of the Monte, the finance department of Florence, were so badly damaged that Cosimo had Vasari, who by then was his chief architect, prepare a depository for them in the Palazzo di Parte Guelfa. It is curious to think that amongst the papers he was rehousing was so much material from which so many corrections were to be made to his own book.

It was weary work, and Giorgio writes that he would often have despaired of it, had it not been for the encouragement of his friends, and that if something stated in one place is repeated in another, it is because of delays in collecting the material and constant interruptions between the writing and printing. With all his other commitments he owned it was almost impossible to avoid mistakes. Errors and inaccuracies there were and inevitably these have been emphasized by the correction of them. Vasari was attempting a vast-scale work for which there was no precedent. Printed sources were very few, and a manuscript once read might not easily be again accessible. There were no books of reference. His own note taking, with the pressure of his other commitments, had always to be hurried. Even terminology for much of what he wrote was uncertain and only established by his use of it. Anyone who has worked over the same field, with all the modern

apparatus of catalogues, photographs and dictionaries, can only view with wondering admiration Vasari's handling of his most elusive material.

The writings of two great predecessors, Leon Battista Alberti and Leonardo da Vinci, were known to Vasari, but he seems to have made little use of them. In his *Vita* of Alberti he refers to his books on architecture and painting, and mentions that the *De Re aedificatoria* had been translated "into the Florentine tongue" by Cosimo Bartoli. Giorgio himself designed the frontispiece for it, and it was published by Torrentino in 1550. He must have discussed it with his close friend, the translator. The *Della pittura* he states was translated into *lingua toscana* by Lodovico Domenichi, a learned Florentine who acted as a reader for the Torrentino press.[17] Alberti is to Vasari an example of the enduring influence of the written word, so that his repute stands higher than that of many abler artists, "for books go everywhere and are relied upon, provided they are honest, truthful statements." It is a passage in which Giorgio must have had his own undertaking in mind, but there is little direct trace of Alberti's thought in his writings. When Vasari makes close use of a text, his phraseology reflects that of his source. Much that Alberti had first argued had by the mid-cinquecento become accepted and familiar views, influencing anyone who wrote or talked on the subject, and it was in this diffusion of opinions that Vasari seems to have absorbed Alberti's theories. He is also curiously critical of Alberti's architecture, and very vague as to his actual part in various buildings mentioned. In the second edition, by which time his own Uffizi was in his mind, he adds to Alberti's *Vita* a digression on his favorite theme, the use of architraves as opposed to arches.

Some of Leonardo's writings had been shown to him by Francesco Melzi in Milan, and also in Florence by another Milanese artist, whose forgotten name is left blank and who had come to consult Vasari about publication. Seen only in manuscript, in Leonardo's left-handed, reversed writing, they seem to have meant little to Vasari, though he was well aware of Leonardo's technical interests and innovations, and particularly interested in his anatomical studies. Leonardo's concept of sensory experiment, of the satisfaction of the senses through the qualities of forms, was a speculation outside Giorgio's range of thought.[18]

The book was dedicated to "the most illustrious and excellent Lord

[17] On the considerable problems of the Italian text see J. R. Spencer, *Leon Battista Alberti on Painting*, Yale, 1966; K. Clark, "Leon Battista Alberti on Painting," *Proceedings of the British Academy*, xxx, 1944.

[18] For Leonardo's treatise on painting see L. H. Heydenreich, *Leonardo da Vinci*, London, 1954, i, pp. 95–108, and A. P. McMahon, Leonardo da Vinci, *Treatise on Painting*, 2 vols., Princeton, 1956.

31. Palazzo Altoviti, Rome
From a photograph before the palace was demolished to make way for the Lungotevere.

Opposite

32. Vasari, *Conversion of St. Paul.* Rome, S. Pietro in Montorio
The bearded figure on the extreme left is a self-portrait. The central group has more feeling than Vasari usually achieves.

Cosimo de' Medici, Duke of Florence." Giovio had helped him with the draft of the dedicatory letter, which recalls the protection given him by Cardinal Ippolito, Alessandro and Ottaviano, though it also expresses the great hope that all artists had in the patronage of the new pope, Julius III. On the latter's election, Vasari had hastened to Rome, where he once more resided in Bindo Altoviti's palace [31] on the banks of the Tiber by the Ponte S. Angelo. Both in this Palazzo and in Bindo's villa outside Rome, Vasari was employed designing and decorating loggias. A ceiling painted for the palace survived the latter's destruction in 1888, and is now in the Palazzo Venezia, another instance of Vasari's decorative skill, showing Ceres receiving the homage of the Seasons.[19] His hopes of patronage, however, looked further. Altoviti was much trusted by Pope Julius, who had appointed his son Antonio archbishop of Florence, though Cosimo refused to allow him entry to his diocese. Through Altoviti, Vasari received various papal commissions: the memorial chapel for the pope's uncle in S. Pietro in Montorio; and the designing of a country retreat for him, the Villa Giulia, both architectural works due partially to Michelangelo's recommendation and encouragement. Over the del Monte chapel Michelangelo intervened with the designs, and persuaded Giorgio to omit some carved foliage.[20] In return Giorgio was careful in the altarpiece of the *Conversion of St. Paul* [32] that he painted for it to take an unusual incident, St. Paul's blindness cured by Ananias, so as not to have to stand comparison with Michelangelo's recent rendering of the *Conversion* in the Cappella Paolina of the Vatican.

[19] D. Gnoli, "Il Palazzo Altoviti," *Archivio Storico dell'Arte*, I, 1888, pp. 202–11.
[20] Barocchi, *Michelangelo*, I, p. 88; IV, p. 153.

But Julius III soon proved an irresolute and capricious patron. "He did not wish in the evening," wrote Giorgio, "what had pleased him in the morning."[21] The Villa Giulia was completed by other architects, and a commissioned painting, the *Calling of Peter and Andrew*, was never paid for. Bishop Minerbetti was urging him to return to his wife in Arezzo, and he himself was longing for his home and garden. His uncle Don Antonio, for whom he had been trying to secure a canonry, died in 1552. There must have been business to attend to and, as Borghini put it, Donna Niccolosa must be wanting to perform the miracle of Macometto (Mahomet), presumably meaning that if Giorgio would not come to her, she would go to him. He was back in Arezzo in 1553 and wrote to Bishop Ricasoli of Cortona in Florence that he did not want "to go gypsy-like throughout Italy till his death." If he could obtain a post in Florence, he could settle there and it would "restore a son to his mother, a husband to his wife, a friend to his companions." Ottaviano de' Medici, who might have done much for Vasari at this time, had died in 1546. Paolo Giovio, with his coarse and shrewd counsel, died in 1552.

Cosimo had by no means been neglecting Vasari. As far back as 1542 he was using him to negotiate about the purchase of some ancient statues in Rome and addressing him as "Giorgio charissimo." While Vasari was in Ravenna, in 1547, he had written inviting him to Florence, but it was at a moment when Giorgio was very fully committed elsewhere. Minerbetti, staying in Florence, wrote urging him to come there with his family now that he had "eaten the St. Martin's goose at Arezzo and paid his conjugal debts." In Rome, "l'avara Babilonia," "expenses were very great," and in Florence commissions were being offered. There was one in 1549 for the family chapel of the Martelli in S. Lorenzo in commemoration of Sigismondo Martelli, and it had been well received when despatched from Rome. It represented the martyrdom of St. Sigismund thrown down a well with his wife and children. Known now only from a drawing at Lille, set in one of Vasari's architectural frames, it seems to have been a fine turbulent scene. Borghini wrote to him that Bronzino on seeing it was rumored to have made some changes in the painting he himself was working on, and "here as you know he is lord of the rulers."

Now in 1553 there was a commission to paint the façade of the house of Cosimo's close friend, Sforza Almeni. The scheme was to be based on Vasari's six ages of man, Childhood, Boyhood, Youth, Manhood, Old Age and Decrepitude. "Il mio rarissimo e divinissimo Vecchio," that is Michelangelo, had seen and approved the designs. Gior-

[21] *M*, vi, p. 478: for the chapel in S. Pietro see J. Pope-Hennessy, *Italian High Renaissance and Baroque Sculpture*, pp. 376–77.

gio was anxious that this façade should set an example to all Florence, and undertook to do it himself ("di mia mano"), even though, as he wrote to Almeni, the *mal di fianco*, "enemy of fresco work and moist bodies such as mine," always affected him. These painted façades were something of a novelty in Florence. Vasari's friend, Bishop Ricasoli, had recently had his palace decorated in this way, and thereby had given the idea to Almeni. The latter's father had been a trusted adviser of Cosimo's mother, Maria Salviati, and Sforza as a boy had been at the court of Alessandro, where he and Giorgio had probably been acquainted. Vasari gives a very detailed account of these paintings because, as he rightly thought, they would not last for long, and already by the time of the second edition they had been much damaged by rain and frost.[22] The fashion for façade paintings and the vast output of *apparati* for ceremonial occasions diverted much artistic talent into transitory ends. Soon, despite his intention to carry it out with his own hand, he was in need of the help of his former assistant, Cristofano Gherardi, but unfortunately Gherardi was still under sentence of banishment. He had been working with Giorgio in 1554 and 1555 at Cortona, where they had been frescoing the ceiling of the chapel of the Compagnia del Gesù [33]. Vasari in his *Life* of Gherardi admits that the work was done mainly by his assistant, and that he himself only made sketches, some designs on the plaster and some retouches. As always it was a happy combination of talents, and Gherardi's colors and poses have a lightness and charm that Vasari alone never achieved. Many of the sketches survive, mostly from Gherardi's hand; with a fine disregard for iconography, some of them changed their names in the course of transference to fresco, Moses of the sketch for instance, becoming Nehemiah of the fresco.[23] Now Almeni intervened to secure these admirable services for Florence, and Cosimo gave a pardon to Gherardi. The duke, writes Vasari, was much surprised at this "very best little manikin in the world," not the strapping rebel that he expected. Cosimo took to him. He was amused at his general untidiness and, because his cloak was generally on inside out, had a special one made for him the same on either side. "Let your excellency look at what I paint, not how I dress," said Cristofano.

For the moment, however, the duke was busy with outside matters. Pietro Strozzi had secured French support for an attack on Florence by its banished citizens. Amongst his officers was Giovanni Battista Altoviti, Bindo's son. Bindo himself died in 1557, and his death loos-

[22] Frey i, pp. 368, 371, 373–9, 387. The house is now the Palazzo Cuccoli, but there are no remains of the frescoes.

[23] Barocchi, *Vasari pittore*, pp. 37–38; see catalogue, *Arte in Valdichiana, secoli 13–18*, Cortona, 1970.

ened Vasari's links with Rome. The war hit Vasari personally, for he
now owned an estate at Frassineto in the Mugello and it was here that
Strozzi's forces were plundering the countryside. He wrote to Michel-
angelo that all his cottages and granaries had been burned and his
cattle driven off. On 2 August 1554, however, at Marciano, south of
Arezzo, the Medicean forces won a complete victory over the rebels.
Siena, which had risen against the imperialist forces, was after a long
siege forced to capitulate on 2 April 1555 to a combined Spanish and
Florentine force. It was while Cosimo [34] was thus expanding his
power that Vasari was taken into the duke's employment, with a
monthly salary of twenty-five florins, the normal payment for the
duke's chief artistic controller. Forthwith he brought his family to
Florence.

The remodeling of the Palazzo Vecchio and the frescoing of its walls
were to be his first priority, but there were soon many other under-
takings. The building of the Uffizi, that long, severe and so familiar
colonnade; a negotiation about bringing a classical column from Rome,
eventually set up in the Piazza S. Trinita; and in Pisa the Palazzo dei
Cavalieri, with its graffito decoration, where Gherardi's help would
have been certainly employed but was no longer available. He died
early in 1556. "He has taken with him not only my content, but part
of my soul."[24] And in another place Giorgio has the touching phrase,
"He would have made grief laugh." With him a certain lightness and
gaiety goes from Vasari's work, and it becomes more self-consciously
impressive and ponderous.

To the duke he was, in the words of the seventeenth-century biog-
rapher of the Medici, "singularly acceptable. . . . To his professional
merits he added a certain sagacity and readiness of mind, so that
Cosimo much pleased himself with his company."[25] In 1560 he went
to Rome in the suite of the boy cardinal, Cosimo's son Giovanni, who
was warmly welcomed by the new pope, Pius IV, a genial, art-loving
man whose Casino in the Vatican gardens was to provide opportunities
for a new generation of artists. Vasari wrote a long account of the
reception to Antonio de' Nobili, the duke's officer of works, particu-
larly stressing that Cardinal Strozzi, of the rebel house, had been the

[24] Frey I, p. 442.
[25] R. Galluzzi, *Istoria del Granducato di Toscana sotto il governo della casa
Medici*, Florence, 1781, I, pp. 393–98.

33. Vasari and Cristofano Gherardi, *Sacrifice of
Isaac*. Cortona, Compagnia del Gesù
In his *Ricordanze* Vasari recalls how he began
the work for the Compagnia del Gesù on 13 De-
cember 1555 and was paid 200 scudi for it.

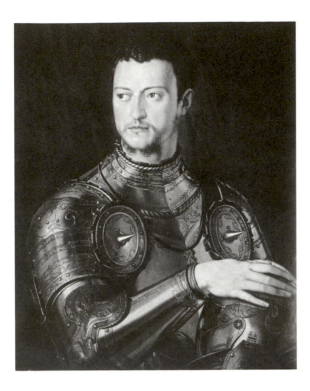

34. Bronzino, *Cosimo de' Medici*. Florence, Pitti
Palace
 Probably painted about 1545 when Cosimo was
twenty-six. There are many versions of the por-
trait, which seems to have been used as the offi-
cial likeness.

first to call on Cardinal Giovanni; and in fact Cosimo now pardoned
many of the banished Florentines. An era of peace and, for Vasari,
congenial times seemed opening, but a darker period lay ahead. In
November of 1562 Giovanni, the young cardinal, fell ill of malarial
fever caught out hunting. He died on 20 November and within a fort-
night his brother, Garzia, followed him. News of this second death
was kept from their mother, the Duchess Eleonora [35], already in a
decline through grief for Giovanni: but it was of no avail, and five
days later she too was dead. She had won much devotion from the
artists and could, Vasari had written of her, be compared, even
preferred to the famous women of antiquity, a typical humanist
commendation.[26] He wrote to Giovanni Caccini in Pisa: "With a thou-
sand griefs and sighs I have heard of the death of the duchess. I
thought the cardinal would have sufficed as an offering for our sins,
but I hear now that Don Garzia has accompanied him and afterwards
our lady duchess. O unhappy house of Medici! Fortune, that raised it
so high, has changed its gifts and by the hand of death, alas, has laid
waste the fairest and most virtuous family that a prince has ever had."
After these losses, Cosimo was a changed, less reliable, more violent
man.
 Vasari turned from these gloomy happenings to intensified research
for the second edition of his book. In the conclusion of the first edition
he had promised a supplement dealing with any new facts he discov-

[26] *M*, vi, p. 441.

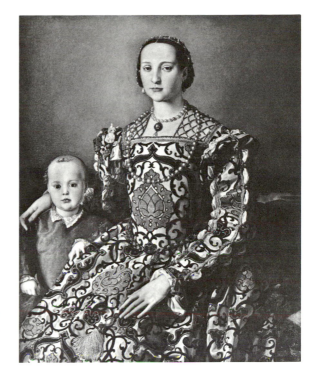

35. Bronzino, *Eleonora of Toledo, Wife of Cosimo de' Medici, with her Son, Giovanni.* Florence, Uffizi

It has the vaguely tragic reserve that Bronzino could so well impart to his sitters. The splendid dress was that in which in 1562 she was to be buried.

ered, and also with artists still living whose work had reached maturity. What was now undertaken was, however, a complete revision. His friends were busy providing more detail and checking difficult points. Cosimo Bartoli wrote from Pisa that he had spilt (he used a coarser word) blood reading the scrolls on the paintings in the Camposanto and had spent six hours at it. Later, when he was in Venice, where he was Cosimo's agent from 1561 to 1572, he collected information about St. Mark's (he thought it had been designed by a German) and about Venetian artists.[27] Miniato Pitti was revising the index; Giovanni Caccini was finding out about Foppa, whom a relative of his had known, and was trying to discover the names of the architects of the Leaning Tower and the Camposanto. Further details of Veronese artists were received from Fra Marco de' Medici and the sculptor Danese Cattaneo, whom Vasari must have known in Florence when, a refugee from the Sack of Rome, he was working for Duke Alessandro. From papers left by Baldassare Peruzzi, some of them used by Serlio in his architectural treatises, and from information from one of Baldassare's pupils, Francesco of Siena, Vasari learned much "that I could not know when this book came out for the first time." An erudite Fleming from Liège, Dominic Lampson, a friend of Cardinal Pole, wrote to Giorgio that he had learnt Italian in order to read his book, and supplied him with much new information about Flemish artists.

[27] For Bartoli see *Lo zibaldone*, ed. A. del Vita, p. 68; for the letters Frey i and ii, passim; Appendix A.

Above all Vincenzo Borghini was rereading and criticizing the whole work. It was by his advice that Vasari shortened and sometimes even omitted the moralizing introductions. Borghini had a considerable library. He lent Giorgio the *Ottimo commento*, the earliest commentary on Dante with its account of Giotto, provided extracts from Paulus Diaconus, and introduced him to the *novelle* of Sacchetti, suggesting that some extracts from them would be welcome to readers and would fill out lives such as that of Buffalmacco where information was scant. At the same time Borghini was urging greater precision in his references to works of art: he must give the names of buildings, not speak simply of "a façade on the Grand Canal," or at least identify them by describing the subject painted, and he must always give the places where particular works were to be found, Venice, Milan, Naples. The men of whom he was writing were important for their works, not for the incidents of their lives.[28] Perhaps he felt that Giorgio's liking for anecdote was getting the upper hand, those personal touches such as Giorgio's reminiscence of the old Andrea della Robbia telling him that as a child he had been one of Donatello's pall-bearers. There is, too, a different balance in the material. On the whole the first edition allots space according to Vasari's estimate of artistic importance: in the second the available information sometimes lengthens a life disproportionately. That, for instance, of the architect Simone Pollaiuolo, whom Vasari calls by a nickname, Cronaca (Chronicle), which already included some very varied matters, is lengthened out by the results of Vasari's own researches into the construction of the great hall of the Palazzo Vecchio. Composition becomes more rambling, and the phrase "I must now return" closes more and more digressions. Material in fact accumulated too quickly to be tidily placed in the general scheme. But if a certain shapeliness is lost, there is a new richness and variety in the texture.

An example of the process of revision can be found in the *Vite* of della Quercia and Nanni di Banco. In the first edition, writing of the tympanum of the Porta della Mandorla [36] in the Duomo, Vasari states that many people think it to be by Nanni, but argues for it being by della Quercia. In the second edition Nanni's authorship disappears, and the long account of the carving is a central feature of della Quercia's *Life*. The symbolism of the bear is now left to everyone's interpretation, whereas in the first edition Vasari thought it represented the devil. The relief is in fact by Nanni di Banco, and the commission in 1414 and later payments for the work are documented.[29]

Some *Vite* were omitted. Galasso Galassi, a Ferrarese painter, whose

[28] Frey II, pp. 101–02, 262–64, and passim: Borghini's letters provide an astonishing piece of criticism of the *Vite*.
[29] H. W. Janson, "Nanni di Banco's *Assumption of the Virgin* on the Porta della

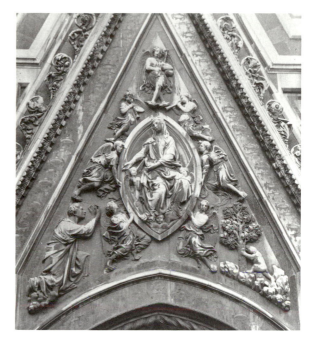

36. Nanni di Banco, Tympanum of the Porta della Mandorla, Duomo, Florence

"The Madonna in a mandorla is carried to heaven by angels, playing and singing, with the most beautiful attitudes, flying with a movement and boldness that had not been seen before . . . there have been many explanations of the bear climbing the pear tree, but I say nothing of it, to let everyone decide for himself."

name occurs in the city's records but of whose work nothing today is certainly known, is relegated in the second edition to a final section at the end of the *Vita* of Niccolò Aretino. Vasari admits that "neither in Ferrara nor elsewhere" could he find any paintings by him except some frescoes. Along with Galassi, a short section on a pupil, Cosmè, is also transferred: "a better draftsman than painter, and, as far as I have been able to discover, he cannot have painted much." Between the editions Vasari had found "many other things" and had added a drawing by Cosmè [Tura?] to his own collection. It remains, however, a poor appreciation of the striking and original artist known to us as Cosimo Tura. Chimenti Camicia was also deprived of his *Vita* and a much shortened account of him appended to the *Vita* of Paolo Romano, a very confused piece of work which ends with the statement "Manca il fine," "the end is lacking."

A significant change is made in the planning of the close to the second part. In the first edition it ended with Perugino, the master of Raphael. In the second this place is given to Signorelli, Vasari's kinsman, and a passage is added stating that the Orvieto frescoes were always much praised by Michelangelo, who borrowed from them some details of angels, demons and the order of the heavens. Giorgio could have had an opportunity of revisiting Orvieto on his journey to Rome with the young Medici cardinal in 1560, and, if borrowings are

Mandorla," *Studies in Western Art: Acts of the Twentieth International Congress of the History of Art*, ii, pp. 98–107; M. Wundram, *Donatello und Nanni di Banco*, Berlin, 1969.

nowhere easily identified, might well have thought these overpower-
ing works a fitting link with the climax of his third part.

There were also considerable alterations in the introductory matter.
Vasari now prefixed the third part of the work with a long letter from
Giovambattista Adriani, the noted Florentine orator, on the artists of
antiquity. Largely based on Pliny, but with borrowings from other
classical writers, this learned treatise is a definitive account of the
humanist view of the visual arts of antiquity, and thus provides a
background to much of Vasari's reflections. Its measured prose is in
marked contrast to that of the *Vite*, a fact of which Adriani was well
aware when he writes admiringly of the *leggiadria*, the easy facility
of Giorgio's writing. The "Introduction to the Three Arts of Design,"
the all-important account of techniques and materials, was also con-
siderably enlarged, by about a seventh of its original length. In par-
ticular there had been requests from Flanders for a more elaborate
treatment of this section, but Vasari, obviously after some thought,
had concluded that his purpose was to write the lives of artists, not to
instruct in the arts. He therefore retains the original form, and the
longest addition is a discussion of the nature of design, a key passage
to much of his theory. He had, too, in the interval between the two
editions read the late fourteenth-century book by Cennino Cennini,
Il libro dell'arte, o trattato della pittura, of which Giuliano di Niccolò
Morelli, a goldsmith of Siena and friend of Beccafumi, had a manu-
script copy. There was not much here for Vasari: "All these matters,
which he then considered great secrets, are now fully known"; but it
gave him some information about older methods, and Borghini, who
also read it, advised him to consider more closely the problem of the
origins of painting in oil. Cennino confirmed the place Vasari had
assigned to Giotto, whom he described as translating the art of paint-
ing from Greek into Latin. Vasari had also read the *Trattato d'architet-
tura* (1464) by Antonio Filarete, a copy of which was in the Medici
library; there were some good things in it, particularly about the
artists of his time, but much of it Vasari thought "ridiculous and
silly."[30]

Further travel, however, was what was most needed, and he was
anxious as far as possible to write of things that he had seen. "I have
not seen them, so I cannot give my own opinion," he writes in one
place, but with the widening scope of the work he had to depend
more and more on reports and comments from others, and he does
not always distinguish between what is at first hand, what at second.
In 1563 he escaped for a brief period, three and a half weeks in all,
from the gloom of the ducal court: he went first to Arezzo and from

[30] Frey II, p. 26: for Cennini see *Il libro dell'arte*, English ed. by D. V. Thomp-
son, Yale, 1933: for Filarete, *Treatise on Architecture*, text and trans. by J. R.
Spencer, 2 vols., Yale, 1965.

there to Cortona, Perugia and Assisi, where he gathered much more information, then to Ancona and by ship to Venice to stay with Cosimo Bartoli, a family establishment despite Bartoli's clerical rank, for he lived with a mistress, La Piccina, and had a son, Curtio, by her. Vasari was back in Florence on 5 June, but three years later he was able to take a more extended tour. "I wanted regardless of expense or labor to see again Rome, Tuscany, part of the Marches, Umbria, Romagna, Lombardy and Venice with all her dominions to see the old things once more, and the many things done since 1542." He wished to add information lacking in the first edition, and also to write of the excellent works of certain artists who were still alive.

This journey brought some revision of earlier opinions, and also a great increase in the scope of the work. We can follow its course through his letters to Borghini. It was a wet spring when he set off and there were muddy roads till he got to Perugia: he lost some notes, needed by Jacopo Giunti the printer, visiting "an ancient relic at Cortona": then by Arezzo, Assisi, Foligno and Spoleto ("What a painter was Fra Filippo!") to Rome. Daniele da Volterra had just died. "I trust God will have mercy on him," wrote Giorgio, "while I make enquiries of his friends so as to be able to add his life and portrait to the *Lives*."[31] There speaks the true researcher. Then to Loreto, where he noted in admiring detail the reliefs of Andrea Sansovino on the Virgin's House. From there to Ancona, Rimini, Ravenna, Bologna.[32] Even in modern conditions of travel it would have been a rapid journey. In Milan he found the Leonardo *Last Supper* so ruined that it was only a confused mess ("macchia abbagliata"). Fortunately, Fra Girolamo Bonsignori had made an excellent copy of it. Then to Venice where he renewed old acquaintances. Pietro Aretino had died in 1556, but Titian and other friends were still at the center of Venetian artistic life. Amongst newer contacts, he had long talks with Paris Bordone, a man of sixty-five (Vasari put him at seventy-five) living quietly in Venice and "finished with vain and competitive ambitions." Then by Ferrara he returned to Florence, arriving there at the beginning of June, ready to incorporate his very considerable amount of new material, particularly about the northern painters. Rearranging and inserting was a considerable task. Notes of conversations are notoriously tricky evidence, and even someone so methodical as Giorgio would have had a problem in writing up his daily record as he moved from one contact to another. Surely he must have suffered from the ills common to all of us: the account that seemed clear at the time but that proves to lack an essential fact; the illegibility of a name

[31] Frey II, p. 229.
[32] Frey II, pp. 226–43. For questions of travel see G. B. Parks, *The English Traveller to Italy*, I. *The Middle Ages to 1525*, Rome, 1954, p. 280; M. A. Devlin in *Speculum*, IV, 1929, pp. 270–81; Appendix B.

written in haste; the locked door on a hurried visit; the variation
between one consultant's memory and another. It is surprising that
there are not more muddles and errors. Given the time and resources
at his disposal, it is an astonishing piece of research, and one for which
there was no established standard of accuracy.

The setting up of the second edition had begun in 1563. This time
it was in the charge of Jacopo Giunti. Lorenzo Torrentino had fallen
on evil days. Lodovico Domenichi, his reader, was convicted of pub-
lishing a work by Calvin, and there was strong suspicion that Torren-
tino had printed it; heresy had become a much more serious business
since in 1551 the Dominican Michele Ghislieri, the future Pius V, had
become Inquisitor General in Rome. In 1557 there was a mysterious
business in which Torrentino was caught at night in the street carrying
two long knives and was fined twenty florins of gold. He still had the
goodwill of Duke Cosimo, but in 1562 he withdrew to more liberal
Piedmont and died there the following year. Giunti no doubt thought
the second edition, with an almost assured sale, worth the trouble of
the constant alterations and additions that were being sent in up to
the last moment. By the beginning of 1568 it was available for the
public.

It appeared in three volumes, the first containing the first and second
parts, the second and third the third part ending with the letter from
the author to the artificers of design and an errata list with 101 cor-
rections. It had some new status symbols. There was a fresh title page
[37] embellished with a print where Fame awoke with a blast of
horns the dead from their graves, approvingly watched by the three
muses of painting, sculpture and architecture. Around it was inscribed
HAC SOSPITE NUNQUAM HOS PERIISSE VIROS VICTOS AUT MORTE FATEBOR
("I shall claim that with this breath these men have never perished,
nor been conquered by death"). This was followed by a page with a
framed portrait of Vasari [Frontispiece]. In the first edition he had
called himself only "pittore Aretino"; now, with the extension of his
activities, he adds the qualification "architetto."[33]

[33] The *Hac Sospite* print was repeated at the end of the work. There are linguis-
tic variations in the use of the term *architetto*: the title page of the first edition
refers to *architetti*, that of the second to *architettori*. In the first edition the order
is *architetti, pittori, et scultori*; in the second, *pittori, scultori, et architettori*.

37. Title page of the second edition of Vasari's
Lives

In letters from his friends and in Michelangelo's
sonnet the point is constantly made that Vasari
has preserved the fame of the artists. Here he
gives this comment visual form.

LE
VITE DE' PIV ECCELLENTI
PITTORI, SCVLTORI, ET ARCHITETTORI,

Scritte, & di nuouo Ampliate da M.

GIORGIO VASARI PIT. ET ARCHIT. ARETINO.

HAC SOSPITE NVNQVAM HOS PERIISSE

I VIROS, VICTOS AVT MORTE FATEBOR.

CO' RITRATTI LORO

Et con le nuoue vite dal 1550. insino al 1567

Con Tauole copiosissime De'nomi, Dell'opere,
E de' luoghi ou' elle sono.

IN FIORENZA APPRESSO I GIVNTI 1568.
Con Licenza, e Priuilegio.

There were further embellishments. Vasari aimed at giving as far as it was possible portraits of the artists carried out in wood engraving. He added to the preface to the whole work a passage that can only be called by the modern term "blurb," explaining the expense and exertion that this had cost him, and the advantage of a portrait rather than a written description; and apologizing for the fact that engravers always slightly distort the image, and that the portrait of a man at eighteen or twenty would not be like one made fifteen or twenty years later. At the end of the *Lives of the Engravers* he refers again to these portraits "designed by Giorgio Vasari and engraved by Maestro Cristofano, who has made and continues to make in Venice many things worthy of memory." This is, as we know from one of Vasari's letters, Cristofano Coriolano, or rather Christopher Lederer, for he came in 1560 from Nuremberg to Venice, where he adopted the classical and high-sounding name of Coriolanus.[34] The collection of these portraits, the making of drawings of them and the despatch of these to Venice for engraving, where Cosimo Bartoli was handling the business, must have been a considerable added burden to Vasari's work. Some of them were obtained from friends, Jacopo della Quercia from Beccafumi, Baldassare Peruzzi from one of his pupils. Others were copied from paintings where Vasari, often quite wrongly, thought the artist was represented: Cimabue [38] and Simone Martini in the Spanish chapel [39];[35] Arnolfo in Giotto's *Death of St. Francis* in S. Croce; Masaccio's self-portrait in the *Tribute Money*; Spinello Aretino from a fresco in the old Duomo at Arezzo; Orcagna [40] from his relief in Orsanmichele; Michelozzo from Fra Angelico's *Deposition*; Marcantonio [41] from the figure in Raphael's *Expulsion of Heliodorus* [42]. But these woodcuts, broadly hatched and set in a repetitive series of frames, are hardly flattering and no doubt many of them are imaginary. Borghini thought he had made Nicola Pisano look too like a man of their own times. For some artists no portrait was available, and this led to a grouping of artists under one heading. In the *Lives* of Fra Giocondo, Liberale and other Veronesi, Vasari wrote "Let no one wonder if I place all under the effigy of one (Liberale), as I am forced to do this, not having been able to find portraits of the others." Out of the 144 effigies included, it has been calculated that ninety-five have some claims to be considered true likenesses. For his description of his own works Vasari repeated the self-portrait of the frontispiece.[36]

[34] *M*, v, p. 441. Vasari in both editions left a blank after Cristofano, and he was not identified as Coriolano till the edition of 1647: see Frey II, p. 14.

[35] The figure selected by Vasari for Cimabue wears the order of the Garter, and must be one of the prominent Englishmen in Florence; several candidates have been proposed, none as yet altogether convincingly.

[36] Frey II, pp. 100–02; W. Prinz, "La seconda edizione del Vasari," *Vasari*, XXIV, 1936, pp. 1–14.

GIOVANNI CIMABVE PITTO-
RE FIORENTINO.

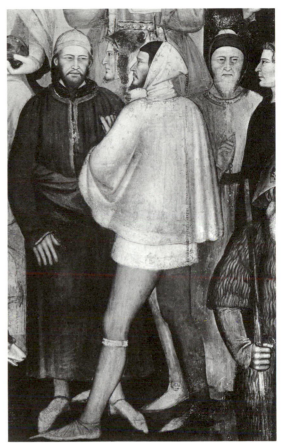

38. Portrait of Cimabue in the second edition of the *Lives*

Above right

39. Andrea da Firenze, *The Church Triumphant* (detail). Florence, S. Maria Novella, Spanish Chapel

"The portrait of Cimabue can be seen in profile, with a thin face, and small reddish and pointed beard, with a hood that is wound round the throat according to the fashion of the time. Beside him is Simone, who painted himself with two mirrors in order to get his head in profile." The figure taken by Vasari for Cimabue among other improbabilities wears the order of the Garter; there have been many theories as to his identification.

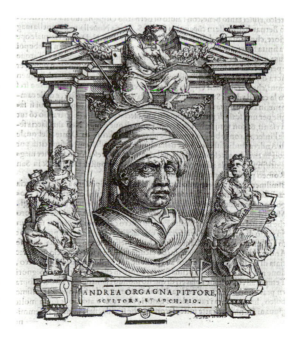

40. Portrait of Orcagna in the second edition of the *Lives*

The head, Vasari states, was based on the self-portrait of Orcagna on the tabernacle of Orsanmichele, but the woodcut does not follow this at all closely, apart from the hood; Vasari describes Orcagna as shaven, whereas in the relief he is bearded.

ANDREA ORGAGNA PITTORE,
SCVLTORE, ET ARCH. FIO.

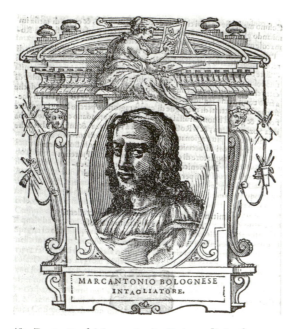

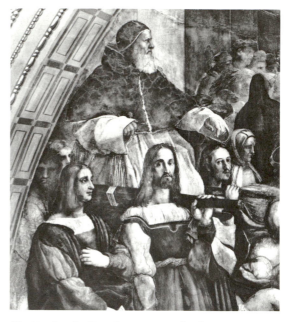

41. Portrait of Marcantonio Raimondi in the second edition of the *Lives*

42. Raphael, *Expulsion of Heliodorus* (detail). Vatican, Stanza d'Eliodoro

The pope is a portrait of Julius II: the bearer on the pope's right is Marcantonio Raimondi; the bearer on the left is probably a portrait of Raphael. The likeness between the so-called Marcantonio and the self-portrait of Dürer has been frequently commented on.

Several of these cuts, such as those of Antonio Rossellino and of Mino da Fiesole, are based on drawings in Vasari's collection. He had been collecting for many years. The beginning of it was perhaps the drawings he got from his friend, Vittorio Ghiberti, in 1528, including several by Vittorio's great-grandfather and some by Giotto.[37] "If I had known what I know now," Vasari writes regretfully, "I might easily have had many other outstanding things," and indeed Vittorio Ghiberti's collection could well have had wonderful pieces in it. But the opportunity passed, for in 1542 when on a journey he was robbed and murdered by his servant. Amongst other items, Vasari had many drawings by his master, Andrea del Sarto, some of them perhaps the ones he had lent to Salviati. To Vasari his *Libro dei disegni* was an

[37] A. Wyatt, "Le *Libro dei disegni* de Vasari," *Gazette des Beaux-Arts*, 1859, pp. 338–51; Otto Kurz, "Giorgio Vasari's Libro dei Disegni," *Old Master Drawings*, No. 45, 1937, pp. 1–15, and No. 47, 1937, pp. 32–44; catalogue, C. Monbeig-Goguel, *Giorgio Vasari, dessinateur et collectionneur*; B. Degenhart and A. Schmitt, *Corpus der Italienischen Zeichnungen, 1300–1450*, Berlin, 1968, II, pp. 628–38.

appendix to the *Vite*, and he constantly refers to it in the course of his narrative in support of his judgments on a painter's ability. It was in fact not one book but several, at least five volumes, generally measuring 2 by 1½ feet; there were two or three drawings on one mount, set by Vasari in elaborate frames [43], with attributions, at times reconsidered, repairs and retouchings carried out, and often a highly imaginative conjunction of subjects. Once again one is amazed at his

43. Filippino Lippi, Drawings mounted by Vasari for his *Libro dei disegni*. Oxford, Christ Church

The two upper scenes of centaurs may not be by Filippino, but the lower scenes, *The Virgin and Saints* and *The Afflictions of Job*, are accepted attributions. The inserted portrait is a print of the woodcut for the *Lives*.

methodical industry. Though his collection, taken to France, was dispersed, a fair number of the drawings survive and have been identified, in some cases still on their Vasarian sheets. The title page of the collection had an engraving by Giorgio Ghisi of Michelangelo [44], a far better work than Coriolano's cuts.

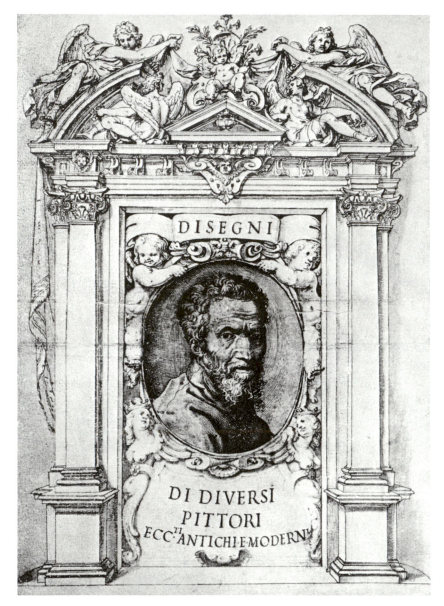

44. Giorgio Ghisi, *Michelangelo*. Florence, Uffizi
 Title page of Vasari's *Libro dei disegni*, using an engraving of Michelangelo by Giorgio Ghisi (ca. 1520–82).

III. The *Maniera Greca*

VASARI's view of the history of the arts is based on three periods: their rise to perfection from unknown origins in ancient times; their ruin, which he dates as beginning with the age of Constantine; and "their restoration or to say better, rebirth," this last being the subject of his book. The first period is called by him antique (*antico*), the second old (*vecchio*) and the third modern (*moderno*). The ancient Greeks as opposed to the old Greeks, the Byzantines though that is a term Vasari seldom uses, were the most excellent of artificers, but in common with most of his contemporaries Vasari had seen little authentic classical Greek work, and made no distinction between it and later Roman copies. "I call Roman," he writes, "for the main part those works that, after the subjugation of Greece, were taken to Rome, where all that was good and beautiful in the world was brought."[1] It was the rediscovery of some of these works, "dug out of the earth," that made possible the achievements of the cinquecento. The *Laocoön* had been discovered in 1506 on the Esquiline and had been placed in the court of the Belvedere, along with the river gods identified as the *Nile* and the *Tiber*, the so-called *Cleopatra*, the *Torso*, the *Apollo Belvedere* and other pieces. When that singularly unpleasing work, the *Farnese Bull* [45], was found in Rome in 1546, it was thought to be a Labor of Hercules, and was considered "a work of extraordinary beauty."[2] With the softness and precision of their contours, their postures, not contorted but moving with the fullest grace (*graziosissima grazia*), they were the reason that the dryness and pedantry of the quattrocento were overcome. As well as that of the Vatican, there were other collections in Rome, in particular that of Cardinal Andrea della Valle, "who was the first," Vasari writes, "to put fragments together and have them restored," a process which in Giorgio's opinion and also that of Michelangelo gave them more grace than before.[3] Lorenzetto Lotti, the sculptor, was the first to carry out these restorations, but

[1] *M*, I, pp. 242, 483; see Panofsky, *Renaissance and Renascences*, pp. 1–35.
[2] Barocchi, *Michelangelo*, I, p. 87, IV, pp. 1553–55; Maclehose, *Technique*, pp. 102–07 and 115–16.
[3] *M*, VIII, p. 158.

45. *The Farnese Bull.* Naples, National Archaeological Museum

"There was found in that year [1547] in the Antonine baths a marble seven *braccia* on every side on which the ancients had carved Hercules, holding the bull by its horns." It is in fact Dirce, punished by the sons of Antiope.

Opposite

46. Tommaso Lauretti, *Exaltation of the Faith.* Vatican, Sala di Costantino

Painted in 1585, after Vasari's death, when Pope Gregory XIII misguidedly altered the ceiling of the room, it celebrates, with Counter-Reformation enthusiasm, the overthrow of the idols that Vasari so much deplored.

later Fra Guglielmo della Porta, when he was given the office of the Piombo, was entrusted with completing heads and arms on Vatican sculpture.

Good Aretine that he was, Vasari was aware also of "Tuscan" sculpture, somewhat rude but still of interest. He knew an Etruscan tomb, called of Porsenna, at Chiusi and had a family interest in the Aretine red and black vases. He knew also the statues found at Viterbo under Alexander VI: it seemed to him that in these carved and painted figures art was nearer its zenith than its beginning.

The decline from the splendor that was Rome began with Constantine. In a long and discerning account of his arch in Rome, Vasari compares the sculptures taken from earlier monuments with those of the Constantinian carvers, much to the disfavor of the latter. The final blow to the arts was the removal of "so many fine works" to Constantine's new seat of empire "in Bisanzio," one of Vasari's rare uses of the word. For him Constans II plundering Rome in 663 is little different from the barbarian invaders, and "this very villainous Greek" is "justly" assassinated in Sicily.

The Christian Church also plays its part, a very great one according to Vasari, in the destruction of ancient and therefore pagan works of art. He is repeating here a theme enunciated by Ghiberti, and adds to it the popular legend that Pope Gregory the Great had been par-

ticularly vigorous in destroying images [46]. This was done out of
piety, "to cast down the gods of the heathen," but there was none the
less a great loss to the arts.[4]

Of ancient, classical figure painting Vasari can have had little
knowledge. The *Aldobrandini Marriage* was not discovered on the
Esquiline till 1605, and excavations in the Forum had revealed no
examples so complete as those of Pompeii or the House of Livia. It
was the Golden House of Nero that provided most knowledge of the
subject, and here it was the grotesques, the decorative elements, that
chiefly influenced cinquecento artists. "Only in our own day," Vasari
writes, "have many of these rare works been rediscovered." On the
roof of one of the rooms in the House of Nero Giulio Romano's name
can still be seen inscribed.[5]

[4] See T. Buddensieg, "Gregory the Great, the Destroyer of Pagan Idols," *JWCI*,
XXVIII, 1965, pp. 44–65.
[5] N. Dacos, *La Découverte de la Domus Aurea et la formation des grotesques à
la Renaissance*, London, 1969.

Of Byzantine art or history he knew practically nothing. Since the loss of Constantinople in 1453, travel had been much restricted, though Venice still held Cyprus and Crete. Gentile Bellini, Vasari knew, had been well received at the Turkish court, and he had seen the great gold chain that the Sultan had given him, but already at the time of Gentile's visit (1479) Byzantine frescoes and mosaics were disappearing under Turkish whitewash. To Vasari the achievements and progressive changes of Byzantine art were unexplored and remote fields, and he had no conception of their influence upon the West. For influence indeed there was. The great frescoes and mosaics might be inaccessible, but smaller objects could circulate, ivories, manuscripts and icons; and the pillage of the fourth crusade, or the flight from Latins or Turks of refugees, bringing, as has been so sadly familiar in our time, their portable treasures with them, had increased a process already firmly based on trading contacts.[6]

For Vasari then these admirable sculptures and paintings of the ancient world remained buried and unknown in the ruins of Italy and "what was left of the old craftsmen of Greece made images of clay or stone, or painted monstrous figures, only coloring the outlines." But being the best, indeed the only, practitioners of these arts, they were invited to Italy, bringing with them mosaic, sculpture and painting, as they knew them, and so they taught their own rude and clumsy style to the Italians. "Every old church of Italy has examples of it," he wrote and cited the Duomo of Pisa, St. Mark's in Venice, S. Miniato and S. Spirito in Florence, S. Giuliano and S. Bartolomeo in Arezzo, and St. Peter's in Rome; they were full of figures with frightened eyes and outstretched hands, standing on the tips of their toes. Still today in many Italian churches, as for instance in S. Agostino or S. Maria del Popolo in Rome, old icons can be seen, much blackened by votive candle smoke, often claimed as painted by that most prolific artist St. Luke, and generally encased and obscured by elaborate settings. In 1306, while Giotto was at the height of his powers, Fra Giordano da Rivolta preaching in S. Maria Novella had proclaimed that ancient paintings that came long ago from Greece had great authority because they were based on paintings made at the time of Christ.[7] Artistic merit was not the only criterion.

[6] Much has been written on this subject in recent times. See K. M. Setton, "The Byzantine Background to the Italian Renaissance," *Proceedings of the American Philosophical Society*, c, 1956, pp. 1–76; J. H. Stubblebine, "Byzantine Influence in Thirteenth-Century Italian Panel Painting," *Dumbarton Oaks Papers*, xx, 1966, pp. 85–102; O. Demus, *Byzantine Art and the West*, New York, 1970, pp. 205–24; D. Talbot Rice, *Byzantine Painting: The Last Phase*, London, 1969.

[7] Quoted by J. Larner in *History*, liv, 1969, p. 16.

Of the many medieval wall paintings scattered throughout Italy, Vasari took little note, and it is impossible today to assess which of them he may have seen. Much has perished since his time, but also much has been rediscovered. The frescoes of Castelseprio were not within his ken; the frescoes of the lower church of S. Clemente were still buried; Anagni and S. Angelo in Formis he never visited. A long process of development in the arts was, in many cases literally, hidden from him and looking back on his "olden times" he had no glimpse of the problems that exercise our minds today.

Mosaic was to Vasari of all works in color the most resistant to winds and water, but the criterion of its excellence was that seen from a distance it appeared to be a painting. Of all mosaics the greatest was Giotto's *Navicella* in the portico of St. Peter's, where it seemed to him that even a painter working with the brush could hardly have done better. He writes further of mosaic in the *Lives* of Gherardo del Fora and of Domenico Ghirlandaio, and quotes Domenico as saying that mosaic was the true painting for eternity; but it was a craft that Vasari himself never practiced, and he had little true appreciation of it, thinking of it as he did in terms applicable to fresco painting. In his "Three Arts of Design" he admits that the mosaics at St. Mark's in Venice are very beautiful (*bellissimo*), as also are the mosaics at Ravenna (his only mention of them) and in the Florentine Baptistery. These last he describes in his *Life* of Andrea Tafi, amid various confusions of dates and personalities, lumping the whole series together as exciting laughter rather than pleasure, though he admits some improvement in the later stages. Tafi, Vasari states, was helped by a Greek, Apollonius, whom he met in Venice, and another mosaicist working in the Baptistery was Jacopo Torriti. The information about Tafi comes from Antonio Billi (who calls him Tassi); he remains an undocumented character, unless he is the painter of that name enrolled in the Florentine guild in 1320, in which case he may have worked on the final stages of the mosaic scheme but was certainly not its originator. Fra Jacopo da Turrita seems a conflation of a Fra Jacopone, who in actuality began the work in the Baptistery in 1225, and Jacopo Torriti, the distinguished mosaicist who was working in Rome at the end of the century. In this revival of mosaic art Florence led the way. In detail and general design the Baptistery mosaics, where the depicted dividing columns continue the architecture of the building, are a remarkable achievement, and the great *Christ in Majesty* [47], more than eight feet high, is one of the most splendid works of the late dugento. Even Vasari has to admit that it merits high esteem. This triumphant figure is far from the normal Greek tradition of the

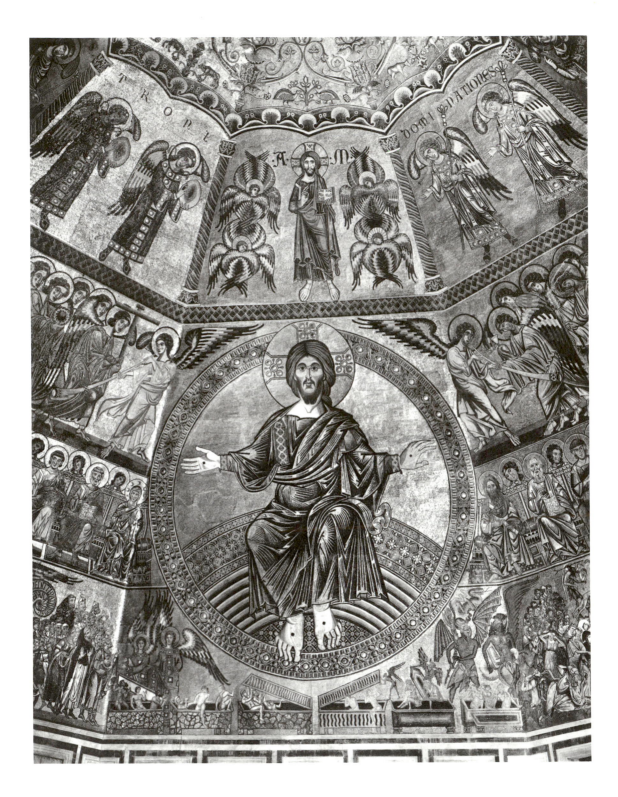

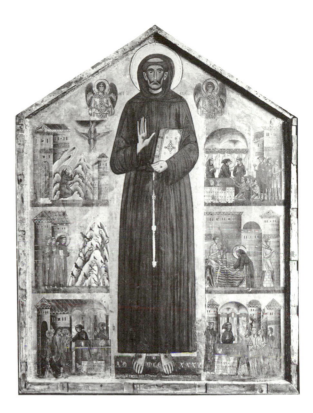

Opposite

47. *Christ in Majesty*. Florence, Baptistery
"This work became famous throughout Italy, and was highly reputed in the artist's home city: it merits much honor and praise."

48. Bonaventura Berlinghiero, *St. Francis*. Pescia, S. Francesco
Dated 1235, eight years after the saint's death. Vasari does not mention it, but with its stark outlines, staring eyes and feet on tiptoe it exactly corresponds to his idea of the Greek manner.

suffering Savior, as he appears in the dome of Daphni or, more human but still melancholy, in the Deesis mosaic in S. Sophia. Nearer to the West, in Macedonian Ohrid, the frescoed eleventh-century *Christ* comes closer to the Florentine type, and a similar Byzantine version may have been known in Italy in some smaller product. But to Vasari, who can have seen fewer icons than those the thirteenth-century masters found in circulation, Byzantine art remained a static, retrograde phenomenon, and any Italian art inspired by it seemed of little moment.

The Berlinghieri family, a name unknown to Vasari, are documented at Lucca between 1228 and 1243, and were working in a full Byzantine tradition, producing Madonnas on an icon pattern. Notable among their paintings is one of St. Francis at Pescia signed by Bonaventura Berlinghieri [48] and dated 1235, only eight years after the saint's death, a standing frontal figure, between scenes of the legend. This is undoubtedly what Vasari meant by the Greek manner. The figure has the flatness and rigidity that repelled him, it is standing on tiptoe and the drapery is linear. But the little scenes of the miracles were fresh, unprecedented subjects, and already a new liveliness comes into them. Little did Vasari know that a much more skillful

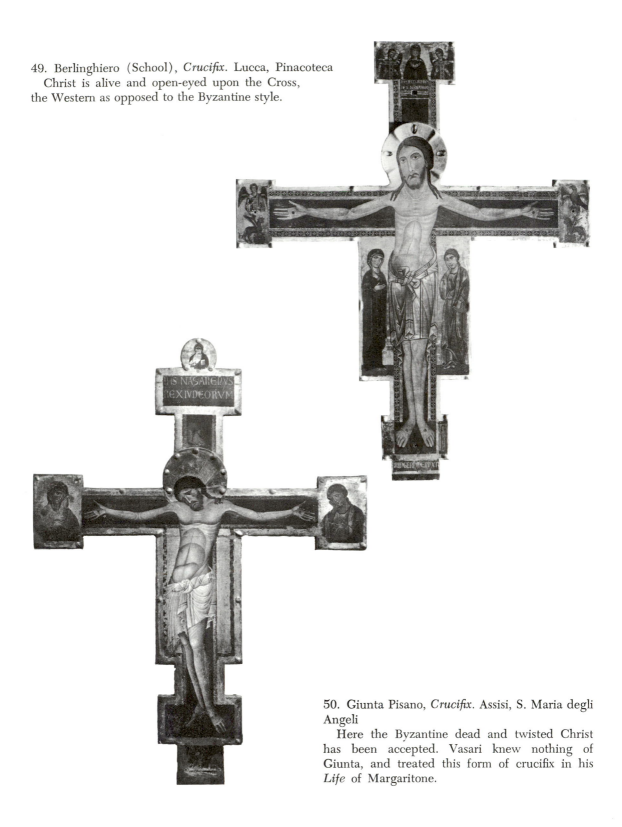

49. Berlinghiero (School), *Crucifix*. Lucca, Pinacoteca
 Christ is alive and open-eyed upon the Cross,
the Western as opposed to the Byzantine style.

50. Giunta Pisano, *Crucifix*. Assisi, S. Maria degli
Angeli
 Here the Byzantine dead and twisted Christ
has been accepted. Vasari knew nothing of
Giunta, and treated this form of crucifix in his
Life of Margaritone.

series of frescoes of the saint's life had been painted in Constantinople about 1240 under the Latin Empire.[8] In the crucifixes of the Berlinghieri School the living Christ, with open eyes, belongs to a Western tradition [49]. It was only gradually in the thirteenth century, as for instance with Giunta Pisano's crucifix of 1236 at Assisi [50], that the Byzantine dead and drooping Christ won Italian acceptance. Vasari thought, wrongly, that the Assisi crucifix was painted by an Aretine, Margaritone, whose signed altarpiece [51] in the London National Gallery is a good example of the faults that Vasari was emphasizing. The subject is the Virgin and Child with on either side scenes from the life of St. Margaret. As an Aretine, Margaritone (or more correctly Margarito) receives kindly treatment, but his works were *alla greca* and he died aged seventy-seven (in 1313, according to the first edition, but Vasari gives no date in the second), "grieving that he had lived so long as to see all the honors going to the new art." "His works were greatly prized by the people of the time, although they are not valued today except on account of their age." It is interesting to note that when the St. Margaret altarpiece was acquired by the National

[8] For the Constantinople frescoes see C. L. Striker and Y. Dogan Kuban, "Kalenderhane Camu," *Dumbarton Oaks Papers*, XXII, 1968, pp. 185–93.

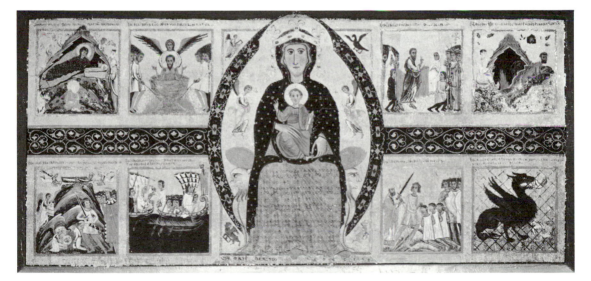

51. Margaritone, *Virgin and Child Enthroned, with Scenes of the Nativity and Lives of the Saints.* London, National Gallery
 Painted probably as a retable: signed *Margarit' de Aritio me fecit.*

Gallery in 1857 it was "to show the barbarous state into which art had sunk even in Italy before its revival."[9]

In the familiar theme of the Virgin and Child there were, however, thirteenth-century developments. Coppo di Marcovaldo, today a high-ranking artist, is another name unknown to Vasari. A *Virgin and Child*, signed by him and dated 1261, is in S. Maria dei Servi at Siena, and another, unsigned, in the church of the same order in Orvieto. The latter is the more advanced: the small angels no longer are suspended in the air, but rest on the background of a throne which has a new substantiality, and on which the Virgin is firmly seated; the Child has a new liveliness; the draperies are striated in gold in the Byzantine manner, but the thrust of the Virgin's leg is quite clearly marked. Many of these features are common to Byzantine work of the second half of the thirteenth century. The painting of the Virgin seated in a great curved throne, now in the National Gallery of Art at Washington, has the same gold striations and as great an interest in depth as contemporary Italian examples, while retaining the Byzantine ethereal, other-worldly quality that few Italian masters achieved.[10] A tradition so long concentrated on spiritual values and regulated by close ecclesiastical rules did not easily yield its inner power to an alien culture.[11]

Such was the great Vasari legend: that Italian art was sunk in crudity, and dependent on Greek instructors: "the race of artists was completely extinguished." "Then as it pleased God, there was born in the year 1240 in the city of Florence, Giovanni, surnamed Cimabue, to shed the first light on the art of painting." Very little is certainly known of Cimabue. Vasari was relying on earlier writings, such as Ghiberti's commentaries where Cimabue is described as the master of Giotto, and in the second edition he added information from the *Ottimo Commento*, one of the earliest commentaries on Dante, of which his friend Vincenzo Borghini had a copy. Undoubtedly Dante's

[9] National Gallery Report, 1858, printed as Appendix I in M. Davies, *The Earlier Italian Schools*, National Gallery, London, 1951, pp. 435–37. Margaritone's dates are now generally given as ca. 1216–ca. 1290.

[10] For the Washington *Virgin* see O. Demus in *Jahrbuch der Oesterreichischen byzantinischen Gesellschaft*, vi, 1958, p. 87. Guido da Siena was equally unknown to Vasari. His Palazzo Pubblico *Madonna*, of which the date is so much in dispute, shows, whatever its other qualities, less understanding of Byzantine art than is found in Coppo's work. For a recent discussion of these problems see J. White, *Art and Architecture in Italy 1250–1400*, London, 1966; R. Oertel, *Early Italian Painting to 1400*, London, 1966; J. H. Stubblebine in *AB*, xlviii, 1966, pp. 379–81.

[11] The Council of Nicaea in 787 had decreed that the form of images was not the invention of the painter, but was based on tradition and rules of the church. The painter was concerned only with the execution of the work, and its composition was not his concern. Had Vasari known this statement he would have deeply disapproved of it.

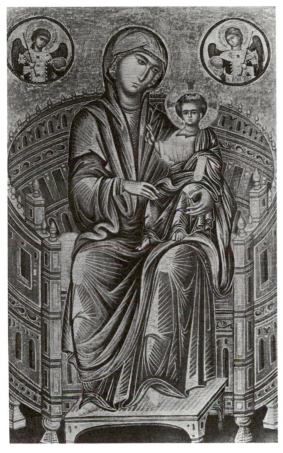

52. Byzantine School, *Virgin and Child Enthroned*. Washington, D.C., National Gallery of Art

It will probably never be decided whether this is a Byzantine work or Byzantino-Italian; but it represents trends in Byzantine art in the second half of the thirteenth century.

53. Cimabue, S. *Trinita Madonna*. Florence, Uffizi

"Having undertaken to make for the monks of Val l'Ombrosa, in the abbey of S. Trinita of Florence, a large painting, he showed in that work, using every diligence so as to justify his repute, better invention and a beautiful pose for Our Lady."

famous couplet about Cimabue and Giotto was the basis of the for-
mer's reputation: "Cimabue in painting was thought to hold the field
and now Giotto has the cry, so that the former's fame is obscured."[12]
Cimabue is documented as working in Rome in 1272, and in 1301–02
in Pisa where he was engaged on the apse mosaic and almost certainly
was responsible for the figure of St. John. The last mention of him is
at Pisa in July 1302, two years after the date given by Vasari for his
death. There is general agreement that he painted the S. *Trinita
Madonna* in the Uffizi [53]; the *Madonna* from S. Francesco, Pisa, in
the Louvre; the crucifixes in Bologna, Arezzo and S. Croce, the last
badly damaged in the floods of 1966; some of the frescoes in the upper
church at Assisi; and possibly the much repainted *Virgin and Child
with St. Francis* in the lower church at Assisi. In this Assisi fresco the
golden striated lines are still applied to the stool and floor, but now
are used to mark the angle at which the throne is placed. In the S.
Trinita Madonna the throne itself becomes an almost architectural
feature, framing the heads of the prophets and enclosing the figure
of the Virgin. The shadowy remnants on the transept walls of Assisi
still have a force and dramatic power not seen before. Many of them
were already "wasted by time and dust" when Vasari saw them, and
his assessment of Cimabue's work in S. Francesco includes much that
cannot today be assigned to him. He is also far from specific as to the
nature of Cimabue's innovations, describing them as "a certain quality
of excellence in the turn of the heads and the fall of the draperies."
But he was right in realizing that innovations were there, however
wrong in his sweeping condemnation of all that went before.

Cimabue is the forerunner. It is Giotto who, "though born among
inept artists, by the gift of God, resuscitated that which had fallen into
evil ways, and reduced it to a form that could be called good."[13]
Vasari sums up his achievement in the preface to his second book:
"The Greek manner, first with Cimabue, then with the aid of Giotto,
became outmoded and a new manner took its place, that I would like

[12] *Purgatorio*, xi, 94–96.

[13] Vasari gives the date of Giotto's birth as 1276. After much controversy this
date is gaining favor: see A. Smart, "The St. Cecilia Master," *BM*, cii, 1960, p.
437.

54. Giotto, *The Miracle of the Spring*. Assisi, S.
Francesco
"There can be seen the lively desire for water,
and he who lies on the earth to drink from the
spring is done with very great and marvelous skill,
so that it might be a real man who drinks."

to call the manner of Giotto, since it was discovered by him and his pupils, and was then generally respected and imitated by all. Here were abandoned the profiles outlining all the figures, the staring eyes, the feet on tiptoe, the pointed hands, the absence of shadow and other of these Greek monstrosities, and a good grace was given to the heads and soft shading to the colors." Giotto in particular contrived better attitudes for his figures, and showed a beginning of liveliness in his heads; he made the folds of his draperies crease more naturally than before, and discovered in some measure how to foreshorten his figures. "He was the first to give expression to the emotions, so that fear, hate, anger or love became recognizable." Vasari's Giotto is, however, a very different artist from the master as he is accepted today. Giorgio had no doubt, in the second edition, that the Assisi St. Francis cycle [54] was his work, and he devotes two of his longest descriptive passages to the *Story of Job* in the Camposanto at Pisa (now given to Taddeo Gaddi, as in fact Vasari had stated in the first edition) and to the *Life of the Blessed Michelina* in the cloister of S. Francesco at Rimini. This pious lady died in 1356, so that it is unlikely that Giotto would have celebrated her actions some quarter of a century earlier, but, as nothing remains of the frescoes, no stylistic test can be applied Vasari, however, may have seen them, for the cloister survived for some time the alterations, to which he refers, by which S. Francesco was converted into the Tempio Malatestiano. These paintings and others, such as the fragment of the frescoes in St. Peter's at Rome, preserved when the wall on which they were painted was pulled down, are matters where Vasari has the advantage of us. His surprising gap is the very summary reference to the Arena frescoes in Padua.[14]

In 1261 the Byzantine forces reconquered Constantinople from the Latins, and Michael Palaeologus was declared emperor. During the thirteenth century, the most consistent development of Byzantine art is to be found in the churches of Yugoslavia. At Sopočani (ca. 1260) there are frescoes which show an increased plasticity and naturalism, as compared with Comnenian linearism, a return to classical forms, more nearly paralleled by the Gothic art of the North than by anything in Italy.[15] This is carried further in the carefully modeled figures at Studenica at the close of the century. At Mount Athos, particularly in the Vatopedi and Chilandari monasteries, there are fresco cycles of the same period. In Constantinople itself the revived empire of 1261

[14] See Appendix C.
[15] S. Radojcic, "Sopočani et l'art européen du XIII siècle," *L'Art byzantin du XIII siècle, Symposium de Sopočani*, ed. V. J. Djuric, Belgrade, 1967, pp. 197–206.

was distinguished by an increased artistic output. This Palaeologan style is characterized by a sense of movement, fluttering draperies and the oblique setting of the architecture. It reaches its climax in the mosaics and frescoes of Kariye Çami, commissioned by Theodore Metochites ca. 1310 and completed ca. 1321. Here narration takes on a new naturalism; the figures move in defined spaces; oblique perspectives aim at a new sense of depth; the *maniera Greca* advances into a new range of accomplishment. In the Arena chapel Giotto had painted a series of scenes from the life of the Virgin. In Kariye Çami, the church of the Savior, there was within a decade of the Paduan work a similar cycle, in mosaic, as original in its treatment as that of Giotto, as careful in the setting of the figures in a landscape, but with a greater sense of movement than Giotto, deeply involved in solidity, achieved. There are great differences in approach. Tradition was stronger in Byzantium. The scene, for instance, of the *Annunciation to St. Anne* [55] is still, as it was more than two hundred years earlier at Daphni, set in a garden where the Virgin's mother looks at a nesting bird, and feels a reproach to her own barrenness. At Daphni the saint's tall figure bears no relationship to the tree and the house behind her; at Kariye Çami a new sense of proportion governs the arrangement of the scene. The incident is taken from the apocryphal Gospel of St. James, but in Giotto's day there was no Latin translation of this work and the story was known in the *Golden Legend* of James of Voragine, where the episode of the nesting bird is not included. Giotto, ignorant of it, showed St. Anne praying within a room, and in doing so imposed a new realism on his version of the tale [56].

In 1311 was completed another great series of scenes of the life of Christ and of the Virgin, though on a smaller scale, and in the case of the Virgin concentrating on the legend of her death, the *Maestà*, painted for the high altar of Siena cathedral by Duccio di Buoninsegna. Vasari is here much confused by his errors in chronology. He thought that Cavallini was painting in Rome about 1364, whereas he was an established artist before 1300; and Duccio he thought worked in Siena about 1350, whereas he is mentioned as early as 1278 and died in 1318. The new naturalism of thirteenth-century Byzantine art, with its sense of space and its pliancy of action, must be related through some channel to the mosaics of Cavallini in S. Maria in Trastevere [57], where much of the iconography has Byzantine elements, and the placing of the figures in localized settings has much in common with the wall paintings of Studenica. In Cavallini's St. Cecilia frescoes also there is a careful modeling of the features that recalls some contemporary Byzantine work, with a greater sense of volume

Opposite, above

55. *Annunciation to St. Anne.* Istanbul, Kariye Çami

The scene illustrates the text of the Protoevangelium where Anne laments her barrenness, and that she is not likened to the birds of the air, the beasts of the field, or even "unto these waters."

Opposite, below

56. Giotto, *Annunciation to St. Anne.* Padua, Arena Chapel

Anne is in a homely room, furnished with bed, curtain and marriage chest; outside her maid is spinning. It is a piece of realism, a genre scene, only broken by the angel's appearance on the side wall.

57. Cavallini, *Nativity.* Rome, S. Maria in Trastevere

Vasari much enlarged his account of Cavallini in the second edition, but only succeeded in confusing the chronology still further.

than any extant Greek paintings achieve.[16] In the art of Duccio, transmuted by his own strong individuality, there are many reflections of Byzantine methods and iconography, and a liveliness of movement and gesture that can only be paralleled at Kariye Çami. But in the central feature of his great *Maestà* the enthroned Virgin with rows of saints on either side has no Byzantine prototype. It is the first Italian *Sacra Conversazione*. Vasari had never seen it. With changing tastes, it had been stored away in Siena and he had failed to discover it, though he took the utmost pains in searching for it. In the narrative scenes there are also Byzantine reminiscences. There is the same mixture of frontal and oblique perspective as in Kariye Çami, but the defined interior spaces come nearer Giotto's practice. The figures have the slightness and elegance of Byzantine models; they have far less weight, are less sure-footed, than those of Giotto, but the actual scenes in this most detailed life of Christ [58] seem many of them to be new inventions without any prototype in setting or poses. As with Giotto,

[16] P. Hetherington, "The Mosaics of Cavallini," *JWCI*, xxxiii, 1970, pp. 84–106.

Opposite

58. Duccio, *Christ Healing the Blind Man*, panel from the *Maestà*. London, National Gallery

In 1506 the *Maestà* was removed from the Duomo; in 1771 it was placed in the chapel of the Sacrament and in 1878 transferred to the cathedral museum: during these moves several of the smaller panels were detached and dispersed. The *Maestà* is documented as painted between 1308 and 1311.

59. Duccio, *Rucellai Madonna*. Florence, Uffizi

Writing of it as by Cimabue, Vasari states that, though still in the Greek manner, this painting approached in some ways the execution and method of modern times.

a great original artist is at work, and if we can see some of the stylistic influences that went to form him, it is the expression of a unique and powerful personality that matters.

It is now generally agreed that the *Rucellai Madonna* [59] can be identified with an altarpiece commissioned from Duccio in 1285. Vasari thought it to be by Cimabue, and took from the *Libro* of Antonio Billi the story of it being carried in triumph through the streets of Florence, with such festivity that the place of its passage received the name Borgo Allegri. His narrative is very detailed, involving Charles of Anjou on a visit to Florence, but unfortunately the securely documented account of such a joyous transit is for Duccio's *Maestà* in Siena.[17] Vasari's attribution, however, coupled with this picturesque story, enjoyed lasting popularity, and in 1855 Frederick Leighton could still paint Cimabue's *Madonna* carried in procession

[17] J. A. Crowe and G. B. Cavalcaselle, *A History of Painting in Italy: Early Christian Art*, London, 1923, pp. 187–93. The Landesi (now Bardi) chapel, for which the *Rucellai Madonna* was commissioned, was frescoed by Cimabue and his school, so that there was some basis for associating Cimabue's name with the work; J. H. Stubblebine, "Cimabue and Duccio in S. Maria Novella," *Pantheon*, xxxi, 1973, pp. 15–21.

through the streets of Florence and find a purchaser for it in Queen Victoria.

The *Rucellai Madonna* has a debt to Byzantium, but the gold striations have gone, and instead the wavy line of the Virgin's embroidered hem winds across the figure with a Gothic freedom that has nothing to do with the East. In the little *Virgin and Three Franciscans* (Siena) there is the same winding line, but here set against a diapered background that also suggests French examples. Gothic painting had long had its own contacts with Byzantine art, but by now they had largely been absorbed into a very distinct and differing style, one that was to have many interchanges with Italy. Byzantium has for the moment played its part, and more and more the North is to take over the role of stimulant in the "rebirth" of Italian art.

IV. The *Maniera Tedesca*

THERE was general agreement in Italy of the cinquecento that antique architecture had perished with the barbarian invasions and that these had introduced a period of decadence that lasted up to the quattrocento and the days of Brunelleschi and Alberti. The Goths were taken as the prime cause of this long and little differentiated decline, but the term applied to it was not Gothic but German (*tedesco*). To most Italians the great cathedrals of France and Germany, far more those of England, were unknown. Where more traveled men had had experience of them, their views were less extreme. Even Petrarch, that doyen of classicism, had called the cathedral of Cologne "a very beautiful temple though not completed."[1] Aeneas Silvius Piccolomini, later Pope Pius II, in his *Commentaries* had admired the churches of Frankfurt and Nuremberg, and when he came to build his own cathedral at Pienza, he had designed a *Hallenkirche*, with aisles and nave of equal height, and ribbed vaulting.[2] But general opinion was hardening against medieval architecture. The author of the *Life of Brunelleschi* allowed for a revival under Charlemagne after the barbarism of "the Vandals, Goths, Lombards and Huns," but later there was another decline until "the time of Filippo," that is of Brunelleschi.[3] Filarete, writing at about 1460–64 besought everyone "to give up this modern [i.e. as opposed to antique] usage and not to be advised by masters who make use of this botchery. Cursed be he who introduced it." Filarete adds the interesting view that this debased architecture was derived from goldsmiths' tabernacles and censers, where the forms seemed appropriate enough but were quite unsuited to enlargement.[4] Both these authors' writings were known to Vasari. It is possible that he knew the report on the antiquities of Rome that long went under Raphael's name, though it had not been printed in Vasari's time. Here there is some distinction between the actual period of the

[1] *Epistolae Selectae*, ed. A. E. Johnson, Oxford, 1923, p. 3.
[2] *Germanica*, ed. F. Heininger, Leipzig, 1926, p. 7; L. H. Heydenreich, "Pius II als Bauherr von Pienza," *ZfK*, VI, 1937, p. 105: see Frankl, *The Gothic*, pp. 237–414; E. S. de Beer, "Gothic: Origin and Diffusion of the Term," *JWCI*, XI, 1945, pp. 143–62.
[3] Frey, *Sammlung*, IV, pp. 81–82.
[4] *Tractat über die Baukunst*, ed. Oettingen, pp. 271–72. See also M. Lazzaroni and A. Muñoz, *Filarete scultore e architetto del sec. XV*, Rome, 1908.

Goths and the Middle Ages proper, and it contains the famous and
romantic passage about the Germans copying their architecture from
the interlocked branches of trees.[5] Vasari, therefore, when he writes
of the German style had a climate of opinion; and it is in his *Lives*
that these views were summarized in a form that was to penetrate
widely and long to influence the opinions of Europe. The passage
from his introductory "Three Arts of Design" requires quotation in
full: "We come at last to another sort of work called German, which
both in ornament and in proportion is very different from the ancient
and the modern. Nor is it adopted now by the best architects but is
avoided by them as monstrous and barbarous, and lacking everything
that can be called order. Nay, it should rather be called confusion
and disorder. In their buildings, which are so numerous that they sick-
ened the world, doorways are ornamented with columns which are
slender and twisted like a screw [60], and cannot have the strength
to sustain a weight, however light it may be. Also on all the façades,
and wherever else there is enrichment, they built a malediction of
little niches one above the other, with no end of pinnacles and points
and leaves, so that, not to speak of the whole erection seeming
insecure, it appears impossible that the parts should not topple over
at any moment [61]. Indeed they have more the appearance of being

[5] Golzio, *Raffaello*, pp. 78–92.

60. Doorway of Palazzo della Fraternità dei
Laici, Arezzo
 The façade was begun in the Gothic style in
1375, and completed in 1434 by Bernardo Ros-
sellino. Here are Vasari's columns, "twisted like
a screw," in an example which was very familiar
to him.

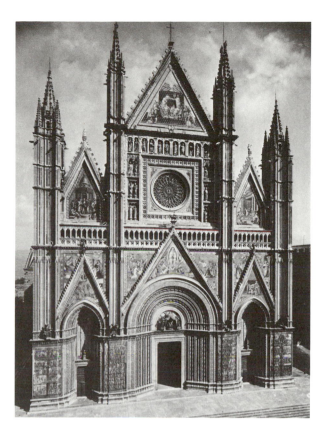

61. Orvieto Cathedral
Vasari thought the façade "was made by Germans," whereas the main design was due to an Orvietan architect, Giovanni di Uguccione.

made of paper than of stone or marble. In these works they made endless projections and breaks and corbelings and flourishes that throw their works all out of proportion; and often, with one thing being put above another, they reach such a height that the top of a door touches the roof. This manner was the invention of the Goths, for, after they had ruined the ancient buildings, and killed the architects in the wars, those who were left constructed the buildings in this style. They turned the arches with pointed segments, and filled all Italy with these abominations of buildings, so in order not to have any more of them their style has been totally abandoned. May God protect every country from such ideas and style of buildings! They are such deformities in comparison with the beauty of our buildings that they are not worthy that I should talk more about them."[6]

Nowhere in his condemnations does Vasari use the adjective Gothic, though he occasionally uses the phrase *maniera dei Goti* and pairs the Goths with the Greeks; but his argument as to Gothic influence was to be the decisive step in the most unhistorical transfer of a word symbolizing barbarism to the glories of pointed architecture. For Vasari himself the term is always *tedesco*, the style of the North, the still barbaric North that in his own lifetime had once more sent forth

[6] Maclehose, *Technique*, pp. 83–84.

invaders to sack Rome. *Tedesco*—it is a word that has had long and lasting overtones in Italy: the fierce tribes from beyond the Alps; Barbarossa and the Lombard war; Henry VI and the ravaging of Sicily; the Lutheran *Landsknechte*; the hidden meanings in Verdi's patriotic choruses; the Austrians in pursuit of Garibaldi; the *partigiani*, hiding in the woods and hills. There is still a growl behind the word *tedeschi* that even the most irritating *americani* or *inglesi* do not elicit. It is a sad counterpoise to the deep affection so many Germans have felt for Italy, and the great contribution German scholars, many of them German-Jewish scholars, have made to the understanding of Italian art.

Vasari is, however, never the slave of his prejudices. He admits that there was a gradual rediscovery of a better manner with some elements of "the good antique style."[7] There were medieval buildings that he admired. In Florence there was the church of SS. Apostoli, for which he had painted an altarpiece, the *Allegory of the Immaculate Conception*. A small eleventh-century basilica, whose legendary foundation by Charlemagne is still recalled by an inscription that Vasari knew, it seemed to him to show that some good architecture was left in Tuscany. Did not in fact its basilican form influence Brunelleschi in his designing of S. Spirito and S. Lorenzo? S. Miniato, where he correctly places the rebuilding in the early eleventh century, shows in its doors, windows, columns and cornices some attempt to use "the good antique order." He was at pains to find out the history of St. Mark's at Venice, "in the Greek style," though Cosimo Bartoli thought it "by a German"; it showed that architecture retained some merits, though in a very bastard form. Byzantine architecture was an unknown field to him, and it is strange that S. Sophia, already in his day a Turkish mosque, had left so little tradition in the West. The highest praise, however, is reserved for the Duomo at Pisa [62], particularly the diminishing tiers of arcades on the façade. He had studied a book of the Opera del Duomo, though no existing documents correspond with the dates he gives for the building; but at least it was worthy of investigation. The name of the architect he gives from a still extant inscription as Buschetto, who he thought was a Greek from the Ionian

[7] *M*, i, p. 272, v, p. 467; W. Horn, "Romanesque Churches in Florence," *AB*, xxv, 1943, pp. 112–31.

62. Façade of the Duomo, Pisa

The architect Buschetto, or more correctly Buscheto, flourished in the second half of the eleventh century and was probably Pisan by birth. He can claim to be an architect of great originality and lasting influence.

island of Dulichium. Echoes of Vasari's appraisals were to be long last-
ing. In 1831 an American traveler Robert Peale could describe the
Pisan Cathedral and Baptistery as "beautiful specimens of the Saxon
Gothic architecture," Saxon having a better ring no doubt than Vasari's
German.[8]

All these buildings were Romanesque and in their style more easily
acceptable. Of the great Gothic (in our sense of the word) cathedrals
of Italy he has little to say: the façade of Siena is admitted to be
"very splendid"; that of Orvieto [61] was mainly the work of Germans.
They are to Vasari settings for sculpture, some of it distinguished, but
as designs (*disegni*) of little moment.

Two Gothic buildings were, however, of particular interest to him:
S. Maria del Fiore, the cathedral of Florence, and S. Francesco at
Assisi. Both of these play an important part in the *Vita* of Arnolfo di
Lapo, which he added to the second edition, as a pendant to Cimabue
in painting and Nicola Pisano in sculpture. In the first edition Arnolfo,
not yet Lapo but called Tedesco, had been given only a paragraph in
the *Vita* of Cimabue. Vasari explains that he wishes to supplement his

[8] R. Peale, *Notes on Italy Written down during a Tour in the Years 1829 and
1830*, Philadelphia, 1831, p. 248.

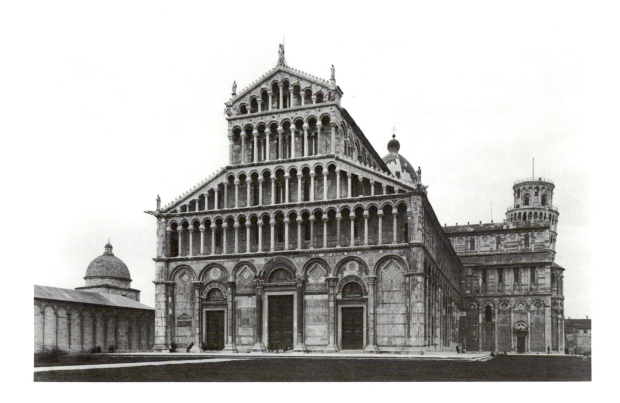

discussion of old buildings in the preface to the *Lives* by mentioning some others made in Arnolfo's lifetime, which he dates 1232–1300 (more likely it was ca. 1245–1302); "for, although the buildings are neither beautiful nor of a good *maniera*, but only large and magnificent, they are notwithstanding worth some consideration." He lists the abbey of Monreale (actually built ca. 1172–ca. 1183), the episcopal palace at Naples (thirteenth-century, rebuilt 1647), the Certosa of Pavia (founded 1396), the cathedral of Milan (founded 1386), St. Peter's (1161–65, rebuilt at various periods) and S. Petronio (founded 1390) in Bologna. "I have seen and considered all these buildings [there is no evidence of him having visited Sicily], and many sculptures of the time, particularly in Ravenna, and never having found any memory of the masters, nor even often in what century they were made, I could not but wonder at the simplemindedness (*goffezza*) and little desire for fame of the men of that time." He continues with an account of an architect Buono, of whom he knows only the name, not his place of origin, and who, he states, worked at Ravenna in 1152, built the Castello Capuano and the Castel dell'Uovo at Naples, the Campanile at Venice, S. Andrea at Pistoia, S. Maria Maggiore at Florence and the Palazzo dei Signori at Arezzo, pulled down in 1533. This striking list of buildings must represent a conflation of various masters, a Buono who worked at Castel dell'Uovo, Buono di Bonaccorso who worked in Pistoia and Florence ca. 1260, possibly the Buonamico who signs some sculpture in the Camposanto at Pisa. At S. Andrea of Pistoia, Vasari seems to have misread the inscription on the architrave to which he refers, GRUMANUS MAGISTER BONUS: he gives the date on it as 1166, but it is more reasonably interpreted as 1196. Of the Campanile at Venice he writes that Buono built it "with much care and judgment, and so well did he drive the piles and lay the foundations that it has never moved a hair's breadth," but no document confirms this attribution. Vasari next deals with Guglielmo, "a German, as I believe," who in conjunction with Bonanno, a sculptor, built in 1174 the leaning tower at Pisa, which he compares with the Garisenda tower in Bologna; he thought it was praised only for its extravagance, not for its design, because no one knew how it could remain standing. He quotes the inscription on the bronze doors of the Pisan Duomo that names Bonanno as the artificer, and it is possible that he also worked as an architect.

Vasari then turns to Rome under Lucius III (1181–85), Urban III (1185–87) and Innocent III (1198–1216), specifying under the last the tower of the Conti (still standing in his day) designed by Marchionne of Arezzo, to whom he also attributes the Pieve at Arezzo; the façade of this he describes in detail, quoting the date 1216 from an inscription still extant, which names Marchionne as sculptor and which

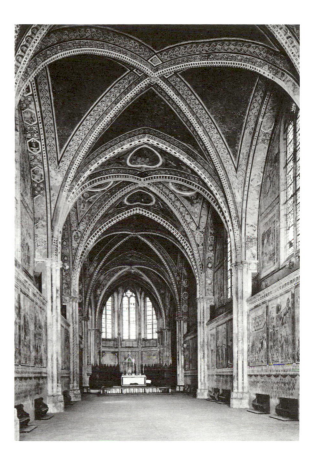

63. S. Francesco, Assisi, interior of the upper church

Vasari has some reason in his assumption that the design was influenced by German examples, but his German architect remains a mythical figure.

can refer only to the tympanum, as the upper stages of the façade were not built till 1300. Apart from the inscription nothing is securely known about this Marchionne, but there may well have been traditions preserved about him in Arezzo.

There follows a long account of the building of the church of S. Francesco at Assisi [63], "brought to completion in four years by the skill of Master Jacopo the German and the skill of Brother Elias."[9] Vasari had obviously studied the church with care when he was at Assisi in 1563, and notes for instance the change in the vaulting plans of the upper church. The friar, Lodovico da Pietralunga, who was completing his chronicle of Assisi about the time of Vasari's visit, states that Elias and Cardinal Ugolino sent for Jacopo "from the parts beyond the mountains." This clearly was a tradition accepted at Assisi, but both Vasari and Fra Lodovico were writing three hundred years after the completion of the building, and contemporary evidence suggests that Elias played a large part in designing the church, assisted by another friar, Filippo di Campello, who at the time of the consecra-

[9] P. Héliot, "La Filiation de l'église haute à St. François d'Assise," *Bulletin Monumental*, cxxxvi, 1968, pp. 127–40; Heinz Kotz, "Deutsche und Italienische Baukunst im Trecento," *MKIF*, xii, 1966, pp. 171–206.

tion of the church is referred to in a papal bull as the master set over
the work. Jacopo, however, has a further part to play in Vasari's nar-
rative. He is summoned to Florence, where he was known as Lapo,
and where he built the castle of Poppi [64] and the Ponte Carraia,
and paved the streets with stones instead of bricks. He died there
"leaving his son Arnolfo, heir no less of his skill than of his fortune."

For Vasari's argument it was necessary that the great Gothic church
of Assisi should have a German origin. Arnolfo, however, is well docu-
mented as being the son of one Cambio of Colle di Val d'Elsa. He was
a pupil of Nicola Pisano and worked with him along with another
pupil called Lapo on the pulpit in Siena cathedral. Hence probably
the confusion of names. At Florence Arnolfo was responsible, accord-
ing to Vasari, for the loggia of Orsanmichele, the Bargello, the Badia,
the church of S. Croce, the Palazzo Vecchio and above all the designs
for the new cathedral. Much of this can be documented, though not
his share in the Palazzo Vecchio, and there is no reasonable doubt that
Arnolfo di Cambio was the presiding genius over the great building
activities of the end of the thirteenth century, which created so much
of the Florence that we still know. When Vasari came to paint the
ceiling of the hall in the Palazzo Vecchio, he chose as one of his sub-
jects Arnolfo showing his plans for the rebuilding of the city [65]. The

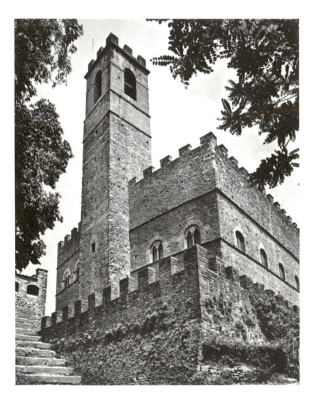

64. The Castle, Poppi, Tuscany
 "Arnolfo built the Palazzo of Poppi for the
count who had for wife the fair Gualdrada."
Guido Guerra married Gualdrada ca. 1180, more
than a hundred years before the castle was be-
gun, but Vasari cannot resist the reference to
Dante (*Inferno* XVI, 37).

Opposite

65. Vasari, *Arnolfo Showing his Plans for the Re-
building of Florence*. Florence, Palazzo Vecchio,
Sala dei Cinquecento
 "I have represented here the architect Arnolfo
showing to the Signoria, in their ancient costume,
the plan of the circuit of the walls and in the
background the bishop blessing the first stone of
the Porta S. Friano."

history of the façade of the cathedral is an extremely complex one.[10]
Work commenced at the western end, and probably the spacing of
the portals still reflects Arnolfo's design, while fragments of his sculp-
ture survive in the Opera del Duomo and elsewhere. The main struc-
ture, except for the dome, was built under the direction of Francesco
Talenti between 1355 and 1365. The façade was not completed till
1875–87 from designs by de Fabris.

There is no reference in the *Life* to Arnolfo's sculpture, or to his

[10] M. Weinberger, "The First Façade of the Cathedral of Florence," *JWCI*, IV,
1940–41, pp. 67–79; H. Saalman, "S. Maria del Fiore: 1294–1418," *AB*, XLVI,
1964, pp. 471–500.

employment in Rome by Charles of Anjou, which is a likely source
for some of the Gothic elements in his work. Realizing that he had left
the account of him incomplete, Vasari introduced a short note before
the index of his first volume, the only instance of this type of after-
thought, mentioning the tombs of Honorius III and of Boniface VIII.
Honorius III (d. 1227) must be a Vasarian slip for Honorius IV (d.
1287). The tomb itself was dismantled in the rebuilding of St. Peter's
and the effigy moved and reset in another tomb of the pope's family,
the Savelli, in S. Maria in Aracoeli. The tomb of Boniface was also
dismantled though the effigy survives, and neither work in its present
state is a natural selection for a study of Arnolfo's style.

In the first half of the cinquecento two famous buildings, S. Petronio
in Bologna and Milan cathedral, were the center of a familiar dispute,
whether to complete the work in the original style or to adapt it to
new fashions. In Bologna, where building had been begun in 1390,
the sixteenth-century controversy involved a galaxy of architectural
consultants, among them Peruzzi, Giulio Romano, Vignola and
Palladio.[11] In the end the façade was left unfinished, but the flat ceil-
ing, a provisional work, was replaced with ribbed vaulting. In 1582
Pellegrino Tibaldi, who is only mentioned in passing by Vasari,
committed himself to the statement that if the authorities wished to
retain Gothic "he would like to see the rules of this architecture
observed, which are in truth more reasonable than others think, with-
out mingling the one *ordo* with the other."[12] Well as he knew Bologna,
Vasari has little to say about this great debate, though it was close to
much that interested him. He twice refers to it, once in the life of
Peruzzi where he states that Peruzzi made two plans and sections for
the façade of S. Petronio, one *alla moderna* and one *alla tedesca*. He
had seen these designs in the sacristy, and they were still extant. More
ambiguous is his comment on the reliefs by Jacopo della Quercia on
the doorway of S. Petronio. "Here," he writes, "he followed the German
order so as not to depart from the manner in which the building had
been begun, filling the spaces not articulated by the pilaster order with
stories from the Old Testament." It is clear that Vasari means the set-
ting of the reliefs as *alla tedesca*, not the reliefs themselves, which he
rightly says were "of very great use to sculpture," though he adds the
surprising explanation that no one since antiquity had hitherto worked
in low relief. Jacopo's is the first life in Vasari's second part, and he is
described as "advancing towards excellence, . . . shaking off the old-
fashioned style." The tomb of Ilaria del Carretto at Lucca [66], that re-
markable combination of a Gothic effigy with Renaissance putti and

[11] R. Bernheimer, "Gothic Survival and Revival," *AB*, xxxvi, 1954, pp. 263–85;
Panofsky, *Meaning in the Visual Arts*, pp. 196–205; P. Pouncey and J. A. Gere,
Italian Drawings in the British Museum: Raphael and his Circle, London, 1962,
pp. 143–46.
[12] Gaye, *Carteggio inedito d'artisti*, iii, p. 447.

wreaths, is described and admired, though its implications for the meeting of styles are not explored. The deeply original, powerful figures of the S. Petronio reliefs [67], which to us today seem a prelude to Michelangelo, clearly gave him cause for thought. It is only in the second edition that they are described as *alla tedesca*, and he omits a passage from the first where he had emphasized della Quercia's advance on the previous work on the façade by Germans "in the old manner." He had in the interval decided that the craftsmen were not Germans but two Sienese, Agostino and Agnolo, though unfortunately here too he is in error: the altar in S. Francesco at Bologna, which he uses as the key piece for the Sienese carvers' work and which he dates as done in 1329, is documented as carved by two Venetians, Jacobello and Pierpaolo dalle Masegne, in 1388. Such were the problems of connoisseurship in these its early stages.

Of the debates in Milan, Vasari was aware but took only a remote interest in them. He vaguely associated the Duomo with German influences in Italy, and thought that in Nicola Pisano's day, that is, in the late thirteenth century, many Lombards and Germans were gathered there, who afterwards scattered through Italy during the dissensions that arose between Milan and the Emperor Frederick. This is Vasari at his most historically confused. Assuming that the Emperor Frederick is Frederick II, not Barbarossa, the former died in 1250. The date of Nicola Pisano's birth is not known. Vasari placed it early in the thirteenth century, but the first documented mention of him is in 1258. The foundation stone of Milan cathedral was laid in 1386, and from then on there was almost continuous dispute as to the building operations.[13] In the sixteenth century these were mainly concerned with the drum over the crossing. Vasari knew that Bramante had had some association with it, and also Cesare Cesariano (1483–1543), whose commentary on Vitruvius, published in 1521, may have been known to him. Cesariano died "of a chronic fever" in a Milanese hospital, which Vasari enlarges, on what evidence is not known, into "he became savage (*salvatico*) and died more like a beast than a man." He states also that Bernardino Zenale of Treviglio was architect of the Duomo and that Silvio Cosini and Francesco Brambilla did carvings for it; they would have become marvelous artists, if they had had the opportunities of study given by Rome and Florence. He saw an *Adam and Eve* [68], a *Judith* and a *St. Helena* by Cristoforo Solari, called Il Gobbo, amongst the statuary on the cathedral.[14] But into the puzzling and highly contentious problems of the cathedral workshop

[13] J. S. Ackerman, "Gothic Theory of Architecture at the Cathedral of Milan," *AB*, xxxi, 1949, pp. 84–111; "Il Duomo di Milano," ed. M. L. G. Perer, *Congresso Internazionale Milano, Museo della Scienza e della Tecnica*, 1968, 2 vols., Milan, 1969.

[14] *M*, iv, pp. 148–50, 484, vi, pp. 516–17, vii, pp. 539–40, 544. Solari's *Adam* is now in the Museo del Duomo in Milan, as is also Zenale's model of the cathedral.

104

Opposite, above

66. Jacopo della Quercia, Tomb of Ilaria del Carretto. Lucca, Duomo

"On the base he made some marble putti, who carry a wreath, so highly finished that they seem like flesh, and on the chest he made with infinite care the image of the wife of Paulo Guinigi, and at her feet a dog in full relief, emblem of her fidelity to her husband."

Opposite, below

67. Jacopo della Quercia, Relief, *Creation of Adam* (detail). Bologna, S. Petronio

68. Cristoforo Solari, called Il Gobbo, *Adam with the Infant Abel*. Milan, Museo del Duomo

"The Adam and Eve by him on the façade of the Duomo towards the east are held rare works, such as can be held equal to any done in those parts by other masters." Such was this sculptor's local fame that some Lombards in St. Peter's were overheard by Michelangelo saying that his *Pietà* must be by "our Gobbo of Milan."

he made few investigations, and in his *Vita* of Francesco di Giorgio he says nothing of him being employed as chief superintendent of the work in Milan.

For Vasari *tedesco* is a term that he confines almost entirely to architecture and sculpture. The reliefs at Orvieto cathedral are for him mainly German work, "considered notable at the time," though he thought that Nicola Pisano had carved the *Last Judgment* there, "surpassing not only the Germans but even himself." The work on the cathedral was begun in 1290, long after Nicola's death, so that this was one of his less happy attributions, and he knew nothing of Lorenzo Maitani, master of the Orvietan work from 1310 to 1330, or of Orcagna's period as *capo-maestro* from 1358 to 1360. Orcagna's tabernacle in Orsanmichele [69] is, he admits, in the German manner,

but its grace and proportions, and the technical skill with which it was fitted together, give it the first place in the works of this time. The Gothic sculpture of France he had of course never seen, and as yet there were no drawings or engravings to give him any conception of it.

There were many other influences at work in Italy. When visiting Naples in November 1544 Vasari must have ridden, unless he went by sea, across the bridge at Capua guarded by Frederick II's tower, still to stand for another thirteen years till in 1557 it was ruthlessly dismantled by the viceroy, Don Pedro of Toledo, to make way for an artillery bastion. In its niches were the statue of the emperor and the busts of his chief ministers, Pietro della Vigna and Taddeo da Sessa, and these busts, refound in 1877, are the most striking examples of the strongly classical revival under Frederick. Vasari thought that the tower had been built by a Tuscan sculptor called Fuccio, to whom he also attributed the tomb at Assisi called "of the Queen of Cyprus," a later work that has no stylistic connections with the Frederickian revival. Nothing is known of any Fuccio, and the name probably comes from the misreading of a Florentine inscription to which Vasari refers; but the transference of it to a Neapolitan and Capuan setting may well be due to some confusion with Foggia, from where came one of the few named sculptors, Bartolomeo da Foggia, of this South Italian school. Vasari knew nothing of the probable connection of Nicola Pisano with Apulia. He states that he copied a sarcophagus in the Camposanto at Pisa and that there were some classical influences in his work. Of other influences from the Gothic North he suspected nothing, and these great achievements of a meeting of styles seemed to him still primitive work.

Of Giovanni Pisano's pulpit in the Pisan Duomo he writes: "It is truly a sin that such cost, such diligence and such labor was not accompanied by good design . . . as would have had any work of our time, made with less cost and effort. Yet it must have roused no little admiration in the men of those times, used to seeing only the crudest things." It is a poor tribute to the sculptor of whom Henry Moore has written that "we are all indebted to him,"[15] but it is a passage typical

[15] M. Ayrton and H. Moore, *Giovanni Pisano Sculptor*, London, 1969, p. 11.

69. Orcagna, *Death and Assumption of the Virgin*, detail of tabernacle in Orsanmichele, Florence

The shrine was set up out of the votive gifts to the Madonna during the plague year of 1348. "Though it is the German manner, it has such grace and proportion that it holds the first place amongst works of that time."

of Vasari's use of a double standard by which any work must be judged both by the perfected rules of the age of Michelangelo, and also by the resources and concepts of the period at which it was made. "In so much darkness, Nicola and Giovanni gave no little light."

Vasari knew something of Avignon, that Simone Martini had gone there and met "the most amorous Petrarch"; he thought, relying on a misreading in the *Ottimo Commento* of Vignone (Avignon) for Vinegia (Venice), that Giotto had been there. But of the interaction between Gothic and Italian art, or of the frescoes painted by Matteo Giovanetti in the papal palace he knew nothing, nor anything of the great patronage of Jean de Berri and the dukes of Burgundy. When he writes of illuminated manuscripts it is the Italian products that he knows. He was aware of the great output of illuminated books in quattrocento Florence, but somewhat confusedly. Much his longest account of any quattrocento work is devoted to a volume of *Silius Italicus* illuminated, as he thought, by Attavante. Cosimo Bartoli had drawn Vasari's attention to it in SS. Giovanni e Paolo in Venice, and had forwarded to him an account of the volume provided by some Venetian noblemen. Vasari himself had not seen it and merely copied down the lengthy information which had, "with much pains," been collected for him. He thought it the master's only known work, whereas numerous examples of the work of Attavante di Gabriello (1452–ca. 1520), many of them signed, are extant. The *Silius Italicus*, of which only a few pages now survive, would not however be included amongst them.[16]

It is characteristic of Vasari's approach to this branch of the arts that he should reproduce this long extract by another hand. He knew something of the art and career of Gherardo del Fora, and some other workers in the medium receive brief notices. Oderigi of Gubbio, whose work he describes as mainly destroyed by time; Franco of Bologna, by whom he had several drawings; Lorenzo Monaco's choir books and others by his brother Camaldolian, Silvestro, that Leo X had so much admired; Fra Angelico's choir books in S. Marco; Liberale of Verona's illuminations at Monteoliveto and the Piccolomini library in Siena: these he had seen and admired. Of the master of the Codex of St. George (ca. 1340), of Giovannino de' Grassi or of Belbello da Pavia, artists more affected by Northern trends, he knew nothing. For him "the most excellent illuminator above all others" was Giulio Clovio (1498–1578), the Croat refugee from Turkish conquest, but his nickname in Rome, "the Michelangelo of little works," shows how far he was from any Gothic connections. "Such works," Vasari reflects, "are

[16] P. Toesca, "Francesco Pesellino miniatore," *Dedalo*, xii, 1932, pp. 85–91, where the *Silius Italicus* is attributed to Pesellino: see also M. L. d'Ancona, *Miniatura e miniatori a Firenze dal XIV al XVI secolo*, Florence, 1962, pp. 254–59.

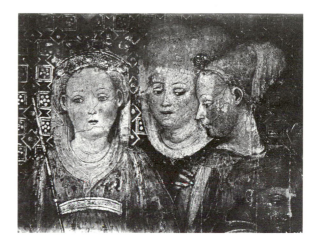

70. The Zavattari, *Life of Queen Theodolinda* (detail). Monza, Duomo
The Zavattari brothers painted these frescoes in 1444, with obvious delight in elaborate costumes, and much gilding in relief. Vasari, who had never seen them, writes of them as ancient Lombard works.

not public, nor in places where everyone can see them, as are paintings, sculpture and the products of the artificers of these our arts."

The term "International Gothic" was coined by the French art historian Courajod in the later nineteenth century to describe the courtly style common to much of European art at the close of the fourteenth century, characterized by a fashionable elegance of costume; flowing curves of drapery; a new joy in nature and in the chase, that aristocratic contact with woodlands; and a sense of overall pattern that recalls the tapestries where similar scenes were portrayed. To Vasari such interests might diverge from but could not interrupt his planned course of artistic development. These Northern elements, coming down through Savoy and Piedmont into Lombardy, would have disturbed him, had he known them better, with their crowded, sometimes brutal vigor. He had no conception of how powerfully this new trend had made its mark. While he writes of Gentile da Fabriano, Pisanello and Stefano da Zevio, no foreign elements are allowed to impede the steady progress of the Vasarian rebirth of the arts, and he seems unpuzzled by unfamiliar elements in their work. The frescoes of the chapel of Queen Theodolinda (d. 628) in the Duomo at Monza [70], signed by the Zavattari and dated to 1444, representing the life of the queen with a gay feudal liveliness, are written off by Vasari as painted by Theodolinda's orders and as evidence for how the Lombards dressed.[17] He had clearly never seen them, but his wild statement, one of the few references to old (as he thought) wall paintings, shows the uncertain information on which he had to rely, and his vague stylistic knowledge in assessing it.

[17] M, I, p. 234.

Gentile's *Adoration of the Kings* [71] was painted in Florence in 1423, almost contemporaneously with Masaccio's work in the Carmine, but there is no suggestion in Vasari's account that this elegant cortège in its cusped frame belonged to another and very different world. The great Michelangelo, Giorgio writes, admired Gentile's work in Rome, and thought it lived up to his name, a shrewd comment for it has indeed the gentle courtly quality that was more familiar in the feudal North. Gentile was a very sensitive artist, aware of classical examples as well as of Northern trends, but Giorgio makes no attempt at analysis.[18] Over Pisanello Vasari took much pains, having, between the editions, learned much of him from a Veronese friar, Marco de' Medici, and also from the section on Verona in the *Italia illustrata* of Flavio Biondo of Forlì. He knew also of poems written on Pisanello by Guarino and Tito Vespasiano Strozzi. It has recently been stated that "one of the most disconcerting facts of Quattrocento Art history is that more

[18] B. Degenhart and A. Schmitt, "Gentile da Fabriano in Rom und die Anfänge des Antikenstudiums," *Münchner Jahrbuch der bildenden Kunst*, xi, 1960, pp. 59–151.

Opposite

71. Gentile di Fabriano, *Adoration of the Kings*. Florence, Uffizi

Signed and dated 1423. "He painted in the sacristy of S. Trinita a panel of the story of the Magi, in which he drew himself from life." Gentile is the figure in a black cap, behind the young king; Vasari used this head for his engraving in the *Vite*.

72. Pisanello, *St. George and the Princess*. Verona, S. Anastasia

"St. George turns with his face towards the people, while he puts one foot in the stirrup and his left hand on the saddle, as ready to mount his horse . . . and everything is seen foreshortened, most excellently in a little space."

111

praise was addressed by humanists to Pisanello than to any artist of the first half of the century."[19] His paintings with their elaborate clothes, their complements of birds and beasts, their background scenes and landscape vistas, lent themselves to the detailed descriptions that were the humanist critics' form of appreciation and opportunity for rhetorical variety and display. The Northern courtly elements, the very Gothic church behind St. George and the Princess, did not trouble them. Pisanello, too, was an esteemed medalist, praised by Paolo Giovio in a letter, quoted by Vasari, to Duke Cosimo, and medals were essentially classically derived and had full Renaissance approval. Before Pisanello's fresco of *St. George and the Princess* [72] in S. Anastasia in Verona, then a far more complete work than it is today, Vasari felt "infinite wonder, even stupor" at the design, grace and judgment displayed. The foreshortening of the horse and the action of the saint, with one foot in the stirrup, seemed to him particularly worthy of comment. That he attempted to explain the artist's merits by a supposed and in time impossible pupilage of Pisanello to Andrea del Castagno shows his desire to bring these splendid scenes into the main Tuscan stream, and also his inability to realize their very different sources of inspiration.

Stefano da Zevio, born in 1375 and last recorded in 1434, is dealt with in the *Lives of Carpaccio* (Scarpaccia Vasari calls him) *and other Venetian and Lombard painters*. Vasari admits that he has not been able to learn all the particulars, and that it was only of Carpaccio that he could find a portrait. Stefano had already been mentioned, surprisingly, in the *Vita* of Agnolo Gaddi, where Vasari groups him with various late Giottesques. In the later account he discusses various frescoes no longer extant: he is aware of "the backgrounds full of trees with fruit," but never suggests the Northern elements in the tapestry-like compositions of this charming artist.

Very different is his later discussion of the German style as associated with engravings and the work of Albrecht Dürer, confused as it is by his belief that Dürer began his career at Antwerp. The impact of these German engravings on Italian art was very clear to Vasari and he had much admiration for the variety of poses, costumes and inventions, but he found in them a dryness and angularity that was the contradiction of all he meant by grace, and also an undue concentration on detail and a failure to unite all the parts in a beautiful whole. Here we have the real conflict between North and South. When Vasari writes of Pontormo's frescoes in the Certosa of Florence [73], he discusses in full this interaction of German and Italian art, and rebukes Pontormo for borrowing from Dürer exactly what Dürer was

[19] Baxandall, *Giotto and the Orators*, pp. 91–96.

73. Pontormo, *The Resurrection*. Florence. Certosa del Galluzzo

Vasari writes that when in 1522 Pontormo went to the Certosa, "he decided to show the world that he had acquired a new perfection and variety of manner." Dürer's prints were much appreciated in Florence and he borrowed poses from them. Vasari admired Pontormo's sleeping soldiers, but could not accept all the German motifs.

seeking to modify by studying the Italians. On Venetian painting, in particular on that of Giovanni Bellini, Vasari thought that Dürer's influence was responsible for "a certain sharpness in the drapery, handled in the German style." He noted this particularly in the *Feast of the Gods*, which he thought, but for this fault, one of Bellini's finest works, though completed by Titian. Compared with his own wide curving folds, the more crinkled fall of Bellini's stuffs may well have seemed lacking in *grazia*. It is an illuminating instance of his stylistic criticism. His prejudice against things German still persists, but in his realization of its impact on the early cinquecento through the new medium of engraving he is at his most perceptive.

As the final comment on the *stile tedesco* in its architectural applications, Vasari's own buildings are possibly the surest statement. Most

familiar of them all, the Uffizi [74], from 1560 onwards, is scenically
a tour de force, contrasting the open vista of the tower of the Palazzo
Vecchio with the loggia through which the Arno can be seen. Vasari
gave a detailed account of his problems in its design. He tells us that
Duke Cosimo was very partial to the Doric order, though one suspects
it was a partiality that Vasari encouraged. He was determined that
the Doric capitals should be correctly covered with a flat architrave,
but this classical convention was hardly suited to support the weight
of the upper storeys required. With an ingenuity that has produced a
lasting piece of work, Vasari succeeded in maintaining his severely
correct façade, while masking much of the support on the interior. In
fact, the austere Doric suits this comparatively narrow passageway.
Vasari concentrated on giving through his heavy cornice and strongly
marked window pediments some play of light and shadow if any pass-
ers through the colonnade looked upward; but it was the vista that
was all important, and his regular simplicity admirably frames the
medieval tower to which it leads. When at Arezzo at the end of his
life he designed the Palazzo delle Loggette, nothing in its low, regular
relief, its concentration on the sole feature of the shadowed colonnade,
could be further from the tiers of pinnacles that he so much disliked
in the Gothic style.

Very different is his creation of the Piazza dei Cavalieri at Pisa [75].
Here he had to adapt some ancient buildings, and build a head-
quarters and church for Cosimo's new order of the Knights of St.
Stephen, created in 1561 to guard the seacoast from Turkish piracy,
and also to associate Medicean rule with past Pisan glories. By allot-
ting to the order the former Palazzo degli Anziani, the duke flattered
the Pisan maritime tradition and also removed one of the landmarks
of their former independence. In a letter of 6 January 1562 Vasari
wrote to Borghini that he had been entrusted with the remodeling of
the Palazzo. Some portions of the ancient building were retained,
"accommodating the old walls to the modern style, as far as possible,"
but the façade is entirely Vasari's design. It has far more incident than
any other of his works. A double staircase links the length of the build-
ing to the central doorway, which is further stressed by a balcony
above it, and the window leading to it is crowned by a heavy car-

74. The Uffizi and the tower of the Palazzo Vec-
chio

"Duke Cosimo charged me to construct a build-
ing for thirteen civil magistrates of his city and
dominion . . . to be placed between his own pal-
ace and the Arno."

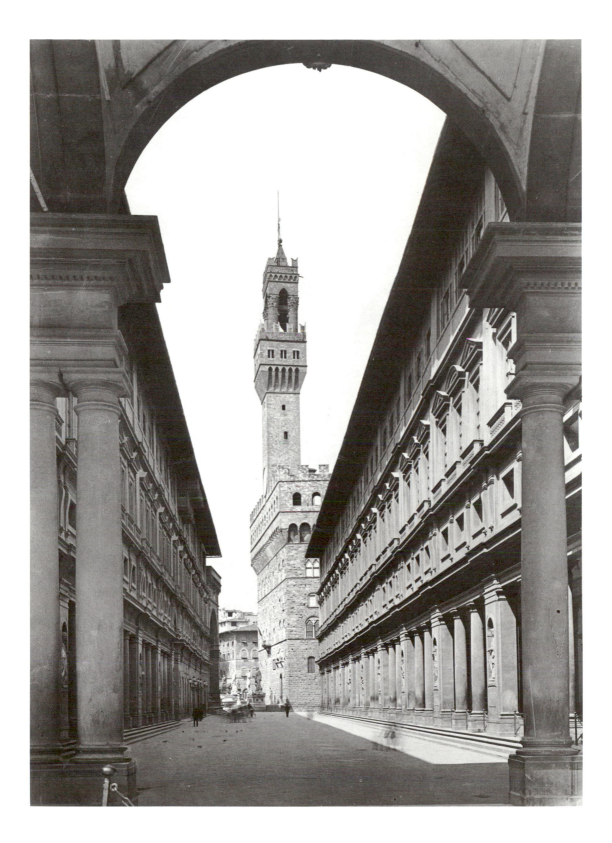

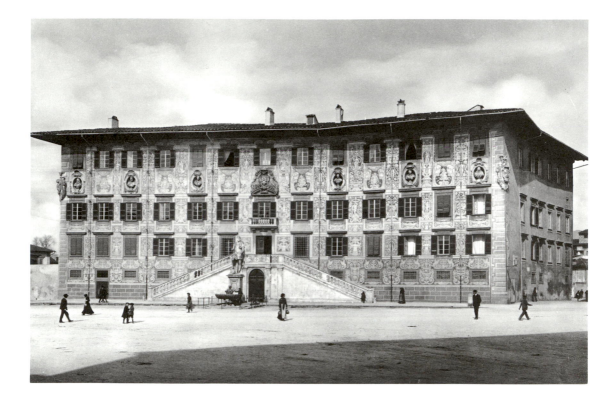

touche. Between the third and fourth rows of windows are roundels
with portrait busts of the Medici. The most surprising effect, however,
is that of the sgraffito or stencil work on the walls. Vasari had long
been deeply interested in arabesques, and he had learned much of
them from Andrea de' Feltrini, when as a young man he was working
for Duke Alessandro in Florence.[20] These large-scale decorations fig-
ured conspicuously in the *apparati* used for state occasions, and the
application of them to walls by stenciling had been Andrea's inven-
tion. They had, too, the sanction of classical prototypes, the *grotteschi*
found in the Roman ruins. Vasari had already used them on the façade
built for Sforza Almeni, and here again on this Renaissance façade at
Pisa there is a luxuriance of detail, a means of escape from the too
great purity of the classical style. Beyond the Palazzo, at the corner
of the square stood one of the famous monuments of Pisa, the Torre
della Fame, where Ugolino della Gherardesca and his sons had per-
ished, immortalized by Dante and still an inspiration to Italian artists
such as Pierino da Vinci, who made a wax model of the terrible scene

[20] M. Salmi, *Il palazzo e la piazza dei Cavalieri*, Bologna, 1932; C. and G.
Thiem, "Andrea di Cosimo Feltrini und die Groteskendekoration der Florentiner
Hochrenaissance," *ZfK*, xxiv, 1961, pp. 1–39.

Opposite

75. Palazzo dei Cavalieri, Pisa

"Pisa is now almost restored to its former magnificence, thanks to Duke Cosimo, who has no object more dear to him than that of improving and restoring the city."

76. Pierino da Vinci, *Ugolino*, wax model. Oxford, Ashmolean Museum

"I saw the three fall, one by one, between the fifth day and the sixth, and I already blind groped over each and for two days called them that now were dead, till afterwards my hunger got the upper hand of grief" (Dante, *Inferno*, XXXIII, 71–75). This horrible incident took place in 1289.

when "hunger got the upper hand of grief" [76]. Vasari thought it as moving as Dante's verses, the words of which he uses in describing it. It was a theme that must have been in his mind as he worked on the Piazza, and he preserved some of the walls of this sinister prison.

A man with his sense of history could not but be aware of the significance of the past, but in his handling of Gothic Vasari could be a drastic restorer. In Florence both S. Maria Novella and S. Croce were reshaped by him, at the express wish of Duke Cosimo.[21] Their choir screens were removed, immensely, Vasari thought, improving the beauty of the buildings, and a new choir was placed behind the high altar, fortunately without serious damage to the frescoes of Ghirlandaio or those of Agnolo Gaddi. The screens themselves had altars built against them, and it is difficult to calculate what losses were involved. We know that a fresco by Domenico Veneziano was cut out

[21] C.–A. Isermeyer, *Studi Vasariani*, pp. 229–36; M. B. Hall, "The Tramezzo in S. Croce," *BM*, CXII, 1970, pp. 797–99; M. B. Hall, "The Operation of Vasari's Workshop and the Designs for S. Maria Novella and S. Croce," *BM*, CXV, 1973, pp. 204–09.

and transferred to another wall. In both churches Vasari removed the altars from the aisles, substituting large Renaissance frames with a series of altarpieces painted by himself and his friends. At S. Maria Novella changing tastes have led to the removal of the frames and the substitution of Gothic revival arches. In S. Croce Vasari's alterations meant the destruction of Orcagna's fresco of the *Triumph of Death*, which Vasari had described in great detail, going into the contemporary portraits it contained. Today its rediscovered fragments are regarded as amongst the most powerful of trecento creations. It is only fair, however, to note that in all likelihood the fresco when Vasari intervened had already been considerably damaged by the terrible flood that swept over Florence in 1557, doing incalculable havoc. Vasari's work in S. Croce, then as now one of the most exposed danger points, may well have been partially motivated by the need to restore order and seemliness to a wrecked interior. But primarily its aim was to minimize the barbaric German manner of these buildings, and to introduce something of contemporary seemliness that would be an apt setting for great ducal ceremonies.

Vasari remained, however, aware that the *maniera tedesca* was a genuine style, which had its historical period and even its rules. Writing to Bishop Minerbetti about alterations to the high altar in the cathedral at Arezzo, he advised him that "something in the modern style never goes with the German"[22] and when he came in his own *Libro dei disegni* to design a setting for a drawing that he wrongly took to be by Cimabue, he framed it in a pointed Gothic arch.[23]

[22] Frey II, p. 155.
[23] Panofsky, *Meaning in the Visual Arts*, pp. 169–225.

V. The Critic

VASARI is at pains, at various points in the *Vite*, to set out the basis of his criticism of the arts. The development that he traces is governed by increasing accuracy, by means of perspective, anatomy and shading of color, in the rendering of the thing seen. Here he follows the doctrine of mimesis, of imitation, as set out by classical authorities, and as restated by writers such as Ghiberti, Filippo Villani and Alberti. "I know," he wrote, "that our art is wholly imitation, firstly of nature, and then, because of itself it cannot rise so high, of the works of those judged the best masters."[1] Ancient sculpture, the great works that had emerged from the ruins of Rome, had made possible the complete achievement of his third period, but it was natural verisimilitude that had been the dominant factor in the rebirth of the arts. He tells of an obscure Ferrarese artist Bernazzano that he painted in a landscape a basket of strawberries so realistically that peacocks ruined the fresco by pecking at it, a version of a tale told by Pliny of Zeuxis.[2] Bramantino painted in the stables at the Vercellina gate in Milan a horse so lively and well done that another horse kicked it.[3] Girolamo dai Libri painted the Virgin sitting under a tree, which looked so real that birds flying about the church tried to perch on it [77].[4] When he writes admiringly of Masaccio it is the naturalism of the figure of the naked man shivering with cold that he twice singles out for praise.[5] Such examples come throughout the whole work.

In a striking passage in the *Vita* of Mino da Fiesole he states at some length his theory of artistic training. Neither nature nor the example of former masters is enough by itself, but the understanding of natural forms must precede the reinterpretation of them by the artist in a personal style. Towards this, study of the achievements of others will be of much value, but it must supplement and refine upon the study of natural objects: "those who always walk behind rarely pass in front." In this copying of nature, the human nude was the basic element, and the study of anatomy one of the means of progress. In the

[1] *M*, I, p. 222. [2] *M*, V, p. 102. [3] *M*, II, p. 493. [4] *M*, V, p. 328.
[5] Quoted both in the *Life* of Masaccio and in the preface to the second part of the *Lives*.

77. Girolamo dai Libri, *Madonna with Child and Saints*. Formerly in S. Leonardo in Monte near Verona. New York, Metropolitan Museum

"The tree, which seems to be a laurel, spreads out its branches over the seat, and between the branches is clear daylight . . . birds which fly about the church have many times been seen to try to perch on the tree, particularly the swallows which have their nests in the beams of the roof; and this many people, most worthy of faith, affirm, amongst them Father Giuseppe Mangiuoli . . . who would not for anything in the world state something that was not true."

Opposite

78. Antonio Pollaiuolo, *St. Sebastian*. London, National Gallery

"This was the most praised work that Antonio ever made. . . . It is all done with much care in the various attitudes, clearly showing the genius and thought that he had given to this work." The one thing that Vasari does not mention is the beautiful landscape of the Arno valley.

Pollaiuolo altarpiece of *St. Sebastian* [78], he writes that Antonio (to whom he assigns the work) "copied Nature as much as he could" and that in his nude archer bending his crossbow "we can recognize the swelling of his veins and muscles and the holding of his breath to have more force." He also states, as did Antonio Billi before him, that a young Florentine nobleman Gino di Lodovico Capponi (whose son Vasari knew) was represented from the life as St. Sebastian. This need not mean he posed for it, in what must have been a somewhat penitential position, but it is quite possible that he did so; and Vasari in another place tells how he was asked by a young nobleman to paint

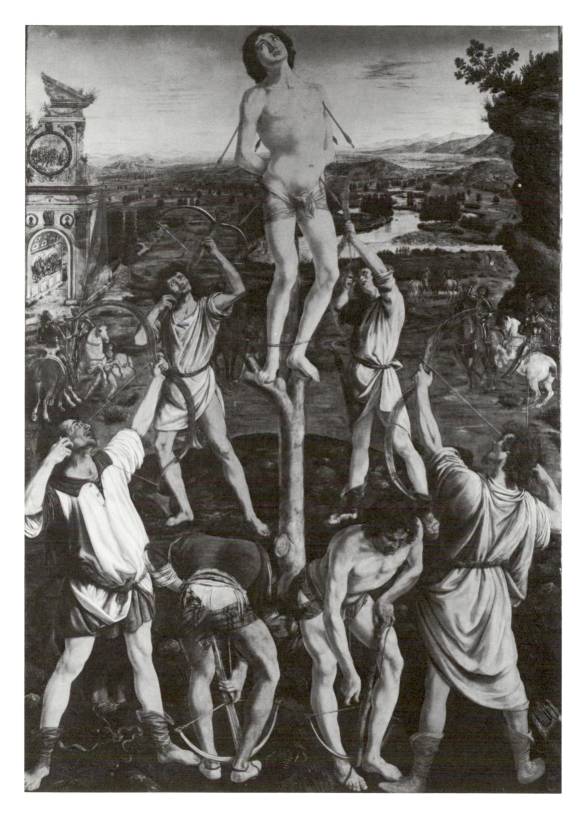

121

him nude as Endymion.[6] Luca Signorelli, when his son was killed at Cortona, stripped the body, and "with great constancy of spirit, without shedding of tears, drew it so that whenever he wished . . . he could see that which nature had given him and hostile fortune taken away."

Signorelli was the great exponent of the nude at the end of the quattrocento, finding and communicating a new comprehension of the body's structure. It was still, particularly when Savonarola was dominant, a dubious subject, and Fra Bartolomeo's *St. Sebastian* was removed from a church because the "women sinned in looking at it for its soft and lascivious imitation of living flesh." But nothing could stop the new zest for anatomy. Vasari was much interested in it and practiced dissections. "Having seen bodies dissected one knows how the bones lie, and the muscles and sinews, and all the order and conditions of anatomy, so that it is possible with greater security and more correctness to place the limbs and arrange the muscles of the body in the figures we draw."[7] It was still a somewhat problematic subject. Bodies were not easily come by and in Florence the official allotment for experiment was the body of one criminal each year.[8] In Arezzo it was even more difficult, and Vasari writes from there in 1537 to his doctor Rontini for the return of "the book on bones and anatomy" as no corpses are available.[9] Vasari knew in Naples the Fleming Jan Stephan van Calcar, who made some of the drawings for Vesalius's *De humani corporis fabrica* published in 1543, a work with which Vasari was familiar [126].[10] He tells us how the young Aretine painter, Bartolommeo Torri, kept limbs and pieces of men under his bed, which made a stench through the whole house; and how Silvio Cosini stole the corpse of a hanged man from its grave, dissected it and made himself a jerkin out of the skin, "thinking it had magical power or some such foolishness."[11]

Proportion plays a large part in this study of the human frame. It was in the making of man that God first disclosed the methods of sculpture and painting, and established a divine canon of scale. In the

[6] *M*, VII, p. 690. [7] Maclehose, *Technique*, p. 210.

[8] R. Galluzzi, *Istoria del granducato di Toscana*, Florence, 1781, II, p. 480.

[9] Frey I, p. 80. Most probably this book was the *Isagogae . . . in anatomiam corporis humani* of Jacob Berengar of Carpi, published in Bologna in 1523. Vasari had been painting plants to give to Rontini for his copy of the *Dioscoride*.

[10] J. B. de C. Saunders and C. D. O'Malley, *The Illustrations from the Works of Andreas Vesalius*, Cleveland and New York, 1950. Vesalius came to Padua from France in 1537 and his *Tabulae* were published in 1538, with wood blocks measuring 19 × 13½ in. The *De fabrica* appeared in Basel in 1547. On the whole question of anatomical studies see L. Price Amerson, "Marco d'Agrate's S. Bartolomeo," *Congresso internazionale, Milano, Museo della Scienza e della Tecnica*, 1968, 2 vols., Milan, 1969.

[11] *M*, IV, p. 483, VI, p. 16.

preface to the *Lives* and in the "Three Arts of Design," Vasari has much to say of this. He lays down as a general standard that the human figure should be nine heads high, intending by this that the torso up to the pit of the throat should be three times the measurement of chin to forehead, the instep to the fork four heads, and the neck and the foot to the instep each one head. This is a curious departure from the standard of eight heads given by Vitruvius, and normally used in classical sculpture. Possibly Vasari's calculation is influenced by a similar one given by Filarete, but it corresponds to his own practice of slightly elongated forms with relatively small heads, a practice common to much Mannerist painting. Vasari adds, however, "the eye must give the final judgment." It is as always with him the painter's own sense of fitness that is the final test.[12]

Perspective next to anatomy was the great guide to naturalism. In his life of Uccello, Vasari describes and discusses the quattrocento enthusiasm for the new discoveries. He is aware that the real basis was laid by Brunelleschi, but his chronology is involved owing to his misdating of Uccello's career. Vasari states that he died in 1432 in his eighty-third year, whereas his death was in 1475, and he was born in 1396 or 1397. Brunelleschi, born in 1377 and dying in 1446, was therefore his senior by some twenty years. Masaccio, who "made many advances in foreshortening over Uccello," and who died in Rome in 1428 aged twenty-seven, is made by Vasari to survive till 1443. The respective shares of the great innovators are therefore thrown into considerable confusion. The echoes of the excitement of this simulated recession can be caught in Vasari's accounts of the painters, but their at times pedantic use of the new methods gave a quality of preciseness to their work that seemed to him, with some reason, dry and a little forbidding. Theory rather than observation he always regarded cautiously. He writes how Donatello said to Uccello, "Paolo, this perspective of yours leads you to abandon the certain for the uncertain." He stresses, in his "Three Arts of Design," that the linear diminishing of forms must be accompanied by gradations in color, which he rightly praises in Masaccio. Art must hide technique, which by itself, whatever the importance of its various stages, is not enough: the "things copied from life" must be improved by "giving them the grace and perfection in which art goes beyond the scope of nature."[13] Here at once with the word *grazia* we come up against the problems of Vasari's vocabulary.[14]

[12] Maclehose, *Technique*, pp. 144, 184–88.

[13] *M*, I, p. 171.

[14] A full linguistic study of Vasari is still lacking: U. Scoti-Bertinelli, *Giorgio Vasari scrittore*, discusses many of the problems. For the textual history of the various editions see P. Barocchi in *Le vite*, Florence, 1967, I. *Commento*.

The term under which all the arts are grouped, *disegno*, is in itself an ambiguous one. In its normal technical use it means "drawing," and Vasari's great collection of *disegni* was the basis of his study of the arts: but in the preface to the third part the word is given a much wider definition: "Design is the imitation of that which is most beautiful in nature in all figures whether carved or painted, which comes from having hand and skill (*ingegno*) to put down all that the eye sees in the picture plane." But "design" is also in the mind of the artist: the grouping and proportion of the things seen represent a concept that is formed by "invention" and it is here that genius is displayed. "It is the animating principle of all creative processes" and an attribute of God himself in the creation of the world. Nature must be correctly rendered, but also selected. And by studying the most beautiful things to produce a perfect figure, the artist achieves *maniera* or style, and from that reaches to the *minuzie dei fini*, the high finish of all details that is the perfection of art. Antonio Rossellino was so sweet and delicate in his works, and of such perfect fineness and polish, that his manner can justly and in very truth be called modern. In Vasari's third period of the arts, introduced by Leonardo, the figures "have motion and breath," the closest copying of nature has been achieved; but that is not all: Raphael, studying both nature and the antique, vanquished nature in his colors, and Michelangelo selected the most perfect members with the most complete grace, "una grazia piu interamente graziosa." We are back in fact at the key word *grazia*, and our English equivalents for it are dangerously misleading. Grace is a word with many theological overtones; gracefulness is something too slight for Vasari's meaning. The theological overtones were not lacking in current Italian use. In Castiglione's last section of *Il Cortegiano*, when Bembo praises divine beauty, *grazia* is a spiritual gift that is linked with the felicity of the soul. These were speculations beyond Vasari's purpose, but his own definition of the word is hardly exact: "a certain charming quality, very agreeable to the eyes of artists." Certainly it includes elegance, an appreciation of what is fashionably acceptable in pose, gesture and the wearing of clothes, a quality much appreciated in the society of the time, but a transitory period quality, as can easily be seen if one compares the elegance of one age with that of another. But grace is something more basic than this: it is the interrelation in curves and spirals of the components of design, and through grace the representation of nature is transmuted into something more appealing in its beauty than that which the natural objects provide.

It can be achieved by study, but it is primarily the result of facility. Michelangelo's dictum, "A good judgment and an exact eye are better

than compasses," was often quoted.[15] An artist must not avoid difficulties: in particular Vasari constantly refers to the problems of foreshortening as a challenge that "calls forth the highest grace," but problems must not be used simply for themselves.[16] The true artist should have mastered his trade to the extent that he can draw figures without constant recourse to the model and take his own liberties with them. "Paintings should be carried out with facility, and their components placed with judgment, and without labor and fatigue, which can make them appear hard and crude."[17] Vasari was himself a very rapid worker, and he believed that this could be a virtue rather than a fault. Annibale Caro once discussed in a letter to him the accusation that he was hasty in his art, and concluded that in painting it is the *furore* that counts, and that something done "with fervor" can be better than pondered work.[18] Vasari himself wrote that "rough sketches (*bozze*), born in a moment of the fury of art, express the idea in a few strokes, and that on the contrary strain and too great diligence sometimes take the force and insight from those who do not know when to take their hands from their work" [79].[19] On the other hand he mistrusted those who put off work waiting for inspiration, "wishing that which cannot be." Regular daily work was his recommendation.

As well as *grazia* there are *vaghezza* and *leggiadria*. The former is a lesser, more superficial quality than *grazia*. Giotto, for instance, lacked it in his color, whereas no one had it to a greater degree than Antonio da Correggio. It is somewhere between prettiness and beauty (*bellezza* or *venustà*, the latter translatable by "loveliness"). Giotto also lacked *leggiadria*, by which figures are softly curved, not clumsy as in nature, but transformed by the art (*arteficiate*) of design and by judgment. This was something that Francesco Mazzola, called Il Parmigianino, had in his figures to an unusual degree, *molto leggiadria*. Vasari may have met this artist, whose paintings embody so much that he admired [80], in Bologna at the time of Charles V's coronation. Certainly he must have heard much of him from the Aretine, Giovanantonio Lappoli, who had known him well in Rome, drawn together by their passion for lute playing. "He gave to his figures, beyond what is given by many others, a certain loveliness (*venustà*), sweetness (*dolcezza*) and pliancy (*leggiadria*) in the attitudes, which was his own and particular to him. . . . so that his manner has been imitated and observed by an infinite number of painters because he has given to the art so pleasurable a light of grace (*un lume di grazia tanto piacevole*)." Vasari had several sketches by him, one of which, of the

[15] *M*, IV, p. 445. [16] Maclehose, *Technique*, p. 217. [17] *M*, V, p. 577.
[18] Frey I, p. 220. [19] *M*, II, p. 171.

126

Opposite

79. Vasari, *Presentation in the Temple*. Paris, Louvre, Cabinet des Dessins

The painting for Monteoliveto, now at Capodimonte, is a heavy, labored work. The drawing, despite its overcrowded composition, has much more rhythm and elegance.

80. Parmigianino, *St. Roch*. Bologna, S. Petronio
Painted in 1527, this altarpiece was well known to Vasari, who describes it in detail: "He made him very beautiful in every part, imagining him somewhat relieved from the pain in his side due to the plague, and raising his head to heaven, in the act of thanking God, as the good do when they come out of adversity."

Virgin and Child, he had bought in Bologna and kept in his house in Arezzo; another was a self-portrait, copied in the *Vite*.[20]

The charm of Correggio's color lay in its *morbidezza*, softness. Vasari takes him, shortening the argument in the second edition, as an example of nature's impartiality in endowing men of genius outside of Tuscany. As opposed to Tuscan linearism, Correggio's figures are so softly shaded, colored with such *morbidezza* that they seem actual flesh. This is an element of "the modern manner," of which Correggio was one of the protagonists. But the creator of it, who took the first steps into the new era, was Leonardo. With him, however, it is *sfumatezza* rather than *morbidezza*: "he added to the manner of coloring in oil a certain obscurity, by which the moderns have given great force and relief to their figures." Vasari seldom uses the term chiaroscuro, but he was well aware of it though cautious himself in its employment.

Two other terms are hard to render in an English equivalent, *terribilità* and *fierezza*. Our English "terrible" and "awful" have been too domesticated to give Vasari's meaning and "awesome" has overtones

[20] The self-portrait is now in the Albertina.

of too much grandiloquence. But it was a function of painting to provoke such a feeling. *Fierezza* again has a certain nobility that savagery lacks. In Vasari's criticism it stands rather for boldness. The angels on the Porta della Mandorla have movement and *fierezza* in their flight. Vasari did not realize how novel were these flying victories, but with his usual perceptiveness he saw a new forcefulness in them.

The facility that Vasari so highly valued is based on a complete absorption of the contemporary *maniera*. Again a word not without difficulties. Vasari uses it for the sum of the artist's gifts as revealed in his works, the "qualities of art adapted to things." It can be both particular to an artist, and also apply to the dominant characteristics of a period. Michelangelo has his own *maniera*, which others could not follow, but he inspired the "third *maniera*," for Vasari the climax of the developments of the arts. Rarely has there been such confidence in contemporary taste. "And, in very truth there is no need now for painters to seek novelties and inventions, and poses, draperies round the figures, new methods of rendering space and impressiveness (*terribilità*), for all perfection that can be given to anything, Michelangelo has given it." So Vasari writes of the Sistine ceiling. The standard is there, and endless variations can be drawn from its example.

In the then fashionable, and today somewhat tedious, controversy as to whether painting or sculpture had primacy in the arts, Vasari, moderate man that he was, took a less decisive line than that of his mentor, Michelangelo, who, as reported by de Hollanda, thought a painting the better the more it approximated to a relief, a relief the worse the nearer it came to a painting. In 1543, Benedetto Varchi, who had supported the Strozzi against Cosimo, was allowed to return to Florence, where he became, despite some later trouble over a charge of homosexuality, the leading literary figure. His earliest *démarche* to assert his influence was to revive the topic of painting versus sculpture by writing to various artists to secure their views.[21] Vasari refers to this controversy in the preface to the *Lives* and sets out both sides of the question, arguing very sensibly that they were sister arts, born at

[21] See L. Venturi, *History of Art Criticism*, New York, 1926, p. 96. Some of the documents are translated in Klein and Zerner, *Italian Art*, pp. 4–16.

81. Antonio Rossellino, *Nativity*. Naples, Monteoliveto

"He made a relief of the Nativity with Christ in the manger, with angels dancing on the roof, singing with open mouths so well done that they had every movement except breath . . . chisel and genius could not do more in marble."

one birth from one father, Design, and that there was no order of precedence between them: one artist might be greater than another, but it was through his own genius, not through any inherent grade of nobility in the art he practiced [81]. It is a view based on the genuine tolerance of appreciation which infuses the whole of the *Vite* and is not one of the least of its merits.

Vasari's views find their demonstration in his own paintings, very typically in the *Allegory of the Immaculate Conception* [20] in the church of SS. Apostoli in Florence. Here we have many of the features of Florentine Mannerism, a term with modern connotations that can no longer be entirely avoided. The *disegno* moves in a serpentine pattern from the Michelangelesque nudes to the Raphaelesque Madonna. The bodies, slightly elongated beyond nature, are modeled with careful muscular study, and the contorted figure of Eve provides for an elaborate piece of foreshortening. The subject is one that is characteristic of a time when commentaries on religious themes, rather than the simplicity of the theme itself, were in vogue, and much research went into the argument to be depicted. These *ragionamenti* or programs figure largely in the creation of the paintings of the time. Many years

later, in 1567, when Vasari painted the *Crucifixion according to St. Anselm* [82] for S. Maria Novella, it was held to demonstrate the grace and fullness that can be given to a work by the addition of things relevant to the main story.[22] St. Anselm points to the seven virtues that lead as steps to Christ. These elaborate schemes applied to altar-pieces reflect the far larger undertakings in which much of the artistic energies of the day were occupied, namely the scenic *apparati* for official ceremonies and the decoration of vast interiors. The time, skill and expense that went into transitory civic pageantry is one of the dominant features of the sixteenth century, and such commissions occupied much of Vasari's life. The state entries of sixteenth-century Italy involved popular appeal, political implications and large-scale cooperative production. Vasari has left on record the description of the *apparato* made in Florence for the marriage of Francesco de' Medici with Joanna of Austria in December 1565.[23] The plan, as we know in detail in surviving letters, was worked out by Borghini, and Vasari was in charge of the work as a whole. It included a dramatic representation in the hall of the Palazzo Vecchio, with painted scenes, such as Vasari had periodically been producing throughout his career. Certain items were of a more permanent nature, planned for some time but given a new urgency by the approach of the wedding festivities: the column from the Baths of Caracalla given by Pius IV in 1560 was erected in front of S. Trinita, though the bridge, destroyed in the great flood of 1557, had not yet been completely restored; Vasari's passageway from the Uffizi across the Ponte Vecchio to the Pitti Pal-

[22] Cf. R. Borghini, *Il Riposo*, Florence, 1584, p. 102.

[23] The *Descrizione dell'entrata e dell'apparato* for Francesco's wedding was written for Vasari by Domenico Mellini and Giovanni Battista Cini, published in 1566 and incorporated in the second edition (*M*, VIII, pp. 521–622). Copies of the drawings for the archways etc. exist among Borghini's MSS. and are reproduced by P. G. Conti, *L'apparato per le nozze di Francesco de' Medici e Giovanna d'Austria*, Florence, 1963.

82. Vasari, *Crucifixion according to St. Anselm*. Florence, S. Maria Novella

Painted in 1567 for "my old and most lovable patron, Alessandro Strozzi, bishop of Volterra." The picture is based on a vision of St. Anselm, where the seven virtues lead by seven grades to Christ. Raffaele Borghini particularly praised this painting because all the figures added to its meaning and were not simply nude or partially unclothed figures put in to add grace and fill the space. Behind the Cross at the top of the seven grades the Virgin and the shepherds adore the infant Christ.

83. Giulio Romano, *Battle of the Milvian Bridge*. Vatican, Sala di Costantino

84. Vasari, *Battle of Torre di* S. *Vincenzo*. Floren ce, Palazzo Vecchio, Sala dei Cinquecento
Defeat of the Pisan army on 17 August 1505. The two central horsemen probably derive from Leonardo's cartoon.

ace was completed; and work was pushed on for the completion of
Ammanati's fountain in the Piazza della Signoria. But the triumphal
arches and many of the large painted scenes were dismantled after
use; so frequent were such ceremonies that one suspects that much of
the material was stored to be refurbished for the next occasion. It is
hard to imagine how all this magnificence looked, produced as it was
in a continuous battle against time. But its detailed historical and
allegorical inventions can be traced in the written accounts.

Very similar programs were required and provided for frescoed
walls of palaces. Under Clement VII Giulio Romano and Giovanni
Francesco Penni had completed the Sala di Costantino in the Vatican.
How far they were relying on designs of their master, Raphael, and
the exact stages of the resumption of the work are difficult questions,
and Vasari's account is probably oversimplified, but the novelty and
inspiring effect of this stupendous room live in his account of it. He
notes in particular the feigned niches in which sit the popes, provid-
ing as it were an architectural setting for the paintings, so that it is no
longer simply a flat wall on which is painted a series of episodes in
the traditional sense of something seen through a window. What
Vasari does not mention is that the great scenes themselves are simu-
lated as tapestry hangings, thereby creating a further illusion of unity
between room and decor. Raphael had already experimented with a
somewhat similar scheme of feigned hangings on the ceiling of the
Stanza d'Eliodoro. It is the negation of the vistas on which the walls of
the Segnatura seem to open. The huge scene of the battle of the Milvian
Bridge [83], with its horizontal lines dominating a wealth of detail,
was, as Vasari rightly says, "to prove of great assistance to those who
later represented battles" [84]. When Vasari went up to Mantua and
stayed with Giulio he saw further examples of his decorative style and
in particular the Sala dei Giganti overwhelmed him with its sense of
the great figures, precipitated as it were into the room [85]. "No more
terrible or frightening work of the brush exists . . . and anyone enter-
ing the room cannot but fear that everything is going to fall in ruins
about him." Everyone now was working with the new illusionism.
Perino del Vaga was combining painting with stucco to produce the
great effects of the Doria Palace in Genoa. In the oratory of S. Giovanni
Decollato in Rome, that small concentrated center of Mannerism, the
scenes were linked with the space of the room, and Salviati's two
apostles appear in feigned architectural settings. Vasari himself in the
hall of a Hundred Days had painted steps descending from the fres-
coes into the room, a fancy that had already been used by Sodoma
in the Farnesina. But it was as far as Vasari went in this particular

fashion. When he came to work on the Sala dei Cinquecento in the Palazzo Vecchio, he placed his scenes once more in their frames without any attempt to link them with the interior space, and similarly in the Sala Regia, despite the admirable stucco decoration of Daniele da Volterra, the huge paintings are firmly held within their allotted boundaries.

Narration is for Vasari the aim of art, and not only the story but appropriate emotions must be conveyed to the spectator. This can be achieved even when the technical means of representation are faulty or not yet mastered. When Vasari deals with the frescoes of the Camposanto or the Spanish chapel he fills pages with an appreciative account

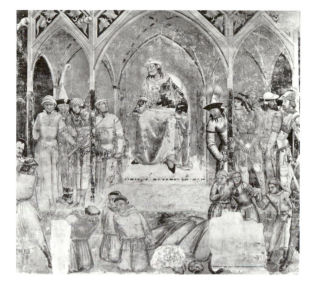

Opposite

85. Giulio Romano, *Fall of the Giants* (detail). Mantua, Palazzo del Tè

Work on the frescoes was begun in 1532; the designs were by Giulio, much of the execution by assistants.

86. Ambrogio Lorenzetti, *Franciscan Martyrs.* Siena, S. Francesco

The scene of martyrdom was painted on the wall of the chapter house and transferred in 1857 to the Piccolimini chapel inside the church. Ghiberti, followed by Vasari, described the frescoes as in the cloister, and the accounts given of them cannot with certainly be related to the chapter-house painting.

of the episodes depicted, so that we shall understand their subject matter. This is based on the rhetorical figure known as *ekphrasis*, the detailed recapitulation of pictorial incidents. It was a method used by Pliny, and followed by Ghiberti; Lucian's famous description of the *Calumny* of Apelles became the basis for contemporary renderings of the same theme; to Vasari it is the obvious and essential approach to painting, and he is untroubled if as subjects recur in his text there are repetitions in his descriptions of them.[24] These are not always quite accurate. There is the famous example when, in describing Raphael's *Parnassus*, he refers to "an infinity of naked cupids scattering garlands" which do not exist in the fresco, but were added to Marcantonio Raimondi's engraving of it [127]. Sometimes, too, he is writing, not from things seen, but at second hand. He summarizes Ghiberti's account of a series of frescoes by Ambrogio Lorenzetti in the cloister of S. Francesco at Siena, dealing with some Franciscan martyrs [86], but whereas it is clear in Ghiberti that he is describing a continuous row of incidents, Vasari's abbreviation makes it appear as one painting, which certainly does not correspond to the only surviving scene. Ghiberti thought it a marvelous piece of pictorial narration: Vasari, faithful to his main argument, adds that it shows, particularly in the rendering of a storm, new inventions, unused hitherto and meriting much

[24] S. L. Alpers, "Ekphrasis and Aesthetic Attitudes in Vasari's *Lives*," *JWCI*, XXIII, 1960, pp. 190–215.

commendation. He greatly praises the frescoes painted by Francia in the palace of the Bentivoglio at Bologna; the subject was Judith and Holofernes, and he describes how while the latter lies "sweating with the heat of wine and sleep," Judith's old serving-maid, her eyes intent on her mistress, holds a basin for the decapitated head of "the drowsy lover." These frescoes perished in the sack of the palace in 1507, four years before Vasari was born. He may have seen a drawing for them that Raphael had asked for, but his account of them must be based on reports learned in Bologna.

Nowhere is his delight in narration more enthusiastically displayed than in his account of Palma Vecchio's *Tempest at Sea* [87], almost the fullest account he gives of any single picture. He does not mention in the second edition that in the first he had given it to Giorgione, and now was transferring the whole section on it to Palma. It is in fact a problem piece, possibly designed by Giorgione, later completed by Palma, and then, according to some authorities, worked on by Paris Bordone. Painted for the Scuola di S. Marco, where it still is (now Biblioteca dell'Ospedale Civile), it was cleaned in 1955 and can be seen to be a patchwork of restorations, some of them being insertions of new pieces of canvas.[25] It is hard, therefore, to recapture the emotions it roused in Vasari, but his description of it still has the excitement he experienced before a work that he had, from his change of authorship, clearly considered and investigated with care. "In it is depicted a ship which brings the body of St. Mark to Venice, and there can be seen, feigned by Palma, a horrible tempest of the sea, and some ships struck by the fury of the winds, done with much judgment and with fine imagination: there is too a group of figures in the air, and various forms of demons, that blow like winds against the ships, that are struggling with their oars and in every way to break through the hostile and immensely high waves threatening to submerge them. In sum this work, to say true, is such and so beautiful by invention and all else that it seems impossible that color or brush, used by any hand however excellent, could express anything more like the truth or more natural, in that in it are seen the fury of the winds, the fortitude and perils of the men, the movement of the waves, the lights and flashes of the sky, the water broken by the oars, the oars bent by the waves and the efforts of the oarsmen. What more? I for my part do not remember ever having seen a more terrifying (*orrenda*) picture than this, being so carried out with such observation in the design, invention and color that the panel seems to quiver, as though everything painted on it were true. For it Jacopo merits the greatest praise and to be ranked amongst those who possess the art, and have the power of

[25] T. Pignatti, *Giorgione*, London, 1971, pp. 138–39.

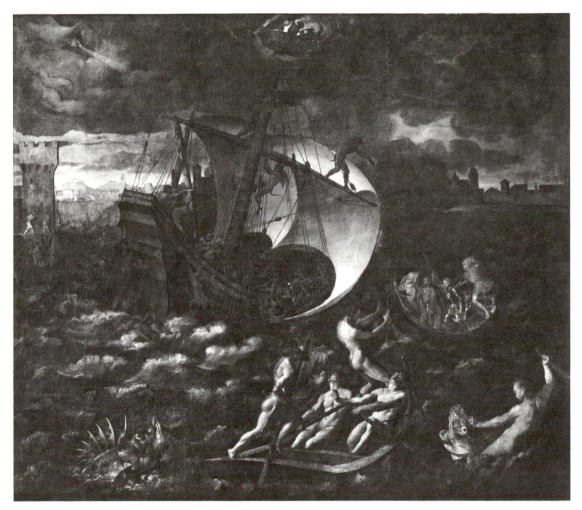

87. Palma Vecchio, *Tempest at Sea*. Venice, Accademia

expressing in painting all the problems of their concepts." The words
"the power of expressing their concepts (*concetti*)" are a key passage
for understanding Vasari's views as to the communicative function of
painting.

It was not only the narrative content of a painting that interested
him. He also regarded it as a merit in a work if it awoke in the specta-
tor the emotions represented. Correggio's smiling angel moved every-
one to smile [88]. Barna of Siena painted in a chapel of S. Agostino,
recently pulled down when Vasari wrote, the story of a young man led
to execution "as well done as could be imagined, with the pallor and
dread of death so truly shown . . . that it was clear Barna imagined
how this horrible incident must have been and was full of bitter and
cold fear." Francesco Bonsignori was criticized by the Marquis of

88. Correggio, *Madonna of St. Jerome* (detail). Parma, Pinacoteca

"There is a putto that smiles, holding a book in his hand in the guise of a small angel, who smiles so naturally, that all who look at it are moved to smile, and no one however melancholy can see it without being gladdened."

Mantua for not representing in a *St. Sebastian* "the fear which should be imagined in a man bound and shot at." In order to demonstrate the right effect, Bonsignori tied up his model, a handsome young porter, and the marquis suddenly appeared and furiously threatened the trussed youth with his sword. This enabled the painter, Vasari concludes, to make his painting as perfect as possible [89].[26] In the Prato frescoes of Fra Filippo Lippi, an artist Vasari greatly admired, the passions were so well shown, both the fury of the persecutors and the grief of the mourners, that the spectator could not see them "without being greatly moved." A more purely cathartic example is given when Properzia de' Rossi, being spurned by a youth of whom she was enamored, carved a relief of *Joseph and Potiphar's Wife* [90], so that with this figure of the Old Testament she sublimated something of her own ardent passion.

A critical passage to which he seems to have attached some importance was that dealing with Fra Giovanni da Fiesole, "with good reason always called Frate Giovanni Angelico." Vasari particularly admired the *Coronation of the Virgin* [91] now in the Louvre. It is an example of how holy things should be painted by holy men. In the first edition the *Vita* opens with a discussion of this theme: those who believe little in religion can often in their paintings show a lascivious mind, bringing the whole work into disrepute. He did not mean, as some people argue, that the saints should not fittingly be shown as more splendid and beautiful than life, and if this caused lustful thoughts, the fault was in the thinkers. In the second edition he shifts this passage to a place at the end of the work, a rare transposition, and

[26] *M*, v, p. 302.

138

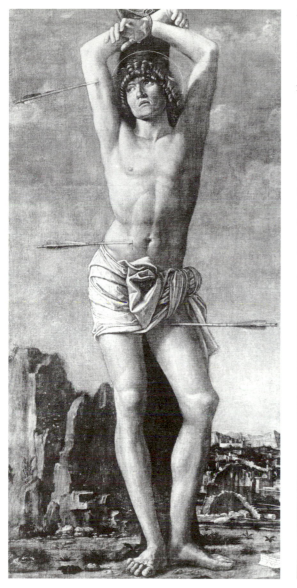

89. Bonsignori, *St. Sebastian*. Formerly in Berlin

The painting in Vasari's story of the terrified model is still in the Madonna delle Grazie outside Mantua. The Berlin version (destroyed in May 1945) could well have been drawn from the same model.

Below

90. Properzia de' Rossi, *Joseph and Potiphar's Wife*. Bologna, S. Petronio

"Because at that time the unhappy lady was deeply in love with a beautiful young man, who seemed to care little for her, she depicted the wife of the master of Pharaoh's house, who enamored of Joseph and as if desperate in her appeals to him, in the end seized his cloak from him with a wonderful action of feminine grace."

adds to it a statement that he does not of course defend paintings in churches where the figures are almost nude, for that shows lack of consideration for the place. It was a point that in 1550 could be passed over: in 1568, with a reforming pope upon the throne enforcing the decrees of the Council of Trent, with even Michelangelo's nudes in question, it was wise to safeguard the discussion.

Connoisseurship as we know it was entirely foreign to Vasari's mind and his time. He lived in a world where a successful painter had a

139

school of pupils, and the studio rather than the individual produced the completed work. Over-reliance on pupils he condemned, quoting his own error when he left too much to assistants in the hall of a Hundred Days, but his determination after this was "to finish everything myself, after the preparatory work had been done from my designs by my assistants." He somewhat tactlessly blames Taddeo Zuccaro for

91. Fra Angelico, *Coronation of the Virgin*. Paris, Louvre

"The saints are so well made, with such various attitudes and expressions, that it gives incredible pleasure and sweetness to behold them: it seems as though the blessed spirits in heaven cannot be otherwise, or, to say better, could not be, if they have bodies . . . and I for my part can truly affirm that I never see this work but it appears something new, and I leave it never satisfied with looking at it."

using pupils too much, and obviously there was some doubt as to where the line should be drawn. It was also a period when copies were very freely commissioned and made. Andrea del Sarto copied Raphael's portrait of Leo X so well, even the grease spots, that it deceived Giulio Romano; and Vasari also copied this same portrait for Ottaviano de' Medici. Lorenzo di Credi sent a painting to Spain, copied from one by Leonardo and indistinguishable from the original; Giovanni Francesco Caroto assimilated so closely the style of his master Mantegna that the latter sent some of his pupil's works abroad under his own name. The young Michelangelo made copies of old masters, blackening them with smoke to look like originals, to say nothing of a marble *Cupid* that was buried for a time and then passed off as an antique. It is not surprising that our day of careful attribution has some problems left to it. Restorers were also already at work: Giuliano Bugiardini restored in Vasari's time Uccello's battle pieces (not the San Romano scenes), "and did them more harm than good." Sodoma restored Signorelli's *Circumcision* [92], giving rise to Vasari's reflection that it is sometimes better to keep things done by excellent artists half perished than to have them retouched by lesser men. Vasari was himself a most professional painter. Anything connected with his craft was of the utmost interest to him, and any new methods are always mentioned and discussed. But the autograph nature of brushwork was something that he seems never to have considered. The high smooth finish that was popular obscured the individual touch and this particular pleasure was one with which he was not familiar.

Another problem that he hardly mentions must have been a very real one to him, the visibility of paintings that he writes of. In private collections they could no doubt be examined with an even greater ease than in the museums of today, but altarpieces and frescoes in churches,

141

92. Signorelli, *The Circumcision*. London, National Gallery
Vasari wrongly speaks of a fresco, but the painting, originally in Volterra, is on panel. The Child has undoubtedly been repainted, and Sodoma's part in it is generally accepted.

some of which are now well lit, must then have been reasonably visible only at certain hours of the day when the light penetrated a particular chapel. The familiar Baedeker warning "best seen in the afternoon" must have been of very real significance to this industrious investigator, and one's admiration for his thoroughness is increased by the reflection that in many churches only one wall would have light on it at a given time. The altarpieces themselves were often obscured by altar fittings, as for instance the donors in Masaccio's *Trinity* in S. Maria Novella, "not much in evidence, being covered by gold ornament"; and they were also subject to constant blackening by candle smoke.

Some of his judgments are surprising enough. Against Botticelli he has certain prejudices. The first edition has a long introductory passage to his *Life* about the "bestiality" of those who show little government in their lives, squander what they make and die miserably in the hospital as did Sandro Botticelli. Improvidence was a fault that Vasari particularly disliked, but there is no supporting evidence for his account of Botticelli's unhappy end, which he misdates by five years, 1515 instead of 1510, at the age of seventy-eight instead of sixty-six. The *Birth of Venus* and the *Primavera* are briefly dismissed, under the heading of paintings of nude women, "expressed," it is true, "with grace." They were then in the Villa Castello, where Vasari was much employed and, at least by the time of the second edition, he must have known them well. He is more interested in the identification of members of the Medici family in the Uffizi *Adoration*, though he does not name the three most generally accepted portraits, those of Lorenzo, his brother Giuliano and of Botticelli himself. He devotes also a long passage to the altarpiece of the *Assumption* [93] painted for Matteo Palmieri and to the charges of heresy brought against the donor for his *Città di vita*, which had circulated in manuscript and may still have been talked about in Vasari's day. This strange, uneven work is not now given to Botticelli, but Vasari's statement is very positive and it must have had some association with him.[27] The *Life* is further filled

[27] See M. Davies, *The Earlier Italian Schools*, National Gallery, London, 1951, pp. 94–98, where it is assigned to Botticini.

143

out with stories of Botticelli's joviality, and of his adherence to the teaching of Savonarola, another dubious point, as it seems to have been Simone, his brother, who was a devoted follower of the friar. Botticelli's art had long to wait for a more sympathetic appreciation.

Bernardino Pinturicchio is another artist who found little favor. "Fortune sometimes pleases to raise up men, who would never gain recognition through their own merits." Of the Borgia apartments Vasari writes that "it was Bernardino's practice to make ornaments in gold relief for his paintings to satisfy those who understand little of art, a very clumsy thing in painting." In the fresco of *St. Catherine*, the arch in the background is picked out in relief, so that it seems to stand out in front of the foreground figures. Such a method, applied to monumental fresco, was hardly likely to please Vasari. The fact that Giulia Farnese, the mistress of Pope Alexander VI, poses as the Virgin he states without comment, as is to be expected, for the lady was the aunt of his great patron, Cardinal Alessandro.

More discerning is his treatment of Pietro Perugino. Hard-working and thrifty, too thrifty for he would have done anything for money, he had qualities that Vasari understood: for his irreligion and refusal to believe in the immortality of the soul he had less sympathy. He rightly finds his merits in his use of landscape, though this was not "in

93. Botticini (attributed to), *The Assumption* (detail), London, National Gallery

This strange picture, measuring 90 by 148½ inches, was described in detail by Vasari as being by Botticelli, painted for Matteo Palmieri, on a design given to the artist by the donor, "a learned and worthy man." "But with all the beauty of this work, there were some ill-wishers and detractors, who not being able to condemn it otherwise, said that Palmieri and Botticelli had sinned grievously in heresy, as to the truth of which do not expect a judgment from me."

the new manner," his experiments in oil painting, for which all artists are under obligation to him, his diligence and the grace of his coloring. His defect was that he repeated his figures, and his work became so stylized that they all looked the same. This is fair comment: but, Vasari concludes, "his style so pleased his time, that many came from France, Spain, Germany and other provinces to learn it."

One piece of criticism can be taken as indicative both of his limitations and the openness and at times penetrative quality of his mind: his opinion of Venetian painting. Tintoretto's art he found puzzling and alarming.[28] He probably met him in Venice, and speaks of him as socially agreeable and a skilled musician: but he seemed to Vasari "the most terrible brain there had ever been in painting." He abandoned all accepted conventions, and "worked at random and without design, as though regarding this art as a trifle . . . and sometimes he has left sketches as finished works so that the strokes of the brush are seen" as if made by chance or passion (*fierezza*), rather than by design and judgment [94]. This Venetian freedom he found difficult to assess.

[28] Tintoretto's life (1518–94) is given in that of Battista Franco, *M*, VI, pp. 587–94.

Page 146

94. Tintoretto, *Last Judgment*. Venice, Madonna dell'Orto

Painted in 1546, Vasari could have seen this painting on his second visit to Venice in 1563. "Had this fantastic invention been carried out with correct design according to the rules, and had the painter attended diligently to the particular parts, as he has done to the general effect, expressing the confusion, turmoil and terror of that day, it would have been a most stupendous picture; at first sight it seems a marvel, but considered more minutely, it seems painted as a jest."

145

146

147

95. Titian, *The Annunciation*. Venice, S. Salvatore

Painted shortly before Vasari's visit to Venice in 1563, when he saw the painting. "But these last works, although one still sees something of good in them, are not held in much esteem by him, and do not have the perfection which is found in his other pictures." Vasari's statement as to Titian's opinion of his later style must be taken with some doubt.

There was something of it too in later works of Titian, "done with broad brush strokes and with blotches of color" [95]. But he realized that though "at a close range these works cannot be seen, at a distance they appear perfect." It was, Vasari thought, a dangerous example, leading others to attempt it because it seemed to be done without labor, which was far from the truth. This problem of the distance at which a picture should be seen was on his mind, but never thoroughly investigated. He was, however, clear that the problem was there.[29]

In one of his most celebrated passages of description, that on the *Mona Lisa*, he was writing of a picture which had been in France since before he was born, "in the possession of Francis, King of France at Fontainebleau," and which therefore he had never seen. Some Florentine must have told him of it, but his detailed account of the hairs of the eyebrows, "in the way in which they issue from the skin, here thick and there scanty," does not correspond with the plucked brows of the portrait.[30] "She was," he writes, "very beautiful and while Leonardo was drawing her portrait, he had singers and players, and continuous jesting, to cause her to be happy," an anecdote collected by him that was to pass into the final clause of Pater's famous eulogy: "and all this has been to her but as the sound of lyres and flutes, and lives only in the delicacy with which it has moulded the changing lineaments and tinged the eyelids and the hands."

[29] In the *Life* of Donatello he discusses the importance of the position from which works of art are seen, *M*, II, p. 401.

[30] Lord Clark, one of the few scholars who has seen the *Mona Lisa* out of its frame, said in a recent lecture that he thought the brushwork of the eyebrows had been removed in cleaning, so that Vasari may after all be right.

VI. Assisi and Pisa

VASARI visited Assisi at least three times. In the first edition he talks of it in very general terms, but he studies its problems more carefully in the second edition. He writes of "seeing again" on his visit in 1563. Arezzo to Assisi is approximately 100 kilometers, and he may well have visited this great center of pilgrimage as a young man, though it would be a two days' ride, and the hire of a horse expensive in his more penurious times. After 1550 he twice visited Assisi, in May 1563 and again in April 1566. On neither occasion could he have spent any length of time there. On the earlier he traveled from Arezzo on 2/3 May via Cortona, Perugia, Assisi and Loreto to Ancona, arriving there on 14 or 15 May and on the following day sailing for Venice. It is probable that he spent three nights (8 to 11 May) at Assisi, and on his next visit in 1566 when he left Perugia on 7 April and arrived on 10 April in Rome, his stay must have been even shorter.[1] It is to 1563 that he himself refers when he revises his opinions of Cimabue's work there. As always, however, he made good use of the time.

The architecture of S. Francesco was to take a new position in the second edition of the *Vite* in connection with the *Life* of Arnolfo di Cambio, which Giorgio must already have had in mind. He made various notes and calculated some measurements. He believed the church to have three storeys, rightly thinking that the hidden tomb of the saint (not rediscovered till 1818) was in a crypt; he noted that in the upper church there had been some change in the vaulting scheme, and thought, probably wrongly, that the semicircular buttressing towers were a later addition to strengthen it. He states that the campanile had originally a pyramidal spire, which had to be taken down.[2] He describes the plan based on the letter T, but does not know the mystic significance of the form to the Franciscans. He was aware that in the lower church several chapels had been added later. One of these, the

[1] Frey I, pp. 759–61, II, pp. 226–29; Kallab, *Vasaristudien*, p. 267.

[2] For Assisi see D. Kleinschmidt, *Die Basilika S. Francesco in Assisi*, 3 vols., Berlin, 1914; I. B. Supino, *La Basilica di S. Francesco d'Assisi*, Bologna, 1924; E. Zocca, *Assisi (Catalogo delle cose d'arte e di antichità d'Italia)*, Rome, 1936; W. Krönig, "Hallenkirchen in Mittelitalien," *Kunstgeschichtliches Jahrbuch der Bibliotheca Hertziana*, II, 1938, pp. 1ff; W. Schöne, "Studien zur Oberkirche von Assisi," *Festschrift Kurt Bauch*, Munich, 1957, pp. 50ff.

chapel of St. Nicholas in the south transept, he attributes to Agnolo di Ventura, dating it vaguely after 1344.[3] This is demonstrably wrong. Napoleone Orsini, as Vasari states, built the chapel, probably when he was legate in Assisi in 1300, and the young priest in an alb who lies upon the tomb is almost certainly his brother Giovanni, who died in 1294. The work, on an analogy with that of the signed tomb of Cardinal Gonsalvo Rodriguez (d. 1299) in S. Maria Maggiore, Rome, is generally given to Giovanni di Cosma. The tomb of "the Queen of Cyprus" he thought to be by a sculptor called Fuccio Fiorentino, who also worked for Frederick II at Capua, and that it represented the queen seated on a lion as emblematic of her fortitude.[4] The monument itself [96], a strange piece of work with few parallels, certainly none at Capua, has the royal arms of Jerusalem, but who it commemorates remains uncertain.[5] The name Fuccio, of whom nothing is known, was given to Vasari by Fra Lodovico da Pietralunga, who adds in his own *Descrizione* that the name of the queen was Elizabea, a Venetian or a Cypriot, who was a great benefactress of the monastery. Fra Lodovico, who came from nearby Città di Castello, completed his own account[6] of the basilica about 1570 and died in 1580. He had, therefore, an opportunity of seeing Vasari's second edition, but he does not entirely follow it. Vasari does not mention him by name, but there is strong likelihood that he was at Assisi in 1563 and that, interested as he was in the history of the convent, he was Vasari's chief informant.

Vasari also noted, in the second edition, the crucifix in the upper church that he attributes to Margaritone, "painted in the Grecian manner . . . and much prized by the people of that time, though today we could only value it as something old, and good when art had not reached its present height." This is probably the famous crucifix commissioned by Elias of Cortona from Giunta Pisano, signed and dated 1236, but now lost. Another crucifix by Giunta survives in S. Maria degli Angeli [50]. But in painting it was, and is, the frescoes that mattered, and here Vasari on the whole coincides with Pietralunga's views. In the vaults, apse, tribune and upper rows on either side of the nave the frescoes are for him by Cimabue assisted by "some Greek masters," works that were "truly very great and rich and most excellently carried

[3] For Agnolo see Cohn-Goerke, "Scultori senesi del Trecento," *Rivista d'Arte*, xx, 1938, pp. 242–89.

[4] *M*, I, p. 296.

[5] Yolanda or Elisabetta of Brienne, wife of Frederick II, d. 1228, and Mary of Antioch, claimant of Cyprus, who died in Italy ca. 1299, are possible names, but the female figure is clearly symbolic and the tomb could equally well be that of a man, such as Philip of Courtenay, titular emperor of Constantinople, d. 1283. Ramo di Paganello is a name sometimes put forward as the sculptor.

[6] *Descrizione della Basilica di S. Francesco in Assisi*, printed in Kleinschmidt, *op.cit.*, III, pp. 8ff, and in *Boll. della Deputazione di Storia Patria per l'Umbria*, xxviii, 1926, pp. 1–87.

96. Tomb of the Queen of Cyprus (detail). Assisi, S. Francesco

The crowned woman seated on a lion has never been satisfactorily explained.

out . . . and must in those days have made the world wonder." Of the influence, so much discussed, of the Roman school on these worn paintings, particularly on those of the Old Testament series, of the Isaac Master or of the young Giotto, Vasari, not surprisingly given his confused chronology, has nothing to say. These were problems not yet adumbrated.[7]

Giotto, he asserts, was summoned to Assisi by Fra Giovanni di Muro della Marca (Fra Giovanni Mincio di Murrovalle). Fra Giovanni was Minister-General of the order from 1296 to 1304. He attempted to restore the rule of poverty and to win over the extreme Spirituals, but this does not necessarily mean, as is sometimes argued, that work on the cycle of paintings must have been suspended. They were a visual statement of Bonaventura's official Franciscan legend, and as such had relevance to the existing disputes. Vasari, in agreement with Fra Lodovico, though the latter does not mention Murrovalle's minister-generalship, is confident that they were by Giotto, who painted there thirty-two (they are, in fact, twenty-eight) scenes from the saint's life. Ghiberti in his *Commentaries* had used a puzzling phrase that Giotto in the church of Assisi had painted "quasi tutto la parte di sotto" ("almost all the lower part"). Two others of Vasari's sources, the *Libro* of Antonio Billi and the lives of Italian artists known as the *Codice dell'An-*

[7] For a careful and balanced discussion of the Assisi problem with relation to both Cimabue and Giotto see John White, *Art and Architecture in Italy 1250–1400*, London, 1966, pp. 115–48 and 227–32. C. Gnudi, *Giotto*, Milan, 1958, gives the accepted Italian point of view as to Giotto's authorship of the St. Francis frescoes. A. Smart, *The Assisi Problem and the Art of Giotto*, Oxford, 1971, is an able review of the evidence, deciding against Giotto's authorship. L. Tintori and M. Meiss, *The Painting of the Life of St. Francis in Assisi*, New York, 1962, is essential for the technical process of the frescoing. See also P. Murray, "Notes on Some Early Giotto Sources," *JWCI*, xvi, 1963, pp. 58–80.

onimo Magliabechiano, refer to Giotto's work at Assisi, the former simply stating that Giotto continued the work begun by Cimabue, the latter that as well as continuing Cimabue's work he painted all the lower part ("parte di sotto") of the church. Vasari in the first edition gives the continuance of Cimabue's work and adds "then he painted all the side below" ("banda di sotto"). Linguistically, the easiest interpretation of this obscure statement is that Vasari thought Giotto had completed the scenes from the Old and New Testaments in the upper church and then painted the St. Francis legend below, though he does not explicitly name it. In the second edition all the St. Francis cycle is confidently assigned to Giotto, and on Vasari's authority was long to go unquestioned under his name. Few statements in the *Vite* have had a more stimulating effect on controversy.

In particular Vasari admired the *Miracle of the Spring* [54], with the drinking man so wonderfully rendered that he might be thought to be a real person. It is perhaps characteristic that the variety of hands that today seems so obvious in the frescoes passes unnoticed by Vasari. Used as he himself was to large-scale schemes carried out with numerous assistants, he undoubtedly took for granted that Giotto directed the work of various artists. The St. Cecilia Master's altarpiece in the Uffizi, now regarded as a key piece in the problem, he thought to be by Cimabue. On the other hand the *Miracle of the Spring* is everything that Giotto meant to him. Here are the figures standing solidly on their feet, the strong shadows, the realistic hands that he commended as features of the new style. Amid all the ingenuities of attribution that have been lavished on these frescoes, the Vasari tradition must always have its place.

In the lower church Vasari assigns to Giotto the vaults over the crossing with the *Glorification of St. Francis*, and gives very full and accurate details of their iconography, which clearly greatly interested him. But "the most excellent of all Giotto's paintings here" seemed to him *St. Francis Receiving the Stigmata* [97], above the sacristy door. It is indeed a masterpiece, "tender and devout" as Vasari calls it, but it is not above the sacristy door and it is today generally given to Pietro Lorenzetti.

97. Pietro Lorenzetti (attributed to), *St. Francis Receiving the Stigmata*. Assisi, S. Francesco, lower church

The setting is more detailed and the architecture more elaborate than in the version of the scene in the upper church. Above St. Francis is seen the falcon that awoke him every morning before matins.

Before Vasari, no one had given any account of this artist. Giorgio's interest in him came from the frescoes and signed polyptych in the Pieve at Arezzo, of which he writes in detail, but in his *Vita* of him (under the misread name of Pietro Laurati) he makes no mention of Assisi. It was left for the discernment of Cavalcaselle to argue that the paintings of the north transept were the work of the Sienese master.[8] Few today would question that some of them, notably the *Crucifixion* and the *Deposition*, were by Pietro's hand. The scenes of the Passion, in their lively, crowded detail, suggest another and lesser artist. Vasari attributes the *Crucifixion* to Pietro Cavallini, and claimed to recognize in it the arms of Walter, Duke of Athens, a possible patron by Vasari's dating of Cavallini, but not by the painter's actual life span. He adds that "the manner (*maniera*), apart from the public voice, shows that it is by his hand," an unusual piece of stylistic criticism. In fact Pietralunga found the arms in the chapel of St. John, on a small painting on the altar. The other Passion scenes Vasari gives to Puccio Capanna, with whom he deals as a pupil of Giotto's at the end of the latter's *Life*. He heard much of Puccio at Assisi, where some of his descendants were still living. Fra Pietralunga is less clear on the matter: "some think they are by Giotto, but in a much improved manner; others by

[8] J. A. Crowe and G. B. Cavalcaselle, *A History of Painting in Italy*, London, 1908, III, pp. 91–108. See also C. Volpe, *Pietro Lorenzetti ad Assisi*, L'Arte Racconta, Milan, 1965, XXII.

'Antonio Cavallino,' so called because of his skill in painting horses";
yet others by Puccio Capanna of Assisi. Dono Doni, the Umbrian
painter who was working at Assisi in Pietralunga's time, thought that
Puccio had found out much truer systems of perspective. Doni was at
Assisi in 1563, and was compiling an account of the basilica, which
was still extant in 1882. He also must be regarded as one of Vasari's
informants.[9] Vasari surprisingly attributes also to Puccio "as far as it

[9] Doni died in 1575 while he was working on the frescoes of the Cappella S.
Stefano (still extant). Fra Lodovico does not mention them and refers to the
chapel by its older name of S. Lodovico. It is therefore probable that his *Descrizione* was completed before 1575.

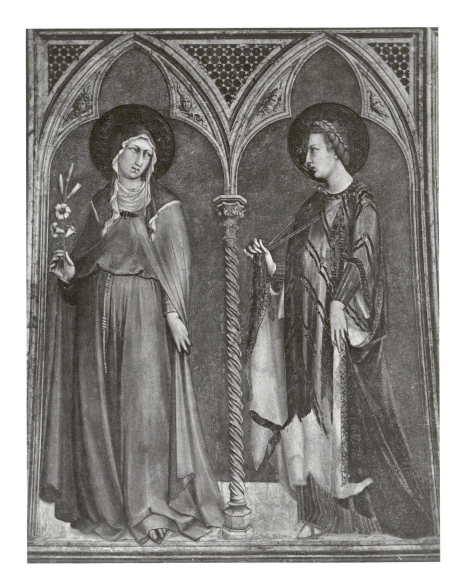

is known" the frescoes in the side chapel of St. Martin. Pietralunga
states that there is no record as to who painted them, but comments
on the beauty of the saints painted on the outside entrance wall [98].
These are in fact by Simone Martini, to whom Vasari rightly attributes
them, while failing to realize that the scenes of the life of St. Martin
are also by him, assisted by Lippo Memmi, "not at all in Giotto's style"
as Pietralunga rightly comments. Martini also began some small scenes
and a *Christ on the Cross* in the refectory, but these were not com-
pleted and Vasari saw only the *sinopia*, of which today no trace
remains; it gives him an opportunity of discussing the use of red out-
line drawings on the *arriccio*, the preliminary plaster layer.

Another follower of Giotto mentioned by Vasari is the mysterious
Pace da Faenza, to whom he assigns frescoes, no longer extant, in the
chapel of St. Anthony in the lower church at Assisi, commissioned by
a duke of Spoleto, killed in fighting at Assisi along with his son, and
buried in this chapel, "as is stated in a long inscription on the tomb
chest." Tomb and inscription still survive, and the date of their death
is given as 1368. The name Pace may represent some confusion with
Pacino di Bonaguida of Florence, at present a name often mentioned
in connection with the St. Francis cycle, and in particular with the
Miracle of the Spring.[10] Pacino, however, is last heard of in 1330, so
that the association with the Spoleto tomb would seem improbable.
He was, however, a distinguished miniaturist, and has that in common
with Pace, whom Vasari praises for "his little figures."

Vasari's other attributions at Assisi, to Stefano, Buffalmacco and
Tommaso called Giottino, lead directly into the most tangled problem
of the trecento. In various sources, Ghiberti's and Landino's commen-
taries, the Pisan *Libri di entrata e uscita* of S. Giovanni Fuorcivitas,[11]
a *novella* of Sacchetti, and the *De viris illustribus* of Filippo Villani,
there are lists of the leading Florentine painters of the mid-fourteenth

[10] Smart, *op.cit.*, pp. 235–48.
[11] Crowe and Cavalcaselle, *op.cit.*, II, p. 126. For Buffalmacco see Smart, *op.cit.*,
pp. 258–59; for Stefano, M. Gabrielli, "La 'Gloria Celeste' di Stefano Fiorentino,"
Rivista d'Arte, XXXI, 1956, pp. 3–23.

98. Simone Martini, *St. Clare and St. Elizabeth
of Hungary*. Assisi, S. Francesco, lower church
Two of the much admired figures on the outer
wall of the chapel of St. Martin. Vasari thought
them "good and very well colored," and that they
had been begun by Simone and completed by
Lippo Memmi. His memory of them was not very
accurate as he describes them as knee-length
figures.

century. All include Stefano and Taddeo Gaddi; three of them have the name Maso; two have Buffalmacco (or Buonamico); one, the *Libro di entrata*, includes Puccio. Billi is the first writer to make any mention of Giottino. The attempts to fit paintings to these names have been many and ingenious, but, apart from Taddeo Gaddi, none has any finally agreed corpus of work. There is some evidence that Stefano was Giotto's nephew, the son of his sister Caterina. Ghiberti, who in a famous phrase calls him "the ape of nature," states that he began a *Gloria* at Assisi, "which, if finished, would have astounded every noble mind." Vasari writes that it was in the apse of the lower church and describes it in careful detail. Though not finished, it was so fine that "it seemed almost impossible that it could have been made by Stefano in those days, and yet he made it." Nothing of this now remains, and the apse fresco of the *Last Judgment* is the work of Cesare Sermei in 1623.

Buffalmacco is a slightly more substantial figure. He is a character who figures frequently in Boccaccio's *Decameron*, and from this Vasari drew a picture of a lively buffoon, full of practical jokes, filling it out even further in the second edition, on Borghini's recommendation, with excerpts from the *novelle* of Sacchetti. The moving and accomplished

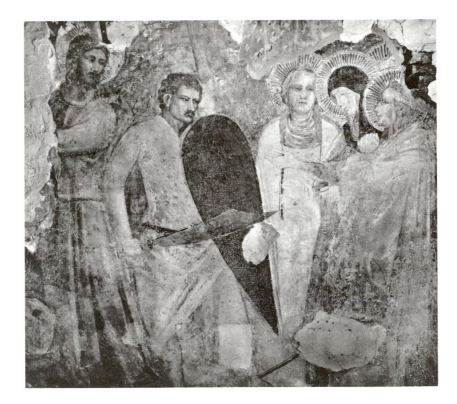

fragments of fresco from the Giochi Bastione chapel in the Badia at
Florence [99] are assigned to him by Vasari, but are now, not alto-
gether convincingly, attributed to Nardo di Cione.[12] The frescoes of
the life of St. James painted by him in the Badia di Settimo were
already ruinous in Vasari's time, owing he thought to a faulty mixture
of paints used for the flesh tones. In Assisi Vasari reports that it is said
that he frescoed the chapel of St. Catherine in the year 1302, and that
returning later he painted in fresco "all the chapel of the Cardinal
Egidio Alvaro" (Albornoz). These chapels are one and the same, the
date of the commission was 1368 and the artist Andrea da Bologna.
Bonamico called Buffalmacco was registered in the Compagnia de'
Pittori of Florence in 1351 and Vasari writes that he was sixty-eight
when he died. He could therefore have survived to 1367 (though
improbably if he was in Assisi in 1302), but the St. Catherine frescoes
must be excluded from any putative list of his works.

The deepest confusion is reached with Vasari's *Life* of Tommaso
Fiorentino (Giotto da Maestro Stefano).[13] To him
Vasari assigns the frescoes of *St. Sylvester* [100] in S. Croce, given by
Ghiberti to Maso di Banco, a name not used by Vasari. These notable
works, amongst the most original of trecento achievements, are now
generally accepted as a basis for Maso's style.[14] Giotto, known as Giot-
tino, the son of the painter Stefano and great-nephew of Giotto, is
credited with the *Deposition of St. Remigius* now in the Uffizi, "a
marvelous thing" that Vasari praises highly for the skill with which it
shows the emotions of the participants; and the tabernacle of the Vir-
gin and saints in the Via del Leone in Florence, rediscovered in 1908.
At Assisi Vasari gives to him the *Coronation of the Virgin* above the
pulpit in the lower church, and the scenes from the life of St. Nicholas
in the Orsini chapel. To these on stylistic grounds, whoever painted
them, should be added the story of St. Stanislaus (canonized by Inno-
cent IV at Assisi in 1253) on the archivolt, which Vasari does not men-
tion, and in fact wrongly places the St. Nicholas scenes in that posi-
tion: Pietralunga assigns them to Puccio.

[12] *Omaggio a Giotto*, Florence, 1967, pp. 54–55.
[13] *Ibid.*, pp. 51–53.
[14] R. Longhi, in *Paragone*, III, 1959, p. 5.

99. Nardo di Cione or Buffalmacco, *The Road to
Calvary*. Florence, formerly in the Badia, now in
the Forte del Belvedere
Vasari admired Buffalmacco's costumes and
armor, and borrowed from them for some of his
scenes in the Palazzo Vecchio.

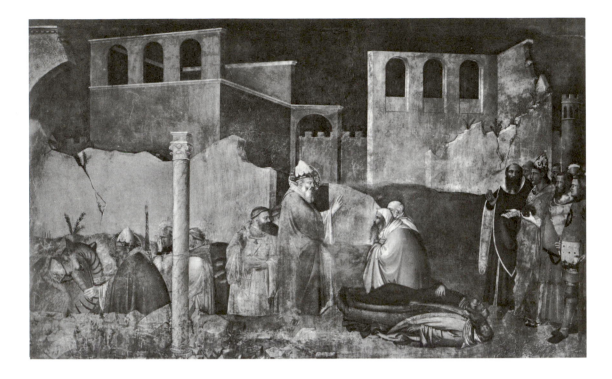

Such were some of the Assisi problems that he had to attempt to disentangle. Similar difficulties met him in the Camposanto at Pisa. His first acquaintance with that town was in 1527 when he went there to escape the siege of Florence, but in the period between the two editions he came to know Pisa much better. Duke Cosimo constantly held his court there and from 1561 onwards Vasari was involved in the designing of the Palazzo and Piazza dei Cavalieri; he was also painting altarpieces for the Duomo and advising them on the rearrangement of their chapels. But these were busy and specific visits that can have left little time for research. The Camposanto had been begun in 1278.[15] Vasari thought that the inscription naming John as master of the works referred to Giovanni Pisano, whereas the architect was in fact Giovanni di Simone, though the Gothic tabernacle above the entrance doorway with the Virgin and saints is certainly of the Pisani school. Six years after the work had been begun, in 1284, came the crushing defeat of Pisa by Genoa at the battle of Meloria, in which the whole Pisan fleet was destroyed, and it was not till the fourteenth century that work was continued on it. By the mid-century it was complete, and the great campaign of frescoing its long walls was

[15] P. Sanpaolesi, M. Bucci and L. Bertolini, *Camposanto monumentale di Pisa*, Pisa, 1960.

158

100. Maso di Banco, *Miracles of St. Sylvester.*
Florence, S. Croce
 Pope Sylvester closes the jaws of the dragon
and raises the two magi poisoned by its breath.
Vasari in writing of these frescoes praises the fine
understanding of gesture in the figures.

begun. With on one side an open colonnade,[16] the wall paintings were
but half sheltered from the elements. Restorations on several of them
were carried out in 1530 by Giuliano di Castellano, called Il Sollazzino
(the joker), briefly dismissed by Vasari as "a painter of our day." In
1669 more wholesale restoration was undertaken by Zaccaria Rondi-
nosi. When in 1812 Lasinio published his volume of engravings, which
was to be the inspiration of the Pre-Raphaelite Brotherhood, the great
cycle was still reasonably complete. Then on 27 July 1944, a shell fired
from an American battery, in an attempt to silence some German guns
controlling the Arno, hit the roof and soon, in that hot summer
weather, all the timbers were alight. The damage and loss were great.
Some of the frescoes were completely destroyed. But there was also
gain. With the frescoes detached or fallen from the walls, the original
sinopie became apparent, fresher and more vigorous than the faded
painting that had covered them. They are now rehoused in a wing
built on to the Camposanto in 1952, and the process of creation can
be studied here better than anywhere in Italy; the knowledge of these
controversial works is now fuller than ever before.
 The most celebrated of them all, the *Triumph of Death* [101], is
fortunately reasonably well preserved. Vasari gives a detailed and
enthusiastic account of it, and attributes it to Orcagna, presumably
on the basis of the similar subject painted by him in S. Croce, well
known to Vasari and only fragmentarily to us. Stylistically this attribu-
tion cannot stand. A popular candidate has long been Francesco
Traini. Vasari writes of him (improbably) as Orcagna's best pupil,
and attributes to him two altarpieces of *St. Dominic* and *St. Thomas
Aquinas*, both still extant in Pisa. The former is signed by the artist
and dated by documents to 1345. The latter, unsigned and undocu-
mented, despite Vasari's attribution, seems to be by another hand. The
small scenes on the wings of the *St. Dominic* altarpiece have some-
thing of the vivid narrative power of the *Triumph of Death*. No men-
tion of Traini is found in Pisan sources after 1345; but he could still
have been practicing about 1350 when, given the work on the building,
the frescoing of the Camposanto probably began. Opinion, though

[16] There are indications that at one time some of the arcading was glazed, but
it is improbable that this was ever completely carried out.

much divided, now inclines for the *Triumph* towards an anonymous
master influenced by Tommaso da Modena and the Emilian School of
Vitale da Bologna, and places the *Last Judgment*, the *Crucifixion* and
the *Stories of the Thebaid* in the same artistic circle. The *Thebaid*
Vasari gave to Pietro Lorenzetti, but there is no evidence that Pietro
ever worked at Pisa, and a strong probability that he died of the Black
Death in 1348, the grim devastation that is reflected in the subject
matter of the Pisan frescoes. It is only gradually that a notable Pisan

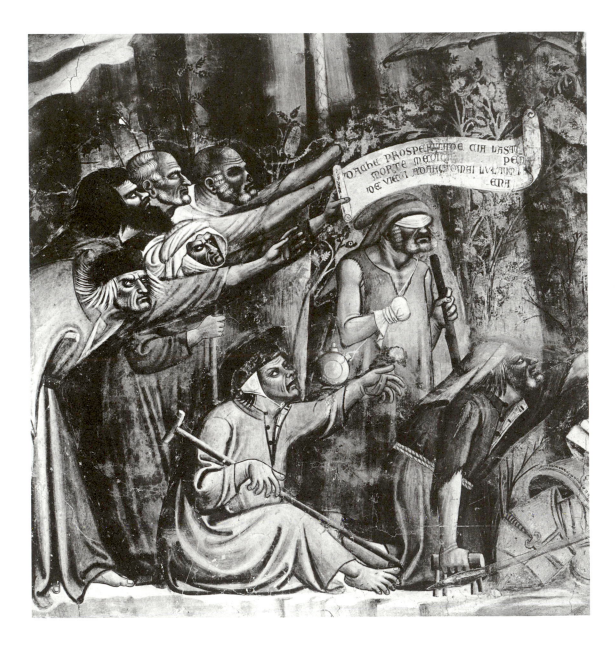

school of painting is emerging from the confusion into which Vasari plunged it.[17]

The *Assumption of the Virgin* was given by Vasari to Simone Martini, but he also writes of a fresco of Our Lady by Stefano. The *Assumption* was one of the total losses in 1944, so that its problems must remain unsolved: the attribution to Simone or possibly Lippo Memmi has had some support. Vasari also gave to Simone the top row of the *Life of St. Ranierus*, assigning the bottom to Antonio Veneziano, with admiration of his realistic rendering of emotions, and the freshness of his colors owing to his sound fresco technique and the fact that he never retouched *a secco*. The latter attribution is supported by the Pisan records, which similarly establish that the upper series is the work of Andrea di Bonaiuto of Florence. This artist, of whom Vasari knew nothing, was also responsible for the frescoes in the Spanish chapel, which Vasari considered, with some consistency, to be the work of Simone.[18] His account of the Spanish chapel details with pleasure Arnolfo's model of S. Maria del Fiore, the spotted dogs symbolizing the Dominicans fighting with heretical wolves, and the many portraits included. He particularly admired how the whole wall was filled with these various scenes without divisions between them, and therefore without placing earth four or five times above air "as older artists used to do and even some modern ones as in the Cappella Maggiore in this same church," a blow at Ghirlandaio though he does not name him. Obviously Vasari the decorator had some special response to these remarkable works, but the fact that he dated them to Simone who died in 1344, whereas Andrea was working there about 1377, is part of his whole trecento confusion, and unfortunately destroys the possibility of Simone's friends, Petrarch and his Laura, being portrayed there from the life.

Following the St. Ranierus episodes in the Camposanto came scenes from the lives of two Pisan saints, Ephesus and Potitus. These are

[17] M. Meiss, "The Problem of Francesco Traini," *AB*, xv, 1933, pp. 97–173, and "Notable Disturbances in the Classification of Tuscan Trecento Painting," *BM*, cxii, 1971, pp. 178–88.

[18] P. Bargellini, *I chiostri di* S. *Maria Novella e il cappellone degli Spagnoli*, Florence, 1954.

101. *The Triumph of Death* (detail). Pisa, Camposanto

Vasari thought the use of scrolls with words coming from the characters represented had been introduced as a jest by Buffalmacco, and "this clumsy device" had been foolishly copied by others.

given by Vasari to Spinello Aretino, and no one disputes the attribution. The *Story of Job*, whose misfortunes were very real to trecento Italy, was in the first edition given to Taddeo Gaddi, a view that today has much support, but in the second this was unfortunately changed to Giotto. For the beginning of the Old Testament cycle, the *Cosmography*, *Creation* and *Building of the Ark*, Vasari put forward the name of Buffalmacco, whereas documents make it certain that they were painted in 1390–91 by Pietro di Puccio of Orvieto, another artist of whom Vasari knew nothing. Whether it was his death or some other interruption that cut short the work, there was now a pause till 1464, when for twenty years Benozzo Gozzoli worked on twenty-six large frescoes from the *Drunkenness of Noah* to *Solomon and the Queen of Sheba*, one of the largest and most inventive schemes of the quattrocento, much of it now hopelessly damaged. Here Vasari knew the facts and admired the works, but for the scenes of the Crucifixion, Resurrection and Ascension, he once more put forward the name of Buffalmacco; of these the *Resurrection* is completely lost, and all have suffered considerably from seventeenth-century restoration; the *Crucifixion* still stands out as a moving and powerful work, but one by an unknown master. Vasari in the second edition quotes several of the inscriptions on the frescoes, which Cosimo Bartoli had written down for him, and supposes that they were to the taste of the time. He characteristically much regrets that no one had recorded the names of the figures in the *Last Judgment*, many of which he was sure were portraits. The pope shown he thought to be Innocent IV.

Of all the old buildings of Italy the Pisan Duomo was the one that Vasari most admired, and he shows throughout the *Vite* a detailed knowledge of the works of art in it. These included two altarpieces by himself, painted in 1543, and no longer known, destroyed probably in the fire of 1595, which did such great harm to the cathedral. They were a *Virgin with Six Saints*, for which there is a study in the Louvre, and a *Pietà at the Foot of the Cross*. These were in the nave: the paintings round the apse were more fortunate and survived the fire. Vasari recalled how Beccafumi, when he had been painting one of them, told him he could never do his best work away from the air of Siena.

VII. Arezzo and Florence

WHEN Vasari was having some difficulties with his workmen in Florence, Cosimo wrote to him "The Florentines never agree with one another, and you being an Aretine should not get involved in their disputes."[1] It is a characteristic comment on the abiding intensity of Italian local feeling, where each city held such pride in its history, its periods of independence and its cultural achievements. For Vasari Arezzo is always the home town, full of memories, where churches, sculpture and paintings were all imprinted on his receptive youthful mind, and where "the air is fresh and health-bringing" [102]. To be an Aretine by birth was in itself a recommendation, and one that gave artists a place in the *Vite* that some of them could hardly claim on merit. He wrote to Pietro Aretino: "I have been unable to discover that Arezzo has ever produced an artist above the level of mediocrity, and I hope that with me the ice will be broken."[2] This is too rash a statement and contradicted by his own assessments in the *Vite*, but he indeed hoped that his career would reflect credit on his native city, and many of his works were done for its embellishment. "Be sure," he wrote to Borghini about the title page of the *Lives*, "that I am called 'painter of Arezzo.'"[3]

There was one great master who, though not himself an Aretine, had left his mark on the town. Piero della Francesca had worked there from 1452 to 1464 and again in 1466. His frescoes in S. Francesco were well known to Vasari, and from his detailed description must have been much studied by him. He admired their pondered planning (*considerazioni*) and poses. Particularly he liked the garments of the ladies, "done in a new manner"; the workman who stands with a spade listening intently to St. Helena [103]; the "divinely measured row of Corinthian columns," the foreshortened horses, the anatomy, "a thing little known then," of some of the warriors, above all the flying angel in the vision of Constantine, "coming from above to below." In the battle scenes Vasari comments on the expressions of fear, animosity, distress and violence, and the sheen on the armor. Did he perhaps remember this last in his own difficulties with Duke Alessandro's portrait? Piero's

[1] Frey I, p. 640. [2] Frey I, p. 47. [3] Frey I, p. 257.

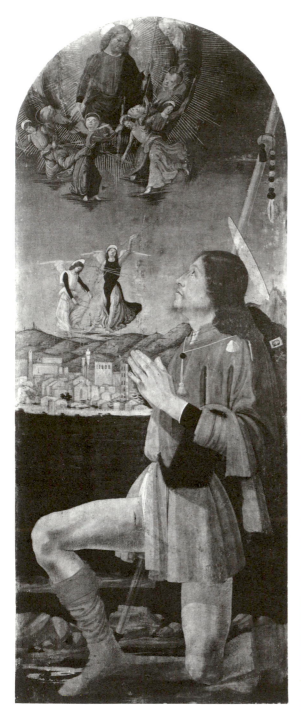

102. Bartolomeo della Gatta. *St. Roch Interceding for Arezzo during the Plague.* Arezzo, Pinacoteca

In the foreground of the town can be seen the campanile of the Pieve; to the left S. Francesco; beyond the Palazzo Pretorio, and on the furthest point the new cathedral.

Below

103. Piero della Francesca, *Finding of the True Cross* (detail; before recent cleaning). Arezzo, S. Francesco

"There is a peasant, who, leaning with his hands upon his spade, is so prompt to hear St. Helena speak, while the three crosses are being disinterred, that it could not be better done."

achievements seem to him to have given examples to the moderns, to reach that highest grade where the arts "in our time" stand. "He rendered Arezzo illustrious by his talents." Much today that we experience in S. Francesco was beyond Vasari's range of analysis and expression. It is still the vivid power of narration that comes first in his estimation, as it well might in this great piece of propaganda painted in the very years when Constantinople was lost to the Turks. But, reading his account of them in the *Vita* of Piero, we can have no doubt of the deep impressions these marvelous frescoes made upon the young Aretine.

Arezzo was undergoing many changes in Vasari's youth. First of all, there was the building of the new cathedral. Vasari always distinguishes between "the old cathedral" outside the town beyond the present railway station and the new building that he calls the Vescovado. The "old cathedral," dating from 1033, was pulled down in 1561. It had been occupied by Pietro Strozzi in the rising of 1554 against the Medici, and now, despite great opposition by the townsfolk, it was sacrificed to the replanning of the city's defenses.[4] Of this old cathedral, on rising ground to the west of the town, Vasari has much to say. He thought it was built by the Aretines more than thirteen hundred years ago at the time that they were converted by St. Donatus. It was an octagonal building on the inside with sixteen outside faces, and was built with columns and marbles taken from ancient buildings. "And for my part I do not doubt that the Aretines with all they spent on it could have made something marvelous, had they had better architects. Still it was as beautiful as anything made in the very old times could be."[5] It was dedicated to St. Stephen and St. Donatus and "many martyrs put to death there by Julian the Apostate." All this no doubt is the Arezzo tradition, and is needless to say largely legendary. Julian the Apostate's intervention seems improbable; Donatus, the second bishop, was martyred towards the end of the fourth century, and on the discovery of his body in 1023, Bishop Albert erected a cathedral that was consecrated in 1033. Albert had previously been bishop of Ravenna and brought from there a master mason, Maginardo, so that the octagonal plan has clear Ravennese associations. Within there were treasures enough and here Vasari's list, if uncertain in its attributions, must be reasonably accurate. There were frescoes by Spinello Aretino, an *Adoration of the Magi* and *Christ in the House of Simon*

[4] Pietro Farulli, *Annali di Arezzo*, Foligno, 1717; G. Rondinelli, *Relazione della città d'Arezzo*, Arezzo, 1775; A. and U. Pasqui, *Le cattedrale aretina*, Arezzo, 1880; A. del Vita, *Il duomo di Arezzo*, Milan, n.d.; U. Viviani, *Arezzo e gli aretini*, Arezzo, 1922; C. Signori, *Arezzo*, Arezzo, 1904; F. Coradini, *Il duomo di Arezzo*, Milan, 1966.

[5] *M*, I, pp. 680–82.

the Pharisee, from one of which Vasari copied a self-portrait for the woodcut in the second edition. Gaddo Gaddi, that somewhat elusive figure, covered part of the vaulting with mosaics, but these vaults, made of spungite, Vasari tells us, were too heavy for the walls, fell down in the episcopate of Gentile of Urbino (1473–97) and had to be restored in brick. It seems likely that when the old cathedral was destroyed it was in a ruinous state, but there can be no doubt that much was lost of great artistic interest. A *Virgin and Child* by Spinello was held in such reverence by the Aretines that they cut it out of the wall and placed it in another church.

The new cathedral, the Vescovado, crowning the hill at the top of the town, had been begun in 1277, but the great defeat by the Florentines of the Aretines under their warlike bishop Guglielmo Ubertini at Campaldino in 1289 held up the work. Vasari says disapprovingly that the bishop spent on war the money that had been collected for building the church.[6] He thought that Jacopo, father of Arnolfo di Cambio, was the original architect and that the work was carried on by Margaritone, but these were attributions from a very insecure historical knowledge. The cathedral is a Gothic building with stone vaults and takes its place beside S. Maria Novella and S. Croce as an example of the Tuscan version of this style. Giotto, Buffalmacco and Jacopo del Casentino all, according to Giorgio, painted frescoes there, and of these some fragments of the work of Buffalmacco remain, and are key pieces in the debate that centers round him.[7] Some of the sculptural works of the Vescovado, which Vasari describes in great detail, still remain, in particular the tomb of Bishop Guido Tarlati (1312–27) signed and dated in 1330 by Agostino and Agnolo of Siena, who were, Vasari thought, chosen for the task on the recommendation of Giotto. In Vasari's time the tomb [104] had been damaged and

[6] *M*, ɪ, p. 364.

[7] P. P. Donati, "Proposta per Buffalmacco," *Commentari*, xvɪɪɪ, 1967, pp. 290–96.

104. Agostino di Giovanni and Agnolo di Ventura, Tomb of Bishop Tarlati: detail, *The Building of the Walls of Arezzo*. Arezzo, Cathedral

The tomb is dated 1330, and Vasari gives a detailed account of Giotto making the design and choosing the sculptors, a statement not supported by other sources. Vasari, to whom Bishop Tarlati was a figure of great local interest, names all the subjects of the reliefs on the tomb: "In the first, aided by the Ghibelline party of Milan, who sent him four hundred workmen and money, he remade the wall of Arezzo completely anew."

partially dismantled "by the French of the Duke of Anjou" and this perhaps explains some inaccuracies in his account of the subjects represented. These constitute a long pictorial propaganda for the doings of the Tarlati family. The high altar and shrine of St. Donatus he held to be the work of Giovanni Pisano, but documents establish that it was carried out by Betto and Giovanni di Francesco in 1369. Vasari's account of the relics that the altar contained and the sums paid for it by the Aretines ends with one of his more unfortunate slips when, wishing to state that the Emperor Frederick III much admired the shrine on his return from his coronation in Rome (1452), he inadvertently calls him Frederick Barbarossa. From 1510 there was a new period of activity in the Vescovado, in which Vasari's teacher, Guillaume de Marcillat, played a considerable part, both in stained glass [105] and in roof decoration. "As in a fair body," Giorgio wrote in one of his sonnets, "that which is beyond all other beauties is the eye, so in the cathedral of Arezzo, that which is fairest are the windows."[8] Then in

[8] Scoti-Bertinelli, *Vasari scrittore*, p. 283.

1535 he himself designed the supports for the organ, his first and somewhat clumsy architectural work, covering over, he complacently states, some marble ornaments designed by Giovanni Pisano.

Other churches were being built or enlarged in Arezzo in the cinquecento. Antonio da Sangallo the Elder completed SS. Annunziata, or S. Maria delle Lagrime as Vasari always calls it, from a miraculous happening there in 1490. It had originally been designed by Don Bartolomeo della Gatta, abbot of the Camaldoline house of S. Clemente in Arezzo, and Vasari criticizes Sangallo for failing to adapt his additions to the style of the earlier work. Fra Bartolomeo is one of the great Vasarian problems. In documents, which correspond with works noted by Vasari, the abbot of S. Clemente is always called Don Piero d'Antonio Dei, born in 1448 and dying about 1502, whereas Vasari, having earlier referred to a painting carried out in 1468, makes his Bartolomeo die in 1461. Vasari was in close touch with the Camaldolines in Arezzo. It is impossible that he can have no basis for this *Vita*, and there may be some confusion over personal names and names in religion. But the mystery has never been solved, so that uncertainty hangs over an artist whose accredited works, such as the *St. Jerome* in the Vescovado that Vasari describes in detail, have considerable distinction.[9]

Apart from the cathedral organ-case, Vasari's first building in Arezzo was his own house. He bought the site, with the house partially built, in 1540. His brother and sisters were now settled, and he felt he had carried out his responsibilities towards them. His mother presumably moved into the new house when it was habitable, to care for it in her son's constant absences. It is externally a severely simple, solid dwelling [107], opening on the street, but within to the side there is a small walled garden [108], raised above the street level. Here as so often Vasari's luck has not failed, and the house survives comparatively unchanged.[10] He began with the aid of Cristofano Gherardi to fresco the walls and ceiling, using his Venetian experience with good effect. In the first room the central ceiling painting shows Fame seated above the globe of the world, and in ovals round the wall painters associated with Arezzo, and Vasari's two masters Andrea del Sarto and Michelangelo. The next room is dedicated to Apollo and the muses, with Cosina represented amongst them [28]. The third room he painted in tempera "because I always honored the memory and works of antique times," but his floating God the Father was too rash a Michelangelesque challenge, and he is happier with the surrounding *grottesche*. The Salone has in the center *Virtù* seizing Fortune by the

[9] A. Martini, "The Early Work of Bartolomeo della Gatta," *AB*, XLII, 1960, pp. 133–41.

[10] L. Berti, *La casa del Vasari in Arezzo*, Florence, 1955.

105. Guillaume de Marcillat, *The Calling of St. Matthew*, window, ca. 1520. Arezzo, Cathedral

"Those who wish to judge of his power in his art should look at the wonderful invention in the window of St. Matthew . . . the sleeping apostles wakened by one another, and St. Peter talking with St. John, each so fine that they truly appear divine."

Below

106. Bartolomeo della Gatta, *St. Jerome*. Arezzo, Cathedral

"He made for a chapel in the Vescovado a St. Jerome in penitence, who being thin and shaven, with his eyes fixed most attentively on the crucifix, and striking his breast, gives us to understand most fully what an ardor of love virginity could rouse in that most worn flesh."

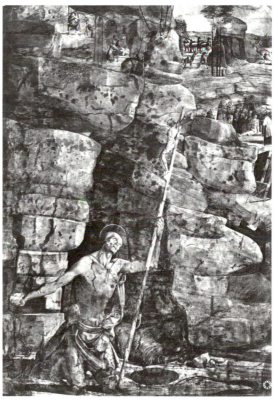

forelock and trampling upon Jealousy. Around the walls were figures of the virtues, prominently amongst them Diana of the Ephesians [109], signifying Liberality but also recalling the home town of Apelles, whose story, with those of other artists named by Pliny, is represented in chiaroscuro below. Today the house is a Vasari

museum, and it is very easy to feel close to him within its walls. In a letter from Rome to Bishop Bernardetto Minerbetti of Arezzo, "the friend of all men of talent," he wrote: "Instead of the seduction of the court, I could do very well with a house with a little garden, where I could be lazy when I like . . . with food sufficient for my old mother, my wife, myself, one servant and the lad who looks after a worn-out nag." He cannot long have thought so; laziness and Giorgio were incompatibles.

His further buildings in the town were carried out when he was an established figure, first of all one of the priors of the town, elected by his fellow citizens, then in 1561, on Cosimo's recommendation, gonfalonier of the city. Ten years later his brother Pietro, again at

Opposite

107. Vasari's House, Arezzo (Via xx settembre)

The house originally had five windows on each floor and a central doorway. In 1687, when it passed in accordance with Vasari's will, on the failure of heirs, to the Confraternity of S. Maria della Misericordia, it was extended on both sides and the main entrance moved to the right hand doorway, which was enlarged at the expense of the window above it.

108. Vasari's House, Arezzo; from the garden

"Then there is my garden thirsting for want of me. I know that it put forth fresh buds when it heard I was coming back." (Letter of 26 October 1553 to Bishop Minerbetti.)

109. Vasari's House, Arezzo; interior

Diana of the Ephesians presides over one wall. In the spaces between the allegorical figures, Vasari painted landscapes of places where he had worked. On one side at the right hand corner a false perspective shows a figure drawing at a window.

Cosimo's intervention, and his heirs in perpetuity were enrolled amongst the gonfaloniers of the city. The main works he undertook in these years were alterations to the Pieve and the Badia, and last of all the designing of the Palazzo delle Loggette in the Piazza Grande. The old church of the Pieve with its Romanesque façade and tympana had a great place in Vasari's affections, but the interior, dark and ill-kept, repelled him. "I have myself restored this ancient collegiate church, moved by Christian piety, and by the affection which I bear to the venerable building, because it was my first instructress in my early childhood and contains the bodies of my forefathers. This I did also, because it appeared to me to be abandoned, and it may now be said to have been called back to life from the dead."[11] He began by removing the choir, making a new one behind the high altar, and opening out larger windows, thereby destroying one by Lorenzo Ghiberti, "made of strongly colored Venetian glass, tending to darken the interior." He carefully moved the Pietro Lorenzetti polyptych to another altar, and some of Lorenzetti's frescoes of the *Life of the Virgin* in the east end were preserved. The high altar itself was replaced by one of Vasari's most extraordinary inventions, a family shrine with a large tabernacle containing relics behind iron gratings, and a carved wooden ciborium, 15 *braccia* high (about 29 feet), visible from all sides. The altarpiece facing the nave was the *Calling of Peter and Andrew*, the painting made for Pope Julius III but never paid for, and on the back was Vasari's patron saint fighting the dragon [110]. On the sides were four panels, each with two life-size saints (Giorgio and his wife figure as Lazarus and Mary Magdalen [111]) and smaller panels with portraits of the Vasari family. Borghini from

[11] *M*, I, pp. 474–76. See "Descrizione delle opere eseguite in Arezzo da Giorgio Vasari," *Omaggio della R. Accademia Petrarca per il quarto centenario della sua nascita*, Arezzo, 1911.

Opposite, above

110. Vasari, *St. George*. Arezzo, Badia of SS. Fiore e Lucilla

The painting was carried out in Florence largely by Stradano. It is on the rear of the shrine, visible from the choir, whereas for the front there was the more autograph work of the *Calling of Peter and Andrew*.

Opposite, below

111. Vasari, *St. Mary Magdalen and St. Lazarus* (detail). Arezzo, Badia of SS. Fiore e Lucilla

The figures, which are portraits of Vasari and Cosina, probably by Stradano, are full length. Lazarus was presumably chosen in honor of Vasari's ancestor, Lazzaro.

Florence took a great interest in it, inspecting the paintings that were being done by Vasari's pupils. He thought that *St. George*, largely the work of Giovanni Stradano, had too much of his native Flemish manner, and that Vasari should retouch it, "giving it his own style with a few strokes of the brush," an interesting indication of studio methods. The shrine was dedicated to Vasari's own St. George and to a local Aretine saint, Mustiola of Chiusi, who had given to her native town the marriage ring of the Virgin, which the Perugians had carried off in 1473. It was to be a memorial family chapel. Writing in the second edition in the *Vita* of Lorenzo di Bicci he had wryly remarked: "Let anyone who desires to leave of himself an honorable memorial, do so himself in his lifetime, and not trust in the good faith of posterity and of his heirs, as it rarely happens that a thing is fully carried out when it is left to the care of successors." He had taken this to heart, but his plans have gone adrift. In 1863 the Pieve was once more restored, this time in an attempt to give it its original form and to remove Vasari's modifications, incidentally removing also the remains of Lorenzetti's frescoes. The Vasari altar was sent to the Badia of SS. Fiore e Lucilla

112. Badia of SS. Fiore e Lucilla, Arezzo, with the Vasari shrine behind the high altar

In 1865 when the Pieve, where the memorial altar originally stood, was restored to its Romanesque style, the altar was dismantled. Thanks to the good offices of the rector of the Confraternity of S. Maria della Misericordia, the altar was re-erected in the Badia, a church which Vasari himself had remodeled. Vasari and his wife were buried in the Pieve, but the exact site of the tomb is now unknown.

113. Palazzo delle Loggette, Arezzo

Vasari designed this building at the very end of his life, and it was completed seven years after his death in 1581.

and re-erected there [112]; this was another church altered by Vasari but one where his alterations survive.[12] Vasari hoped also to remodel in Arezzo the monastery of S. Cristofano (now the Conservatorio di S. Caterina) and made plans for it, but they were altered by the city authorities, and Vasari takes the opportunity of an attack on these wiseacres (*saccenti*) who arrogantly think that they know about architecture.[13]

His last work in his native city was at the very center of it, the Palazzo delle Loggette [113] begun in 1573, a three-storeyed building, with a high ground colonnade which makes a covered passageway for shops and stores. Despite this feature, Vasari has preserved, under the usual heavy cornice of his roof, a sense of one continuing wall space, severely restrained in its decoration, the most puritanical and probably most personal of all his buildings. Unlike, however, the Uffizi, the colonnade is arched not flat, supported by square pilasters not columns. It is a surprising departure from the elevation on which he had so much prided himself, but columns meant more expense, and

[12] See C.-A. Isermeyer, *Festschrift für C. G. Heise*, Berlin, 1950, pp. 137ff. Vasari describes the shrine in detail in the *Ricordanze*, Frey II, p. 877, and in a letter to Duke Cosimo, Frey II, p. 71; Frey III, pp. 185–86; F. Corradini, "La chiesa monumentale della SS. Annunziata in Arezzo," *Rivista d'Arte*, xxxv, 1960, pp. 107–42.

[13] *M*, II, p. 278.

also this was a less isolated and concentrated position than the twin façades of the Uffizi. The round arches echo those of the Romanesque apse of the Pieve, and have the same sense of the general scene that Vasari had shown at Pisa. Needless to say, much of the work was supervised by assistants, and was not completed till 1581, after his death. As he had written in his *Life* of Alberti: "I (if anyone) know from personal experience the help an architect can have from someone who can carry out his work faithfully and lovingly."

His own paintings are numerous throughout the city: a fresco and later a banner [114] for the Company of St. Roch of which he was once a member; the huge *Feast of Ahasuerus* for the refectory of the Badia, a panel 15 *braccia* long, in which Giorgio took much pride and which he painted on the spot in order to study the lighting; a *Coronation of the Virgin*, again for the Badia. And in his accounts of the work of other artists we have a complete picture of the treasures of Arezzo in the mid-cinquecento, some now lost but many still in the place where he described them. In the convent of his friends the Olivetani there was Filippo Lippi's splendid *Coronation of the Virgin*, which is now in the Vatican Gallery. In San Domenico, that Gothic *Hallen-kirche*, designed as Vasari thought by Nicola Pisano, there are still frescoes by both the Spinelli, Aretino and his son Parri (some of the latter's recently cleaned and detached); in the chapel of St. Christopher there are the frescoes that Vasari assigned to Jacopo del Casentino, now more discreetly called fourteenth-century school, and in another chapel frescoes of the Sienese school that Vasari gave to Luca di Tommè of Siena, and thought suitable to the German style of the chapel. And shadowy but still legible there is the *St. Vincent Ferrer* [1] by Vasari's great-grandfather, Lazzaro. The *Deposition* that Vasari painted for the high altar in 1536–37, when Niccolò Soggi resigned his own commission, "a thing that few artists of our own day would do," in favor of the young painter, has been moved to SS. Annunziata; it is much worn and damaged, but a drawing of it in the Wadsworth Atheneum, Hartford, shows Giorgio acting on his own precepts of careful, muscular study of the nude, and also on his knowledge of the *Deposition* that Rosso had been painting in Borgo S. Sepolcro.[14] In place of it now hangs Cimabue's great crucifix, of

[14] B. F. Davidson in *AB*, XXXVI, 1954, pp. 228–29.

114. Vasari, *St. Roch*. Arezzo, Pinacoteca
Painted in 1568 as a banner for the Company of S. Roch. Recently cleaned, the light blues and pinks of the drapery show a sense of color that Vasari does not always achieve.

which Vasari makes no mention, unless it is included in "the many things" done in that church by Margaritone.

Soggi's *Circumcision* [115], painted in collaboration with Domenico Pecori, "with columns and arches in perspective . . . considered very beautiful," was above its altar in S. Agostino till 1922, when it was stolen and recovered only in fragments; but Giovanni Angelo Montorsoli's tomb of Angelo Lancini is still in S. Pier Piccolo; Simone Mosca's chimney-piece for the Palazzo Fossombroni [116], now in the Pinacoteca Comunale, is described in detail by Giorgio, who always had "much affection" for Mosca; in the Palazzo dei Priori there is still Sebastiano del Piombo's portrait of Pietro Aretino, who "gave it to his native place." At S. Maria delle Grazie, with its memories of St.

115. Niccolò Soggi and Domenico Pecori, *The Circumcision*. Formerly in S. Agostino, Arezzo

Vasari tells us that Pecori, a pupil of Bartolomeo della Gatta, was assisted in this work by a Spanish painter who was skilled in working in oils: the architecture was painted by Soggi.

Below

116. Simone Mosca, Chimney-piece from the Palazzo Fossombroni. Arezzo, Pinacoteca

The chimney-piece was made in *macigno*, a gray green sandstone, easily cut. Vasari gives a very detailed account, and had clearly made full notes on it. He thought it "rather a miracle than a work of art" in the fineness of its detail.

Bernardino's preaching in Arezzo, there is still Benedetto da Maiano's elegant portico, whose ingenuity so much pleased Vasari, and within there is Parri Spinelli's *Madonna della Misericordia*, in its della Robbia frame: the miraculous painting, now much spoilt by restoration, said to have been commissioned by St. Bernardino himself.

Parri Spinelli, an artist who today enjoys more favor than in the past, clearly gave Vasari much cause for reflection. The first edition has an introduction about those who do honor to their *patria*, that is Arezzo, and also about heredity in art. This is omitted in the second edition, but the *Vita* is very much lengthened, and many other works included, particularly those commemorating St. Bernardino in the old cathedral. Vasari comments on how many of this artist's works have been destroyed by damp and demolition. Where they have survived, however, the colors are remarkably fresh, which Vasari attributes to the fact that he was "the first who ceased to employ *verdaccio* as a ground for the flesh tints," and that he mixed "solid colors" painting directly with them.[15] Recent cleanings bear out the soundness of Parri's technique and the excellent preservation of his work. Vasari also commented on Parri's elongated figures (eleven or even twelve heads high where others made them ten) and their supple, bending poses [117]. Perhaps it was these Mannerist qualities which attracted him to this late Gothic painter who recalls so much of the international style. Vasari thought that he had been brought to Florence by the learned Aretine, Leonardo Bruni, whose tomb in S. Croce is so familiarly admired, and that there he had been a pupil of Ghiberti and a friend of Masolino. There is no other evidence for this, but it is not improbable, and Parri's use of perspective settings for his mannered figures, with their draperies falling in Gothic folds, are congenial parallels to Masolino's work at Castiglione d'Olona.

One Aretine painting, now no longer extant, is of particular interest. Matteo Lappoli, father of the better-known Giovanni Antonio, painted on the outer wall of the chapel of St. Peter at S. Agostino an *Annunciation* in which the Virgin was a portrait of Pietro Aretino's mother. Aretino was very anxious to have it copied, and wrote twice to Vasari about it, saying that with his skill he could make it as though she were alive and present in the room. "Madre mia" was a potent term, even with the thick-skinned Pietro.[16]

Vasari was not altogether fortunate in his more famous Aretine contemporaries. Leone Leoni, the celebrated sculptor in bronze, was two

[15] M. Salmi, *Vita di Parri Spinelli, Le vite . . . scritte da Vasari*, xxi, Florence, 1914; Catalogue, *Frescoes from Florence*, London, 1969, pp. 123–28; C. Gerolami, "Note e aggiunti al Vasari a proposito di Niccolò Soggi," *Rivista d'Arte*, xxvii, 1953, pp. 195–219.

[16] Frey i, pp. 227–28, 233.

years his senior. Vasari knew him well, corresponded with him and describes the extraordinary house he had designed for himself in Milan, the Palazzo degli Omenoni [118], with its row of atlantes, the figures of prisoners with bound wrists. They have, Vasari significantly states, been variously interpreted. That is the nearest he gets to any comment on Leoni's nefarious career. He writes of some of his main commissions for Charles V, and of the tomb of Gian Giacomo Medici of Marignano in the Duomo at Milan; he comments on the excellent likeness of Michelangelo on a medal made by him. But of the scandals that punctuate Leoni's life, how he was condemned to the galleys for a year, having, it is true, confessed only when the judges threatened to torture his wife and mother; how he sent an assassin to Venice to avenge himself on a *garzone* who had left him for Orazio Vecelli, the

180

117. Parri Spinelli, *The Virgin Protecting the People of Arezzo, with St. Lorentinus and St. Pergentinus.* Arezzo, Pinacoteca

Painted for the Company of S. Maria della Misericordia in 1435; "And on the 2 June, this painting is taken out, raised on a stand, and carried by the said Company in solemn procession to the church of the said saints, where there is a silver chest . . . with their bodies within it."

118. Leone Leoni, Palazzo degli Omenoni (of the Giants), Milan

Designed by the sculptor Leone Leoni for himself. "Full of capricious inventions, so that there is not perhaps another like it in Milan."

son of Titian, and how the boy escaped alive but permanently disfigured; and how ten years later in 1559 Leoni committed a similar outrage on Orazio himself, who was at the time his guest in Milan: all this is left unsaid.[17] There can be no doubt that Vasari knew of it, and it was the kind of melodrama that he would have enjoyed retelling, but local feeling was strong; also perhaps there was the desire not to get involved in a case where Titian was so interested.

Over one Aretine, the sculptor Niccolò di Pietro Lamberti (ca. 1370–1451), Vasari lapses into surprising confusion, assigning to him the *Madonna della Misericordia* on the façade of the Palazzo della Fraternità, one of the most familiar features of the Piazza Grande in Arezzo, and in fact carved by Bernardo Rossellino in 1435. Little sense can be made of this *Life*, and there is possibly some conflation with another Niccolò, a brother of Spinello Aretino, recorded as a goldsmith. Of Lamberti's works in Arezzo the two most likely attributions are the much worn statues of St. Luke and St. Donatus from the Duomo, now in the Aretine Museum, and already in Vasari's time "almost destroyed by frost."

[17] For a lively account of Leoni's misdoings see R. and M. Wittkower, *Born under Saturn*, pp. 190–92.

It is not only of works of art that Vasari writes. He gives us a vigorous picture of the ways and customs of Arezzo. The fraternity of S. Maria della Misericordia was one of its activities that particularly interested him. Founded by some of the richer citizens at the time of the Black Death in 1348 (according to Vasari, but probably earlier), its aims were collecting alms for the poor, visiting the infirm and burying the dead. Spinello Aretino was a member of the guild when the plague once more visited Arezzo in 1383, and he painted a fresco for them on the façade of their church of S. Lorenzo of the Virgin protecting Arezzo. His son, Parri, painted a standard [117] with a similar theme (now in the Pinacoteca at Arezzo) which on 2 June every year was carried in procession by the members of the confraternity and set up above an altar in a tent, because the church was too small to hold the crowd. Besides processions there were plays. Giovanni Antonio Lappoli designed scenery for a comedy written by Vasari's old tutor, Giovanni Pollastra, which, first performed when Duke Alessandro visited the town in 1534 by a group of noble youths known as the Infiammati (the enflamed), was so successful that it was performed again in 1540 when Duke Cosimo and the Duchess Eleonora visited Arezzo. It was on this occasion that his friends the Montaguti wrote to Giorgio asking him to come and supervise the production. It was so well received that the performers were invited to Florence to play it at the carnival. Another festival in 1556 had a more sinister conclusion. In S. Francesco a baldacchino, painted by Domenico Pecori, was borrowed for a mystery play, and owing to the large number of lights caught fire. The unfortunate man representing God the Father, being bound into position above the baldacchino, was burned to death, and sixty-six people were crushed to death in the panic that ensued.[18] Vasari later painted a new baldacchino. There were riots, too, as when in 1529 the Aretines rose on behalf of the pope and the Medici and destroyed the citadel. In 1554 Cosimo undertook a large-scale refortification of the city, and it was during the work on this that was found the bronze *Chimera Wounded by Bellerophon*; it was presented to the duke and placed in a room of the Palazzo Vecchio (now in the Archaeological Museum in Florence). As Vasari rightly thought, the lettering on one of the paws is in Etruscan script.[19] Two copies of it confront each other across the station square in modern Arezzo [119].

As with many Italian towns, the coming of the railway gave a new orientation to the city's layout. In 1870 the broad Via Guido Monaco was made from the station to the Piazza S. Francesco, and in the course of the work one of the churches demolished was that of S. Rocco, from which part of Vasari's fresco and his standard were

[18] *M*, III, p. 223.
[19] C. Ricci in *Vasari*, II, 1928, pp. 18–23.

119. *The Chimera.* Copy in the garden of the station square at Arezzo

removed to the Aretine Museum. There have been losses and changes; but from the close of the cinquecento till the days in 1799 when it was Arezzo that rallied Tuscany against the French, it was a placid town of little growth and much of it, apart from the traffic that fills it, would still be recognizable to the man who so much hoped to be remembered as one of its greatest citizens.

If Arezzo was his native land, with his house and garden, Florence was the city "where men became perfect in all the arts." The great and very Vasarian panegyric of it comes in the *Life* of Perugino, where he contrasts the narrow, violent provincialism of Perugia with Florence, where the air breeds freedom of mind, discontent with mediocrity and a desire for glory: but men, he adds, must know how to make money there, for Florence has no large and fruitful territory, so that its prices are always high. His Florentine house, to which he moved his wife and mother, at 8 Borgo S. Croce, was conveniently placed for his work in the Palazzo Vecchio; he rented it in 1557 and bought it in 1561, giving it frescoed decorations as he had done at Arezzo. Here the subjects were scenes from the lives of Apelles and Zeuxis, in elaborate painted architectural settings, with figures in feigned niches [120a, b]. Diana of the Ephesians once more appears as a local motif. But the portraits of artists in the frieze are very different from the local names at Arezzo, and seem like a highly personal synthesis of the argument of the *Vite*: Cimabue, Giotto, Masaccio, Donatello, Brunelleschi, Perino del Vaga, Giulio Romano, Rosso, Salviati, Raphael, Michelangelo, Leonardo and Andrea del Sarto. No Pontormo nor Bronzino: the omissions are as interesting as the selected names. Vasari's own portrait was on

120. Vasari, Frescoes in his house in Florence, Borgo S. Croce

(a) Apelles draws his own shadow, the origin of painting, and a vigorous winged figure typifies sculpture. Below, the pilasters of the fireplace are repeated in feigned perspective.

(b) The girls from whose beauties Apelles should design a perfect form are brought to his studio. Diana of the Ephesians points the way.

the great stone chimney-piece which he designed, a simplified version of the Arezzo organ-case, with its pilasters copied in feigned perspective around the room. It could hardly be considered a modest decor but no doubt seemed suitable to the dwelling of the duke's leading painter. The "casa Vasari" was something of a center. A letter from one of the duke's secretariat dealing with the question of Vasari's salary remarks: "I know that when anyone from Arezzo, or any of his friends (and he has many) comes here, they make his house their headquarters, so that it costs him a good deal for hospitality."[20] This was not like Arezzo, a place to be lazy in, with a small garden.

Vasari, needless to say, knew Florence intimately; not a small shrine at a street corner nor any detail of carving or iron work missed his notice, and he knew the various depositories where unfinished works had been left unclaimed. But primarily it was with the Palazzo Vecchio [121] that he was concerned, and few people can ever have known the building more thoroughly.[21] It was begun in 1299 and the design was influenced, according to Vasari, by the castle of Poppi [64] built by Arnolfo in 1274 (Vasari attributes it to his father, the more or less imaginary Jacopo or Lapo). Giorgio for the dates relies on Villani's chronicle, but this makes no mention of Arnolfo, who died in the first decade of the trecento, and who, if he was consulted about the work, could not have seen its completion. Vasari adds that it was built off the square because the Signoria refused to have its foundations on the land where had stood the house of the rebel Uberti, and also that Arnolfo had to incorporate in it the tower of the Foraboschi, called the Torre della Vacca. Arnolfo's walls he found to be well built, but the design being out of the square and "devoid of all reasonable measure" was a constant source of difficulty. In particular the columns of the courtyard were uneven in size and irregular in placing, and in 1438 some of them were crumbling and endangering the whole building. Michelozzo Michelozzi was entrusted with their restoration, ingeniously shoring up the roof while he worked on them. Vasari states that Michelozzo's new octagonal pillars are easily distinguishable, and they still are, from Arnolfo's old ones. Michelozzo also rebuilt the courtyard from the arches upwards, lightening the weight by inserting larger windows, and strengthened the tower with large iron stays. Work was also being done on the two main rooms of the second storey, the Sala dei Gigli and the Sala d'Udienza, and here between 1472 and 1478 Benedetto da Maiano was the leading figure; his marble doorway,

[20] Frey II, pp. 387–88.

[21] A. Lensi, *Palazzo Vecchio*, Milan, 1929; J. Wilde, "The Hall of the Great Council of Florence," *JWCI*, VII, 1944, pp. 65–81; J. Paul, *Der Palazzo Vecchio in Florenz*, Florence, 1969. For the general planning of the Uffizi and the alterations in the Palazzo Vecchio see G. Kauffmann in *Blunt, Studies . . . Presented to*, pp. 37–43.

"executed with wonderful diligence and care," is still in position. Painters were also being employed; Filippo Lippi painted two over-doors, an *Annunciation* and *St. Bernard's Vision of the Virgin* Vasari calls them, and these may well be the two panels now respectively in the National Galleries of Washington and London. Of Botticelli's *Adoration* and Antonio del Pollaiuolo's *St. John the Baptist* no trace remains. In 1478 a heavy task fell to Botticelli, to paint on the gate of the Dogana the Pazzi conspirators as their bodies hung from the windows of the Palazzo. A happier commission was that to Domenico Ghirlandaio in 1482, whose fresco of *St. Zenobius between St. Lawrence and St. Stephen*, "some Florentine saints" Vasari vaguely calls it, still can be seen, well preserved, in the Sala dei Gigli.

The next development in the Palazzo was the building of the Sala dei Cinquecento in 1495 for Savonarola's great council. This was entrusted to Simone del Pollaiuolo, known as Cronaca because he could detail so accurately his knowledge of the antiquities of Rome, which he had studied and measured, knowledge which he had put to good use in his much admired cornice for the Palazzo Strozzi. More relevantly for the present commission, he was a devoted adherent of the friar. The creation of this great hall, the largest in Italy at the time, only achieved by knocking down interior walls, was no mean feat of engineering, and Vasari in recounting it becomes absorbed in the technical details of the roof, and the intersection of the beams so as to cover such a wide span. It was for this hall that in 1504, in the gonfalonierate of Piero Soderini, Leonardo and Michelangelo began to work on their great battle cartoons, which in Vasari's phrase "became a school for artists." Leonardo started his painting characteristically experimenting with a new medium that proved unsuccessful, darkening in the upper half and running in the lower. "It began to run and spoil what had been begun," wrote Vasari, "so that in a short time he had to abandon it." This from other sources seems an overstatement, but as Vasari himself removed the remains of Leonardo's painting to make way for his own compositions, he was on somewhat difficult ground. Michelangelo does not appear to have begun to paint on the wall, and his cartoon, according to Vasari, was destroyed out of

121. Palazzo Vecchio, Florence
 This photograph has the advantage of showing no cars parked in the square. The fact that the copy of Michelangelo's *David* is not in position dates it from between 1873, when the original *David* was moved, and 1906 when the copy was erected.

jealousy by Baccio Bandinelli in 1512, when Soderini, the great repub-
lican leader and commissioner of the cartoons, was deposed, and the
Medici restored. Vasari, who himself had never seen the cartoon, in
1542 persuaded Aristotile da Sangallo to make a copy in oils of a
drawing he had done before the cartoon's destruction, probably the
grisaille now at Holkham, the fullest record of this work.[22] The fate
of Leonardo's cartoon, certainly cut into pieces, is not known. That
great opening decade of the century when Leonardo, Michelangelo
and Raphael had all been at work in Florence was over, and Rome
now became the center of the arts. The Salone Grande was turned into
a barracks by the Medici, and Leonardo's unfinished fresco covered
with boards.

In the Palazzo Vecchio the next work undertaken was by Baccio
Bandinelli, when Cosimo decided to use the palace as his residence.
Bandinelli designed the elaborate stone platform at the north end of
the Sala dei Cinquecento. The work was completed when Vasari
took over the schemes for the Palazzo, but he preserved Baccio's north-
ern end. Vasari's own work, apart from the decoration, was to raise
the ceiling from 21 *braccia* to a height of 33, inserting also a gallery
on columns at the southern end. This entailed major alterations of the
second storey of the building, now to be inhabited by the duke and his
family, and Vasari's task was to improve the stairs and the inter-
communication between the rooms. In this haphazard building of
uneven levels it was a considerable problem and Vasari's various solu-
tions have much ingenuity. The Palazzo certainly gained in residen-
tial comfort, and Vasari's double staircase from the courtyard at last
gave it an entrance of some impressiveness.

The structural alterations completed, Vasari turned to the paintings
that should decorate them. On the walls and ceilings the history of
Florence, from its legendary foundation to the glories of Cosimo's
reign, were to be displayed, with a strongly partisan emphasis on the
part played by the Medici family. The research on the subjects and
the organization of a studio to carry them out were to be the great
preoccupations of Vasari's later years.

In 1560, arising from the adaptation of the Palazzo Vecchio to ducal
living quarters, a further work was entrusted to Vasari, the building
of an adjoining new wing to house the administrative departments of
the duchy, the Palazzo degli Uffizi. The remains of the ancient church
of S. Piero Scheraggio, already much ruined, were partially swept
away and the great double colonnade was erected leading from the
Piazza della Signoria to the banks of the Arno. From under the arch
at the river end can be seen one of the world's most famous vistas [74],

[22] G. Neufeld, "Leonardo da Vinci's Battle of Anghiari," *AB*, XXXI, 1949, pp.
170–83; C. Gould, *Michelangelo's Battle of Cascina*, Newcastle-on-Tyne, 1966.

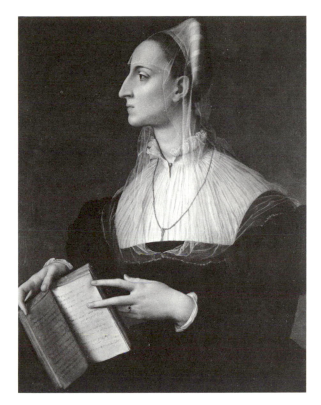

122. Bronzino, *Laura Battiferri*. Florence, Pa-
lazzo Vecchio

The wife of Ammanati is here shown holding
a volume of Petrarch. The portrait leaves no
doubt that she was a formidable personality.

Vasari's reticent, dignified façades leading to the great medieval tower,
at the foot of which stand the copy of Michelangelo's *David* and
Bandinelli's *Hercules and Cacus*. It is a contrast of styles superbly
handled.

With Cosimo's new palace, the Pitti, Vasari was less directly con-
cerned. When in 1558 the Duchess Eleonora, who had acquired it nine
years previously, decided to enlarge the building from Brunelleschi's
original design, it was Vasari's protégé, Ammanati, who was entrusted
with the work. Bartolomeo Ammanati was Giorgio's exact contempo-
rary, being born in 1511, but both in Rome and Florence his main
employment was due to Vasari's intervention. Vasari, however, gives
only a very brief account of him as one of the pupils of Sansovino.
"I could," he wrote, "say much of him, but as he is my friend and
others as I understand are writing of him I shall say no more." Giorgio
had a great admiration for his wife, the poetess Laura Battiferri, and
addressed two sonnets to her. "Of iron within and outside ice," Bron-
zino described her, and his striking portrait of her bears out the
description [122].[23] Under her influence her husband adopted the
extreme rigors of the Counter-Reformation, renouncing much of the
earlier pleasantries of his work. Ammanati's works are evident through-

[23] Scoti-Bertinelli, *Vasari scrittore*, pp. 281–83.

out the city: the Ponte S. Trinita, the Neptune fountain in the Piazza della Signoria, the courtyard of the Pitti Palace, and work in the gardens both of Castello and the Boboli.

Vasari himself had a real feeling for gardens and writes much of them; the hills and slopes of the Boboli gardens, full of all kinds of trees, pleasant groves and shrubs that for all the year are green, could not, he writes, be imagined by any who had not seen them.[24] Of Castello, where he was much engaged, he wrote at length in his life of Tribolo. But it was not only palaces and their adjuncts that concerned him. His alterations in S. Maria Novella and S. Croce brought him into close touch with two of the chief churches of Florence. He attributes the building of S. Croce to Arnolfo in 1294 (a foundation stone gives the date 1285) and admired his ingenuity in roofing its wide nave and aisles. Of the Pazzi Chapel, that wonderful piece of Brunelleschian simplicity, Vasari surprisingly has little to say, and it is dismissed briefly as "a work of great and varied beauty." Of his own work in S. Croce he gives an account at the end of the autobiography. As in S. Maria Novella it consisted in the removal of the screen, the placing of the altar behind the choir, and the creation of fourteen chapels along the walls of the aisles with, again as at S. Maria Novella, a new series of large altarpieces, here dealing with "the chief mysteries of our Savior, from the beginning of his Passion to the sending of the Holy Spirit." These two series of altarpieces constituted great commissions for the artists of Vasari's school.

The history of S. Maria Novella had a particular interest for Vasari, because he had had access to a chronicle of the building that belonged to the Dominican fathers. He correctly states that the order obtained possession of the site in 1221, and that then they set about raising funds for building. This began, according to Vasari, on St. Luke's day (18 October) 1278, when the first stone was laid by Cardinal Latino Orsini, the papal legate. The architects were, in his account, Fra Giovanni of Florence and Fra Ristoro da Campi, and one of the main contributors to the fund was Fra Aldobrandino Cavalcanti, later bishop of Arezzo. The chronicle, though quoted by other writers, has not survived and there are still some problematic points. Building of the choir was begun in 1246, by the two Dominicans, Fra Sisto and Fra Ristoro. The foundation stone of the nave was laid on 8 October 1279, and in the fourteenth century the work was carried on by Jacopo Talenti and Fra Giovanni da Campi. The façade, however, was left incomplete, to be designed by Alberti and finished in 1470 or 1477.[25]

[24] *M*, II, p. 373.
[25] J. W. Brown, *The Dominican Church of S. Maria Novella*, Edinburgh, 1902; V. Chiaroni, "Il Vasari e Fra Ristoro da Campi," and C.-A. Isermeyer, *Studi Vasariani*, pp. 140–43 and 229–36; A. del Vita, "Opere d'arte distrutte e salvate

What particularly fascinated Vasari was that Alberti succeeded, by soaking the stone in goats' blood, in carving on porphyry a memorial to Bernardo Rucellai, the historian, on the doorstep to the central entrance, a splendid example of lettering that still exists.

The *Vita* of Brunelleschi is Vasari's great paean on quattrocento architecture, S. Lorenzo, S. Spirito, and above all the dome of the cathedral. This last, which, though he did not know it when he wrote the *Vite*, was to be so closely connected with his own declining years, receives a fuller account than any other building in the book, only marred by the squabbles with Ghiberti, whom Vasari cannot pardon and to whom he is perhaps not entirely fair.

With the fortifications of Florence Vasari had curiously little to do. The Fortezza da Basso, the great strong-point made by Duke Alessandro, with its notable use of rusticated masonry, was begun in 1534, on designs by Antonio da Sangallo the Younger. Giorgio wrote an account to Pietro Aretino of the laying of the foundation stone. It was an occasion that demonstrated Medicean power, and Vasari notes that "I saw more than one white face in the crowd, for it seemed as though the bit and curb were being prepared for some who formerly had held the reins."[26] He mentions the actual fortress briefly in his *Life* of Antonio da Sangallo as having "a worldwide fame," but these were not matters of prime interest to him. More space is given to Sangallo's spiral well at Orvieto, "unequaled by any thing done by the ancients."

His memories of Florence are punctuated with accounts of disasters. There was the great landslide in 1284 when the cliff of the Magnoli on the south bank of the Arno fell onto the Via dei Bardi; a landslide which happened again in Vasari's own time in 1548, so that Cosimo prohibited all building on the site. It was on this last occasion that Lorenzo Nasi's house was destroyed and Raphael's *Madonna of the Goldfinch* split in two pieces. But floods were the main danger. The Carraia and S. Trinita bridges were carried away in 1269, and again in 1333, when the Ponte Vecchio was also destroyed. Vasari claims that it was rebuilt by Taddeo Gaddi, so well that in the great flood of 1557 in his own time it withstood the impact, when the Ponte S. Trinita was once more carried away, and large parts of the town were covered in mud. Four hundred years later a greater disaster hit the city, but now the mud brought with it oil and chemical refuse of a much more pernicious nature.

Greatest of all misfortunes to the city in Vasari's time was the siege

da Vasari," *Vasari*, ɪɪ, 1929, pp. 155–65. Mrs. Marcia Hall's forthcoming book on the renovation of S. Croce and S. Maria Novella will add greatly to our information.

[26] J. R. Hale, "Fortezza da Basso," in *Florentine Studies*, ed. G. N. Rubinstein, London, 1968, pp. 501–32.

of 1529. In his fresco of it in the Palazzo Vecchio the besiegers' camp
is shown surrounding the walls and engulfing churches and villas that
stood outside the circuit [8]. Some buildings had been pulled down
by the defenders so that they should not provide cover for attack.
Amongst such casualties were S. Giovanni fra l'Arcora with its frescoes
by Buffalmacco, and S. Benedetto, with its paintings by Andrea del
Castagno. Benedetto da Rovezzano's shrine for St. John Gualberto
was being worked on at S. Salvi when it was mutilated by the soldiers,
and the fragments were afterwards disposed of by the monks; but
when the soldiers came to the refectory of the monastery they allowed
it to stand, because of Andrea del Sarto's great *Last Supper* on its
walls. Filippino Lippi's *Vision of St. Bernard* was moved for safety
from the abbey at Le Campora to the Badia, where it still remains.
Above all, the notable convent of the Gesuati was destroyed, with its
gardens, its foundry for glass windows, and its still-room for medica-
ments, the best equipped and finest of any in the Florentine state.
Vasari felt called upon to leave a detailed account of it and of the
works of art it contained, particularly the frescoes of Perugino. Baccio
d'Agnolo's campanile at S. Miniato was bombarded by artillery, but
not destroyed, "so that it acquired no less fame for its resistance to
the enemy than for the beauty of its workmanship." Vasari para-
phrases, without, perhaps tactfully in view of Medicean involvement,
actually quoting, the opening of Ariosto's seventeenth canto, the list
of most atrocious tyrants sent by God as a judgment on men's sins:

Di questo abbiam non pure al tempo antiquo,
Ma ancora al nostro, chiaro esperimento.
(Of this we have had, not only in ancient times,
but still in our own, clear experience.)

When Lorenzo Naldini returned from France to his native Florence
in 1540, he drew his cap over his eyes as he rode into the city, so as
not to see the ruins around him.[27]

As well as disasters there was much gaiety. Carnivals, marriages,
state entries, stage performances were all occasions for specific display,
and called upon the artistic resources of the city. "Many were the
spectacles both for companies and fraternities, but also in their own
houses for gentlemen, who used to form societies, and have periodic
joyous meetings, and there were always artificers ready to make pleas-
ant inventions for these feasts."[28] The city clergy led processions
through the streets, with their acolytes, in the long surplices that Bot-
ticelli liked to depict, carrying banners, while the citizens hung rugs
and draperies from their windows. Vasari tells us of the competition

[27] *M*, vi, p. 621. [28] *M*, iii, p. 197.

between Giuliano de' Medici, the pope's brother, and Lorenzo, Piero de' Medici's son, in the Florentine celebrations of Leo X's election. Pontormo and Baccio Bandinelli were responsible for much of the work. Two years later, in 1515, when Leo made his state visit to Florence, Jacopo Sansovino and Andrea del Sarto built a wooden façade [123] for the uncompleted west end of the Duomo, so fine that Pope Leo regretted it was not the real and permanent one. Battista Franco and Ridolfo Ghirlandaio worked on the designs for the marriage of Cosimo and Eleonora of Toledo, and with the coming of Cosimo these celebrations seem more and more to have been limited to ducal occasions [124, 125].

Of one dramatic performance Vasari has a lurid tale. It was a play by Lorenzino di Pier Francesco and the sets were being designed by Aristotile da Sangallo with the young Vasari as assistant. When the two of them found that the author insisted on a roof insufficiently supported, saying that it would be better for the music, and would not hear of Vasari's suggestion of side beams to support it, they became suspicious that this was a plot to destroy Duke Alessandro and his court. Only when Giorgio said that he must go to the duke, were they allowed to take adequate precautions. As it was the same Lorenzino who later murdered Alessandro, the sinister nature of this plot may well have been somewhat enlarged upon.

Francesco d'Angelo, known as Cecca (the Magpie), was credited with having invented wooden clouds that could surround the angels and divinities and could be moved on wheels, improving on the elaborate apparatus whose invention was attributed to Brunelleschi. Tied to iron bars that rose, fell and rotated, the performers had to have considerable endurance. One boy, gilded all over for one of Pontormo's inventions, died as a result of it. Scenes of martyrdom were sadistically popular, and Cecca had much ingenuity in representing men apparently pierced by lances or swords. One of these spectacles, not a pleasant one, but strange and horrible, Vasari describes at some length. It was planned by Piero di Cosimo for the carnival of 1511, and showed, on a car drawn by black oxen, a figure of death surrounded by tombs, from which, at a trumpet blast, rose men dressed as skeletons. Some thought it, surely improbably, an allegory of the return of the Medici, but whatever its inner meaning and despite its apparent unsuitability for a carnival, its novelty and *terribilità* pleased everyone.

Florence was above all a city of many patrons. The *Vite* are full of references to Florentine collectors: Jacopo Capponi, Antonio de' Nobili, Giovanni Battista di Agnolo Doni, Bartolomeo Gondi, Lelio Torelli, Battista Nasi, the Taddei family and many others. Vasari knew them all, and the works of art contained in their houses. They were

194

Opposite, above

123. Jacopo Sansovino, *Susanna and the Elders*.
London, Victoria and Albert Museum

"In 1514 in the *apparato* for the coming of Leo
X to Florence, Sansovino made a false façade for
the Duomo, part of the decoration of which was
reliefs with scenes from the Old Testament."

Opposite, below

124. Vasari, *Baptism of Christ*. London, British
Museum

Design for the Baptistery, on the occasion of
the baptism of Francesco de' Medici in 1541.
"I will say (and I can say it with truth) that I
have always carried out my paintings . . . with
great promptness. Of which can be witness the
very large canvas I painted in S. Giovanni in
Florence, in only six days, for the baptism of lord
Francesco Medici."

125. Columns (detail) in the courtyard of the
Palazzo Vecchio, Florence

The stucco ornamentation was part of the dec-
orations for the marriage of Francesco de' Medici
in 1565.

settings for the accomplished, elegant conversations of the wealthier Florentine class.

Some of the artists preferred a more Bohemian life. The center of this group was Battista del Tasso, from 1548 till his death in 1555 Cosimo's master of works for the Palazzo Vecchio. "An excellent man," Benvenuto Cellini thought him, "always smiling and ready with a song." "A merry fellow who wasted his time in talking and jesting, but an excellent wood-carver," was Vasari's summing up of his predecessor. His gang of followers did not wash or clean their houses, drank from the bottle and only made their beds once a month. Giorgio found it all very repugnant, and one day when he was coming back from a visit to Miniato Pitti, one of them, Jacone, hailed him with "Giorgio, how is your lordship?" "Earning 3000 crowns, with a horse and servant and doing very well," was the reply, though whether it was quite so daunting to Jacone as Giorgio suggests remains open to question.[29]

Florence was never to Vasari his home town: that remained Arezzo. He was not one of those who like Ridolfo Ghirlandaio "could never lose sight of the cupola," or like Lorenzo Ghiberti thought it worth a thousand years to return to Florence. But it was a city he loved and left his mark on, and few have known it better.

[29] *M*, VI, p. 453.

VIII. Foreign Parts

For Vasari the center of the arts outside of Italy was Flanders, and the term *fiamminghi* was one of wide application including Martin Schongauer and Albrecht Dürer, along with many other artists, whose names he somewhat incorrectly interpreted. Of Flemish paintings of the fifteenth century he could have known but few. When he was at Rimini in 1548 he had visited Urbino and must have seen Justus of Ghent's *Communion of the Apostles* (though he lists Justus as an artist who never left his country) and probably the mysterious *Women Bathing* by Jan van Eyck; Hugo van der Goes's Portinari altarpiece was then in S. Maria Nuova in Florence, but Vasari does not mention it. Duke Cosimo owned two paintings by Hans Memling (if Hans is the correct translation of Vasari's "Ausse"), of which Vasari mentions the *Passion of Christ*. Of van Eyck's works he also knew, and may have seen, a panel sent to Naples and a *St. Jerome* that had belonged to Lorenzo de' Medici.[1] By the mid-sixteenth century there were many Flemings working in Rome, such as Michel Coxie (Cockuysen), whose frescoes in S. Maria dell'Anima in Rome Vasari knew, Maarten van Heemskerck, and Jan Stephan van Calcar [126], whom Vasari met in Naples, an artist of great promise who died young. Federico di Lamberto, Sustris, whose father had left Amsterdam for a long sojourn in Venice, settled in Florence and became a member of the Academy of Design. But Vasari was best acquainted with two men who worked for him, Jan van der Straet, known in Italy as Stradano [210], and Jean de Boulogne of Douai, to become famous as Giovanni da Bologna. Both these men gave Vasari information about Flemish painters from which he compiled his list of names, for it is little else. He knew many "Flemish" works in engravings, but these he admits often fall short of the actual work and do no justice to the original. On their evidence the name of the Flemish Raphael given to Frans Floris seemed to him too high a claim, though he had great skill in expressing the emotions. Another source of information was from Dominic Lampson of Bruges,

[1] Vasari discusses these artists in ch. xxi of his "Introduzione alle tre arti del disegno" (see Maclehose, *Technique*, pp. 226–29) and the account of various Flemish artists at the end of the *Vite*, a section to which he gave no title and which Milanesi headed "De diversi artefici fiamminghi." The Memlings have been the subject of much discussion, and there is no certain identification of them.

126. Jan Stephan van Calcar, illustration for Andreas Vesalius, *De humani corporis fabrica*, Basle, 1543

The anatomical designs for Vesalius were done by Calcar when he was Titian's pupil in Venice, and there has been much discussion as to Titian's share in them. Vasari twice specifically states that they were the work of Calcar, "and worthy of honor for all time."

who had in 1564 written to Vasari telling him that he had learned Italian in order to read the *Vite*. "I was then ignorant and without judgment, but now by repeated reading of your writings, I understand enough, however little it may be, to have new pleasures and joy in life."

Subject matter he, unwontedly, deals with but little. He must have known of the view attributed to Michelangelo that Flemish painting consisted in old houses and green meadows, with some trees and bridges.[2] Flanders above all meant to Vasari the development of new techniques in painting with oils. He realized that this was a long-debated problem, frequently discussed by artists, and he knew that receipts were suggested for it by Cennino Cennini as far back as the trecento. He assigns, however, to John of Bruges (Jan van Eyck), add-

[2] Francisco de Hollanda, *Four Dialogues on Painting*, trs. A. F. G. Bell, London, 1928, pp. 15–18; reprinted in Klein and Zerner, *Italian Art 1500–1600*, pp. 34–35.

ing in the second edition the name of his brother Hubert (he shirks
no problems), the first invention of coloring in oil, unfortunately by
one of his saddest misprints dating it to 1510. Facio of Spezia in his
De viris illustribus, written as early as 1456, had claimed for van Eyck
"many discoveries in the properties of colors," but there is no evidence
that Vasari knew this, as yet unprinted, work. Filarete, however, he
had read, who credits to van Eyck, not the invention, but certain
improvements in oil technique. Vasari enlarges these hints into the
story, which was to enjoy a long authority, of how Antonello da Mes-
sina, having seen a painting by van Eyck in Naples, went to Bruges to
learn his methods and brought them back to Italy. Unfortunately for
the Vasarian version, Jan van Eyck died in 1441, when Antonello can-
not have been much more than ten years old, too young even for those
precocious days. Certainly he had contact with Flemish painting, pos-
sibly with the Peter of Bruges who was in Milan in 1457 and is some-
times identified with Petrus Christus.[3] Antonello may well claim an
early synthesis of Flemish and Italian outlooks, and to have brought
new influences to Venice, but, as Vasari writes, other painters such as
Baldovinetti and Domenico Veneziano were experimenting with color
mediums, though nothing in the scarce survival of their work suggests
any approach to Flemish methods. Borghini wrote to him in 1564 say-
ing that he had been reading Cennini for three hours the previous
night and that Giorgio must think carefully about Antonello's part in
introducing oil painting. Discerningly Vasari points out that with oils
a broader brush stroke can be used, whereas painting in tempera had
to be done with the point of the brush.

Engravings were another matter. Vasari knew a surprising number
sufficiently well to describe them in detail.[4] As a young man in Rome
in the early thirties he had met Jerome Cock, who was busied there
making engravings for Michel Coxie and other artists. Vasari gives a
long and clearly familiar account of his works. He makes a bold claim,
however, for Italian priority in the art, attributing its invention to
Maso Finiguerra (1426–64), the friend of Antonio Pollauiolo. Maso
was a worker in niello, the silver plates engraved with a burin and
the resulting lines filled with a black compound. Vasari argues that
he printed on paper from the unfilled silver plate. This theory is, how-

[3] S. Bottari, *Antonello da Messina*, New York, 1955. It is in Antonello's *Life* that
there is the main discussion of van Eyck's technique, but Vasari also dealt with
it in ch. vii of his "Three Arts of Design": for a discussion of his account see
Maclehose, *Technique*, pp. 294–97; E. Emanuel, *Van Eyck und Vasari im Lichte
neuer Tatsachen*, Tel-Aviv, 1965; and L. C. Vegas, "I rapporti Italia Fiandra,"
Paragone, xvii, 1966, no. 195, pp. 9–24, no. 201, pp. 44–69. Painting in oil on
walls is dealt with in the *Life* of Sebastiano del Piombo.

[4] Engraving is discussed in the *Life* of Marcantonio Raimondi and in the "Three
Arts of Design," Maclehose, *Technique*, pp. 274–75.

ever, unsupported by other evidence and Benvenuto Cellini, who dis-
cusses Finiguerra's niello in his treatise on gold work, makes no men-
tion of the printing process.[5] But for Vasari, it was from the niello
work that was derived "the copper plates from which we see so many
impressions throughout all Italy of both Italian and German origin,"
and in Italy it was followed up by Baccio Baldini's engravings after
Botticelli. These are the celebrated illustrations to Dante, but Giorgio
thought them ill engraved. The process was then taken up by Man-
tegna, and his *Triumphs* were the best that had yet been seen in this
medium. In wood engraving, Vasari describes the "chiaroscuro" blocks
of Ugo da Carpi (ca. 1450–after 1516), claiming them also to be an
original discovery. Having made these patriotic gestures, he can then
discuss in detail the work of the German engravers. He begins rightly
with Martin Schongauer, though wrongly situating him in Antwerp
and confusing his monogram with that of Martin van Cleef. He then
comes, still at Antwerp, to "Alberto Duro." Dürer was in Flanders in
1521–22, and it was presumably from Flemings that Vasari had much
of his information about him; he must also have heard something of
him in Venice; but of his life and of Nuremberg he knew little or
nothing. The engravings, on the other hand, he knew well. The *Prodi-
gal Son*, the *Nymph and the Sea Monster*, the *Doctor's Dream*, the
Girl on Horseback with a Landsknecht, the *Melancholia* "with all the
instruments that measure the life of man (*riducono l'uomo*) and what-
ever inclines him to melancholy," the *St. Eustace*, the *St. Jerome*, the
Great Fortune, the portraits of Erasmus and Cardinal Albert of Bran-
denburg, they are all in his list as well as the woodcuts of the *Apoca-
lypse* ("that has been a great light to many of our artificers"), the
Great Passion and the *Life of the Virgin*. "And I think that Alberto
could hardly have done better, considering that, having no other
opportunity, he drew when he had to represent a nude from one of
his *garzoni*, who generally, like most Germans, did not look well
stripped, though they look fine men enough when clothed." Many
other "Flemings" are mentioned, in particular Lucas van Leyden, some
of them known only by their monograms, one or two of them indi-
cated by a blank that Vasari failed to complete. He knew of the great
windows by Jan van Acken in the chapel of the Sacrament at St.

[5] *I trattati di Benvenuto Cellini*, Milan, 1927, p. 5.

127. Marcantonio Raimondi, engraving after
Raphael's *Parnassus*
This famous engraving adds flying cupids to
Raphael's design, and Vasari followed the engrav-
ing in his description of the fresco.

Gudule in Brussels, and had probably learned of them from Wauter and Joris Crabeth, two Flemish glass painters who were working between 1555 and 1576 in Florence, at times on designs provided by Vasari.

The influence of these engravings in Italy was, Vasari rightly states, considerable. A pupil of Francesco Francia in Bologna, Marcantonio Raimondi, seeing some of Dürer's works in Venice began to copy them, so well, including the monogram, that Dürer had to protest against their circulation. The exact truth of this story remains uncertain. What is certain is that the organization by Raphael of a regular output of engravings of his work by Marcantonio [127] brought this art to a new level of accomplishment in Italy, and that it was Raphael's admiration of Dürer and their interchange of gifts that was part of the inspiration of it. Vasari sums up "per ultimo di tutto" that both the ultramontanes and the Italians have greatly gained through their knowledge of each other's work by the circulation of prints, and that few have

equalled Marcantonio in their production. Unfortunately his skill was
not always used to good purpose, and Vasari tells of the notorious
episode when Marcantonio engraved some drawings by Giulio Romano
of "the postures of lewd men and women lying together," accompanied
by a very lewd sonnet by Pietro Aretino, "so that I do not know which
was the worse, the designs to the eye, or the words to the ear." Clement
VII was much displeased, and for a time Raimondi was imprisoned.
Giulio was out of reach in Mantua; Pietro was not called to question,
and in fact claims that he was responsible for Marcantonio's eventual
release, defending in a letter to a friend the sonnets as good bawdy
stuff on classical models.[6] Vasari says nothing of this incident in his
Life of Giulio in the first edition, but by 1568 all the parties concerned
were dead and Giorgio could express his disapproval of such abuses
of God-given talents.

There was considerable coming and going of artists between Italy
and France, and Giorgio was able to question them. From Ridolfo
del Ghirlandaio he learned of the latter's uncle, Benedetto, who
worked for a time in France, and prospered well enough; but Vasari
is vague about his career, giving him fifty instead of forty years at his
death in 1497, and making the surprising statement that he gave him-
self not only to painting but to the militia (*milizia*), almost certainly
a misprint, emended by Milanesi to *miniatura*, an art which Benedetto
is known to have practiced. At the courts of Charles VIII and Louis
XII from 1495 to 1505 there was the remarkable Veronese architect
and engineer whom Vasari calls "by the name everyone gives to him,"
Fra Giocondo, and of whom between the two editions he collected
much information from books and those who knew him.[7] He rebuilt,
or had some part in rebuilding, the bridge of Notre-Dame over the
Seine.

Of the courts of Francis I and Henry II he had much fuller informa-
tion. From 1516 till his death in 1519 Leonardo da Vinci was in France,
and Vasari must have heard something of him from his master, Andrea
del Sarto, who had gone to Paris in 1518, where he "experienced the
liberality and courtesy of that magnanimous king." Vasari is full of
admiration for the high position that Andrea held there, and clearly
regards it as an example of his "timidity of spirit" that he returned to
Florence after less than a year's absence, and allowed himself to be
persuaded by his wife, not, as we have seen, one of Giorgio's favorite
characters, to remain there; this was a decision ill received by Francis
I, who for a long time after "looked askance at Florentine painters."
Fra Giovanni Agnolo Montorsoli, Giorgio's close friend, had, at the

[6] *Lettere*, I, p. 258.
[7] For Fra Giocondo see Pecchiai, *Vite*, II, p. 729, n. 2.

suggestion of Cardinal Ippolito de' Medici, worked in France, though there had been trouble about payments because the king was preoccupied with the English war, a typical Vasarian approach to political issues.

In 1528, out of work after the expulsion of the Medici, Giovanni Francesco Rustici, the sculptor and friend of Leonardo, went to France, and was commissioned to make a bronze equestrian statue of the king, twice life-size. Francis died in 1547 before it was completed and in the new reign the scheme was abandoned. Rustici was now an old man in his later seventies with few resources, but Pietro Strozzi, the Florentine exile living in Paris, found him a home in an abbey at Tours where he died in 1554.

Lorenzo Naldini, a Florentine and an assistant of Rustici's, forms a link with a greater artist, who in 1530, discouraged by the Sack of Rome, went to Paris, Giovanni Battista Rosso. He had been well known to Giorgio when he took refuge in Borgo S. Sepolcro and then Arezzo, and the latter has an endearing story of how the final incident that induced Rosso to leave Italy was a brawl in a church when he struck a priest who was chastising one of his *garzoni* for disturbing the service by heating up some of his materials. Rosso was always prone to incidents, but when with a recommendation from Pietro Aretino, he went to the French court, he greatly pleased Francis I who put him in charge of the decorative work in the rebuilding of the palace of Fontainebleau. Here in 1532 he was joined by the Bolognese, Francesco Primaticcio (1504–70), who had been working with Giulio Romano in Mantua,[8] and they each gathered a body of artists, largely Italian, round them. Of these Lorenzo Naldini was best liked by Rosso, and Vasari may have met him when he returned to Florence in 1540, for he knew he had taken his mother back to France with him, and was still living there when Vasari was working on the second edition. He may well have been a relative of Vasari's assistant, Battista Naldini.

The splendors of Fontainebleau, Vasari, however much he heard of them, knew only at second hand. "If I am rightly informed" is how he qualifies his account of the great gallery, with its amazing decor of stucco figures, more lavish than any Italian work of the time, making the long gallery, in itself an unfamiliar form to those Italian workmen, a vista of projecting motifs that denied all flatness to the walls. Removed from their basic inspiration and from the standards of Italian criticism, these *dépaysés* artists gave their inventions an abandoned

[8] See A. F. Blunt, *Art and Architecture in France 1500–1700*, London, 1953, pp. 34–36, 64–72. S. Pressouyre, "Fontainebleau, 'A New Rome,'" *Bulletin Monumental*, cxxvii, 1969, pp. 223–39; H. A. D. Miles, "The Italians at Fontainebleau," *Journal of the Royal Society of Arts*, cxix, 1971, pp. 851–61.

128. Primaticcio, *Alexander Breaking In Bucephalus*, fresco framed by stucco decorations. Palace of Fontainebleau, Escalier du Roi

freedom that astonished and greatly influenced the northern world. Changing tastes in a building constantly a royal residence have deprived us of much that today we would eagerly preserve, though there is no evidence to support Vasari's statement that Primaticcio destroyed much of Rosso's work. Rather is it Rosso who has been the better spared by time, and the gallery of Francis I survives in all its fantasy whereas Primaticcio's Gallery of Ulysses is only a memory, replaced in 1737 by the new buildings of Louis XV. But in the ballroom with its crowded and much repainted assemblage of the gods Nicolò dell'Abate, working on Primaticcio's designs, has left the visible pattern of this exuberant style [128].

Vasari thought, probably rightly, that this expansion of the use of stucco was due to Primaticcio, and the outstanding swags and figures could owe something to his Mantuan experience, though used here with unprecedented boldness. Vasari was in correspondence with him, and it was his intervention that enabled Prospero Fontana to join

Primaticcio's team. Vignola was another of Giorgio's colleagues who went to France to aid Primaticcio in casting bronze copies of antique sculpture. Lorenzo Sabbatini, who worked with Vasari in Florence and Rome, would have gone to Paris also, had he not, as Vasari puts it, "been encumbered with a wife and several children." Vasari knew also of Primaticcio's design for a mausoleum and tomb for Henry II. He admiringly records that Primaticcio lived more like a lord than an artist, and showed himself most friendly to his fellow-artists. In fact he had achieved the position at which Andrea del Sarto should have aimed.

Very different was the end of Rosso, though he too "lived like a prince." He was by ten years the senior artist and his tense, uneasy imagination must lie behind much of the Fontainebleau school. His *Pietà* [129] in the Louvre, carried out for Anne de Montmorency, shows the strange coloring and vehement expressiveness of the Florentine manner still at his command. But he was a man easily discouraged, and perhaps never fully recovered from the horrors he had gone through in the Sack of Rome. Having been robbed in Paris of 100 ducats, he accused a Florentine, Francesco di Pellegrino, and when

129. Rosso, *Pietà*. Paris, Louvre
 "For the constable [Anne de Montmorency] he painted a dead Christ, a rare thing."

the charge was indignantly disproved, Rosso was so deeply ashamed of having brought it that he poisoned himself. Vasari's account of him sending a servant for some poison, on the excuse that he needed it for varnishing, and of the man having his finger almost eaten away where he had held it over the mouth of the bottle, is one of the most macabre of the *Vite*'s anecdotes. Its truth has been questioned on the grounds that Rosso's funeral service and burial were in Notre-Dame, an honor that would hardly have been accorded to a suicide. Causes of death, however, could be, and often were, suppressed. Some rumor must lie behind Vasari's detailed story, and the quarrel with Francesco Pellegrino has documentary support. Characteristically Vasari is a year out in his dating, giving 1541, whereas Rosso died on 14 November 1540.[9]

Francesco Salviati, Giorgio's closest friend, also went to Paris, in 1554, after Vasari himself had turned down an invitation to go there. Though welcomed warmly by Primaticcio, Salviati, always a restless man, was soon on his way back to Italy having accomplished nothing. "The men of that country," wrote Vasari, "like gay and jovial men, who live freely, and are fond of company and banquets." The melancholy, difficult Salviati, whose health required a careful diet, made little impression on them.

In short, Francis I emerges in Giorgio's pages as a great patron: "and indeed nothing more inflames souls to *virtù* than to see that they are prized and rewarded by princes, as has always been done in the past, and now more than ever by the illustrious house of Medici, and as it has been done by the truly magnanimous King Francis." Painters, sculptors, architects, engravers, gem cutters such as Matteo del Nassaro of Verona, all were welcome, all qualities were appreciated. "After accepting many of his intaglios," Vasari writes of Nassaro, "the king took him into his service, making good provision for him, holding him no less dear as a good musician and excellent player on the lute than as a carver of gems."

[9] M. Roy, *Artistes et monuments de la renaissance en France*, Paris, 1929, pp. 148–55.

130. Vasari, *Marriage of Catherine de' Medici and the Duke of Orleans, later Henry II, at Marseilles, 1533*. Florence, Palazzo Vecchio, Sala di Clemente VII

The painting contains a galaxy of portraits all detailed in the *Ragionamenti*: amongst them Pope Clement VII, Francis I, Maria Salviati, Cardinal Ippolito, and Mary of Guise, Queen of Scotland. The two dwarfs had come with Catherine from Italy.

With France the Medici had a family link, and one that was much
in Vasari's mind. In October 1533 Caterina de' Medici had married
Henry, later heir to the French throne. Through her short married life
and long widowhood she was to be a powerful influence in France
and a strong link with her own family. Vasari had painted her as a
young and lively girl, full of mischief. It was to be a great gap in time
from her childish prank of blackening the face of her portrait to the
scenes of the Massacre of St. Bartholomew that Giorgio painted on
the walls of the Sala Regia in the Vatican. In the Palazzo Vecchio, in
the room of Clement VII, he painted the scene of her marriage [130],
with Maria Salviati, Cosimo's mother, standing behind the bride, and
Henry's tame lion cub roaming awkwardly but no doubt symbolically
about the bridegroom's feet.

Not only artists went to France; there was a lively traffic also in
their works. Raphael "did many pictures for France," in particular the
St. Michael, which Vasari describes in detail, presumably from an
engraving, calling it a marvelous work, and not listing it amongst those

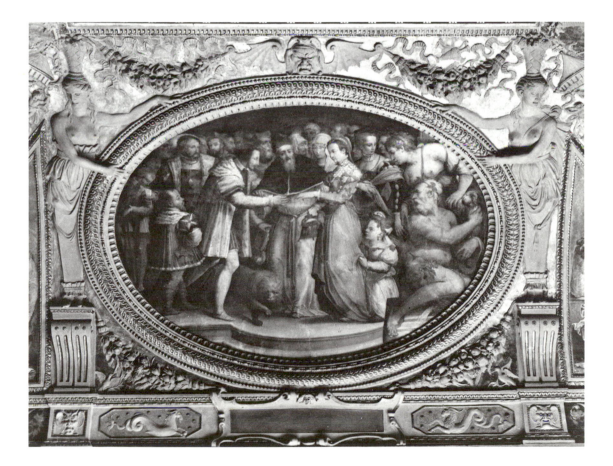

largely by Giulio Romano, though in other paintings for Francis I, Vasari tells us, Giulio took a considerable part. Recent cleaning of the *St. Michael* suggests that Vasari was right in thinking it mainly by Raphael.

These were papal presentations or royal commissions. Others went as gifts from men hopeful of patronage: such were Salviati's portrait of Pietro Aretino, which the latter, with his customary sense of public relations, sent to King Francis, or Aristotile da Sangallo's copy of the Michelangelo cartoon which Paolo Giovio presented to the same recipient. There were others who dealt more commercially with works of art. A Florentine Bernardino de' Rossi paid Perugino 100 gold crowns for a *St. Sebastian*, and then sold it to the king of France for 400 gold ducats. And scattered throughout Vasari's pages there are notices adding up to a vivid picture of Giovanni Battista della Palla's activities in the art market. His period of business as agent for Francis I was in the first quarter of the sixteenth century, when he "bought up as many notable sculptures and pictures as he could and had copies made of those he could not buy, despoiling Florence of an infinity of choice pieces, for furnishing an apartment of the king of France." Vasari tells us how he commissioned Andrea del Sarto to paint two pictures, a *Sacrifice of Isaac* (now in Dresden) and a *Charity* (now in Washington). These, however, were not sent to France, probably because they were completed just before or during the siege of Florence, and after the Medici returned della Palla was imprisoned as one of their opponents. Amongst the works he had sold to France, "packing up and sending off daily," Vasari says, were a figure of Nature by Tribolo made as a support for an antique vase, at one time at Fontainebleau; a *Mercury* by Baccio Bandinelli; a *St. Sebastian* by Fra Bartolomeo, the painting that had so distracted the women when hung in a church; and a *Raising of Lazarus* by Pontormo.[10] During the actual siege, he was at his busiest, and even managed to despatch to Fontainebleau, where it stood in the gardens for many years, a giant *Hercules* by Michelangelo.[11]

[10] *M*, IV, p. 188, V, pp. 27, 50, VI, p. 619, VII, p. 145.
[11] L. Châtelet-Lange, "Michelangelos Herkules in Fontainebleau," *Pantheon*, XXX, 1972, pp. 455–68.

131. Bachiacca, *Scenes from the Life of Joseph* (detail). London, National Gallery

"In the chamber of Pier Francesco Borgherini, of which mention is often made, Bachiacca and others made many figures for *cassoni* and chairbacks."

In one case, however, he met his match. Pier Francesco Borgherini had withdrawn to Pisa when the papal–Medicean forces began to blockade the city. Della Palla, who was well seen by the republican government, and could also urge the advantages of a pro-French policy, persuaded the Signoria to authorize a forced sale of works of art in the Borgherini palace, amongst them Pontormo's *Joseph in Egypt* [164] now in the National Gallery in London. When, however, della Palla and his aides arrived the lady of the house, Donna Margherita, stood firm: "Do you dare to come here, Giovambattista, worthless pedlar that you are, a fourpenny bagman, to confiscate the ornaments of gentlemen's rooms [131], and to despoil this city of its rich and honorable works, as you have done and always do, to beautify the countries of foreigners and our foes. I do not wonder at you, a plebeian man and enemy of your country, but that the magistrates of the city should sanction this abominable villainy, at that I wonder greatly. This bed that you seek to carry off for your own interests and gluttony of gain, feigning piety as you do it, is my marriage bed, and all this magnificent decoration of it was prepared by my brother-in-law, Salvi, which I honor in memory of him and for love of my husband, and

which I intend to defend with my blood and with my very life. Leave this house with your robber band, and tell those who sent you to take my goods that I am one who will not allow any one to enter here or anything to be moved. And if those who believe in you, base and worthless as you are, wish to present something to King Francis of France, let them despoil their own houses. And if you dare to come again to this house, I shall teach you to your heavy loss the respect that the likes of you owe to the houses of gentlemen."[12] Before this robust vehemence della Palla withdrew, and it is perhaps hardly surprising that when the Medici entered the city, his career ended in captivity, where he died, having, it was thought, poisoned himself. His allegiance to the republican cause had been genuine enough, and Michelangelo wrote to him as his "dearest friend." At a time immediately preceding the siege, when he had suspicions of some of the ruling clique and had, on a warning from an unknown man, left the city, Michelangelo had tried to persuade della Palla to go to France with him, but the latter had been firm in persuading him to return to Florence. The attempt on the Borgherini household may well have been more in the interest of the republican treasury than his own pocket.[13]

Of Italian sculptors such as Girolamo da Fiesole or Antonio and Giovanni Giusti, working on important tombs in France, Vasari seems to have heard nothing. He knew that Sebastiano Serlio had dedicated his treatise on architecture, a book that he himself had used, to Henry II of France, but nothing of his sojourn there. He knew little also of any French artists, or of the great Franco-Burgundian culture around 1400. One Frenchman, however, makes a brief appearance. Giovanni Fochetto (in the second edition changed to Foccova) is recorded in the *Life* of Filarete as painting a portrait of Eugenius IV with two attendant figures. He can be identified from other sources as Jean Fouquet, in Rome from 1443 to 1447, but Vasari knew nothing of the achievement behind the name, or of possible influences of the portrait of Eugenius on later papal representations.[14]

With Spain there was less intercourse. In his *Life* of Dello (ca. 1404– ca. 1466), the *cassoni* and furniture painter, some of whose work, "since it is good to preserve some memory of these old things," Vasari

[12] *M*, vi, p. 262.

[13] Ramsden, *Letters of Michelangelo*, i, pp. 290–94; K. Frey, *Sammlung Ausgewählter Briefe an Michelagniolo Buonarroti*, Berlin, 1899, p. 301; G. Milanesi, *Le lettere di Michelangelo Buonarroti*, Florence, 1875, p. 457.

[14] C. Schaeffer, "Fouquet le Jeune en Italie," *Gazette des Beaux Arts*, lxx, 1967, pp. 189–212; K. Schwager, "Über Jean Fouquet in Italien und sein verlorenes Porträt Papst Eugenius IV," *Argo, Festschrift für Karl Badt*, Cologne, 1970, pp. 210ff.

had retained in the Medici palace, he tells how he went to Castile and returned to Florence, rich, splendidly dressed and a knight. However, his old companions mocked his pretensions, and he went back to Spain, where "he could work and live like a noble, always painting in a brocade apron." Vasari places the incident of his return when Pippo Spano was in Florence, that is in 1410, when Dello was about six years old, and the whole anecdote may be imaginary, but it stood for something the Florentines felt about Spanish haughtiness. Gherardo Starnina, of whom little is known outside of Vasari's *Vita*, is described as going to Spain as a rough fellow, and coming back much polished in manners.

Of the patronage of Philip II Vasari knew little. Sofonisba Anguissola [149], whose doings so much interested him at Cremona, lived in Spain "in the queen's suite, with an ample provision" and the court "admired her excellence as a marvelous thing." Vasari had heard something of Jacopo Nizzola da Trezzo, Philip's medalist, but calls him Cosimo. He was aware of the many commissions given to Titian, and he must have discussed the arts in Spain with Leone Leoni, who was in Spain from 1556 to 1558, and whose son Pompeo settled there.[15] In 1573 he himself received an invitation from Philip to go to Spain, on very liberal terms. But it was too late, and Giorgio never showed any inclination for foreign parts. Characteristically he wrote to Borghini that he did not now need the money or further fame. He would finish one more task, the frescoing of Brunelleschi's dome, and then "close my eyes in eternal sleep."

Andrea Sansovino went for five years (Vasari gives nine) to Portugal, but no work of architecture survives there which can be certainly assigned to him. Vasari states that he carried out some "extravagant and difficult architecture, according to the custom of that country," and that he had seen drawings of it in a book belonging to his heirs. It was Vasari's one contact with the Manoeline style.

England was a remote and unknown place. A few artists went there: Toto del Nunziata, of whom Vasari heard something from Ridolfo Ghirlandaio; Girolamo da Treviso, Torrigiano, who later went to Spain and fell into the hands of the Inquisition; Benedetto da Rovezzano, who had some part in the never completed Italianate tomb that Henry VIII wished to have made for himself, and who designed the sarcophagus for Cardinal Wolsey that now holds the remains of Nelson in the crypt of St. Paul's.[16] But surprisingly Vasari had acquired some infor-

[15] A. de Bosque, *Artisti italiani in Spagna*, Milan, 1968.

[16] M. Mitchell, "Works of Art from Rome for Henry VIII," *JWCI*, xxxiv, 1971, pp. 178–203.

mation about a group of Flemish painters employed in England, the Horenbout family, working as miniaturists and including a daughter, Susanna, and Simon Benninck with his daughter, Lavinia Teerlinc, "who was prized by the Queen Mary, as she still is by the Queen Elizabeth."[17] Holbein is a name that is nowhere mentioned.

[17] *M*, VII, p. 587: see E. Auerbach, *Tudor Artists*, London, 1954.

IX. Errors and Omissions

FEW of Vasari's confusions have led to so many controversies as his *Lives* of Masolino and Masaccio. For the former he had very little information available. His usual authorities, Albertini, Billi and the *Anonimo Magliabechiano*, agree that Masolino painted in the Brancacci chapel in the Carmine at Florence, and also at Pisa. Gelli adds that he painted the "Sala degli Anni" (not now identifiable) at Rome. Vasari states that he died at the age of thirty-seven, thereby cutting short the expectations he had raised, and that he was painting around the year 1440. For Vasari he is an example of a promising life too soon ended. We know, however, that Tommaso di Cristoforo Fini, called Masolino of Panicale, was born in 1383 and died after 1435, possibly as late as 1447. According to Vasari, he was a pupil of Ghiberti and one of his best finishers (*rinettatore*), but at the age of nineteen he turned to painting and studied under Gherardo Starnina.[1] Vasari, and we have no other authority, states that Starnina died in 1408 (in the second edition 1403), and if Masolino was then nineteen and painting round 1400, his youthful cutting off seems exaggerated. Of his paintings Vasari only lists the frescoes of the Brancacci chapel, including the vaulting now destroyed. He describes in some detail the surviving fresco of *St. Peter Raising Tabitha and Healing the Lame Man* [132], commenting on the treatment of the cripple, so well placed in its surroundings and shaded in its coloring that the man appears to be actually kicking the wall. Of Masolino's documented paintings at Empoli (1424) Vasari knows nothing, and nothing of his journey to Hungary in 1427, where he had some unspecified claims on the heirs of Pippo Spano, who, exiled from Florence, became Sigismund of Hungary's leading general. In 1432 Masolino was in Todi and in 1435 he had completed his cycle of frescoes (signed) at Castiglione d'Olona in the Lombard foothills of the Alps, works again unknown to Vasari and outside any of his travels. The Carmine frescoes were, however, as he explains in a paragraph added in the second edition, well known to him: "I have many times examined his works, and find the manner much varied from those who went before him," in particular his color-

[1] U. Procacci, "Gherardo Starnina," *Rivista d'Arte*, xv, 1933, pp. 151–90. The *Lives* of Masolino and Masaccio are usefully annotated in A. M. Brizio, *Vite scelte di Giorgio Vasari*, Turin, 1964.

ing and the sense of relief that he gave to the bright clothes of his young men. Filarete, whom Vasari had read, rebukes Masolino for clothing his saints in fifteenth-century dress.[2]

Masaccio is a very different matter.[3] Here he is writing of an artist "who has always been held in reverence and admiration by artists both the old and the modern, so that many designers and masters to this very day continually frequent this chapel." Vasari gives a roll call of the great names who studied there and recalls how when Perino

[2] Filarete, *Tractat über die Baukunst*, ed. W. von Oettingen, Vienna, 1890, p. 653.
[3] M. Salmi, *Masaccio*, Milan, 1948, and U. Procacci, *Masaccio, la cappella Brancacci*, Florence, 1965; F. J. Mather, "The Problem of the Brancacci Chapel Historically Considered," *AB*, xxvi, 1944, pp. 175–87; U. Procacci, "Sulla cronologia delle opere di Masaccio e di Masolino tra il 1425 e il 1428," *Rivista d'Arte*, xxviii, 1954, pp. 3–55.

214

132. Masolino, *St. Peter Healing the Lame Man*
(detail). Florence, Carmine
"Masolino began to give the faces of his women
a sweeter air and his young men more elegant
clothes than the old painters had done, and also
he set out the perspective reasonably."

del Vaga came to Florence in 1522, the Florentine artists challenged
him to paint a figure that would rival one of Masaccio's apostles.
It is one of Vasari's great set pieces, and it was not without its effect.
In 1690 and again in 1748 when there were schemes to modernize the
decoration of the chapel, the frescoes were saved by the urgent pro-
tests of the Accademia di Belle Arti, and when in 1771 the church was
largely destroyed by fire, plans for a complete rebuilding were stayed
when they came to the works of Vasari's "inventor of the Art."

Here then was a *Life* of the first importance and of lasting influence.
Vasari went over it in careful detail for the second edition, but despite
this he is badly out over his dating. Masaccio, he states, died at the
age of twenty-six in 1443, whereas there is sound evidence that he
was born in 1401 and died around 1427–29. In his account of the Car-
mine frescoes, Vasari credits to Masaccio the works that today are
generally agreed to be his, and particularly admires the *Tribute Money*
[133] and the shivering man [134] in the scene of St. Peter baptizing.
He began, Vasari says, to practice when Masolino was at work in the
Carmine, and followed in the footsteps of Brunelleschi, who was a
close friend, and of Donatello. He describes, among works now known,
the Pisa polyptych, dated by documents to 1426–27, and partially still
extant, and the *Virgin and St. Anne* in the Uffizi. He then recounts how
Masaccio went to Rome and painted frescoes of the *Crucifixion* and
the *Life of St. Catherine* in S. Clemente, and also a painting in a chapel
of S. Maria Maggiore, of the *Miracle of the Snow*, with four saints "so
well executed that they appear to be in relief." Here is where the
trouble begins. The *Crucifixion* in S. Clemente [135], beneath its heavy
repainting, has some hints of Masaccio in the wide landscape and one
or two of the figures, but this confused design cannot come from the
master of the *Tribute Money*; even less, the scenes of the life of St.
Catherine. If Masaccio worked here, it was work completed by Maso-
lino, after his return from Hungary and after the death of Masaccio.
Vasari's story is that it was the death of Masolino, and the return of
Cosimo de' Medici to Florence (1434) that led to Masaccio's recall to
complete the Brancacci chapel. The triptych in S. Maria Maggiore
raises similar problems. Unbeknown to Vasari, it was painted on both
sides, which at a later date were cut apart but are still extant: the

Miracle of the Snow and its reverse, the *Assumption*, at Naples, the four saints of one wing in Philadelphia, the others in the National Gallery in London. The *Assumption* with its flat decorative pattern could not be by Masaccio, though his facial types recur in it. The *Miracle of the Snow*, which Vasari says contains portraits of Martin V and the Emperor Sigismund, has the stiff elegance and slightly pedantic use of architectural perspective that we find in Masolino's Carmine *Raising of Tabitha*, and, more pronouncedly, in his later Castiglione d'Olona frescoes. But two of the National Gallery saints, *St. Jerome*

133. Masaccio, *The Tribute Money* (detail). Florence, Carmine

"Here can be seen the ardor of St. Peter in his question, and the attention of the apostles in their various attitudes around Christ, waiting his reply with such appropriate gestures that truly they seem alive."

Below

134. Masaccio, *St. Peter Baptizing* (detail, *The Shivering Man*). Florence, Carmine

"Yet in this second stage, one sees some most rare works of the masters, as that in the Carmine by Masaccio, who made a naked man who trembles with the cold."

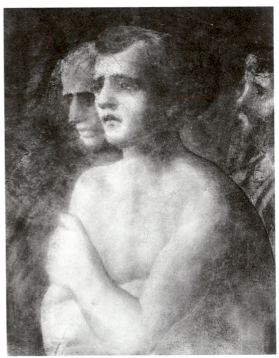

and the Baptist [136], are sterner stuff. It is hard to believe that these heads, with their heavy, shaded modeling, came from Masolino's hand, and equally hard to dismiss Vasari's statement that Masaccio had some part in it.[4]

Here then were two artists working certainly in close collaboration, both talented, both experimental, but one, the younger, with a genius capable of deepening the whole range of visual expression, handling the new ideas of perspective with a certainty that no one had hitherto achieved, and molding his figures by the use of light and shade into a new nobility of substance. Vasari writes of one of his most notable works, the *Trinity* in S. Maria Novella in Florence [137], that the coffered vault diminishes with such skilful foreshortening that there seems to be a hole in the wall. The donors kneeling below were half hidden by the ornaments of the altar in Vasari's day, and he does not mention that below them on the wall was painted a skeleton with the

[4] M. Davies, *The Earlier Italian Schools*, National Gallery, London, 1951, catalogued as Masolino; K. Clark, "An Early Quattrocento Triptych from S. Maria Maggiore, Rome," *BM*, XCIII, 1951, pp. 339–47.

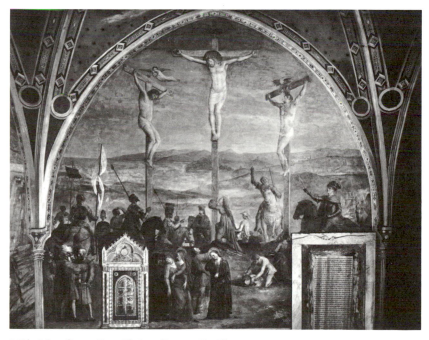

135. Masolino, *Crucifixion*. Rome, S. Clemente
The fresco has been heavily cleaned, and frequently restored. Some of the poses are borrowed from Masaccio, but the work is now given to Masolino.

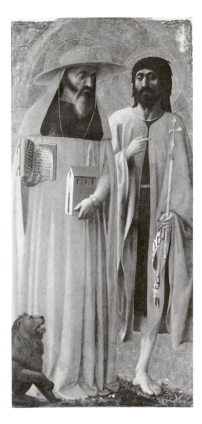

136. Masaccio, *St. Jerome and the Baptist*. London, National Gallery

The Gallery attribution is to Masolino, but the quality of the work seems to support Vasari's claim that Masaccio had a hand in it.

Opposite

137. Masaccio, *Trinity*. Florence, S. Maria Novella

The skeleton, unmentioned by Vasari, was according to other authorities visible ("A Trinity with Death below," Antonio Billi). Vasari, in his alterations at S. Maria Novella, covered the fresco, despite his admiration of it, with his own altarpiece, the *Madonna of the Rosary* [138].

motto "I was that which you are and what I am that will you be": a curiously medieval reminder beneath this triumph of the new science.[5]

Masolino took another course. His Hungarian journey and his work in Lombardy, perhaps also contacts with Gentile da Fabriano in Rome, moved him eventually far from these hints of solidity that he had learnt in the Brancacci chapel. His frescoes at Castiglione d'Olona are still interested in perspective, but they are bright, linear designs and Herod's court has an elegance that looks to Gothic illumination rather than Florentine realism. The International Gothic style laid its mark on him, and his paintings show the battle of these warring conventions, a battle which in the twenties was a lively factor in the art of Italy, but which round 1440, when Vasari thought these men were at work, had, at least in Florence, less significance.

One of Vasari's strangest inventions is a brother of Donatello, called Simone, whom he describes as working for Eugenius IV in Rome and responsible for the tomb of Martin V, and who shares a *Life* with Filarete. Outside of Vasari's pages there is no evidence of this brother's existence and the works attributed to him, where still extant, do not

[5] U. Schlegel, "Masaccio's Trinity Fresco," *AB*, XLV, 1963, pp. 19–33; J. Coolidge, "Further Observations on Masaccio's Trinity," *AB*, XLVIII, 1966, pp. 382–84.

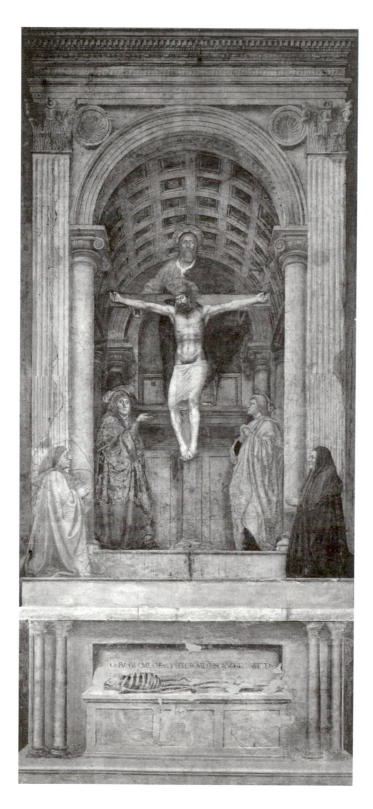

219

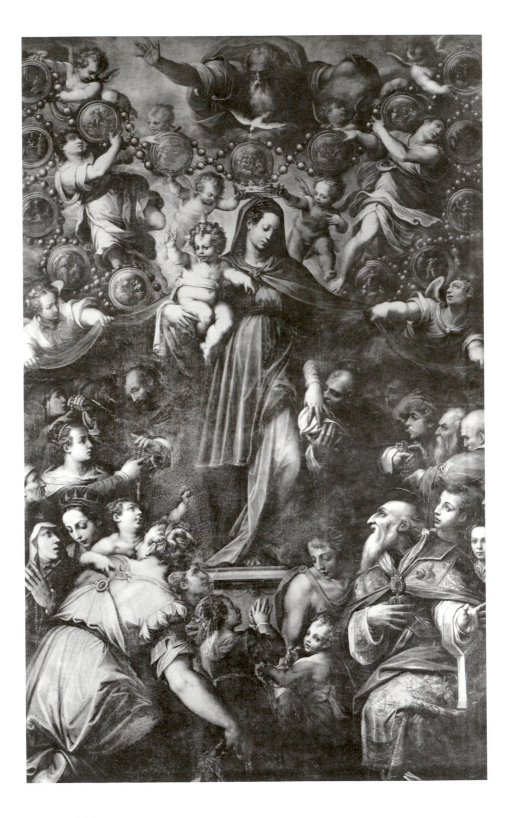

220

138. Vasari, *Madonna of the Rosary*. Florence, S. Maria Novella

Painted in 1569, this crowded composition shows the Virgin and Child in a cloud of angels bearing roundels with the various mysteries of the rosary, while the devout kneel in prayer and rosaries are distributed to them. The invention of it is praised by Raffaelo Borghini, writing from the standpoint of the Counter-Reformation.

139. Filarete, Bronze Doors of St. Peter's, Rome (detail of *Martyrdom of St. Peter*).

"If Pope Eugenius had made diligent search for excellent men for the work . . . it would not have been carried out in so unfortunate a way."

create a convincing picture. Besides the papal tomb, they are the carvings of the chapel of S. Sigismondo at Rimini (the work of Agostino di Duccio); a font in the cathedral at Arezzo (attributed to Francesco Ferrucci); and the tomb of Orlando de' Medici in SS. Annunziata (by Bernardo Rossellino). Agostino di Duccio, with his markedly personal style, is a sculptor of whom Vasari seems to have known nothing, but there was some Simone–Agostino confusion in his mind, as elsewhere; discussing the early history of the block of marble from which Michelangelo carved his David, he states the marble had been previously worked on by Simone of Fiesole, whereas it had in fact been given to Agostino in 1463. There was a goldsmith, Simone di Giovanni Ghini, who worked for the papacy in Rome, and a Simone di Ferrucci of Fiesole, and one or other, or possibly both, may lie behind Vasari's fictitious character. Certainly he had no share in Filarete's bronze doors for St. Peter's [139], as stated by Vasari, for they are inscribed with the names of all his assistants and no Simone figures amongst

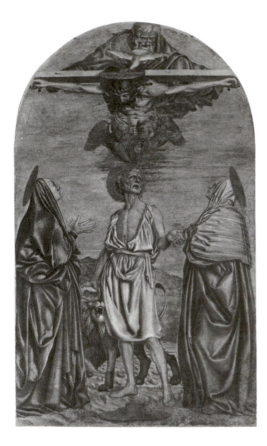

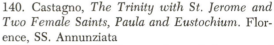

140. Castagno, *The Trinity with St. Jerome and Two Female Saints, Paula and Eustochium*. Florence, SS. Annunziata

"He painted a St. Jerome, dry and shaven, and above a crucifix, so well foreshortened that Andrea deserves much praise, having done it in a better and more modern manner than any before him."

them. The doors themselves did not impress Giorgio. Eugenius IV is blamed for entrusting work of such importance to Filarete at a time when Brunelleschi and Donatello were alive, and Ghiberti was completing the *Gates of Paradise*. The pope, or rather his officers to whom he entrusted the matter, Vasari complains, not understanding the work, chose worthless and unskilled artists. He describes, inaccurately, the subjects of the panels, but does not explain his dislike of them. This, however, is easily understandable. Compared to Ghiberti's sense of pose and space these crowded scenes, with their elaborate classical allusions, are clumsy works. Vasari notes one of the small contemporary scenes, but without giving it the credit it deserves for novelty and freshness of approach.

Most celebrated of all Vasari's howlers is his account of Andrea del Castagno and Domenico Veneziano, and how the former murdered the latter. Vasari had a good journalistic liking for a murder story; there are several scattered throughout the *Lives*, and in those violent times they were not hard to come by: Vittorio Ghiberti robbed and murdered by his groom; Polidoro da Caravaggio strangled in his sleep by his servant and his body left outside his mistress's house, so that it should seem some vengeance of her kin; Lippo, a name that cannot be

certainly identified, "a man who preferred discord to peace," stabbed
in the street; the wife of Cola dell'Amatrice hurling herself from a
precipice to escape from licentious soldiery.[6] But in the case of Cas-
tagno the dates defeat the story. His death from the plague is recorded
in the *Libro dei morti* in August 1457, and Veneziano, the supposed
victim, survived till 1461. Vasari's authority for his melodrama is both
Billi and the *Anonimo*. He lists Andrea's works from his usual sources,
but the only date he gives comes from a misunderstanding of state-
ments that Andrea painted on the wall of the Palazzo del Podestà
effigies of traitors hanging head downwards, which earned him the
nickname of Andrea degl'Impiccati. This gruesome practice was com-
mon form in Florence, and the occasion of Andrea's employment was
the defeat of the Albizzi in 1440, whereas Vasari assigns it to the
attempted assassination of Lorenzo and Giuliano in 1478. Andrea del
Sarto performed the same unpleasant commission during the siege of
Florence in 1530. Castagno's nickname perhaps played a part in the
sinister repute in which he was held, and the at times brutal realism
of his types bore it out. "He was," Vasari writes, "extremely bold
(*gagliardissimo*) in the movements of his figures, and fearsome (*ter-
ribile*) in his heads." These rugged qualities have more response today
than in earlier periods.[7] Cavalcaselle found Castagno "one of the most
vulgar of the realists." Neither he nor Vasari, owing to the rigors of the
clausura and later whitewashing (only removed in 1890), knew some
of Andrea's finest work, the wall of the refectory of S. Apollonia, where
he linked the Last Supper with the Crucifixion, Deposition and Resur-
rection in a design of bold originality. Vasari much admired the fore-
shortening of the figure of Christ in the *Trinity* in SS. Annunziata
above what he calls a "dry and shaven" St. Jerome [140]; but by the
time of the second edition this picture had been covered over and
could no longer be seen. It was perhaps too strong meat, and we know
now that the *sinopia* for it was a much gentler and more conventional
design; the painting as it stands was pricked from a cartoon. Andrea
in fact had difficulty over his foreshortening, and painted two seraphs
al secco over Christ's lower body, paint that has now nearly all peeled
away. Vasari also commended the *Flagellation* in the cloister of S.
Croce, but this lost work already in his day was decaying, much
defaced by children scratching the faces of the tormentors as though
to avenge the wrongs done to Christ, a striking reaction to Andrea's
realism. Vasari adds that Castagno was himself not above defacing

[6] *M*, v, p. 214.

[7] M. Salmi, *Andrea del Castagno*, Florence, 1961; L. Vertova, *I cenacoli fioren-
tini*, Turin, 1965, pp. 31–37. A recent appreciation of some sides of Castagno's
work is given by T. Yuen, "The Bibliotheca Graeca: Castagno, Alberti and Ancient
Sources," *BM*, cxii, 1970, pp. 725–36.

some of his rivals' paintings. It was in color that Vasari claims he was deficient, and this is made the basis of his hostility to Domenico Veneziano, who was using a new technique with an oil medium, and whose light, pleasing tones are indeed very dissimilar from Andrea's violent reds and browns. The records of the hospital of S. Maria Nuova, where Domenico was painting the choir, show that he was supplied with some quantity of linseed oil, but whatever his method, it was in modified tempera that he worked.

Then "one summer evening as he was wont, Domenico took his lute, and went out by himself to his pleasures. Andrea, unbeknown, waited

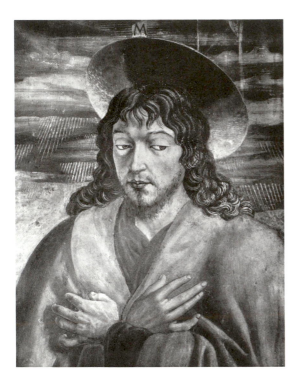

141. Castagno, *St. Julian* (detail). Florence, SS. Annunziata

The fresco was covered over in the Baroque alterations to the church and when found again in 1857 the lower part was damaged; this explains the absence of the foreshortened dog praised by Vasari.

Below

142. Vasari, Portrait of Castagno in the second edition of the *Lives*

This is probably based on the tondo in S. Maria Nuova, where, according to Vasari, Andrea painted himself as Judas Iscariot, "as he was in appearance and in deeds."

ANDREA DAL CASTAGNO
PITTORE.

his return hidden in a corner, and when Domenico reached him, he smashed both his lute and his belly with a bar of lead. But, thinking he had not killed him, he struck him on the head, and then leaving him on the ground, returned to his room, his act never being discovered till his confession at his death." There was an artist murdered in Florence in 1443, a certain Domenico di Matteo, and from this episode, of which the details are not known, the story probably arose. It is of course possible that Andrea was involved in it. It is easy to imagine some dark secret behind the brooding *St. Julian* [141], possibly a self-portrait, the murderer saint. Vasari piles on the effect by stating that in S. Maria Nuova (now destroyed) Castagno painted himelf as Judas [142]. For Vasari at least he remained the example of cruel, diabolical and treacherous jealousy, and so for many generations his record was handed down.

Another painter who fares badly, if possibly less unjustly, at Vasari's hands is Giovanni Antonio Bazzi of Vercelli, known by the unattractive sobriquet of Sodoma.[8] Vasari never suggests that he met him personally, but he had various sources of information about him. In 1505–1506 Sodoma frescoed the walls of the cloister in Monteoliveto near Siena, a monastery which Vasari knew well, and an order with which, as we have seen, he had close contact. He had also a considerable circle of acquaintances in Siena. There was Domenico Beccafumi, whose quiet, devout and retiring personality was congenial to Giorgio, "an honest, clean-living, God-fearing man" he calls him; and one who in the early part of his career both rivaled and learned from Sodoma. Beccafumi's friend, Giuliano di Niccolò Morelli, the goldsmith, was also known to Vasari, and seems to have been a man very much at the center of the art world of Siena. There were plenty of sources of talk about the "foreign" artist from Vercelli, whose flamboyant clothes, menagerie of beasts and passion for horse racing, in particular the Sienese Pallio, gave him a great popularity, as Vasari admits, among the common people, the plebs, of Siena. The monks of Monteoliveto nicknamed him Mattaccio, "the buffoon," and insisted on him clothing the nude courtesans in his painting of the temptation of St. Benedict. When a Milanese nobleman, Giovanni Ambrogio, joined the order, the splendid cloak he discarded was bought by Sodoma who painted himself wearing it in one of the frescoes [143], with some of his animals at his feet. "He thought," wrote Vasari, "of nothing but pleasure, worked when he pleased and only cared about dressing himself grandly like a mountebank." For Vasari it is a moral tale leading to an old age of wretchedness after an extravagant and bestial career

[8] R. H. H. Cust, *Giovanni Antonio Bazzi*, London, 1906; E. Carli, *Cat. Mostra Vercelli e Siena*, 1950.

[144]. Summoned to Florence by the Olivetan monks to paint a *Last Supper* in their refectory, probably in 1515–16, Bazzi entered a horse for a race, and when the name of the owner was called out as Sodoma, the crowd was indignant and began to pelt him with stones and dirt. "He was," says Vasari, "a gay licentious man, who spent his time in pleasures and enjoyments, in which he always had around him boys and beardless youths, whom he loved beyond measure, whence he acquired the nickname Sodoma." In the Olivetan *Last Supper*, now a sad ruin, but in no way worthy of the ridicule Vasari gives to it, Gior-

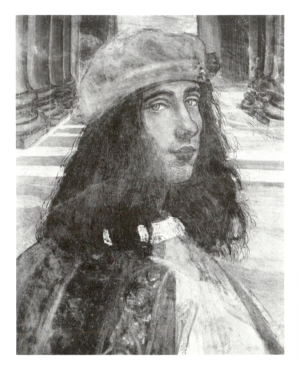

143. Sodoma, *Self-Portrait*. Detail from fresco in Monteoliveto Maggiore

Sodoma shows himself full length, in his splendid cloak, with at his feet a bird and two badgers wearing collars.

Below

144. Vasari, Portrait of Sodoma in the second edition of the *Lives*

Vasari describes a portrait with a beard in a tabernacle at the S. Viene gate (Porta Pispini) in Siena. Some fragments of the fresco, but not the portrait, remain. Sodoma died in 1549 (not 1554 as given by Vasari) aged seventy-two, and Giorgio might easily on some occasion have seen him.

GIOVANNANTONIO SODDOMA
PITTORE.

gio failed to note that here Judas, turning to face the spectator, is almost certainly a self-portrait.

Homosexual attachments were no doubt part of the Renaissance way of life, and conduct in the studio, with the *garzoni* often posing nude for their masters, like poor Pippo del Fabro whom Sansovino made to stand naked in the winter cold, may easily have led to laxities. In the easygoing morality of the days of Julius II or Leo X much could be overlooked, but it remained a serious offense, which under stricter regimes such as those of Paul IV or Pius V was to meet its penalty of death by burning. It is unlikely that the nickname was so freely used, even in legal documents, if there was much matter behind it. Bazzi was a married man with two daughters, and Vasari's insinuations that the marriage broke down appear unfounded. He was fined in the court of Siena in 1514, largely it seems because of his failure to answer a summons; and there were later some further taxation problems, in the course of which he sent to the city fathers an impudently facetious declaration, listing all his menagerie and claiming exemption for them with a nice selection of bawdy puns and epithets, the whole firmly signed "Sodoma." He was undoubtedly a lively card, which did not prevent Leo X making him a papal knight in 1515 or 1516. He enjoyed continuous commissions in Siena, and there is no indication of his being reduced to poverty in his later years. The nickname is probably an example of the rough and ready freedom of speech of the time rather than a serious indictment.[9]

Vasari, disapproving of the man, admired some of his works. The *St. Sebastian* [145] is "a truly beautiful and admirable work." He quotes Baldassare Peruzzi, who had worked with Sodoma in the Farnesina, as saying that he had never seen fainting better represented than in Sodoma's *Swoon of St. Catherine* in S. Domenico at Siena, and Vasari himself had a drawing for it. "He did some things excellently, though they were very few." In the *Execution* scene [146], again in S. Domenico, he criticizes Sodoma's idleness in making no cartoons for his frescoes and drawing on the lime with his brush, thereby falling short of perfection. The earlier frescoes of the Farnesina he dismisses with a reference to the numerous cupids, though we know he was familiar with the villa and on one occasion had shown it to Titian, who could hardly believe that the Peruzzi perspectives were only paintings. Surprisingly he does not comment on the languorous sensuality that appears so clearly in Sodoma's work, whether Sebastian or Catherine is the subject, or more fittingly Alexander and Roxana. Nor does he notice the architectural settings, and the fine and often evoca-

[9] For a discussion of the name, see Cust, *op.cit.*, pp. 15–25.

tive landscapes. Few artists of this period had such a sense of nature at one with the theme, and the details—the hawk in pursuit of the heron, the nesting stork, the cat climbing the prickly branches of the tree—are background comments handled with immense individuality.

Of Sodoma's origins in Vercelli Vasari knew little, and of his first master, Martino Spanzotti (ca. 1455–1526/8), there is no mention in the *Vite*. It was an area that Vasari had never visited, and he had, in common with many others, heard nothing of the cycle of frescoes in

Opposite

145. Sodoma, *St. Sebastian*. Florence, Pitti Palace

"He painted on a banner to be carried in procession St. Sebastian, bound naked to a tree, balanced on his right leg, with the left foreshortened, raising his head to the angel who crowns him, a truly beautiful and admirable work."

146. Sodoma, *St. Catherine Intercedes at the Execution of a Criminal*. Siena, S. Domenico

"The head has been struck off, and the soul can be seen rising to heaven. Thus can the prayers of such holy persons reach the goodness of God."

the little church of S. Bernardino, now enclosed in the Olivetti works at Ivrea, frescoes which, if probably painted after Sodoma had left the Spanzotti studio, reveal influences which must have molded his early years.[10] Vasari had heard vaguely, but in no detail, of another great series of frescoes, those of Gaudenzio Ferrari at Vercelli [147]. In the first edition Gaudenzio gets a brief mention at the end of the life of Pellegrino da Modena, and the only painting that Vasari knew was the *Last Supper* in the church of the Passion at Milan, which he wrongly describes as unfinished, though he refers to "works" at Vercelli and Veralla (Varallo). In the second edition he adds the altarpiece in S. Celso (the *Baptism*) and the *Passion* fresco in S. Maria delle Grazie, both Milanese churches. But it is brief, ill-informed stuff. "He is omitted by Giorgio Vasari in Lives of the Famous Painters, Sculptors and Architects, an argument that he intended only to eternize his own Tuscans." So wrote G. P. Lomazzo in his *Trattato dell'arte della pittura, scultura et architettura* of 1584. To say that Vasari "omitted" him is an exaggeration, but Lomazzo makes ample atonement for the scantiness of Vasari's treatment and places his old master, Gaudenzio,

[10] G. Testori, *G. M. Spanzotti*, Ivrea, 1958.

229

147. Gaudenzio Ferrari, *The Assumption*. Vercelli, S. Cristoforo

It would have been interesting to have Vasari's views on these remarkable and highly individual frescoes, painted in 1532–33, but Vercelli lay outside his range of travel and he had only vaguely heard of them.

with Raphael, Polidoro, Leonardo, Michelangelo and Titian as one of the seven pillars of the Temple of Art.[11]

Place is the main influence on these omissions. It is generally possible to feel certain when Vasari is writing of things that he has seen, though occasionally his memory or his notes fail him. He not only describes in detail, but also often gives the exact position of the work, as for instance, "at the door on the right hand on entering S. Pier Mag-

[11] V. Vitale, *Gaudenzio Ferrari*, Turin, 1969. In the *Last Supper* (1544) Gaudenzio was assisted by G. M. della Cerva, so that there may be some truth in Vasari's statement that Gaudenzio did not complete the work on it.

giore Franciabigio made an Annunciation." There were always problems of accessibility and cloisters were on the whole more impenetrable then than now. In Milan, he notes that the nunnery of S. Marta was hard of entrance, though he succeeded in obtaining leave, and saw Bambaia's unassembled tomb of Gaston de Foix, recording his indignation at the carelessness with which the pieces lay about, so that several had been stolen, and admiring the effigy, with its joyful aspect at having died in the moment of victory.[12] Where he had no opportunity of personal observation, he is at pains to secure information. Messer Giovanni Battista Grassi, for instance, gave him many details about the painters of Friuli. In his account of them and their works the phrases "I am informed" and "considered a good work" recur, and we can take it that Vasari here is writing at second hand, though the account of Pordenone's fresco on the façade of the Tinghi Palace in Udine and of other works there is so detailed that it seems possible he may have visited that town when he was in Venice from December 1541 to August 1542. He is unfortunately in some confusion about Pordenone's name, calling him Licinio instead of de Sacchis, though he was aware that in Cremona he was known by the latter name.[13] The apparent explanation is that on an engraving of Pordenone's altarpiece of the *Annunciation* in S. Maria degli Angeli at Murano the artist's name is placed very close to that of the engraver, Fabio Licinio, and that Vasari read them as one. He knew this strange and slightly ridiculous painting had been carried out in competition with Titian, but he does not describe it and probably had never seen the actual work. The name Licinio, however, was to be accredited to the artist for many years to come. Of his early work in Friuli, Vasari has some knowledge, quoting "competent critics" (Cosimo Bartoli had been collecting information about him) and he had seen some of his paintings in Venice and possibly his frescoes in Piacenza. Of his frescoes at Treviso and Cortemaggiore, with their novel treatment of the dome as an open space through which the Almighty descends in a cloud of angels, he knew nothing, and in the *Vita*, where Pordenone's portrait presides over a general section of Friulian painters, he has nothing to say of the great series of frescoes in Cremona, though he admits that Pordenone's figures emerge from the wall as in relief, so that he must be ranked amongst the innovators from whom the arts have benefited. When, however, he writes of Garofalo and other Lombard artists, he has a paragraph on the Cremona Duomo in which he describes Pordenone's frescoes as "having force and liveliness, large figures, strong coloring (*colorito terribile*) and powerful foreshortenings." This is but

[12] *M*, VI, p. 514.
[13] G. Fiocco, *G. A. Pordenone*, 2 vols., 3rd ed., Pordenone, 1969.

148. Pordenone, *Christ Nailed to the Cross*. Cremona, Cathedral

a brief summary of these violent scenes with their decentralized movement and the bold illusionism of their projection into the frontal space [148]. They explode from their frames; the cross to which Christ is nailed juts outward, and a soldier quarreling over the dice leans his hand over onto the cornice; the pointing prophets stretch out from their roundels and Christ's shroud falls over the foot of the picture space. "Pictor Modernus" they called him in the cathedral documents, and never before had there been such disregard for the painted plane. They have, too, a curious contemporaneity, dominated by bullying *Landsknechte*, the dreaded figures of these Northern wars. Painted in 1520, at the same time as the Sala di Costantino, they belong to a different world of reality. Vasari himself, who successfully avoided the major turmoils of the time, depicts his fighting warriors in the Palazzo Vecchio in semi-classical costume, reserving the portrayal of them in the dress of their times for more formal and less passionate manoeuvres.

The painters of the rest of the series on the cathedral arcades are even more rapidly dismissed. Altobello Melone and Giovanni Francesco Bembo, whom he wrongly calls Bonifazio, are mentioned with a reference to a previous and in fact nonexistent account of them. Romanino's

frescoes, striking and powerful works, are not noted. Boccaccio Boc-
caccino, who had begun the series, is given a *Vita* in an earlier part
of the book. Here Vasari passes into complete fantasy, with a story of
how he came to Rome and began to criticize unfavorably the work of
Michelangelo, until his own painting in S. Maria Traspontina was
uncovered amidst general laughter. S. Maria Traspontina was
refounded and rebuilt in 1566, so that there is no trace of any such
painting if it ever existed. It is not even certain that Boccaccino visited
Rome, though his last fresco in Cremona (1518) suggests that he may
have seen the *School of Athens*.[14] He was a painter of some distinction,
though a dubious character, who murdered his unfaithful wife. It is
little wonder that to Cremonese historians Vasari was "a jealous scoun-
drel (*ammaccione invidioso*)."[15]

We can, as it happens, follow fairly closely Vasari's only visit to
Cremona. On 10 May 1566 he left Milan planning to journey to Venice
via Lodi, Cremona, Brescia, Mantua, Verona, Vicenza and Padua,
expecting to arrive in Venice on 23 May. We know that he reached
Mantua on 13 May. That leaves the inside of four days for the journey
to Mantua, on modern routes a distance of 227 kilometers. Cremona–
Brescia–Mantua is a somewhat indirect course, and Giorgio adds "a
very bad road." His stay in Cremona must have been at the most an
afternoon and night. It was, he complains in his letters, a wet summer
and light indoors was probably poor. It is arguable that the heavy
rains of May 1566 have clouded much later judgment on Renaissance
art in Lombardy and Emilia. Besides the cathedral he certainly, to
judge from his comments on their paintings, visited S. Sigismondo,
two and a half kilometers outside the town, S. Pietro al Po and pos-
sibly S. Agata. Far more space, however, is devoted to his visit to the
house of Amilcare Anguissola. So interested was he in the paintings
of a talented daughter of the family, Sofonisba [149], "the marvels of
Sofonisba," he calls them, that though she was absent, he copied an
exchange of letters between her and Pope Pius IV and somewhat
irrelevantly inserted them into the *Lives*. "If," he concludes, "women
know so well how to make living men, what wonder is it that those
who wish to paint them can do it well also." With such distractions
it is perhaps not surprising that the evening in Cremona resulted in
somewhat muddled notes.

If the ferocity of Pordenone might well be little to Vasari's taste,
the gentler Bernardino Luini receives even scantier treatment. Vasari
knew of his paintings at Saronno, probably not at first hand as there

[14] T. S. R. Boase, "The Frescoes of Cremona Cathedral," *Papers of the British
School at Rome*, XXIV, 1956, pp. 206–15.

[15] G. Zaist, *Notizie istoriche de' pittori cremonesi*, Cremona, 1774, I, p. 72.
E. V. Lancetti, *Biografia cremonese*, Cremona, 1820, I, p. 375.

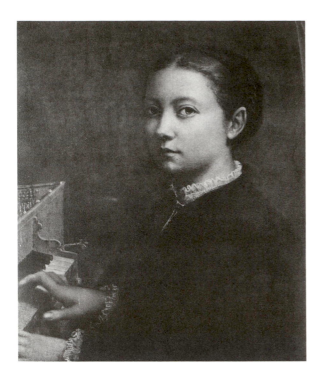

149. Sofonisba Anguissola, *Self-portrait*. Naples, Capodimonte
 Painted in 1559, when she was about thirty years old.

is no reference to Gaudenzio's splendid cupola painting, and in S. Maurizio at Milan; "a very delicate and charming (*vago*) painter," he calls him, and leaves it at that. Ambrogio da Fossano called Bergognone, and the sculptor Amadeo, though Vasari must have seen their notable works at the Certosa of Pavia, are amongst the omitted names, over whom Vasari's lack of knowledge was long to cast a shadow. Another, that of Carlo Crivelli, is particularly tantalizing, for it would have been of much interest to know how Vasari reacted to him. But the little towns of the Marches, where were many of his elaborate polyptychs, were never visited and this strange individual artist, who mixed Renaissance and Gothic details into a style that was entirely his own, was little known till in the nineteenth century his altarpieces were dismembered and disposed of. Giorgio would not have approved of the applied ornaments in relief which are so frequent in his works, and which he had condemned in Pinturicchio as a very clumsy thing in painting.

X. Raphael and Michelangelo

"In a word, for all Vasari commends him to the skies, Michel Angelo was a better Sculptor than Painter: One may say of Raphael and of him, that their characters were opposite, and both great Designers; the one endeavouring to show the Difficulties of the Art, and the other aiming at Easiness; in which, perhaps, there is as much Difficulty." So it seemed to William Aglionby at the end of the seventeenth century. "Raffaelle," wrote Sir Joshua Reynolds in his fifth discourse, "had more taste and fancy, Michelangelo more genius and imagination." Every period of art criticism uses its terms with different inflections of meaning; here are echoes of the Vasarian problem of assessing these two great figures: the dark-eyed, languorous young man, who looks out so romantically from the much re-painted Uffizi self-portrait [150], and the rugged, tortured face, so often rendered by his devoted followers, of Buonarroti [151]. The brilliant, attractive youth, who charmed everyone with his *graziata affabilità*, was in vivid contrast with the withdrawn but pungent "divine old man." It was not only in his art that he triumphed, but also in his behavior ("dall'arte e dai costumi insieme"). Giorgio well understood the prestige Raphael had given to the artificers of design; compared with him many of his predecessors seemed uncouth and unbalanced. He stands forth in a new status, the possessor of such rare gifts that he seemed a mortal god.

Vasari knew that his own deep prejudice made him critical and a little jealous of Raphael's fame. The revisions in the second edition include minor stylistic changes, a nicety which elsewhere he rarely troubled to carry out. It shows how closely he pondered over this particular *Vita*, which itself is only a part of what he wrote about "the miraculous Raffaello Sanzio da Urbino," a name that recurs pervasively throughout the whole work.[1] He himself, a boy of nine at Arezzo when in 1520 Raphael died in Rome, had never seen him, but he had talked with many who knew him, and it is clear that talk about Raphael

[1] The documents, the *Vita*, and other material are admirably compiled and annotated by V. Golzio, *Raffaello*. For the self-portrait see H. Wagner, *Raffael im Bildnis*, Berne, 1969, pp. 52–53; L. Dussler, *Raphael: A Critical Catalogue of his Pictures, Wall-paintings and Tapestries*, London, 1971.

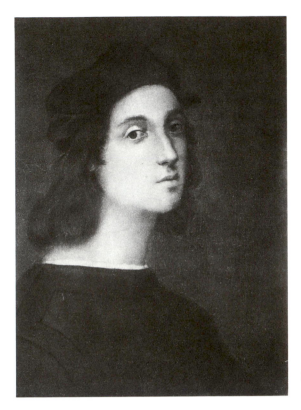

150. Raphael, *Self-portrait*. Florence, Uffizi
"Raffaello, che era la gentilezza stessa."

came very easily, with Giulio Romano in Mantua, with Perino del Vaga gossiping over a drink in Rome, with Giovanni da Udine and with Bindo Altoviti in his Roman palace. Vasari adds in the conclusion of the *Vite* that amongst other written sources he had seen some by Raphael himself. There has been much speculation as to what this can mean. Possibly the draft on the antiquities of Rome by Raphael and/or Castiglione was in circulation in manuscript; more probably some of his friends had letters from him, and Giorgio refers explicitly to correspondence still extant ("come si vede ancora") between him and Timoteo Viti.

He begins with a romanticized account of the early days in Urbino, making play with the fact, how learned he does not say, that Raphael's mother suckled him herself so that he should not be sent out from the home. Perhaps he deduced it from the moving painting of a mother and child that he must have seen in Raphael's house, when he visited Urbino. The boy grows up as his father's assistant and there are many tears from his mother when he is sent to Perugia to be apprenticed to Perugino. It is a pleasant tale, well suited to the supreme painter of the Madonna and Child, but unfortunately his mother in fact died

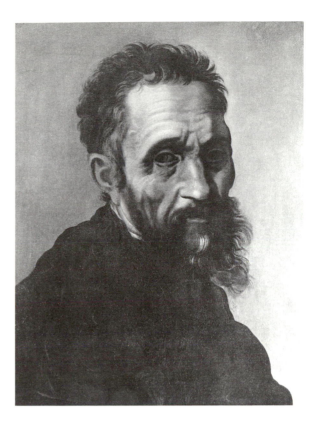

151. Portrait of Michelangelo attributed to Jaco-
pino del Conte. Florence, Uffizi

when he was seven. His father died three years later, having married
again, and Raphael was involved, through his uncle Bartolomeo, in a
legal dispute with his stepmother over the settlement of his father's
estate.

Having brought the young Raphael to Perugia, Vasari has nothing
to say, either here or in his *Life* of Perugino, of the boy's participation
in frescoing the Cambio, where many critics have claimed to find his
hand. He is, however, emphatic that Raphael worked for a time under
Pinturicchio on the cartoons for the Piccolomini library in Siena cathe-
dral, though he rightly stresses that in the early altarpieces, the *Coro-
nation of the Virgin*, the *Crucifixion* and the *Sposalizio*, it is the influ-
ence of Perugino that predominates. The complete absorption of his
style, so that it became almost impossible to distinguish pupil from
master, only stressed the good judgment with which on coming to
Florence Raphael realized its limitations and "became a pupil anew,"
using what he had learned from Perugino as a stepping stone to his
ultimate achievements.[2] He could never surpass Leonardo in the awe-

[2] See J. White, "Raphael: the Relation between Success and Failure," in *Blunt,
Studies . . . Presented to*, 1967, pp. 18–23.

237

inspiring depth of his imagination ("un certo fondamento terribile di concetti") and the grandeur of his art, yet he came nearer him than any other artist. It was an influence that is very clear, clearer today than it was to Vasari, in the Florentine portraits and in a new sense of pose in his figures, but men of such different temperaments required different means. The *Madonna del Granduca*, which Vasari does not mention, may owe something to Leonardo's *morbidezza*; the *Madonna of the Meadow* may reflect his pyramidal design; but they are translated into Raphael's own terms. And in the latter painting the sense of open space and the firm lines of the silhouette show that he could still find use for something of the Peruginesque manner. Vasari particularly admired the *Canigiani Holy Family* [152], "this noble picture," noting the psychological interrelationship between the figures, St. Joseph bending towards Elizabeth as though marveling that so old a woman should have a child, and all of them intent on the children's play, where one reverences the other. Unfortunately he says nothing of the heads of putti which, as X-rays reveal, framed the design, but later were painted out.

In the *Life* of Baccio d'Agnolo, whose son Giuliano was to be Vasari's chief maker of frames, there is a glimpse of the young Raphael's life in Florence, when he had moved there to study the cartoons of Leonardo and Michelangelo of which everyone was talking.

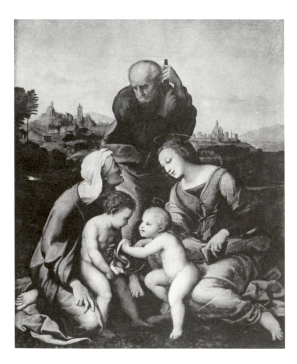

152. Raphael, *Canigiani Holy Family*. Munich, Alte Pinakothek

"St. Joseph, leaning on his staff, bends his head towards the old woman, as though wondering and praising the greatness of God, that someone so far in years should have so small a son."

Opposite

153. Raphael, *Entombment*. Rome, Borghese Gallery

"In composing this picture Raphael has imagined the grief of the closest and loving relatives as they bury the corpse of some most dear person, in whom consisted the wellbeing, honor and livelihood of a whole family."

Baccio's workshop was a great meeting place, primarily of the archi-
tects working with him on the Great Hall, Cronaca and Giuliano and
Antonio da Sangallo; but others came, Andrea Sansovino, Filippino
Lippi, Benedetto da Maiano, Francesco Granacci and, if rarely, Gra-
nacci's friend, Michelangelo. There were fine discourses and argu-
ments about matters of importance, in which Giorgio says, possibly
with hindsight, the young Raphael took a leading part ("il primo di
costoro"). No doubt already he could exercise his famous charm.
Vasari knew most of his Florentine paintings of this period, and tells
us how the *Madonna of the Goldfinch* painted for Lorenzo Nasi was
split in 1548 when the landslide from Monte S. Giorgio, a disaster to
which Giorgio often refers, destroyed the Nasi house, and how the
pieces were carefully collected and put together by Lorenzo's son, Bat-
tista. In the second edition he enlarges his account of the *Entombment*
[153] and adds the statement that it was painted for Madonna Ata-
lanta Baglioni, though he says nothing of the treacherous and slaugh-
tered son it commemorated, a melodrama of which he must have

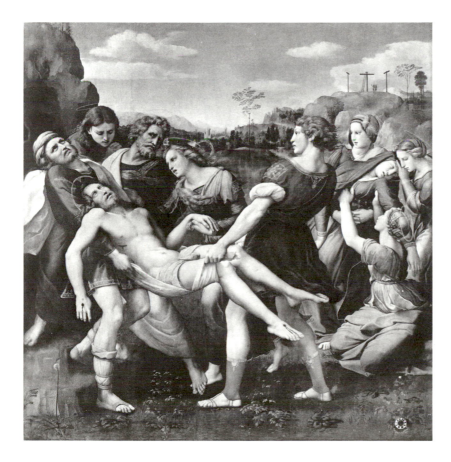

known and which one would have expected him to relish retelling. But about patrons he was generally discreet.

In 1508 Pope Julius summoned Raphael to Rome. It was, Vasari states, at Bramante's suggestion, as there was some relationship between the architect, now sixty-four years old, and the young painter, both of them coming from Urbino. There follows the famous account of how when Raphael began to fresco the Stanza della Segnatura, Julius decided to "throw to the ground" the frescoes already painted by other artists in this connecting group of rooms, including works by Piero della Francesca, Signorelli and Bartolomeo della Gatta,[3] and those in progress when Raphael arrived by Bramantino, Sodoma, Johan Ruisch and Lorenzo Lotto. The last two names are not mentioned in the *Vita*, though documented by payments. Perugino, as appears later, had also been working there. From this grave loss, however splendidly replaced, Raphael preserved a ceiling by his old master, Perugino, had copies made of some heads by Bramantino and kept some of Sodoma's work in the Stanza della Segnatura. How far there was real cooperation with the last named is uncertain, but in the *School of Athens* Raphael has painted beside himself the portrait of

[3] Vasari calls him here Pietro della Gatta; Pietro de Dei is the name by which he is recorded in the Aretine records.

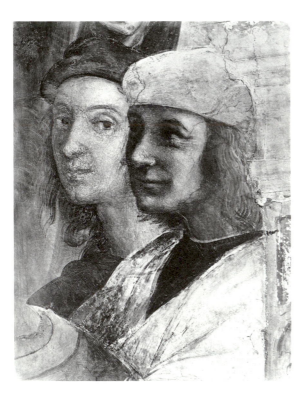

154. Raphael, Portraits of himself and Sodoma (detail from the *School of Athens*). Vatican, Stanza della Segnatura

It was a generous and no doubt conciliatory gesture on Raphael's part to place Sodoma's portrait beside his own, in this room where little of Sodoma's work survived. Vasari comments on Raphael's own portrait as being that "of a very modest young man."

Sodoma [154], unmistakable in its likeness to the self-portrait at Monte-
oliveto [143], a face alert with humorous mischief. About the subject
matter of this greatest of all frescoed rooms, Vasari is in considerable
confusion. The Stanze were not in his day accessible as they now are
to continuous hordes of tourists. When he worked in the Vatican for
Pius V he must have had better opportunities of inspecting them, but
that was after the second edition had appeared. As a young man in
his first Roman visit, he and Salviati had gained admission to the papal
apartments when Clement VII was absent at his country retreat of
Magliana, but the Stanza della Segnatura had been damaged during
the Sack, and repairs had not yet been carried out.[4] It was a long time
ago, and between then and 1568 he had been little employed in the
Vatican. The Sistine Chapel he knew well, and may easily have visited
it with Michelangelo himself: the papal apartments were a different
matter, and papal interviews often took place out of doors, as when
Paul III inspected the drawings for the Farnese Palace cornice while
driving in the Belvedere.[5] Vasari thought the *School of Athens* repre-
sented the evangelists reconciling philosophy and astrology with the-
ology. He takes the kneeling figure writing at the left-hand corner as
St. Matthew, and the young man beside him to be an angel. The
School of Athens is a later name, originating with Bellori in 1695,[6] and
Vasari had no *ragionamento* of the whole scheme, such as scholars in
our day have liberally provided, to guide his interpretation. His
attempt to Christianize the details shows a failure to grasp the sig-
nificance of the room as a whole, but was natural enough. With the
Disputa, described by him as "an infinite number of saints who are
writing the Mass, and arguing (*disputano*) about the Host displayed
on the altar," he is on safer ground. Over the Parnassus he makes his
famous error of discussing a number of naked cupids as they appear
in Marcantonio's engraving [127], but not in the fresco. The meaning
of the program is not, however, Vasari's concern, apart from his usual
interest, which was to be so prominent in his own paintings, in the
identification of various of the figures depicted. It is the expressions
of the faces that he particularly praises [155], and the appropriateness
of the gestures. The disputing doctors show on their visages curiosity
and an eager desire to reach the truth, "enforcing the argument with
their hands and actions, all attention with their ears, wrinkling their
eyebrows, showing astonishment in many ways, all apt and varied."

[4] *M*, v, p. 623. It is with Vasari that the name Segnatura comes into general
use. The room was originally designed as a library. For its use see J. Shearman,
"The Vatican Stanze: Functions and Decoration," *Proceedings of the British
Academy*, LVII, 1972, pp. 369–424.

[5] *M*, v, p. 470.

[6] See Dussler, *op.cit.*, p. 73. Dr. John Shearman tells me he has found an earlier
manuscript reference to the name.

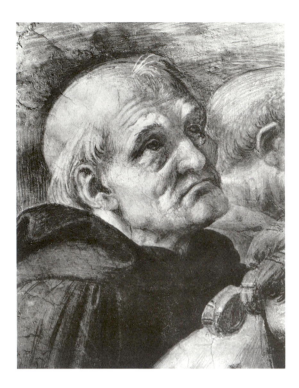

155. Raphael, *Disputa* (detail). Vatican, Stanza della Segnatura

This head is generally called, though not by Vasari, Fra Angelico. It has a possible resemblance to Vasari's woodcut.

The composition of the *School*, to use the familiar term, is well set out with order and measure, adorned with a perspective, but he spends little time on the sense of space that today seems such a prime virtue of the work; and where composition and meaning meet, as in the descending scale of circles in the *Disputa* from Christ's glory through the passage of the Spirit to the monstrance with the Host, he fails to register any comment.

In the following room, "composition" is given more attention. Vasari was much impressed how in the *Mass of Bolsena* and the *Liberation of St. Peter* Raphael had utilized the awkward window-space so as to increase rather than interfere with the completeness of the design. The *St. Peter* [156] amazed him in its technical skill, and twice he comments on what had been a problem of his own, the rendering of reflected light on armor. He passes on to the *Heliodorus* and then to the *Burning of the Borgo*, describing them in admiring detail, more at home with their increased narrative content, and undisturbed by the stylistic changes, such as the placing in the *Burning* of the main incident, the papal blessing, in the background and off the central axis, a practice that was to be much developed by Vasari's contemporaries. Vasari states that Raphael was now using many assistants, working from his cartoons, though he continually oversaw and retouched everything. He refers again to this in the *Life* of Giulio Romano as a method

that Raphael had brought to a new level. Before the *Coronation of Charlemagne* [157], which he calls from the portraits in it Leo X crowning Francis I, he pauses to explain that the kneeling boy holding the crown is Ippolito de' Medici, "to whose most blessed memory I confess myself much indebted, for my beginning, such as it has been, had its origin from him." Such personal details interested him more than stylistic changes. Sebastiano del Piombo wrote to Michelangelo that the later works of the "Prince of the Synagogue," as Raphael was nicknamed in hostile circles, were "figures as though they had been in smoke, or made of iron that gleams; all bright and all black, and drawn in the manner which Leonardo [Sellaio] will describe to you."[7] This is a shrewd enough if crudely generalized comment on the new use of chiaroscuro, which, if approved as it certainly was by Raphael, was exploited by Giulio Romano. Giorgio is too busy with the narrative content to take much note of it.

A similar approach is used in his account of Raphael's other paintings. It is the subject matter, and the fitness of the expression and poses to it, the truth to nature, that are his constant theme. He

[7] Golzio, *Raphael*, p. 71; F. Hartt, *Giulio Romano*, New Haven, 1958, pp. 27, 28.

156. Raphael, *Liberation of St. Peter* (detail). Vatican, Stanza d'Eliodoro

"Here can be seen the shadows in the armor, the broken lights, the reflections and the smoke from the heat of the torches, worked with so dense a shadow that indeed he can be held the master of all others."

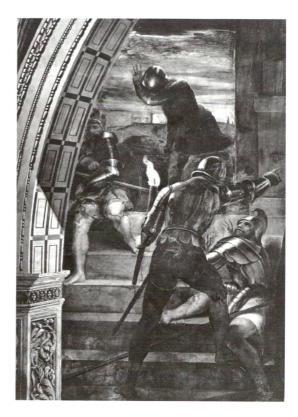

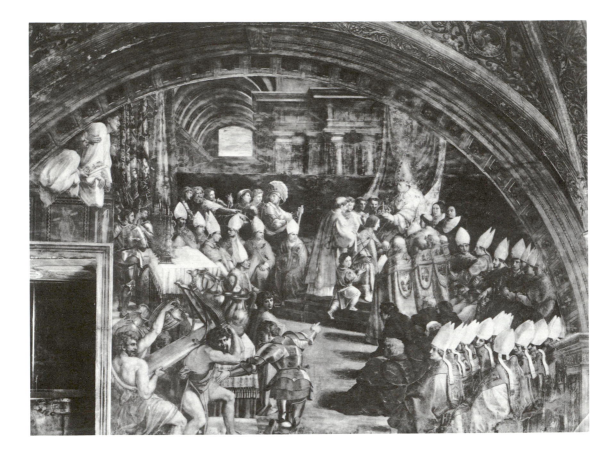

describes in equal detail some pictures that he cannot have seen, the *Christ Carrying the Cross* at Palermo,[8] where it was "more famous than the mountain of Vulcan," and the *St. Michael* that had been sent to Francis I. Curiously, he says but little of the *Sistine Madonna*, "made for the high altar of the black monks of S. Sisto in Piacenza, wherein is Our Lady with St. Sixtus and St. Barbara, truly a most rare and singular thing." No further description is given of this over-powering masterpiece, the climax of Raphael's theophanies, of the rendering of the divine in the human. It is hard not to wonder whether Vasari had seen it. He had certainly passed through Piacenza, but only with his usual rapidity. He describes it as a panel (*tavola*), whereas it is on canvas. He makes no reference to the della Rovere oak leaves on the pope's vestment, or to the fact that the pope is certainly a portrait of Julius II, details that would normally have appealed to him. The various theories associating it with Julius's private chapel or his obsequies have here no support. The saints were

[8] Now in the Prado.

244

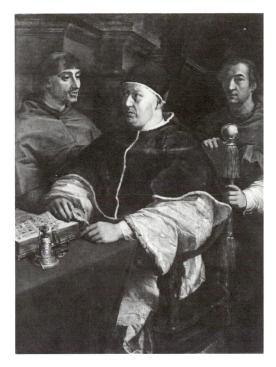

Opposite

157. Raphael, *Coronation of Charlemagne*. Vatican, Stanza dell'Incendio

The complex design of the fresco must be Raphael's, whichever of the pupils carried it out. The two choristers in the balcony on the left with their flowing surplices are a fine piece of painting and invention.

158. Andrea del Sarto, after Raphael, *Leo X, with Cardinal Giulio de' Medici (afterwards Clement VII) and Cardinal de' Rossi*. Naples, Capodimonte

Vasari himself had copied this painting, and knew every detail of it, and the skill with which all the accessories were painted. Andrea's famous copy deceived even Giulio Romano.

both patrons of the Piacenza convent, which possessed relics of them. The church was rebuilt in the beginning of the sixteenth century, and Julius II, while still a cardinal, had given a contribution to the work. Whatever use may have been made of the canvas before its despatch to Piacenza, a town that in 1512 had re-entered the papal states, there can be little doubt that Vasari correctly gives the destination for which it was designed.[9]

Raphael's portraits he knew well, for he himself had made a copy of the *Leo X* [158] and was fascinated by the texture of the materials, the differences between the velvet, the damask and the fur lining; the bell and the illuminated missal; the polished knob on the chair reflecting the light from the window; and the pope's book, all so wonderfully done that no master could improve on it. Of the *Julius II* he writes that the portrait inspired fear as though it were alive. It hung when he knew it in S. Maria del Popolo along with the equally problematic *Madonna di Loreto*, and both paintings were shown on solemn festivals.[10]

In the Raphael *Vita* little is said of Michelangelo. The story is told that when Michelangelo was absent in Florence after a quarrel with

[9] M. Putscher, *Raphaels Sixtinische Madonna*, Tübingen, 1955.
[10] C. Gould, *Raphael's Portrait of Pope Julius II*, National Gallery, London, 1971; K. Oberhuber, "The Portrait of Julius II," *BM*, CXII, 1971, pp. 124–30.

the pope, Bramante, who had the key of the Sistine Chapel, took Raphael in to see the unfinished ceiling, whereupon Raphael repainted his figure of Isaiah in the church of S. Agostino. The *Isaiah* can be securely dated to 1512; the first half of the ceiling was probably completed in 1510, though it was not publicly displayed till 1511; there was no need, therefore, for a secret visit, but it would seem improbable that a young artist working in the nearby Stanze would not have had some opportunity, formal or otherwise, of seeing the work as soon as the scaffolding had been removed, a business which implies considerable coming and going of workmen. In the *Life* of Michelangelo Bramante is said to have intrigued with the pope that the second half of the ceiling should be given to Raphael, and Michelangelo himself seems to have believed this; in a letter to an unknown ecclesiastic he stated that "all the discords that arose between Pope Julius and myself were due to the jealousy of Bramante and of Raphael of Urbino . . . and I have good reason of complaint against Raphael, for all that he had of art, he had it of me."[11] It was a difficult position for Vasari. In Raphael's *Life* he states that the artist painted the sibyls in S. Maria della Pace after having seen the Sistine ceiling but before it was publicly opened. In the *Life* of Michelangelo the sibyls are done after the ceiling is visible to all, and Raphael changes his style having had normal access to it. The probable dating for the work in S. Maria della Pace is 1511–12, so that on either view Vasari was not far out. Whatever were the rights and wrongs of this rivalry, Vasari added to the second edition a long section on the development of Raphael's art. Michelangelo was now dead and splendidly buried. These old bickerings could be resolved and forgotten, and Raphael's balanced composition, seemliness and dignity matched the new rules for the arts laid down by the Council of Trent, forming a bridge between them and Alberti's views of the proper rendering of "grace and beauty" in an *istoria*.

Vasari's thesis is that Raphael, with great judgment, took "a middle course," "choosing from the work of other painters to form from many different styles one that was for always held his own, and will be always infinitely esteemed by artists." It was not easily come by. As Michelangelo said, "he had not his art by nature, but by long study."[12] He spent much time in Florence studying anatomy and dissecting corpses, mastering the articulation of the bones, nerves and veins, and when he realized that in this he could never rival Michelangelo [159], thinking "like the man of great judgment he was that painting did not consist only in making nude men," he devoted himself to reaching the

[11] Golzio, *Raphael*, p. 294.
[12] *Ibid.*, p. 294.

supreme excellence ("un ottimo universale") in other branches of the
art. Would that other artists of our time, Vasari reflects, had not tried
to imitate Michelangelo, and toiled in vain in doing so. *Grazioso* is
the epithet he constantly applies to Raphael, and for him this is very
basic praise, implying an inspired facility for idealizing nature. "For
in truth through him art, colors and invention are unitedly brought to
an end and a perfection that could hardly be hoped for, and which
no one can ever think to surpass." He had not, Vasari implies in
another passage,[13] the profundity of Michelangelo, a reasonable esti-
mate, but one that must be modified by Vasari's failure to understand
some of the depths of Raphael's art. There is no lack of profundity
in the planning of the Segnatura.

There were other grounds for admiration. For Vasari Raphael is the
man who achieved a new status for artists, who lived like a prince,
accepted by all the great in Rome, talked of for a cardinal's hat, offered
a cardinal's niece in marriage. His organizing ability was shown in the
arrangements made with Marcantonio Raimondi for the issuing of
engravings, arrangements that Vasari describes in detail. He never
went out except attended by a troop of pupils and admirers, "the
synagogue" of his detractors. He even, and Vasari, who knew some-

[13] *Ibid.*, p. 256.

159. Raphael, *Burning of the Borgo* (detail).
Vatican, Stanza dell'Incendio

"If he had not sought to extend and vary his
manner, to show that he understood nudes as well
as Michelangelo, he would not have lost part of
the good name he had acquired, for the nudes in
the *Burning of the Borgo*, though good, are not
altogether excellent."

thing of the animosities of the art world, could only wonder at it, conquered the jealousy and backbiting to which that world was prone. "Before his courtesy and his good nature, so gentle and charitable, all vile and low thoughts fell from men's minds," though in view of Sebastiano's gibes this must be regarded as slightly overstated. "Well could painting, when this noble artist died, have died also, for when he closed his eyes, she was left as blind."

After this great panegyric, it is a little bewildering to find Vasari stating that he died through overindulgence in sexual intercourse. It was an explanation of his death that had been given already in a brief account of him by Simone Fornari, published in 1549. Fornari in other respects is no very reliable witness, but that Raphael was amorous by nature his own sonnets, scribbled on sheets of drawings, are there to prove, and the portrait of the nude girl with his name inscribed on the bangle. In the permissiveness of his society it was nothing to cavil at, and early marriages were not in vogue with the artist community. Vasari implies that he had one mistress to whom he was particularly devoted, and surely in the talks with Giulio Romano at Mantua, that Giulio who was not above producing a few lascivious drawings, there must have been some informed gossip about the great man's private life. But the sudden fever that carried Raphael off in spring 1520 at the age of thirty-seven suggests no such cause, and a man involved in as much work as he was had ample reasons for exhaustion.

The *Life* of Michelangelo is the climax to which the whole book leads:[14] "He who among dead and living carries the palm, and transcends and outpasses all, is the divine Michelangelo Buonarroti, who not only holds the first place in one of the arts, but in all three together." So Vasari wrote in the preface to his third part. When he comes to the *Vita* itself, he looks back to what he had written about Giotto, how by God's gift he had begun the revival of the arts: now, "the benign Ruler of Heaven turning his eyes in mercy on the earth, and seeing the endless futility of so many labors, the most ardent studies without any fruit and men's presumptuous opinion, as far from the truth as darkness is from light, to remove such errors resolved to send on earth a spirit that in each branch of the arts, working by himself, should show what perfection means." The praises go on: moral philosophy, poetry, holiness of life are added virtues; and because the Tuscan genius has always led the way, it is of Florence that this inspired being will be a citizen. All this was written in Michelangelo's lifetime. It is little wonder that at times the subject of these encomia thought Vasari protested overmuch, even allowing for the

[14] P. Barocchi, *La vita di Michelangelo*, 5 vols., Milan, 1962, provides the text of both Vasari's editions, monumental notes and commentary, and a detailed index.

grandiloquent level of compliment then in vogue, and still today more lavish in its Italian use than in the Anglo-Saxon tongue.

If the introductory section stands as Vasari first wrote it, the *Life* itself has considerable alterations in the second edition. The *apparato* for the Florentine obsequies of "il divino vecchio" had been in itself a review of his career, and a full account is given of it. There was, however, another and to Giorgio more tiresome factor. In 1553 there had been printed in Rome a life of Michelangelo by one of his pupils, Ascanio Condivi.[15] He was a young man in his later twenties who had come in 1550 to Rome from the township of Ripatransone near Fermo. He had therefore only been "in the close domesticity" of Michelangelo for three years, and it was a somewhat bold step to undertake to correct the statements of older friends, and to describe them as "some who have written about this rare man, without, I believe, having been as much in touch (*cosi practicato*) with him as I have been." This is directed against Vasari, and was not likely to pass without reply. Giorgio had himself made notes of a long conversation about art with Michelangelo, held in 1550, the *anno santo*, when they were riding round the seven churches. He never published them, but no doubt the fact that he intended to do so made Condivi even more of an interloper. The most particular point of disagreement hardly in fact concerned Michelangelo, but was about Domenico Ghirlandaio and his family. Ridolfo, Domenico's son, had been well known to Vasari, and had put various family papers at his disposal, including the contract made between Domenico and Michelangelo's father for his son's apprenticeship, and the receipt from the father for a payment made to the young apprentice. These in themselves, quoted in full by Vasari in the second edition, do not disprove Condivi's statement that Domenico became jealous of the young Michelangelo and tried to hinder him, just as he had sent his own brother (Benedetto) to France for fear of him as a rival. Condivi tells us he wrote this because Domenico's son was boasting of all that his father had done for Michelangelo, whereas he had done nothing, but he admits that the great man himself did not complain of this, and even praised Domenico both as an artist and a man. Vasari had told a very different story, and was ready to rebut these insinuations against the Ghirlandaio family. "Nor do I know anyone who was more in touch with Michelangelo [he uses Condivi's word *practicato*] than I was, or was more his friend and faithful servant, of which there is ample evidence: I do not think anyone can show a greater number of letters, written in his own hand, nor any more affectionate than those he sent to me." It seems a very minor storm, but it obviously roused strong feeling. "He had little luck," Vasari added in

[15] Frey, *Sammlung*, ii; also printed in Pecchiai, *Le vite*, iii, pp. 468–88.

1568, "with those who lived in the house with him. . . . Ascanio of Ripa-transone worked hard, but no result was seen of it in works or drawings, and he pounded away several years at a panel for which Michelangelo had given him a cartoon: in the end all the good expectations of him went up in smoke. I remember that Michelangelo became sorry for his difficulties, and helped him with his own hand; but it was of little avail. If he had had a responsive pupil, as he has many times said to me, he would, even though an old man, have made dissections for him." He did in fact do so for Ascanio: he obtained from his doctor, Realdo Colombo, the corpse of a Moor, a very fine young man. It was kept in Ascanio's lodging at S. Agata dei Goti, "as being a remote spot" (today it is immediately behind the Banca d'Italia) and Michelangelo showed him "many rare and recondite things." For the rest Ascanio made full use of Vasari's *Vita*, and Vasari in turn lifted from him some stories and personal details.

Not, however, all of them. Uncommitted to the Medici, Condivi can give a fuller account of Michelangelo's part in the siege of Florence, when "the house of Medici was driven out for having taken more authority than a free city can tolerate." Nor did Vasari use the touching section in which Ascanio defended his master from gibes about his relationship with Tommaso de' Cavalieri: "He loved the beauty of the body, as one who best knew it, and of this love some carnal men, who do not understand love of beauty unless it is lascivious and wanton, have taken cause to think and speak ill of him, as if the young and handsome Alcibiades had not been most chastely loved by Socrates. I have often heard Michelangelo reason and discuss about love, and I have heard afterwards from those who were present that he spoke of love not otherwise than Plato wrote of it. For my part I do not know what Plato said about it, but I know well, having long and intimately been with him, that I have never heard from his mouth anything but most honest words, which had the power of extinguishing in a young man any ill-ordered and loose desires." This was an aspect of the master about which Vasari had little understanding, and by 1568, with the Inquisition in Rome enforcing the death penalty for homosexuality, it was better left without any reference.

160. Michelangelo, *Night*. Florence, S. Lorenzo, Medici Chapel

"What can I say of the Night, a statue not rare but unique? Who is there who in the art of any century has ever seen ancient or modern statues made like this, showing not only the quiet of one who sleeps, but the grief and the melancholy of one who loses some great and noble thing?"

Giorgio had ample opportunities for studying his works. The two
unfinished Florentine tondos were, for instance, in the houses of Tad-
deo Taddei and of Luigi Guicciardini, to whom it had been given by
Vasari's friend, Fra Miniato Pitti. He particularly admired the *Pietà*
in St. Peter's: "it is a miracle that a once shapeless stone should pro-
duce a form that nature with difficulty produces in flesh"; the *Night*
[160], "showing the quiet of one who sleeps"; the Sistine ceiling with
"the stupendous rotundity of the contours, the grace and slenderness
of the nudes." "This work has indeed been the lantern which has
guided and given light to the art of painting, and has sufficed to illumi-
nate the world which for so many hundred years had been in darkness.
And in truth there is no need now for painters to seek out novelties
and inventions of attitudes, garments on the figures, new settings and
the *terribilità* depicted, for all the perfection that can be given to such
things is here most masterly displayed." But above all it is the *Last
Judgment* [161, 190] that rouses his panegyric. "When I saw it I was
thunderstruck. . . . Here can be seen thoughts and emotions that no
other than he has ever painted. . . . this is the great example sent by
God to men so that they can perceive what can be done when intellects

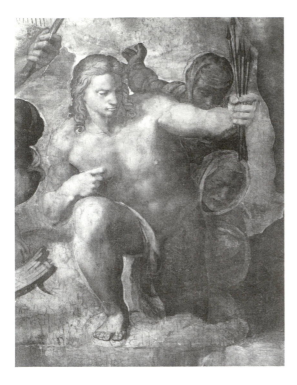

161. Michelangelo, *The Last Judgment* (detail). Vatican, Sistine Chapel

St. Sebastian, normally the benign protector against pestilence, here grasps his arrows in his muscular arm and with the other hand points threateningly to them. Justice has driven out compassion.

Opposite

162. Michelangelo, *Crucifixion of St. Peter* (detail). Vatican, Pauline Chapel

"Michelangelo concentrated solely on the perfection of the art, and therefore here there are neither landscapes, nor trees nor buildings, nor any of the varieties and beauties of the art, as though perhaps he did not wish to lower his great genius to such things. . . . He told me he had painted them with great fatigue, and indeed painting, past a certain age, and especially working in fresco, is not for old men."

of the highest grade descend upon the earth." What particularly impressed him was the unity of the vast scheme: "it looks as if it had been done in one"; the range and recognizability of the emotions expressed; the foreshortenings which seem in relief. This is the great canon of the final stage that art has reached.

The stark settings of the frescoes of the Pauline Chapel [162] "without landscapes or trees or buildings or any variety or charm (*vaghezze*) of art" seem to have been less easily appreciated by Vasari, who reflects that fresco is not an art for old men. To us they are the final maturity of Michelangelo's art, and to younger men in Rome, these large foreground groups against simplified backgrounds brought new ideas.[16]

With Raphael little space had been given to his architectural work (though there is an important list of his buildings);[17] with Michelangelo architecture naturally takes a large place. It was through him that Giorgio, when he was already forty, had begun to study it. In his closely packed career his mastery of architecture, in which he had had

[16] For a criticism of Vasari's views see P. Fehl, "Michelangelo's Crucifixion of St. Peter," *AB*, LIII, 1971, pp. 327–43.

[17] For Vasari's lack of attention to Raphael's architecture see J. Shearman in *Blunt, Studies . . . Presented to*, pp. 12–17.

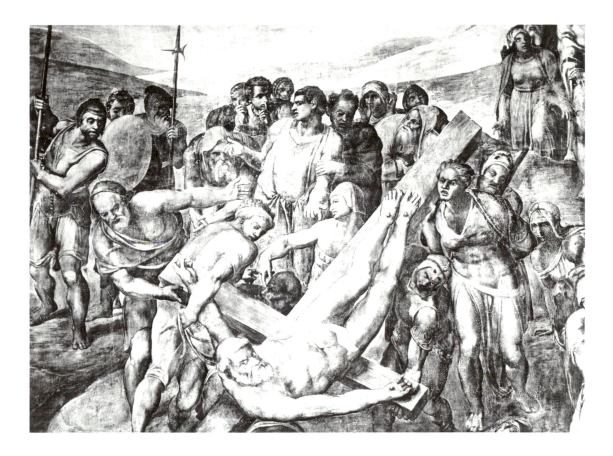

no previous training, is one of the most extraordinary facts. Vasari had of course thought and learned much about architectural practice in the writing of the *Lives*, but without Michelangelo's constant instruction and support the builder of the Uffizi and the Palazzo dei Cavalieri could never have had that technical mastery that he undoubtedly achieved. Regularly he submitted his plans to the "divino vecchio" for his advice, and it is natural that in Michelangelo's *Vita* much space is given to his architecture, and in particular to the problems of the dome of St. Peter's, which must have recalled to Giorgio his own studies of Brunelleschi's dome in Florence.

The admiration piles up, but even more than the artist the man emerges from Vasari's pages. Dedicated, difficult, conscious of his own worth and easily offended, tactless in his dealings with lesser men, particularly if they were pretentious in the arts, but ready also to enjoy the company of simple folk; devoted to his faithful servant Urbano; and at the same time happy in philosophic exchanges with Tommaso de' Cavalieri or Vittoria Colonna. Influenced in his youth

by Savonarola, he remained deeply religious, and he had an ascetic quality that scorned the comforts of easy life. He wrote to Giorgio, after some days spent in the mountains of Spoleto, that true peace can only be found in the woods. In his later years it was sometimes an unkempt squalor rather than asceticism. He had always been used to sleeping in his clothes, to save the trouble of dressing and undressing, and sometimes wore his dogskin boots for months without taking them off. Giorgio recalls how at night Michelangelo fixed a candle to his cap so as to see his work, and got him a supply of the special candles he liked to use. "I am all yours," Michelangelo wrote to Bartolomeo Ammanati in 1559, "blind, deaf, inept in hands and body."[18] He had, however, a ready and sometimes pungent sense of humor and Vasari records many sayings, some of them little likely to win friends, as when he said to Francia's handsome son: "your father knows how to make living figures better than painted ones." He and Pope Julius II were well matched, constantly in dispute, but obviously appreciating each other's vehemence. Amongst the jealousies and elbowing for position of the Vatican artists, Vasari's immense reliability and loyalty must have been a welcome standby, and there is genuine affection in the old man's letters to his pupil. If Giorgio at times brags too much about how well he knew him, it was not an unworthy subject for boasting; and in his last years it was Vasari who persuaded Cosimo to write to the pope to ensure that everything was done for him, to ensure also that on his death all his papers and drawings should be carefully inventoried. In those closing days Miniato Pitti had talked with Michelangelo in Rome, and he had spoken of Vasari's book, saying that in it he had worked alone for more than a thousand others. Then Michelangelo's mind went back to early days and he recalled how he had been taken on his father's shoulder, when Jacopo de' Pazzi had in April 1478 been dragged back a prisoner and hanged from a window of the Palazzo Vecchio among the imprecations of the mob, a scene of horror that must have deeply impressed the three-year-old child, and perhaps had long lived with him.

He died on 18 February 1564, aged eighty-nine, already a legendary figure, with the legend firmly enshrined in Vasari's book. Younger artists were beginning to think in different terms. The profound seriousness of the *Last Judgment*, that overpowering confrontation of man with his destiny, was being disfigured in the name of piety by ill-judged draperies. But few artists have been so little subject to the fluctuations in men's response to visual art.

[18] Ramsden, *Letters of Michelangelo*, ii, p. 186.

XI. Some Contemporaries

EVEN when a boy in Florence, Vasari seems to have been eager to talk of former artists and note down information about them. Benozzo Gozzoli (d. 1498) was "considered by those who knew him to be a man of very great invention and prolific in animals, perspective, landscapes and ornaments." He remembered talking to Andrea della Robbia, who died in 1525 not 1528 as Vasari has it, so that it must have been immediately after Giorgio came to Florence in 1524. Andrea told him that he had been one of those who carried Donatello's bier at his funeral, and "I remember how proudly the good old man (he was ninety) spoke of it." Another older man who seems to have told him much was Ridolfo Ghirlandaio, Domenico's son, and himself a distinguished painter. When Vasari came to Florence Ridolfo was in the early forties, but he lived on till 1561, and though confined to a chair by gout, he was always anxious to hear the latest art news, and if anything was greatly spoken of, he would have himself carried to see it. He had been a friend of Raphael's, who had entrusted him with the completion of one of his paintings (probably *La Belle Jardinière* in the Louvre). When he went to Rome, Raphael tried to persuade Ridolfo to follow him there; but nothing would take Ridolfo from Florence, and "out of sight of the cupola." It must have been through him that Vasari was able to use his father's writings, which he refers to in his final conclusion as one of the sources that had been of much assistance to him.

Of the two great figures of Florentine art in the twenties, Pontormo and Rosso, Vasari has much to say. The latter he came to know in Arezzo and Borgo S. Sepolcro after his flight from the Sack of Rome, and his tense, deeply emotional style had much influence on him. This was Rosso after his Roman sojourn, and above all after his contacts with Parmigianino and Perino del Vaga. With Perino he had worked on designs for engravings, the series of the *Loves of the Gods*, and from these contacts he was finding a new release into a style of serpentine, elegantly elongated figures posed with an inventiveness that seemed to make a break with old traditions. Mannerism is an awkward word, highly debatable and almost indispensable.[1] As with all such terms,

[1] J. Shearman, *Mannerism*, gives a brilliant discussion of the subject and a bibliographical note on recent literature.

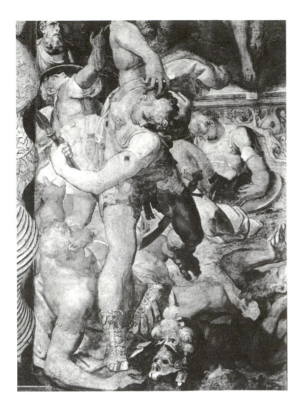

163. Marco Pino, *The Resurrection* (detail). Rome, Oratory of S. Lucia del Gonfalone

"It is said that Michelangelo once advised his disciple Marco of Siena to make his figures pyramidal, and serpentine . . . and that this is best shown in flames." (Lomazzo, *Trattato della pittura*, 1584, ed. 1884, I, pp. 33–34.)

Opposite

164. Pontormo, *Joseph in Egypt*. London, National Gallery

Vasari knew this painting in its original setting in a bedroom of the Palazzo Borgherini. The boy in the foreground is, he tells us, a portrait of Pontormo's pupil, the young Bronzino.

individual genius constantly eludes generalized definitions. Vasari had difficulty enough with his three broad stages of artistic development. The modern concept of Mannerism was of course unknown to him, and the break in continuity between the High Renaissance and the second quarter of the cinquecento was not apparent. For him, with some truth, Michelangelo's ceiling and *Last Judgment* were sufficient explanations of the artistic trends of his time. But in his own definition of contemporary art he defines much that the term Mannerism stands for: a freedom guided by rule but not dictated by it; a certain beauty in every smallest detail; a grace in the figures that exceeds exact measurement; charm of coloring; distance and variety in the landscapes.[2] What he failed to grasp was the stir and excitement of a movement that, consciously or unconsciously, was one of revolt against Renaissance theories of balanced design and decorous representation [163].

To the young Giorgio in 1524 Jacopo Pontormo, then thirty years old, was a man of established position, whose early works had been admired by both Raphael and Michelangelo. Amongst them Vasari signals out his panels of the *Life of Joseph*, painted for the famous room in Pier Francesco Borgherini's palace, that later was to be so

[2] Preface to third book, *M*, IV, p. 9.

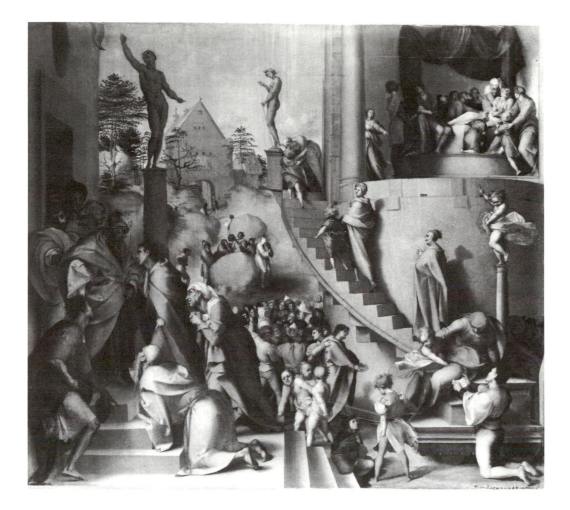

stoutly defended by his lady against the inroad of Battista della Palla. Here he was working along with del Sarto, Granacci and Bachiacca. Most of the other paintings seem to have been set into paneling or furniture, but the *Joseph in Egypt* [164], slightly larger than the others, hung on the wall. "If it were larger in scale [it is 38 by 43⅛ inches] I would venture to say that no picture could be seen done with such grace, perfection and goodness (*bontà*)." Vasari liked its variety of expression and placing of the figures, and it is indeed a strangely ingenious work. It is also full of mannerisms: the irrelevant statues; the curving staircase, so unlike that in one of del Sarto's Joseph scenes; the curious proportions of the figures, and the scattering of the incidents throughout the picture space.[3]

[3] C. Gould, *The Sixteenth Century Italian Schools*, National Gallery, London, 1962; R. Wischnitzer, "Pontormo's Joseph Scene," *Gazette des Beaux-Arts*, XLI, 1953, pp. 145–66; C. de Tolnay, "Les Fresques de Pontormo dans le choeur de San Lorenzo à Florence," *La Critica d'Arte*, XXXIII, 1950, pp. 38–52.

257

The *Joseph* was painted probably shortly after a Borgherini marriage in 1515. More contemporary with Vasari's own presence in Florence were the frescoes painted in the Certosa. In the *Joseph* there is already evidence of Pontormo's study of Northern prints, and the gabled gateway in the background is based on an engraving by Lucas van Leyden. In the Certosa frescoes Dürer is the source of borrowings and Vasari thought that too much use was made of him. "Did he not know that the Germans and Flemings came to these parts to learn the Italian manner?" The result he felt was a hardening of treatment, and a loss of earlier grace. In the S. Felicita *Deposition* Pontormo was still "thinking of new things, painting without shadows and clear, bright lights" and "one could see that his brain was always investigating new conceits and extravagant ways of doing things." His last work, the frescoes in S. Lorenzo, Vasari did not care for, and possibly was prejudiced against for there had been some talk of them being given to his friend, Francesco Salviati. Vasari could understand neither the iconography nor the riot of nude figures; he thought the whole scheme forced beyond nature, and an opinion on the frescoes better left to those who looked at them, which, as they were whitewashed over and destroyed, it is no longer possible to do.

Pontormo the man is one of Vasari's most vivid character studies, a shy, unbusinesslike recluse, often refusing good commissions and then giving his work away, suspicious of everyone when he was working, living in a house where his sleeping and work room could only be approached by a ladder that he drew up after him. "He was so afraid of death that he could never bear to hear it mentioned, and fled from having to see dead bodies. He never went to feasts or anywhere where people assembled, so as not to be caught in a crowd, and he was solitary beyond all belief."

Giorgio could not see that there was much harm in all this. Solitude he had always heard was good for study, and if men only worked when they wanted to, the loss was their concern. It was a time when the artist community had eccentrics enough. Old Piero di Cosimo had died as recently as 1521, "so strange and odd that nothing could be done with him"; Rosso took a great fancy to a baboon, and kept it in his house; Parmigianino devoted himself to alchemy and became almost crazy, wild and unkempt. Silvio Cosini (ca. 1495–ca. 1540), the man who made himself a jerkin out of the skin of a corpse, earns Vasari's understated comment of "capriccioso." The intensity of much Mannerist art had behind it some psychological unrest.[4] The generation that lived through the Italian wars, with the terrible climax of the Sack of Rome, were men acquainted with failure. Their younger

[4] R. and M. Wittkower, *Born under Saturn*, deals with many of the instances of eccentricity.

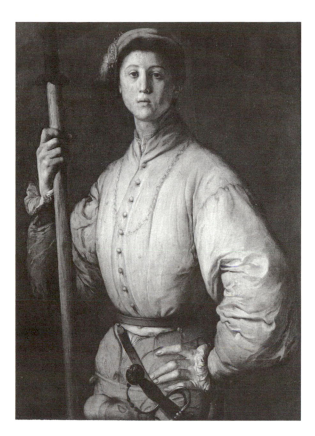

165. Pontormo, *Cosimo de' Medici*. New York, Collection Chauncey Stillman

This magnificent portrait, after much dispute, can be accepted as undoubtedly representing the young Cosimo about the time of his accession to power. It is also a brilliant evocation of the new generation of the thirties.

contemporaries, these haughty, brooding youths, cold and aloof, wearing the caps that had replaced the quattrocento hoods, their hair cut short, vividly portrayed by Pontormo [165], Bronzino and Salviati, were facing new issues, unsympathetic to the past.

One painting by Pontormo that Vasari knew well, for it was a prized possession of Vincenzo Borghini, was the *"Eleven" Thousand Martyrs*, or so Vasari calls it, adding an extra thousand to the already numerous holocaust. This terrible and popular theme was based on the account of a Roman legion accepting Christianity and being massacred on Mount Ararat.[5] It enjoyed much popularity in Florence. There was a very large quattrocento fresco of it in the Carmine, which Vasari attributes to Lorenzo di Bicci; it showed, he states, all the various ways of dying by violence, and many able men borrowed from it. Pontormo's work commissioned by the Ospedale degli Innocenti could not but be influenced by the cartoon of the same subject made by Perino del Vaga in Florence in 1522–23, when he fled there from the plague in Rome,

[5] H. S. Merritt, "The Legend of St. Achatus and the Martyrs of Ararat," *AB*, xlv, 1963, pp. 258–63; catalogue, *The Age of Vasari*, p. 83. Vasari is in some confusion about the legend, calling the emperor Diocletian, when he should be the Persian king, Sapor. Vasari much admired Carpaccio's version of the subject.

a cartoon that Giorgio certainly knew, for when the completion of the painting was abandoned it was left in the house of Giovanni del Piloto, who "willingly showed it to any artist." Vasari, who probably made a copy of it, has given a long and vivid description of "the prisoners kneeling before the tribunal, naked and bound in various ways, some showing the constancy of faith, others the fear of the torment of crucifixion, twisting themselves in their bonds. There can be seen the swelling of the muscles and even the cold sweat of death." The soldiers have "a terrible savagery" and their armor is richly modeled on the antique. In Perino's small preparatory sketch in the Albertina little of this detail can be appreciated, but the cartoon stirred Florence, and the artists thought that there had been nothing so fine since Michelangelo's battle scene. It brought to them all the intricacy and experimental skill of the Sala di Costantino, all the new poses and groupings that were being worked out from the example of Raphael's later work. It remains a centralized design [166]: the emperor points inward towards the scenes of execution; he is balanced by the figure of a soldier gesticulating on the opposite side. With Pontormo all this is changed [167]. The emperor sits off center in the pose of Michelangelo's *Giuliano de' Medici*, but the crowd of victims are driven downwards and outwards from the picture space, and the crucified martyrs are placed on the extreme edge of the upper right-hand corner. In the immediate foreground a tall soldier presents his back view in a twisted, Mannerist pose.

Perino returned to Rome to become a leading figure among the artists working there. Giulio Romano had gone to Mantua, Giovanni Francesco Penni, whose sister Perino had married, to Naples. Giovanni da Udine was still working in Rome, but the Raphael studio was scatter-

Opposite, above

166. Vasari, after Perino del Vaga, *The Ten Thousand Martyrs*. Cambridge (Mass.), Fogg Art Museum, Harvard University

Perino's cartoon was painted in Florence in 1522–23 and Vasari reports the enthusiasm that it caused. He nowhere states that he copied it, but this drawing is generally accepted as being by him and is a copy of Perino's *modello*, which is now in the Albertina. The cartoon itself no longer exists.

Opposite, below

167. Pontormo, *The Ten Thousand Martyrs*. Florence, Pitti Palace

Painted 1529–30: a copy in the Yale University Art Gallery suggests that the Pitti panel has been slightly reduced in size.

ing. Vasari admired Perino's work in S. Marcello, particularly his *Creation of Eve*, and the fresco of the *Visitation* in SS. Trinità dei Monti [168], but the Sack of Rome interrupted these undertakings. Perino was seized by the soldiery and had to pay a ransom, and to keep himself painted cheap works for the Spanish troops. For some ten years afterwards he was in Genoa and Pisa. In the former, the frescoing of the Palazzo Doria provided him with an opportunity of showing his great decorative gifts; motifs drawn from Raphael and Michelangelo are arranged in rhythmic patterns on the frontal plane, with little interest in the depth beyond, a surface pattern on the wall rather than an opening through it. Vasari was particularly impressed with the stucco decoration, and its use is one of Perino's major contributions to the art of his time. When, probably in 1538, he returned to Rome, his position as a great decorator was secure. Important commissions were entrusted to him, such as various rooms in the Castel S. Angelo, and the Sala Regia in the Vatican. He gathered round him a group of able young men, amongst them Daniele da Volterra, Marco Pino of Siena, and Pellegrino Tibaldi from Bologna. These were men eager to push their art beyond the concepts of their master, but till his death in 1547 Perino was the chief dispenser of artistic employment in Rome, and a somewhat jealous one. Giorgio has a long story of how Cardinal Farnese

168. Perino del Vaga, *The Visitation, and the Prophets Daniel and Isaiah*. Rome, SS. Trinità dei Monti

"Isaiah fixes his eyes on his book with one hand to his head, showing how a man is when he studies; Daniel raises his head to contemplate the heavens and unravel the doubts of his people."

had commissioned Aristotile da Sangallo to make a perspective in the courtyard of the Palazzo Cancelleria, and asked Perino and Giorgio to assess the right price to be paid. The former was angry that the work had not been given to him and began to criticize what Aristotile had done. Giorgio had to intervene, pointing out that Perino would only bring himself and all the artists into disrepute. "What would you, who do everything in Rome, think if men valued your work as you do that of others?" It is fair to say that despite what seems a rather ponderous rebuke, Perino took it in good part and a satisfactory settlement was reached. Giorgio thought he undertook too many commissions, leaving the assistants to carry them out from his designs, and then retouching, following Raphael's custom; and that he did not always know what to delegate and what to do himself. It is however arguable, looking at the Sala Paolina in Castel S. Angelo, that Perino knew when young blood and fresh vision must be allowed their chance and that the St. Michael that springs forward with a whirling violence that surely only Tibaldi can have given it is evidence of a great master's handling and encouragement of his pupils. "He was always very occupied, and had round him sculptors, plasterers, woodcarvers, tailors, joiners, painters, gilders and other artificers, and never had an hour of rest. For well-being and content, he found it in going sometimes to an inn with friends . . . saying that was the true blessing, the world's peace and repose from his labors . . . and so one evening talking to a neighbor, he fell down dead of an apoplexy at the age of forty-seven years." Vasari painted his portrait in the frieze of his Florentine house, one of the fourteen artists who were given a place there.

Giovanni da Udine was a very different character. Vasari recounts with enthusiasm how Giovanni and Raphael had seen some newly discovered grottoes near S. Pietro in Vincoli decorated with designs in stucco, which now were given the name grottesques, and how Giovanni experimented with various methods of producing a stucco of equal smoothness and whiteness. In this medium he was to become the supreme master of the Renaissance, and his beasts, birds and *putti*, clambering in garlands and arabesques were to remain unequaled. The cinquecento was only to see a steady coarsening in this much used and copied decoration. He had predecessors. The painter whom Vasari calls Morto da Feltre can with some confidence be identified as Pietro Luzzi (ca. 1474–ca. 1526). He was a pupil of Pinturicchio when the latter was frescoing the Borgia apartments in the Vatican, and "being a strange melancholy fellow" was always wandering about the ruins of Rome studying antiquities, and even going to Baia and Pozzuoli in search of them. Coming to Florence he made friends with Andrea Feltrini (1477–1548), and together they began to decorate in the style

of the ancient arabesques and to experiment with stenciling. What they began, Vasari says, Giovanni da Udine carried on. Morto, a restless being, went to Venice and worked with Giorgione, according to Ridolfi seducing Giorgione's mistress, and thereby breaking his heart; but of this romantic tale Vasari knew nothing and he brings Morto's career to an end fighting with the Venetian forces at Zara and killed in a skirmish. Giorgio knew Andrea Feltrini, who helped him with the decorations for Charles V's entry into Florence, and was a kindly man always good to students. In his last years he suffered from the malaise of the time and on several occasions tried to commit suicide.

To return, as Giorgio would say, to Giovanni da Udine. Having suffered much in the Sack of Rome, he went back to his native Udine, but from 1532 to 1534 he was in Florence, where presumably Giorgio first knew him. Once more in Udine, a worthless son brought troubles on him. He came incognito as a pilgrim to Rome in the jubilee year of 1550, and Vasari going with Bindo Altoviti for the pardon at S. Paolo, recognized him in the crowd, and later succeeded in getting a papal pension restored to him through the intervention of Duke Cosimo. He emerges in Vasari's account as a likable, simple man, a great archer who enjoyed the country and returned laden with game. At Udine a grimmer and certainly apocryphal legend attributed to him the shot that killed the Constable de Bourbon, but Vasari makes no mention of this tale, which he would certainly have recounted had he believed it.

Giulio Romano he only knew in the course of a four days' visit to Mantua in 1541, but "they met one another as though they had been together a thousand times," and Giulio showed Giorgio all his works, particularly his drawings of antique buildings and a great cupboard full of plans for architecture in Mantua. When the cardinal-regent asked Giorgio in Giulio's presence what he thought of Giulio's work, the reply was that he ought to have a statue at every corner of the town. Vasari writes of Giulio's pupilage with Raphael, and gives a long account of the frescoing of the Sala di Costantino. Amongst the portraits in the *Baptism of Constantine* he particularly singles out that of his old Florentine friend, Niccolò Vespucci. In the first edition he opened with a long encomium, largely based on a very fulsome letter from Pietro Aretino trying to persuade Giulio to leave Mantua and come to Venice. This is omitted in the second edition. It was a long time since the Mantuan visit, and violence and turmoil were less fashionable than they had been. But Giulio in his *Vita* is a lifelike character, "neither tall nor short, spare rather than stout, dark-skinned, handsome, with black eyes, and lively, most agreeable manners, frugal in eating, and fine in his dress and deportment." They only met this

once, for Giulio died in 1546, before Vasari was again in the north, but his personality made a deep impression; apart from his charm he was a master to whom Vasari owed much, for the Sala di Costantino with its great narrative scenes set in an architectural framework, and its friezelike battle, was an example that had a most powerful influence on a phase of his own art. In the Sala dei Giganti in the Palazzo del Tè he notes: "a marvelous feature is that the painting has neither beginning nor end, but is continuous without boundaries or ornamental divisions." The fame of this claustrophobic horror chamber [85] was great, though in Mantua far less influential than it would have been in Rome, and it was much talked of. Vasari could wonder at the accomplishment of such a tour de force, but excesses of the kind were not for him, any more than Giulio's chiaroscuro, and could not be allowed, except perhaps very fleetingly, to disturb the decorum of his approach.

A man who played a large part in Vasari's life was the Florentine sculptor, Baccio Bandinelli. Born in 1493 and living till 1560, he was in the affairs of Cosimo's court a constantly disturbing figure. Passionately jealous of Michelangelo and a devoted pupil of Leonardo, he is said by Vasari, with confusion as to the date, to have been responsible for the destruction of Michelangelo's cartoon of the *Battle of Cascina*; but no one else, not even Cellini who misses no opportunity to jeer at Bandinelli, confirms this accusation. He was generally held, as Vasari writes of him, a jealous and malignant man. Three incidents of his stormy career were of particular interest to Giorgio, all centering on the Piazza della Signoria in Florence. First there were the prolonged disputes with Michelangelo over the use of a great block of marble, which eventually became Bandinelli's *Hercules and Cacus*, balancing Michelangelo's *David*, with little advantage to itself, and the subject of much mockery when in 1533 it was erected. The second was the alterations made in the great hall of the Palazzo Vecchio, many of which were changed by Vasari when he raised the height of the roof, but he never ceased to regret Bandinelli's failure to make the audience dais at the end of the hall a true rectangle. "It was," he wrote, "necessary to correct many errors," but this basic miscalculation had to be left. Finally there was the dispute over the fountain of Neptune in the Piazza. Bandinelli had an ally in the Duchess Eleonora, that much-admired lady. Vasari had in 1555 brought to Florence Bartolomeo Ammanati, who had been working with him in Rome, and now used his influence to secure the commission for his friend (friend rather than pupil, for they were exactly of an age). What might have been the outcome was still uncertain when Bandinelli died in 1560,

and a further dispute, this time with Cellini, held up the project, which at the time of the second edition was not yet finished. The *Neptune* is Ammanati's work, the bronze figures are mainly by assistants.[6] Vasari comments harshly on Bandinelli. "He was always speaking ill of and running down other people, and this was the reason that none could bear him, and when they could they got their own back on him with interest." But his drawing, where he showed to best advantage, was such that it atoned for his other defects. Vasari and Salviati as boys had both been in Bandinelli's *bottega* and he speaks gratefully of what he had learned there.

If Bandinelli, first his master and then often his opponent, was one of the problems when Vasari returned to Florence in 1554, Agnolo Bronzino was a welcoming ally. Born in 1502, he was nine years older than Giorgio, who remembered him as Pontormo's devoted pupil, the boy with a basket shown seated on the step in the foreground of *Joseph in Egypt* [164]. "We have been," Giorgio wrote, "bound together in the closest friendship for forty-three years." He could not hope to rival Bronzino as a portrait painter. There his position was well established, and Giorgio assures us that the likenesses were good. This was something to which he attached importance. "Many excellent masters have made portraits of great perfection as works of art, but not like enough to him for whom they are made, and to speak the truth who makes portraits ought to try and make them like without considering what a perfect figure requires. When they are both like and beautiful, then they are indeed rare works, and their artists most excellent."[7] Thus we may take it that Bronzino has left us the Medici family and their court as they appeared [34, 35], stiff in their elaborate clothes, poised, reserved, with the sad beauty of the Duchess Eleonora and the occasional chuckling liveliness of some of the children. His altarpieces and frescoes were in the Florentine manner of the day and shared with Vasari's own tradition the faults of overcrowded designs and excessive muscular emphasis [169, 170]. Bronzino was, Vasari writes in his section on the Academy of Design which he appended to his second edition, "truly a most rare artist worthy of all praise." At that time he was sixty-five years old and was to die five years later.

[6] For Bandinelli see D. Heikamp in *Paragone*, XVII, 1966, no. 191, pp. 51–62 and his edition of Vasari's *Vita*, Club del Libro, Milan, 1964. For the fountain see Pope-Hennessy, *Italian High Renaissance and Baroque Sculpture*, pp. 374–76.

[7] *M*, IV, p. 463.

169. Bronzino, *The Resurrection*. Florence, SS. Annunziata
 Painted in 1552, it received unfavorable notice from Raffaele Borghini as a "lascivious" piece.

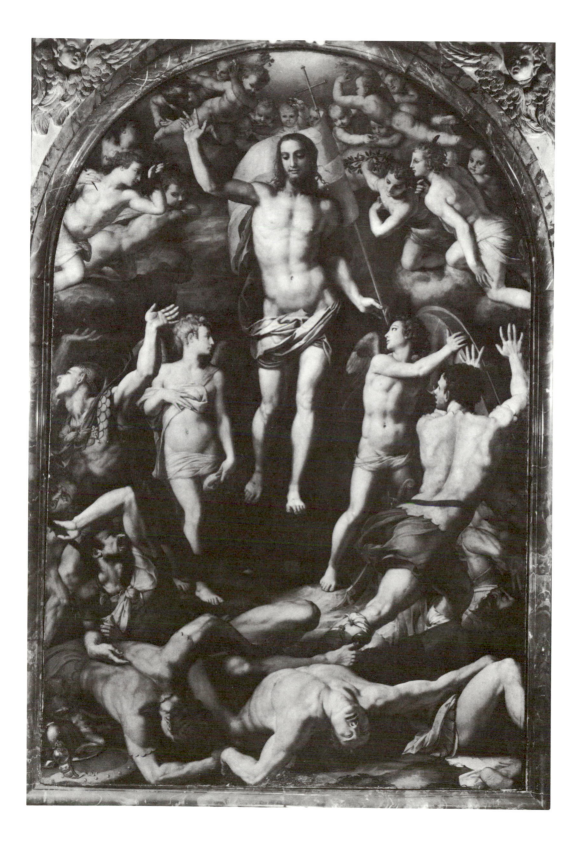

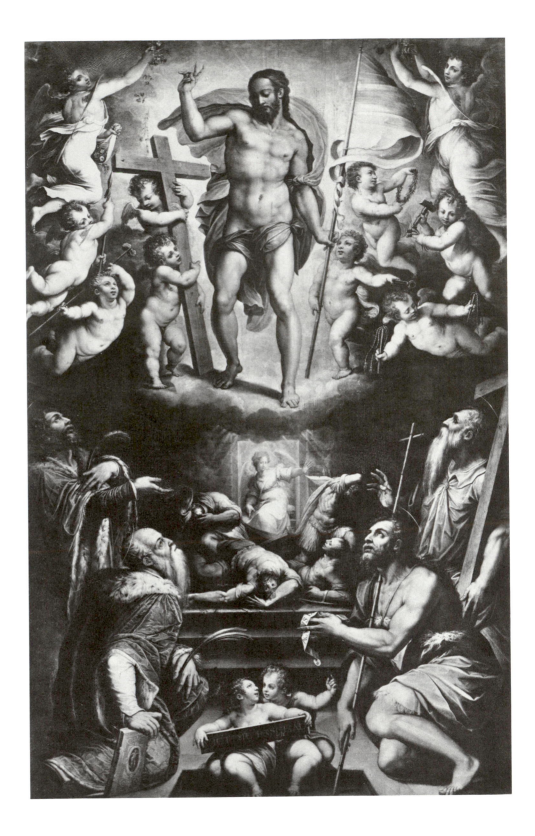

"I weep bitterly for him," Giorgio wrote in a letter to Borghini, "and God help the younger generation that our art become not extinct. . . . Here there are no new men coming on, nobody is willing to go through the drudgery of learning." It is the complaint, constant at all times, of the old about the young.

Very different in their shared interests was Vasari's friendship with Niccolò de' Pericoli, known as Tribolo, because as a boy he "was a very devil at school and always made trouble (*tribalava*) for himself and others."[8] Trained by Jacopo Sansovino, who recognized his skill, he won the favor of the Medici by making during the siege of 1529 a model of Florence, going out at night with considerable peril to himself to complete his survey, and smuggling it out to the papal army that was besieging the city. Clement VII remembered this and named him as one of the sculptors to be employed on the shrine for the Virgin's House at Loreto, a scheme dear to the pope's heart. Clement's interests, however, shifted back to Florence, and Tribolo was sent there to aid Michelangelo in completing the work at S. Lorenzo. One wonders if Michelangelo, who had supervised the defenses in the siege, knew about Tribolo's somewhat ambiguous relations with the attackers.

Art, however, it is clear came before politics, and these craftsmen seem curiously little interested in the schemes of their patrons, as were the latter in the politics of their artists. Michelangelo was in some danger after the siege, but Clement "remembered his genius and sought diligently for him." Tribolo in fact fell ill on returning to Florence, and when he recovered, Clement was dead, Michelangelo summoned back to Rome and the schemes for S. Lorenzo once more in abeyance. Vasari, who had known both Tribolo and his father when he was a boy in Florence, worked with him on the decorations for the marriage of Alessandro with Margaret of Austria, and, when Tribolo went to work in Bologna, urged the duke to recall him. These plans were, however, brought to nothing by the duke's assassination. Under Duke Cosimo Tribolo quickly acquired a considerable position, and at the time of the celebrations for the baptism of Francesco, the duke's

[8] B. H. Wiles in *AB*, XIV, 1932, pp. 59–70; L. Châtelet-Lange in *AB*, L, 1968, pp. 51–58.

170. Vasari, *The Resurrection*. Florence, S. Maria Novella

Painted in 1568 and commissioned by Andrea Pasquali, Cosimo's doctor. Borghini in *Il Reposo* criticized Vasari's departure from the biblical narrative in representing four apostles as onlookers.

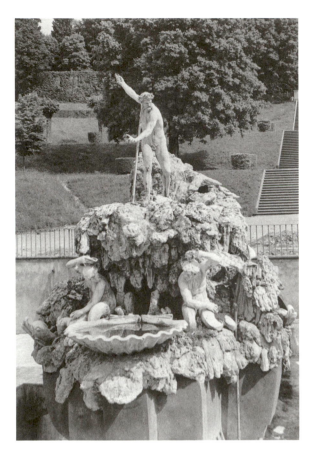

171. Stoldo Lorenzi, Fountain of Neptune. Florence, Boboli Gardens

Lorenzi worked under Vasari on the fountains at Castello after Tribolo's death, and on statuary in the Boboli gardens. His Neptune was based on a design made for the marriage festivities of Prince Francesco in 1565.

eldest son, in 1541 was in turn able to help Giorgio, who came briefly from Bologna to Florence to see about installing the *Immaculate Conception* [20] in the Altoviti chapel in SS. Apostoli. Tasso was in charge of the proceedings for the *festa*, and he and his lively followers were suspicious of the sober, industrious Aretine. Tribolo, however, gave him a large grisaille of the *Baptism* [124] to screen one of the chapels of the Baptistery. It was an urgent job, and the leading Florentine artists, Pontormo, Ridolfo Ghirlandaio and Bronzino, had turned it down as not possible in the time. It was characteristic of Vasari's application that, in the given six days, he was able to carry it through.[9] More and more it was as a surveyor and organizer that Tribolo came to the fore, and in particular he designed the gardens at the Medici villa of Castello and the Boboli gardens at the Pitti Palace. Vasari was to complete his work at both places [171], and in the *Vita* of Tribolo he gives a long and detailed account of the problems and solutions at Castello, based on his own careful research when

[9] There are sketches for the *Baptism* in the British Museum and the National Museum at Stockholm; see Barocchi, *Vasari pittore*, p. 125.

he took over. It is a striking example of the thoroughness with which he entered into a new activity and mastered its complexities. Tribolo's fountains for Castello, one now transferred to the Villa Petraia, were partially the work of Bartolomeo Ammanati and Giovanni Bologna, the two sculptors now so much in demand. Tribolo's later days were clouded by the cares of an unenviable task, the supervision of the banks of the Arno, and because of flood "there was great clamor against him." Vasari, who regarded Tribolo regretfully as one of those who took on tasks and did not finish them, went to see his old friend when he was sick of a fever, urging him, probably a little irritatingly, to let the river alone and go back to the garden at Castello. But it was too late for advice. Tribolo died in 1550, aged sixty-five as Vasari inconsistently states, having already given the date of his birth as 1500.

In some ways the strangest of all his friends was Fra Giovanni Montorsoli. Born in 1507, he was trained in the stone quarries at Fiesole. He soon began his wandering life, Rome, Perugia, Volterra, back to Florence. Then at the time of the driving out of the Medici and the siege, "seeing the world was upside down, he decided to look to the peace and quiet of his soul and become a monk." He went to the Camaldolines, but "not being able to endure the discomfort, fasts and general abstinence," did not stay. For a time he was with the Franciscans at La Verna, then with the Gesuati outside Florence and ended up in 1532 as a priest in the Servite order at SS. Annunziata in Florence, where he gave much satisfaction by replacing the waxen statues of Leo X, Clement VII and other Medici destroyed in the riots of 1527. Pope Clement on Michelangelo's suggestion summoned him to Rome, where one of his first tasks was to restore the left arm of the *Apollo Belvedere* and the right arm of the *Laocoön*. Then on Cardinal Ippolito de' Medici's recommendation he went to Paris, but finding his pay there soon in arrears he returned to Italy, traveling by Genoa, Venice, Padua, Verona and Mantua. He was in Florence working on the *apparato* for the entry of Charles V in 1535, but was soon off to Naples. Returning to Florence, he found that he was out of favor with the duke's major-domo, Pier Francesco Riccio, a supporter of Bandinelli. Tribolo tried to help him but unsuccessfully, and for the next twenty years the friar was working in Genoa and in Messina. His two great groups of fountain statuary in the latter place were both much damaged in the earthquake of 1908, but have been restored. Vasari describes them at length, presumably having the particulars from Montorsoli, for he himself had never seen them. Then in 1557, the severe Caraffa pope, Paul IV, ordered all friars to return to houses of their order, and Montorsoli, having made provision from his considerable fortune for his relatives, rejoined his brotherhood at SS. Annunziata in 1561 as "the most convenient place of his order in which to

spend his declining years." Vasari suggests that one reason for this was that both the unpopular Francesco Riccio and Bandinelli were dead, but this seems in the former case a little premature. Riccio had long been ill, "mad for many years," Vasari says, but did not die till 1564 from a fall from his horse. He had been, however, out of action for some time. Bandinelli had died on 6 February 1560. Vasari cannot take this peripatetic friar entirely seriously. His career, he says, could hardly suggest that men enter religion to avoid fending for themselves, and there is a humorous though very kindly tone in all his account of him. But Montorsoli's great act came at the end. He set up a memorial in the chapter house at SS. Annunziata, renamed the chapel of St. Luke [172, 173], and endowed a Mass to be said there on Trinity Sunday for the souls of all painters, sculptors and architects. The first festival was held in 1562, and to celebrate it Pontormo's remains were taken from the cloister, carried in torchlight procession round the square—how much he would have disliked it—and buried by the new shrine in the chapter house. Montorsoli had already been discussing with Giorgio the possibility of reviving the Compagnia del Disegno founded in the 1350s, but now lapsed into inactivity. It was agreed that it

172. Chapel of St. Luke, SS. Annunziata, Florence

The stucco statues, emerging from their niches, are by Montorsoli, Vincenzo Danti and others of the Academy of Design. The altarpiece on the left is by Pontormo, that in the center by Vasari.

173. Vasari, *St. Luke Painting the Virgin*. Florence, SS. Annunziata, Chapel of St. Luke

Vasari represents himself as the painter. To do so, in the chapel of the Academy, certainly shows no undue humility. His box of paints, palette and maulstick are interesting details.

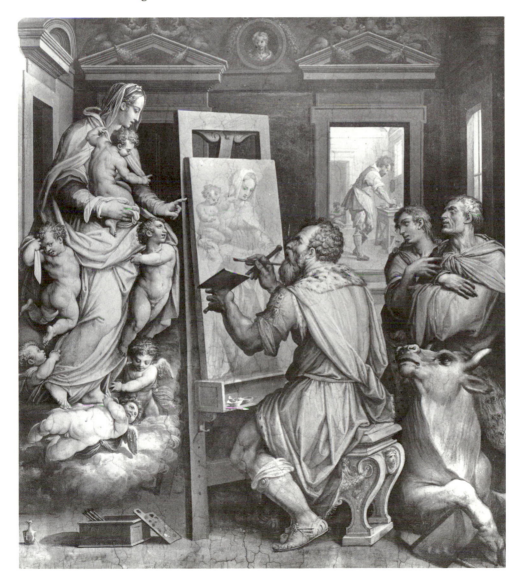

should be refounded as the Academy of Design. Forty-eight of the leading Florentine artists met to discuss the plan and form a committee to draw up rules. Giorgio was sent to secure the patronage of Cosimo, who appointed Borghini as his deputy. But Montorsoli did not live to see his scheme in full action. He died on 31 August 1563. The following day Giorgio wrote to the duke: "he will find in Paradise Giotto and Donato and all our other artists."[10]

With Siena Vasari's ties were less close. His chief contact there was with the goldsmith, Giuliano di Niccolò Morelli, the man who lent him Cennino Cennini's treatise on painting. He never made a long stay there, but it was on the direct route from Florence to Rome and he must several times have passed through it, probably spending a night in doing so. He refers to one such passing visit when Baldassare Peruzzi took him to see Beccafumi's *St. Michael* in the church of the Carmine, which he, Baldassare, could never praise enough. This was commendation from a man who held a very established position. Peruzzi, Vasari's senior by thirty years, was deeply respected for his work in Rome, ranging from the apse of S. Onofrio, with its paintings still recalling the quattrocento, to the Farnesina, of which he was the architect, and its amazing perspective frescoes [174], so much admired by Titian. He had suffered much in the Sack of Rome, for the soldiers thought this grave and dignified man must be some great prelate in disguise. He had reached his native Siena in nothing but his shirt. It was in the period between the Sack and Peruzzi's return in 1535 to Rome that Vasari must have met him in Siena, but he knew well his work in Rome and his penetrating account of Peruzzi's interests must owe something to conversation with him. He selects as displaying his powers to the full the *Presentation of the Virgin* in S. Maria della Pace [175]. This extraordinary painting carried out in 1516–17 shows a group of foreground figures detached from the main incident, which takes place in the background to the right. The central foreground figure, to emphasize his unawareness of what is happening, is reading a book. The whole is set in an architectural perspective including an Ionic portico, an obelisk and a three-storeyed tower. Earlier, in 1513, Baldassare had designed the sets for a performance of Cardinal Bibbiena's comedy *La Calandra*. "It was impossible to imagine how in such a narrow space he accommodated so many streets, so many palaces, such strange temples, loggias and overhanging cornices, so that they all appeared not feigned but real and the piazza not a thing painted and small, but real and very large. . . . This manner of spectacle in my opinion, when it has all its appurtenances, surpasses any

10 There is a full account of the earlier Compagnia del Disegno in the *Life* of Jacopo del Casentino; *M*, I, pp. 673–75.

174. Peruzzi, *Perspective View* (detail). Rome, Farnesina

Painted in the period 1508 to 1511, these false perspectives are still highly convincing. Vasari recalls how Titian could hardly believe they were not real window openings.

Below

175. Peruzzi, *Presentation of the Virgin*. Rome, S. Maria della Pace

"Above all he showed how much he could do in painting and perspective, where he made the story of Our Lady ascending the steps of the Temple, with many praiseworthy figures."

176. Beccafumi, *Fall of the Rebel Angels*. Siena, Pinacoteca

"Being full of fancies and wishing to show his *virtù* and the fine ideas of his mind, . . . he began a shower of nude figures, well done although, being much labored over, it appears somewhat confused."

other in magnificence and sumptuousness." Here Vasari is rightly noting a new influence in the arts, that of the sets for dramatic presentations. These, with their elaborately feigned vistas, never quite in scale with the actors in the foreground, were to exercise a powerful fascination on Roman artists for some time to come, and through the writings of Sebastiano Serlio, who inherited many of Peruzzi's papers, were to be widely imitated in France as well as Italy.

Domenico di Giacomo di Pace, called Beccafumi, was better known to Vasari, as they met not only in Siena but in Pisa where Beccafumi did three paintings for the Duomo. Vasari had, in discussing his *Fall of the Rebel Angels* [176], today in the Siena Pinacoteca, thought him a man of new ideas. He still thought the nudes, now less Mannerist in their elongation, fine in the Pisan paintings of *Moses*, though he is less happy with the *Coronation of the Virgin*. He writes in great detail of the themes, drawn from Roman history, of his Sienese frescoes, and comments on his skill with firelight. He is a marked contrast to the "bestial, licentious and fantastic" Sodoma. Giorgio sums him up as a God-fearing, hard-working, shy man.

Of Sebastiano del Piombo in his sixties, entertaining friends at his pleasant house near Popolo, Vasari gives a lively account, but he could never forgive Fra Sebastiano for holding the much prized office of the Piombo and using it as an excuse for idleness. He reports him as saying that there were so many painters, it was as well that some of them did nothing. He does not seem to have known him well, but he recalls one conversation with him when Sebastiano said that if Titian had gone to Rome and studied Michelangelo, Raphael and the antique, he could have overtaken them all. There spoke the Romanized Venetian that was Sebastiano himself.

It is probable that Vasari met Titian first in Bologna, in the winter of 1529–30, when the coronation of Charles V by Clement VII in S. Petronio brought artists from all over Italy seeking a part in the preparation of the great *apparato*, and when the festivities seemed the opening of a new era, in which the horrors of the Sack of Rome might be forgotten. Vasari has a tale about Alfonso Lombardi and Titian both making pictures of Charles, but documents for payments suggest that this happened two years later. If they did meet in Bologna, it would have been the encounter of a young, unknown man with an artist of already established celebrity. Vasari certainly writes of him to Aretino as though he knew him: "Tell him I adore him," he says in one letter, but it was probably not till his Venetian visit (December 1541 to September 1542) that he really became acquainted with him. Titian took over a commission for the ceiling of S. Spirito in Isola (now in the sacristy of the Salute) which had been first offered to Vasari,[11] and in which Titian shows himself influenced, possibly by Vasari, more likely by Giulio Romano, in the new foreshortenings by which figures seem to rise through the ceiling. When in 1545 Titian at last visited Rome, the pope particularly assigned Vasari to be his guide, and he was present at the famous meeting between Titian and Michelangelo when they saw him at work on the *Danaë* now at Naples [177]. They praised it much "as is done in the presence of the artist," but afterwards Michelangelo said that it was a pity that at Venice they did not study drawing from the beginning, for if he was aided by art and drawing as he was by nature, particularly in counterfeiting life, no one could surpass him. Titian then went on to Florence, visiting Cosimo at Poggio a Caiano and offering to paint his portrait, but the duke declined, "perhaps not to do wrong to so many noble artists of his own city and dominion." Again in 1566 when Vasari was once more in

[11] Vasari states in the "Works of Titian" that Sansovino had obtained from him three designs for the ceiling: there is no note of this in Vasari's *Ricordanze* nor is it mentioned in his "Description of the Works of Giorgio Vasari." Possibly more is made of the proposal than the negotiations warranted. It was in keeping with Giorgio's self-esteem to suggest that Titian was a second choice.

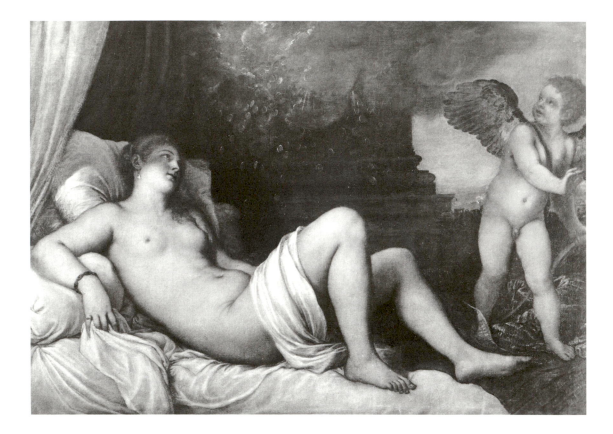

Venice he "visited Titian as his friend, and found him, old as he was, engaged in painting"; in a previous paragraph Vasari tells us that he was seventy-six, though at the beginning of the *Life* he states he was born in 1480. No one, including Titian himself who in one letter implies that he was born in 1477, seems to have been sure about his age, and Vasari is the last person to be relied on in such a question. When ten years later in 1576 Titian died, he was at least in his later eighties, and no doubt he and his friends and followers marveling at his longevity were quite ready to add some years to it.

Vasari's opinion of his art had certain reservations. Here was the Venetian sense of coloring that he recognized in all their paintings, but it seemed to him as to Michelangelo that it concealed a certain inability to draw. The *Death of St. Peter Martyr* with its strongly poised figures was to him, as it was to be to so many others until its loss by fire in 1867, the "most complete, celebrated and best conceived and executed of all his works." The portraits he admired greatly, not perhaps without a certain envy of Titian's distinguished clientèle. "There is scarcely a prince or a great lady but has been portrayed by

278

177. Titian, *Danaë*. Naples, Capodimonte
"Buonarroti much commended it, saying that the color and the manner pleased him, but that it was regrettable that at Venice they did not from the beginning learn to draw well."

him." But Titian's later style presented, as we have seen, real problems to any Tuscan artist. The broad brush strokes and blotches of color, appearing perfect at a distance, were, Vasari knew, the result of long and careful work: others might copy this facility and make sad blunders of it, but with Titian it was the considered plan of a great master. It is to Vasari's credit that he could both analyze and appreciate an art that was so different from anything he had known.

Jacopo Sansovino was another Venetian friend, though by birth a Tuscan. It was only after the Sack of Rome that he went to Venice, where he established his reputation by restorations to the central dome of St. Mark's. Vasari praised both his architecture and his sculpture, and gives a detailed account of all the new buildings and replanning of streets that he carried out in Venice. "With his knowledge and judgment he has as it were renewed that city." Vasari admired his handsome appearance, his vigorous old age and his sociable way of life. His memory for the past was very vivid, and he would recount many things, both prosperous and disastrous, of his life's story. No doubt in Giorgio he found a ready listener.[12]

Michele Sanmichele, busied with his fortifications, was a different character, not without gaiety, but deeply religious and punctual in his observances. He it was who obtained for Vasari the commission to paint the ceiling in the Corner Spinelli Palace. When Giorgio left Venice he asked him to take fifty gold crowns to a woman in Montefiascone whom he had loved in his youth, and who claimed, he thought wrongly, that he was the father of her daughter. "When Giorgio on his way to Rome came to Montefiascone, the good woman freely confessed that the girl was not Michele's child, but Vasari gave her the fifty crowns, worth as much to her as would be five hundred."

Few careers of the time can have been stranger than that of Giulio Clovio or Glovichsich, "the Michelangelo of little things," who came to Italy in 1516 as a boy of eighteen and was in the service of the great Venetian patron and collector, Cardinal Marino Grimani. In 1524 he returned to Hungary, only to be driven from it when the Turk-

[12] A second edition of Sansovino's life, taking it up to his death in 1570, was published after that date as from the edition of 1568, but enlarged and revised by Giorgio Vasari. There seems no reason to doubt this statement from the title page, which has no date or place of issue.

279

ish victory at Mohacs in 1526 overthrew the Hungarian kingdom. Escaping from these dangers, the poor man reached Rome to become a Spanish prisoner. "In such miseries, he had recourse to divine aid, and made a vow if he escaped from the terrors of this ruin and the hands of these new Pharisees to become a friar." This he duly did, taking in religion the name of Giulio, from Giulio Romano who had earlier befriended him in Rome. For three years he remained with his brotherhood, but then had trouble with a broken leg, which did not mend "possibly from wrong treatment, for the friars are often as wrong as the doctors." Hearing of this, Cardinal Grimani persuaded the pope to release him from his vows and once more took him into his service. The ease with which artists could make such transitions is a reflection of the ecclesiastical laxity and tolerance of the first half of the century; the second half was to see very different views in the ascendant. Back in Rome Cardinal Alessandro Farnese employed him, and it was then that Giorgio must have made his acquaintance. In later years there was talk of him going to the Medicean court, it seems at Vasari's suggestion, but in the end he stayed on in his room in the Palazzo Farnese, where Vasari saw him "an old man . . . still always working on something, and ready most courteously to show his works to any visitor who wishes to see them among the other marvels of Rome." It would be interesting to know whether Giorgio met the young Cretan pupil of Titian about whom Clovio wrote to Cardinal Farnese in November 1570. He was to be Clovio's pupil for a time and to become famous under the name of El Greco.

Of all Giorgio's friends, the oldest and closest was Francesco Rossi, known as Salviati [178, 179] from the cardinal of that name, who was his first patron. Like old friends, they spoke their minds freely, and in later life Giorgio was prodigal of advice to the difficult temperamental man, who was always throwing up commissions and alienating his patrons. They were of an age, Francesco or Cecchino as he is commonly called, though not by Giorgio, being born in 1510 and therefore one year the senior. In 1531 when Salviati was already established in rooms in the Borgo Vecchio in Rome with a monthly salary, Vasari was sent to Cardinal Salviati with a recommendation from Ippolito de' Medici. He found Cecchino worried about an unknown young artist who was expected, and there seems to have been some embarrassment when he realized that this was Giorgio. But any coolness was not lasting and they busied themselves in Rome, "leaving nothing of importance which they did not copy." They also did "some anatomy in the cemetery," a somewhat sinister phrase, which recalls Vasari's account of Rosso disinterring the dead in the Vescovado at Borgo S. Sepolcro. As a result of all these activities they both became ill, and Giorgio withdrew to Arezzo. Cecchino stayed on in Rome, painting in

178. Salviati, *Self-portrait*. Florence, Uffizi
 "Though by nature irresolute, suspicious and solitary, he did no harm to any but himself."

Right

179. Vasari, Portrait of Salviati in the second edition of the *Lives*

FRANCESCO SALVIATI
PIT. FIORENTINO.

180. Salviati, *The Visitation*. Rome, Oratory of S. Giovanni Decollato

the chapel of the Salviati palace, in S. Maria della Pace, and in 1538 receiving the commission for a fresco of the *Visitation* in the oratory of S. Giovanni Decollato [180].[13]

The Arciconfraternità della Misericordia to which the oratory belonged was a Florentine foundation, constituted to aid condemned criminals on their way to execution. Their small museum still retains the crosses they held before the victims and some more grisly relics. Vasari knew the confraternity well as in 1553 he painted the *Decapitation of the Baptist* for the high altar of their church [181]; Michelangelo was one of their members, and Bartolommeo Bussotto, who financed some of the work, was a friend and correspondent of Vasari's.[14] Jacopo del Conte,[15] another Florentine and like Vasari and Salviati a one-time pupil of Andrea del Sarto, had already been painting in the oratory, and others to work there shortly after were Pirro Ligorio, who as architect of St. Peter's was to harass the aging Michelangelo, and Battista Franco, a Venetian by origin, who had stepped into Vasari's place in Florence, when the latter left after the murder of Duke Alessandro.

[13] See M. Hirst, *ZfK*, xxvi, 1963, pp. 146–65, *BM*, c111, 1961, pp. 236–40, and *Blunt, Studies . . . Presented to*, pp. 34–36.
[14] Frey i, p. 340.
[15] F. Zeri in *Proporzioni*, ii, 1948, pp. 180–83; J. von Henneberg, *AB*, xlix, 1967, pp. 140–42.

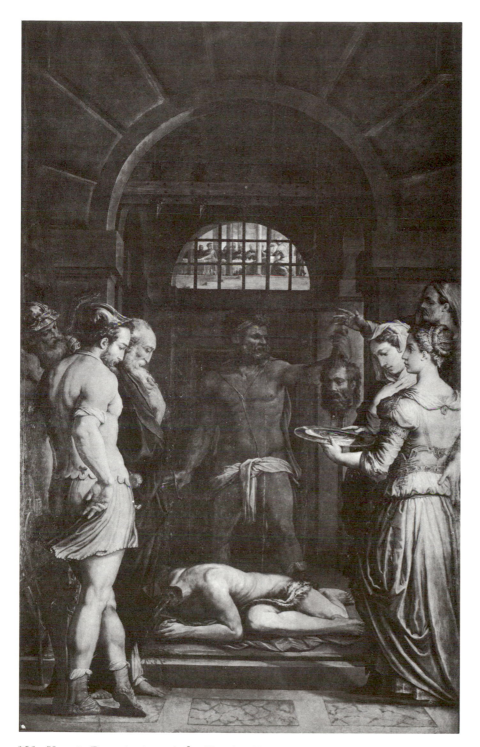

181. Vasari, *Decapitation of the Baptist*. Rome,
Oratory of S. Giovanni Decollato

Painted in 1553, Vasari describes it as "different enough from the others
that are commonly made."

It is therefore hardly surprising that Vasari spends some time over the oratory, still today one of the most evocative rooms for Romano-Tuscan painting of the period. For Salviati's fresco [181] he has the highest praise, "amongst the most graceful and best accorded (*intese*) of all his works, notable for its invention, the composition of the story, the regular observation of the diminution of the figures, the perspective and architecture of the setting, the nudes, the clothed, the grace of the heads and in sum all the parts. It is little wonder that all Rome was struck with admiration." Vasari liked also the painted setting, in feigned marble.

Jacopo del Conte painted frescoes in the oratory and also a *Deposition* as the main altarpiece [182], a picture that Vasari much admired. Jacopo's work as a young man had aroused great expectations, but he turned mainly to portraiture, and according to Vasari, painted almost everyone. Comparatively few of his portraits, however, have been identified. In his later years, he was much influenced by Ignatius Loyola. He was also one of the detractors of Michelangelo over the plans for St. Peter's; "a worthless *contadino* rascal," the great man called him, "of whom little better could be expected."[16]

Of Battista Franco, Vasari has harder things to say. He obtained the commission for the oratory, after Salviati had given up working there owing to his rivalry with del Conte, no doubt a typical example of the former's difficult temperament [183]. Franco's fresco was the *Arrest of the Baptist by Herod* [184]. Vasari rightly found it overlabored in a crude and melancholic manner, without order in its compo-

[16] Venturi, *Storia dell'arte italiano*, IX, 6, p. 220.

Opposite, above left

182. Jacopo del Conte, *The Deposition*. Rome, Oratory of S. Giovanni Decollato

"A very fine painting and the best work that up till then he had done."

Opposite, above right

183. Salviati, *St. Andrew*. Rome, Oratory of S. Giovanni Decollato

On either side of del Conte's *Deposition*, Salviati painted an apostle, St. Andrew and St. Bartholomew. The feigned projection of Andrew's cross is a piece of illusionism typical of the decoration of the room.

Opposite, below

184. Battista Franco, *Arrest of the Baptist*. Rome, Oratory of S. Giovanni Decollato

"For all that this picture was carried out with much labor, it was not held by a long way equal to that of Salviati, being overworked in a crude and dreary manner."

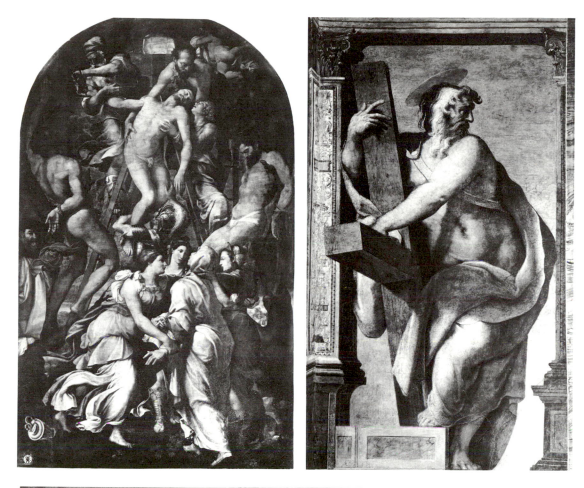

sition or any trace of the grace and pleasant coloring of Salviati's work. The fresco in fact moved Vasari to one of his disquisitions on how to paint a picture, arguing that "knowledge of the muscles and the different parts of the body was not enough, and that everything must correspond proportionately," so that the final effect is without confusion; above all borrowings from others ought to "be used in a manner that is not so easily recognizable." Franco's clutter of foreground figures, recalling poses from the Sistine ceiling, justifies this criticism. They were all borrowing at this stage of Tuscan-Roman painting, Salviati the water-carrier from the *Burning of the Borgo*, del Conte Michelangelo's *Adam*, but they were doing so for the most part with reasonable inventiveness of their own.

Vasari's condemnation of Franco's fresco is an unusual piece of strongly adverse criticism. Franco, however, redeemed himself in Vasari's eyes. At Castel Durante under the patronage of Guidobaldo of Urbino he became a great designer of maiolica, an earthenware that resembled in quality "the ancient ware of Arezzo made in the time of King Porsenna of Tuscany." The Vasari family tradition as potters carries Giorgio into a long digression on firing and glazing.

When Vasari comes to Salviati's second fresco in the oratory, the *Birth of the Baptist*, painted in 1551, he thought it good, but not equal to the *Visitation*. Salviati had in the interval been working in Florence for Duke Cosimo, where he had been employed on the *apparato* for the duke's wedding: then, having as so often abandoned the work before completion, he had traveled northwards to Venice, where his work was much praised by Aretino, who found in it "the discretion with which Michelangelo straightens and rounds the artifice of lives."[17] Vasari in an unguarded moment wrote that his *Psyche* in the Palazzo Grimani was "the finest painting in all Venice." Then Salviati came back to Florence where he frescoed a hall of the Palazzo Vecchio and also provided designs for the newly founded Florentine tapestry work: but he proved himself so difficult, "blaming the work of others and exalting his own," that Tasso, Cosimo's master of works, became irritated with him. Giorgio wrote to Salviati urging patience and saying that he ought to understand better the nature of his own countrymen; but in the end, in 1548, when the commission he had looked for to fresco the choir of S. Lorenzo was given to Pontormo, Salviati returned to Rome, "hoping," Paolo Giovio wrote to Giorgio, "to obtain papal patronage, now that Perino had died." Paul IV, however, gave no encouragement to the arts, and though Salviati remained some six years in Rome, there were no papal commissions. Vasari gives an account of his main frescoes in this second Roman period: the refectory of S. Salvatore in Lauro; a room in the Farnese Palace; and the

[17] *Lettere sull'arte*, pp. 129–31; see I. H. Cheney in *AB*, XLV, 1963, pp. 336–49.

extraordinary outburst of imaginative design with which he decorated
the walls of the Palazzo Sacchetti [185]. But curiously, of one of his
most important works, the paintings of the Cappella del Palio in the
Palazzo della Cancelleria [186], he only gives the vaguest indication,
"beautiful stucco compartments with scenes of St. Lawrence." In a
building where Vasari had painted the great Sala dei Cento Giorni,
he must have seen his friend's notable achievement, even though
painted some years later, but when he did so he cannot have had the
opportunity of taking notes, and perhaps then as now the Cappella del

185. Salviati, *David and Bathsheba*. Rome, Pa-
lazzo Sacchetti

"And in short, the work in this room is alto-
gether full of grace, of the finest imagination and
ingenious in invention."

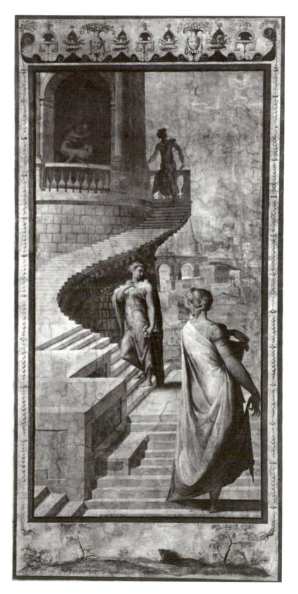

Palio was, in the words of the Touring Club Italiano Guide, "non facilmente visitabile."

Even with such employment, Salviati remained his own enemy. "He was strange in conversation with his friends, being variable and in some ways unstable; those who pleased him one day, he held in hate the next; and he did few things of importance without in the end a dispute about the price, so that many avoided him." Restless as ever he went to Paris in 1554, on an invitation that Giorgio had turned down, but there, even with a warm welcome from the kindly Primaticcio, his sneers at other painters' work made him soon unpopular and he returned to Rome. Once more Vasari came to the rescue ("Leave it to Giorgio" became a proverbial saying)[18] and secured from Pius IV a commission for Salviati to work in the Sala Regia, the main artistic project in the Vatican at the time. Daniele da Volterra had been employed on this since 1547, but with his usual dilatoriness had done little beyond the stucco decoration, and Paul IV had sus-

[18] Marginal note on copy of the *Vite* in the Corsini Library.

pended the work, caring little "for the arts of design." Salviati began by destroying the beginnings of a fresco by Daniele and then became aggrieved because other artists were called in to help complete the work. Vasari had to write urging him to finish the fresco he had begun, modeling himself on the works of Michelangelo in the Sistine and Pauline Chapels; once this was done, the excellence of his work would put him beyond any competition. It was a good opportunity for the kind of moralizing to which Giorgio was so prone. Salviati completed, or largely completed, his fresco of *Barbarossa and Alexander III*, an undistinguished piece that shows waning powers, and death came to him while he was still at work on it at Martinmas 1563. There could be no greater contrast than that between this cantankerous, self-opinionated, unbusinesslike, greatly gifted man and the shrewd, prompt, reliable and skillfully tactful Vasari, but Vasari was very loyal and patient. "If," he wrote of him, "he had known his own nature and given himself to work according to his invention, he would have done marvelous things. . . . Although there was always an honest rivalry between us, by the desire that good artists have to surpass one another, there never was, in matters of friendship, any lack of affection and love."

Of all the painters who were in their early youth in the 1520s studying in Florence, Salviati had the most intense imaginative power. From Pontormo and Rosso he learned a new and liberating range of emotional expression, but the use he made of it is entirely his own. In what is perhaps his most profound masterpiece, the *Pietà* in S. Maria dell'Anima [187], a passionate involvement with the theme is expressed in a concentrated group, framed in the oval formed by the bending angel and Christ's torso. At the top are the frightening powerless fingers of the corpse; in a diagonal across the painting the clasped agonized hands of the Virgin are repeated in the more sober gesture of the praying donor. Entirely different is the construction of his *Conversion of St. Paul* in the Cappella del Palio [186]. The figures spring outward from the fallen saint as though driven by an explosive force, though every unit of the design is closely knit within itself. The colloquy between Christ and the Virgin in the *Marriage of Cana* (S. Salvatore in Lauro) has a depth of communication that few artists have given to it [188]: the falling warrior pierced by a spear is a note of

186. Salviati, *Conversion of St. Paul*. Rome, Palazzo della Cancelleria, Cappella del Palio
 Vasari mentions only the martyrdom of St. Lawrence and says nothing of St. Paul.

290

vivid pathos amongst the confused battle of the Palazzo Vecchio Sala dell'Udienza: in the Palazzo Farnese Ranuccio Farnese triumphs amidst a splendid array of allegory, where the wall surface disappears in a medley of feigned hangings and perspectives; and in the Palazzo Sacchetti the circular staircase that leads to the dark chamber where David and Bathsheba are coupling is pure surrealism [185]. In his work can be found much of the freedom and invention that Vasari lists among the achievements of his third and final period. He did not, however, bear out another commendation of Vasari's, that the great facility of contemporary painters allowed of a far greater output than that of the earlier masters. Vasari's own industry and concentration did not belong to Salviati's temperament, but beside his friend's passionate and twisted thoughts, Vasari's mind remains conventional and prosaic.

During the pontificate of Pius IV (1559–65), the chief papal adviser on artistic matters was the Neapolitan, Pirro Ligorio.[19] After Giorgio in 1560 had been in Rome with the young cardinal, Cosimo's son Giovanni, an approach was made to him to come to Rome and supervise the Sala Regia, but he was too deeply occupied in Florence, and it was Pirro who received the next offer. Vasari devotes no *Life* to him but the name recurs frequently, and generally unfavorably, in the later part of the *Vite*. Ligorio's frescoes in the oratory of S. Giovanni Decol-

[19] D. R. Coffin in *JWCI*, xxvii, 1964, pp. 191–210; E. Mandowsky and C. Mitchell, *Pirro Ligorio's Roman Antiquities*, London, 1970; see also review by C. Dionisotti in *Rivista storia italiana*, lxxv, 1963, pp. 890–901.

lato [189], painted probably between 1540 and 1550, are dismissed with a mere mention, rightly so for they are a poor pastiche of prevailing fashions, with steps leading down into the room, in which three donors appear to be standing, and an elaborate architectural background. Salviati's woman with a basket, taken from the *Burning of the Borgo*, is now in turn copied by Ligorio. Ligorio also was a critic and opponent of Michelangelo: "he anew harassed Michelangelo and went about saying he was in his second childhood." Under the threat of leaving for Florence, whither the duke and Vasari were urging him to come, Michelangelo was left in charge of St. Peter's, but the main commission of Pius's pontificate, the Casino in the Vatican gardens, went to Ligorio. This charming building with its wealth of decorations shows him to have been an architect of imagination and originality. On its walls and ceilings he employed a team of young artists, names as yet unknown but soon to be familiar, amongst them Federico Barocci, Santi di Tito, and Federico Zuccaro, whom Vasari specially commends as surpassing them all. In a striking passage he writes: "The labors of Federico and the others did not receive the recognition that was owing to them, for there is in our artists in Florence and Rome much spitefulness so that, blinded by passion and jealousy, they do not know or wish to know the praiseworthy works of others and the defects of their own, and this is the reason why the genius of young men, being downcast, grows cold, in studies and in work." This encouragement of new men, for the Sala Regia as well as the Casino, led to

a breach between Ligorio and Salviati, formerly good friends, but on the death of Pius IV, Ligorio's supremacy came to an end and, as Giorgio puts it, he was "removed with little honor." He was in fact for a time imprisoned, on a charge brought by Guglielmo della Porta of defrauding the pope over various purchases, and was only rescued by the intervention of Cardinal Alessandro Farnese. He left Rome and went to the court of Alfonso II d'Este, primarily to deal with antiquities. He had been busy compiling a treatise on the "nobility of the ancient arts," several versions of which exist in manuscript. Still unpublished, and unknown to Vasari, these contain reflections on contemporary art and some thinly disguised attacks on Michelangelo and Vasari. Ligorio is above all a defender of decorum in representation of sacred scenes; he disliked the broken pediment in architecture, and he wrote of contemporary painting: "They make supple figures appear to be askew without any harmony, and it seems to them admirable when they depict foreshortened figures in every picture." These were views rapidly growing in currency. In 1564 the Council of Trent issued its decrees on the purpose of art, condemning sensuality and excessive elegance. The treatment must be appropriate to the subject and easily intelligible. Already artists had been turning to a new sobriety of representation as though in reaction against a Mannerist style that had by now been fully explored.

On the papal throne Paul IV from 1555 to 1559 and Pius V from 1566 to 1572 were very different men from Clement VII, the Medici bastard, Paul III, with his Farnese sons and grandsons, and the easygoing Pius IV. Paul IV, while still Cardinal Gian Pietro Caraffa, had established the Inquisition in Rome on the model of that which he had admired as nuncio in Spain. Pius V as Cardinal Michele Ghislieri had been Inquisitor General of the Holy Office. There had been burnings in Rome, and Venice and Florence had been forced to deliver up those suspected of heresy. In 1550 Ignatius Loyola had founded the Jesuit College in Rome, and two years later the Collegium Germanicum, a training ground for missionaries to the heretical North. Protestantism was attacking images with violent iconoclasm. It was needful that Catholic use of them should give no cause for scandal. Always alert to changing moods, Pietro Aretino in the later forties wrote an open letter to Michelangelo (probably never actually sent to him) protest-

189. Pirro Ligorio, *The Dance of Salome*. Rome, Oratory of S. Giovanni Decollato
This clumsy work is dismissed by Vasari with the comment that "some other things" were done by Ligorio in the Oratory.

ing about the lascivious nudity of the *Last Judgment* [190], displayed in the chapel of the pope himself. Aretino had never seen the painting and knew it only in engravings.[20] It is a coarse appeal, from a man in every way least justified in making it, to a new vogue in which the deep seriousness of Michelangelo could be thus mistaken. Paul IV wished to destroy the whole fresco, but in the end contented himself with employing Daniele da Volterra in "covering the shameful parts." Even Pius IV, a more tolerant man, had some draperies added and in the course of these additions one or two figures were completely repainted, though there were delays about it and Michelangelo prob-

[20] For the problems about this letter see M. W. Roskill, *Dolce's "Aretino" and Venetian Art Theory of the Cinquecento*, New York, 1968, p. 27; and E. Tietze Conrat, *AB*, xxv, 1943, pp. 154–56.

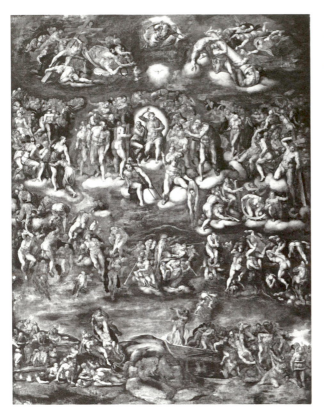

190. Venusti, copy of Michelangelo's *Last Judgment*. Naples, Capodimonte

This small copy was made in 1549 and is therefore evidence for the fresco before the draperies were added, though even in the copy some modifications may have been made.

Below

191. Daniele da Volterra, *The Assumption*. Rome, SS. Trinità dei Monti

ably never saw these additions to his work. "Tell the pope," Vasari reports him as saying, "that he should reform the world, pictures are quickly adapted." It must have been a time of many bitter thoughts for Giorgio, and for him Paul IV was "a man without any taste (*gusto*) for the art of design."

He himself, however, was not impervious to the new mood. In particular illusionist tricks such as the descending steps in the Cancelleria frescoes disappear from his work and the scenes retreat once more within the picture space. When he writes of Daniele da Volterra's *Assumption* in SS. Trinità dei Monti [191], where the scene is set in a curve of pillars that continues the architecture of the chapel, and the altar itself serves as the tomb, he thought it too daring an *invenzione* to please the better judges. Vasari might abandon such spatial fancies in favor of more rigid framing, but, as late as 1583, one of his pupils, Jacopo Zucchi, painted in the apse of S. Spirito in Sassia a *Pentecost*, where the great pillared hall in which the scene is inappropriately set continues the architecture of the nave and is linked to it by two painted columns.[21]

Such ingenuities were temporarily out of favor. The outstanding protagonist of the new approach was a young artist, born in 1529, Taddeo Zuccaro, elder brother of the Federico employed by Ligorio. His early work had been in the current Mannerist style, and when between 1553 and 1556 he was working in the Mattei chapel in S. Maria della Consolazione, his renderings of the *Last Supper* and the *Ecce Homo* placed the main scene in the far background, filling the foreground with violent, foreshortened and irrelevant figures. But when on one wall he painted the *Flagellation* [192], all was changed. The space is filled with large-scale figures aligned against a background of little recession, placed frontally on the picture plane. The work completed, Taddeo was employed painting a chapel in S. Marcello. Here the methods used in the *Flagellation* are continued, large-scale figures occupying the picture space. In the altarpiece, the *Conversion of St. Paul* [193], a scantily clad Mannerist figure plunges, it is true, from the picture space (a stock figure that was to haunt these artists for some time to come), but compared with the explosive, outward drive of Michelangelo's or Salviati's treatment of the subject, this is a centralized design, concentrating on the immediate foreground. When, later in 1563, Taddeo completed the frescoed room left unfinished in the Palazzo Farnese by Salviati, he could still adapt himself to the latter's general scheme, but his figures have a quite different placidity [194].[22]

[21] F. Zeri, *Pittura e controriforma*; E. Lavagnino, *La chiesa di Santo Spirito in Sassia.*
[22] J. A. Gere, *Taddeo Zuccaro.*

Above

192. Taddeo Zuccaro, *The Flagellation*. Rome, S. Maria della Consolazione

The frescoes in this chapel, key pieces for the development of Roman art in the cinquecento, are unfortunately in a sad and apparently unheeded state of disrepair.

Left

193. Taddeo Zuccaro, *Conversion of St. Paul*. Rome, S. Marcello

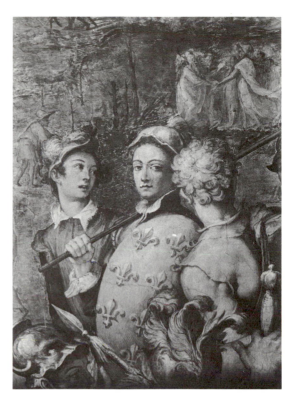

194. Taddeo Zuccaro, Fresco, *The Foundation of Orbetello* (detail), in Farnese Palace, Rome

The cheerful confidence of these good-looking young men is very different from Mannerist emotionalism.

Below

195. Taddeo Zuccaro, *Cardinal Farnese Entering Paris with Charles V and Francis I*. Caprarola, Villa Farnese

The foremost bearer of the baldacchino on the spectator's left is a self-portrait of Taddeo, the bearer behind him is Federico. The respective shares of the two brothers in this painting are matters of some dispute.

Vasari's first contact with Taddeo was in 1553, when the latter was working under Prospero Fontana's direction in the Villa Giulia, built under Giorgio's supervision for Pope Julius III by Ammanati and after him Vignola. It was in association with Vignola that Taddeo was to have one of his most important commissions, the frescoing of the palace at Caprarola that Vignola had designed for Cardinal Farnese. It was the same cardinal, still wealthy and powerful after many vicissitudes, who had entertained the meeting where the *Vite* were first outlined and who had given to Giorgio the frescoing of the Sala dei Cento Giorni celebrating the deeds of the Farnese pope. Now another series of scenes from Farnese doings was to be painted, in a more modern manner. Vasari in his *Life* of Taddeo gives a detailed account of the subjects, and quotes at length a *ragionamento* for some of the rooms, written by Annibale Caro, another of the first promoters of the *Vite*. Nothing here could be less similar to the ebullience of the Sala dei Cento Giorni. Taddeo strictly frames his subjects, restricting them to the picture space, and the figures process in a dignified, unemotional solemnity, parallel to the picture plane [195]. Only here and there, in details such as the woodman looking from the trees, are there hints of how well Taddeo could have handled genre subjects, had such been in demand. Taddeo visited Vasari in Florence, probably in 1564, when the latter was busy with the designs for frescoes in the Palazzo Vecchio, and it must have been an interesting conjunction of the older and new outlooks, and one from which Giorgio was ready to learn.

One man Vasari had little reason to like. Benvenuto Cellini was eleven years his senior and died three years before him. There could be little sympathy between the flamboyant, blustering Benvenuto and the precise, careful Giorgio. Benvenuto thought that Vasari had reported him to Duke Alessandro for uttering threats against the Medici, likely enough since Vasari says of him that he was prone to speak too freely of princes. In his autobiography Benvenuto refers mockingly to Giorgetto or Giorgino, describing him as covered with a dry scab and always scratching, but the unpleasant details that Benvenuto piles up defeat their own credibility. The autobiography was written, but not published, two years before Vasari's second edition, and Vasari knew it existed though there is no evidence that he had read it. He speaks admiringly of Benvenuto's work, and in particular considers the *Perseus* worthy "to stand beside the Donatello *Judith*." "Courageous, proud, lively, very prompt and very terrible," he describes him, a fair enough summary of the man. It was, however, an uneasy business having this quarrelsome person in Florence. Borghini was less generous than Giorgio: "To put that pig of a Benvenuto into your book," he wrote, "shows how gentle and tolerant you are."[23]

[23] Frey II, pp. 97, 98.

XII. The Last Years

On 21 February 1564 Borghini wrote to Vasari that he had news of Michelangelo's death in Rome three days earlier [196]. "A man such as he should never die," but as it had pleased God to take him, it behoved the Academy of Design to busy itself with an imposing funeral service. His wish to be buried in Florence had often been expressed, and the first step was to bring the body from Rome. On 1 March the coffin reached Florence, and on 12 March it was taken to S. Croce and deposited there. The great memorial service in S. Lorenzo, normally reserved for funerals of the ducal house, did not take place till 14 July. These four months were required for the organization and production of a great *apparato*, which would celebrate the work of the divine master, and also display the resources and abilities of the newly founded Academy of Design. Vasari and Borghini were naturally and properly in charge, and inevitably there were disputes over many details. The program, the *ragionamento*, became involved in the fashionable debate as to whether sculpture or painting had pre-eminence in the arts. Benvenuto Cellini put forward his own scheme for the ceremony, and when it was rejected withdrew from any participation in their plans, grumbling venomously about "that pretty pair, Aretine Giorgio and the Frate prior, who act as one." But in the end the catafalque, the paintings and sculptures that lined the church were ready, the work of Vasari's and Bronzino's studio assistants. Benedetto Varchi delivered the oration, and all Florence, with the notable exception of the ducal family and the marked absence of Cellini, crowded to the event.[1]

The obsequies of Michelangelo and the designing of his permanent tomb in S. Croce [197] cut across Vasari's numerous undertakings, the vast enterprise of the Palazzo Vecchio and the work, begun four years earlier, on the Uffizi. In Pisa the Palazzo dei Cavalieri was nearing completion: in Pistoia he had, at the urgent request of his friend Bishop Ricasoli designed a dome for the unfinished church of the Madonna dell'Umiltà;[2] there were commissions for paintings such as the three altarpieces still in the church of S. Pietro at Perugia. In 1565 there was a further interruption, the preparation of a great *apparato*

[1] R. and M. Wittkower, *The Divine Michelangelo*, London, 1964.
[2] *M*, iv, pp. 165–66.

196. Daniele da Volterra, *Michelangelo*. Oxford, Ashmolean Museum

This bust, based on a death mask, and made by a devoted disciple, seems to have been regarded as a good likeness and there are several casts of it extant.

for the marriage of Francesco de' Medici with Joanna of Austria. The *ragionamento* for it required tactful handling, and Vasari and Borghini were somewhat exercised over references to the late duchess, the admired Eleonora, in view of Cosimo's passionate involvement with a new mistress.[3] There was reason for caution. When in 1566 Sforza Almeni, Giorgio's old patron, ventured on the strength of his long friendship with the ducal family to discuss Cosimo's private life with his son Francesco, and the latter tried to talk it over with his father, Cosimo banished Almeni from the court, and then, meeting him unexpectedly in the Palazzo Vecchio, transfixed and killed him with a spear. It was an event so deeply shocking that it enforced silence. Nothing in any of Vasari's correspondence refers to it, but it must have cast fear and suspicion over all the ducal court.[4]

Vasari was now happily settled in his house in the Borgo S. Croce. His mother had died in 1558, and Cosina ran the household, a busy task with its frequent visitors. It was the center for a whole circle of intimates and she proved a good hostess. There are constant messages to her in letters to her husband; Borghini sends her a hare; Cosimo Bartoli has messages to her from his own Piccina and their son Curtio; Don Gabriel Fiamma, the young itinerant preacher, adds special greetings to the cats. "Madonna Cosina comforts me," Giorgio wrote in a letter, and there are several sonnets, not very good ones, written by

[3] Frey II, p. 191.

[4] For the murder of Almeni see A. Manucci, *Vita di Cosimo de' Medici*, Bologna, 1586, pp. 186–87. Cosimo allowed all Almeni's possessions to be inherited by his heirs.

197. Vasari and others, Tomb of Michelangelo. Florence, S. Croce

The tomb had a confused and lengthy history, not being completed till eleven years after Michelangelo's death. Vasari made the design and the sculpture was carried out by Bandini, Valerio di Simone, Cioli and Battista di Lorenzi.

him to his wife, containing apologies for his absence and expressions of his affection for her and hopes that they might have children.[5] But it remained to his deep regret a childless union. Writing to Matteo Botti to congratulate him on his marriage, he wishes for him that he may have offspring, whereas he, Giorgio, could only cover walls, panels, canvas and paper with figures.

The adaptation and decoration of the Palazzo Vecchio to make it living quarters for the Medici family was his overriding concern.[6] Little change was to be made to its famous exterior; "these maternal walls, witness of such great doings" were to be a symbol of the old disordered times now brought into peace and unity, and, within, the mean old rooms ("stanzaccie vecchie") were to be coordinated into a seemly and convenient whole. It was a considerable problem, for

[5] Vasari's poems are printed in Scoti-Bertinelli, *Vasari scrittore*, pp. 263–303.
[6] A. Lensi, *Palazzo Vecchio*, Rome, 1929; G. Sinibaldi, *Il Palazzo Vecchio*, Florence, 1934; U. Baldini, *Il Palazzo Vecchio e i quartieri monumentali*, Florence, 1950; J. Wilde, "The Hall of the Great Council in Florence," *JWCI*, VII, pp. 65–81; P. Bargellini, *Scoperta di Palazzo Vecchio*, Florence, 1968.

the Palazzo was full of different ill-connected levels, and the staircases with which Vasari linked them are a very skillful piece of planning. The great hall, the Sala dei Cinquecento, could not be converted into complete rectangularity, but its proportions were altered by raising the roof, which also permitted lighting by windows above the now unbroken space of the walls that were to display Vasari's frescoes. For the entrance courtyard Francesco Ferrucci, called del Tadda, carved a great porphyry basin as a fountain, a work that Vasari writes of in his "Three Arts of Design," stating that Cosimo had a share in discovering a new method of tempering tools to cut this hard stone. This is possible enough, for both the duke and his son had scientific interests, and the fumes from their laboratory, eventually moved to the Pitti, were one of the problems with which Giorgio had to deal. On the fountain was set Verrocchio's *Boy with a Fish*, "a truly wonderful work" and a link with the great days of the quattrocento.

For the frescoes that were to decorate the walls and ceilings of the rooms Vasari relied greatly on the well-tried advice of Cosimo Bartoli and of Giovambattista Adriani for the classical scenes, with general supervision from Borghini for more recent events. By 1558 a *ragionamento* had been worked out for the whole scheme, and had been sent to Rome where both Annibale Caro and Michelangelo read it.[7] Cast in the form of a duologue between Giorgio and the young prince, Francesco, it deals in detail with the history of the Medici family and portrays in their entourage their advisers, generals and artists. Its compilation must have been a vast labor, and Francesco at the end is rightly made to say "Those who have read Villani and Guicciardini and other historians ancient and modern, who treat of the affairs of our city, will realize that you are informed in every particular." It is today heavy reading, but to anyone such as Michelangelo, who had lived through so many of the events portrayed, it must have had the fascination that we experience from the replay of old news films. Familiar characters constantly recur: Ottaviano de' Medici, Giovanni dalle Bande Nere, Francesco Guicciardini, the Marquis of Marignano, even Sforza Almeni, not removed in any revision; and constantly the Medici themselves, and they all had to recur recognizably. Portraits had to be found, and the ducal collections were searched for examples. Death masks, which dated, Giorgio says, from an invention made by Verrocchio, proved particularly useful. Topographical details had to be settled. How did Florence look when Arnolfo was replanning it? How far had the new St. Peter's progressed under Leo X?

[7] The *ragionamento* is printed by both Pecchiai, III, pp. 1019ff and Milanese, VIII, pp. 199ff. It was published by Vasari's nephew, Giorgio, in 1588 after his uncle's death.

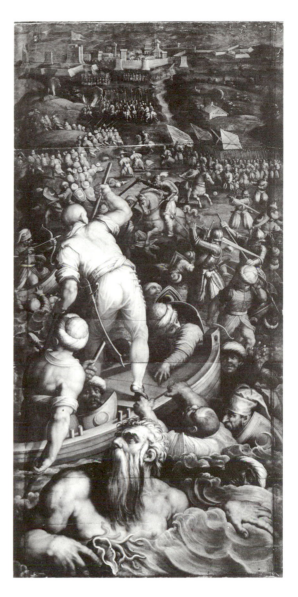

198. Vasari, *Defeat of the Turks at Piombino*.
Florence, Palazzo Vecchio, Sala dei Cinquecento
In 1555 a Turkish fleet landed at Piombino and
began plundering the countryside, but were
driven back to their galleys by Chiappino Vitelli
and his light horse. Francesco asked what was
meant by the large figure in the foreground and
Vasari explained that it was the sea.

Period clothes had to be thought out. Vasari uses a curious medley of
pseudo-classical and contemporary armor, often in the same scene.
For some of the earlier frescoes, he copied old styles from a painting
by Buffalmacco, and also used the *cassoni* painted by Dello that he
had preserved among the ducal furniture, partially for this purpose.
For more recent events [198], the participants in them had to be con-
sulted. His old friend Federico da Montaguto could, for instance, tell
him much about the battle of Monistero.[8] All had to be approved by
the duke, and alterations made to suit his wishes. He did not feel that

[8] Frey II, p. 18.

any councillors were needed in the scene where he planned the attack on Siena, "for we were alone"; some allegorical figures would be more appropriate: and so it is, and he is surrounded by a group of symbolical ladies [199].[9]

Interruptions were not infrequent. Some of the rooms were needed

[9] Frey I, p. 735. Cosimo's letter is dated 14 March 1563, that is after the first draft of the *ragionamento*. Vasari presumably kept revising the text, both for working purposes and with a view to eventual publication.

in 1558 for the marriage of Cosimo's daughter Lucrezia to Alfonso d'Este. In December 1562 the tragic death of the Duchess Eleonora, before ever her rooms were completed, cast a gloom over the undertaking. In 1565 the pillars of the courtyard received their stucco ornament [125] for the marriage of Francesco with Joanna of Austria, an event which diverted most of the city's artistic activity to its celebration. There were also familiar labor troubles. Money was often short, and both the workmen's pay and Vasari's salary were in arrears.[10] As he had written in his *Life* of Baldassare Peruzzi, "To say truth, as it is right to be discreet with magnanimous and liberal princes, so there is need with the avaricious, ungrateful and discourteous to be importunate and aggravating, because while it is a vice to be importunate and demanding with good princes, it is a virtue with the avaricious and it would be a vice to be discreet with them." Cosimo would never have been placed in the bad category, but there is real feeling and experience behind Vasari's advice as to the handling of patrons. Another constant care with its own problem was the supervision of the many assistants working on the frescoes. Stradano, Naldini and Zucchi might make first drafts for the cartoons, and certainly worked on many of the details for them, but surviving drawings [200] show that Vasari kept a strict control, and that the lessons learned in the Sala dei Cento Giorni had not been forgotten.[11] The actual preparation of the walls with two applications of stucco was in itself a lengthy process, and to keep the second layer smooth, "it was necessary to be ever about it with the trowel or spatula."[12]

From 1554 to 1556 he was at work on the rooms of the second floor, the Quartiere degli Elementi that celebrated the gods of classical mythology, "because," Vasari explains, "though they are false gods, it is lawful in this to imitate the ancients, who under these names hid

[10] Frey I, pp. 598, 695, 731.

[11] G. Thiem, "Studien zu Jan van der Straet, genannt Stradanus," *MKIF*, VIII, 1958, pp. 88–111, and "Vasaris Entwürfe für die Gemälde in der Sala Grande des Palazzo Vecchio zu Florenz," *ZfK*, XXIII, 1960, pp. 97–135. See also A. F. Tempesti, "Disegni di Vasari e della sua cerchia," *Vasari*, XXI, 1963, pp. 178–82, and M. N. Benisovich, "Les Dessins de Stradanus," *Vasari*, XXI, 1963, pp. 139–43.

[12] Maclehose, *Technique*, pp. 233–35.

199. Vasari, *Cosimo de' Medici Planning the Attack on Siena*. Florence, Palazzo Vecchio, Sala dei Cinquecento

Cosimo is surrounded, not by his advisers as Vasari had planned, but by Patience, Vigilance, Fortitude, Prudence and Silence.

allegorically the concepts of philosophy." The concepts turn out in Vasari's explanation to be veiled references to the benefits of Medicean rule. Here Cristofano Gherardi [201] was his chief assistant, and much of the actual painting, according to Vasari's own statement, is by him on his master's cartoons. Vasari singles out as particularly beautiful the figures of *Mercury* [202] and *Pluto* between the windows. The rich decoration of garlands and putti also bespeaks Gherardi's intervention.

306

Vasari never used this lavishness with such confidence after Gherardi's death, which occurred while the work on this room was in progress. In the center of the ceiling was a strange, unpleasing subject suggested by Cosimo Bartoli, the castration of Cielo (Uranus) by Saturn [203], represented in some detail. It was an incident that led indirectly to the birth of Venus from the sea, and so was linked to the wall paintings [204]. Bartoli in a long letter found many philosophical and even Christian meanings in it.[13]

[13] Frey I, pp. 410–15.

CHRISTOFANO GHERARDI
PITTORE.

201. Vasari, Portrait of Cristofano Gherardi in the second edition of the *Lives*

Right

202. Vasari and Cristofano Gherardi, *Mercury*. Florence, Palazzo Vecchio, Quartiere degli Elementi

"This is the Mercurial *virtù*, which all princes ought to know, understand, love and delight themselves in, and favor all the arts and fine inventions as does our duke." (*Ragionamenti*)

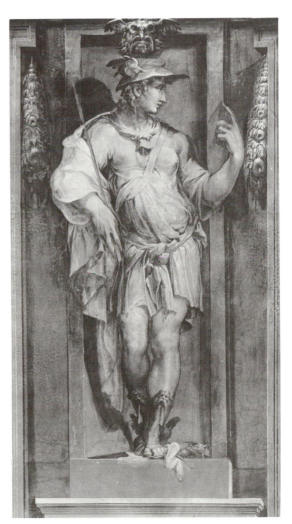

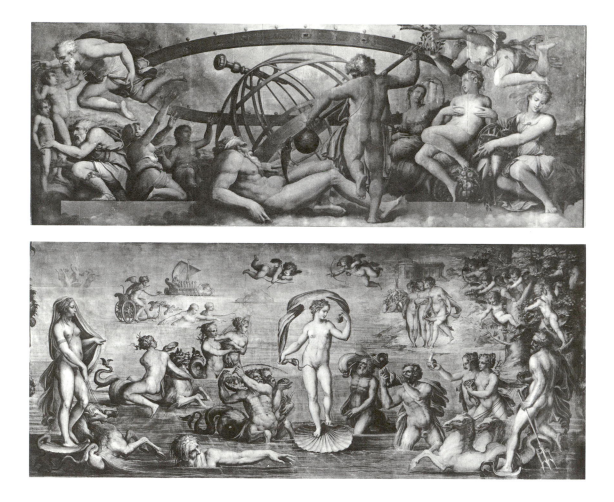

In the quarters of Leo X the Fleming, Giovanni Stradano, takes over Gherardi's place. There is a new solidity in the figures, which fill more of the picture space; the twisting elegance of earlier works is replaced by a more naturalistic stance, befitting the treatment of near-contemporary events. There is something of the lucidity and also monotony of Taddeo Zuccaro's frescoes in Caprarola. The pictures, too, are more solidly framed. In the Quartiere degli Elementi Gherardi's *Mercury* could still illusionistically overlap his niche. Now on ceilings and walls the scenes are well contained [205]. No longer as in the Sala dei Cento Giorni do painted steps bring them into the general space of the room.

To many people the great battle pieces of the Sala dei Cinquecento must be the most familiar of Vasari's works [206]. Historically and top-ographically they are of the greatest interest. Tactics, placing of artil-

Opposite, above

203. Vasari, *Castration of Uranus by Saturn.* Florence, Palazzo Vecchio, Quartiere degli Elementi

Saturn castrates Uranus the sky, from whose genitals Venus is born from the sea. Cosimo Bartoli's letter on the subject suggests that there was considerable uncertainty about the legend, but "it greatly pleased" him.

Opposite, below

204. Vasari, *Birth of Venus.* Florence, Palazzo Vecchio, Quartiere degli Elementi

The birth of Venus is used as the theme for water. The execution of the fresco was largely due to Cristofano Gherardi.

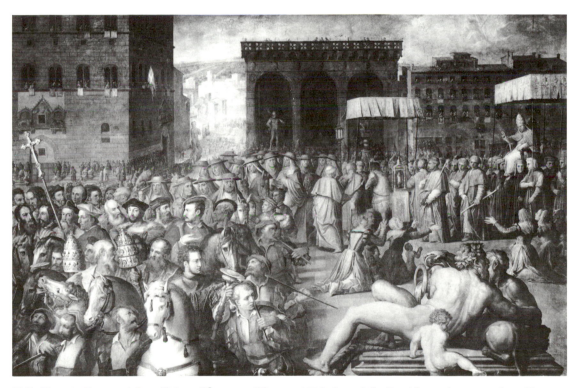

205. Vasari, *Entry of Leo X into Florence.* Florence, Palazzo Vecchio, Sala di Leone X

In 1515 Leo came to Florence for the first time since his election to the papacy. Here is shown his entry into the Piazza della Signoria. Behind Michelangelo's *David* can be seen the old quarters pulled down to build the Uffizi. Lorenzo II de' Medici can be seen in profile in the foreground and on the extreme left there is the bearded head of Pietro Aretino.

lery, use of natural features or isolated buildings, the general lines of
defense works are all portrayed and provide a unique corpus of infor-
mation for military historians, one that has never yet been adequately
exploited. There is some vigor in the action. Interspersed with contem-
porary plate armor, pseudo-classical figures reveal their muscular
torsos and swing the skirts of their tunics. The horses prance and rear
with inventive variety. In some of the smaller ceiling compartments,
the participants strike effective Mannerist poses. But there is a certain
monotony in the transference of all this knowledge into visual terms.

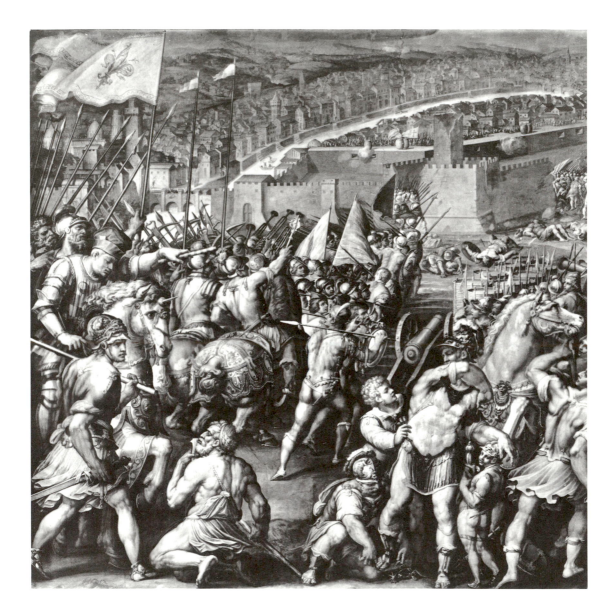

The horizontally stretched battles and marches, with behind them the distant views, recall Giulio Romano's *Battle of Constantine*, that guide to battle painting as Vasari had called it, but they lack the inventiveness of design which gives life and variety to Giulio's turbulence. It is not all bloodshed and alarms, particularly in some of the smaller rooms. In the Sala di Cosimo, the duke is shown in a roundel supported by some of his architects, engineers and sculptors [207]. Vasari himself, with a plan in his hand, looks out from the foreground. On Cosimo's right is Tasso with the model of the Mercato Nuovo, on his left Tribolo with models of the fountains at Castello. Surrounding the duke are the military engineers Nanni Unghero and Sanmarino, Bandinelli, Cellini, Luca Martini and Ammanati. Opposite Vasari in a hat is Francesco di Ser Jacopo, who was in charge of the financial administration of the Palazzo. Some of the men represented wear antique dress, and it has been plausibly suggested that they are men already dead at the time the roundel was painted, hence this idealized treatment.[14] On one of the ceiling panels of the great hall, the *Return of the Marquis of Marignano to Florence after the Conquest of Siena* [208], Vasari inserted a group of six portrait heads, Borghini, Adriani, himself and behind them Naldini, Stradano and Zucchi. At one end of the hall, high up so that Giorgio expressed courtly surprise that the prince could read the inscription, he painted a group of the plasterers, carpenters and gilders who had worked in the Palazzo, with beside them putti holding a scroll with the date 1565 commemorating the works undertaken by Cosimo and entrusted to Vasari and his pupils [209]. Credits were thus fully acknowledged.

In 1564 Cosimo, broken by his family losses and moved perhaps by the example of Charles V, had created his eldest son, Francesco, regent, and ceded many, though not all, of his powers to him. The Palazzo Vecchio became the prince-regent's residence, and it was with him that Vasari had now to deal. Cosimo in a letter of October 1565 warned his son that artists were difficult to handle and always take longer than they say they will "except Giorgio who is most

[14] W. C. Kirwin in *MKIF*, xv, 1971, pp. 105–22.

206. Vasari, *The Siege of Pisa* (detail). Florence, Palazzo Vecchio, Sala dei Cinquecento

The decisive engagement was fought on 8 June 1509 under Antonio Giacomini, who directs the attack on the extreme left. In his hat can be seen the letter sent from Florence ordering him not to attack, which he had set aside unread in the stress of the engagement.

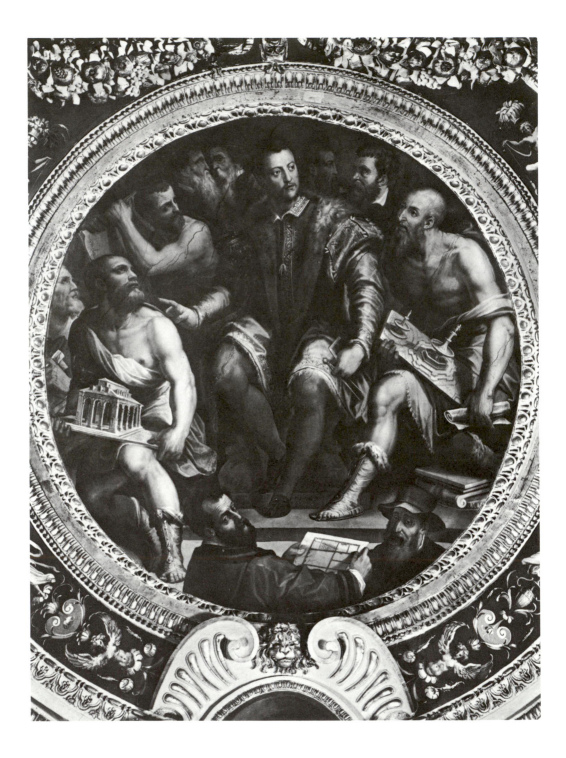

312

207. Vasari, *Cosimo de' Medici and his Architects*. Florence, Palazzo Vecchio, Sala di Cosimo I

Cosimo has a plan open on his knee and holds compasses and a right-angle square as indicative of his active participation in the designs.

208. Vasari, *Return of the Marquis of Marignano to Florence after the Conquest of Siena* (26 June 1555). Florence, Palazzo Vecchio, Sala dei Cinquecento

The marquis is the figure in the cloak, seen in profile, with Federico da Montaguto on his right. Below Vasari leans forward to show a plan to Raffaele Borghini.

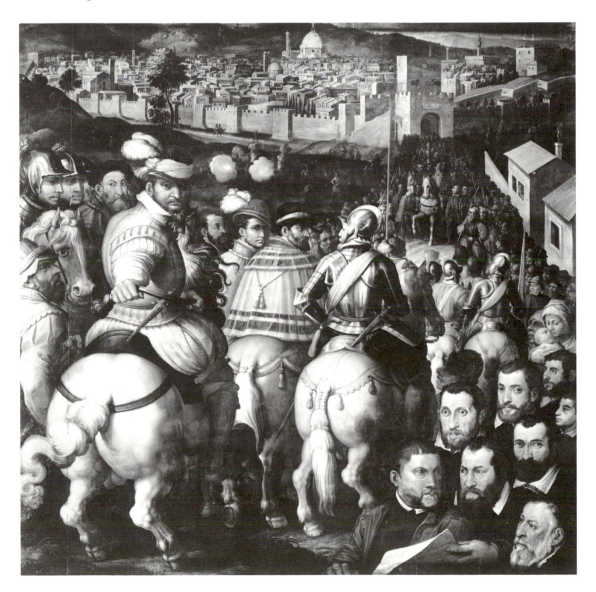

MDLXV
HAS AEDES ATQ AVLAM HANC
TECTO ELATIORI, ADITV, LVMINIB
SCALIS, PICTVRIS, ORNATVQ, AVG
VSTIORI INAMPLIOREM FORMAM
DECORATAM DEDIT, COSMVS
MEDICES ILLVSTRISS; FLORENT
ET SENEN· DVX, EX DESCRI
PTIONE ATQ, ARTIFICIO GEORGI
VASARII ARRET· PICTORIS ATQ
ARCHITECTI ALVMNI SVI

prompt."[15] The young prince, hitherto overshadowed by his dominant father, was a reserved and not easily likeable man. He shared his father's interests in scientific experiment and the collection of antiques, and, as all Florence knew, he had recently, despite his Austrian marriage, formed a liaison with a young Venetian, Bianca Cappello, for whom he was to have lasting affection. It was for him that Vasari now undertook the supervision of the Studiolo opening off the great hall. It was a small, secret room, lit only by a window which was generally covered; it led by a staircase to the room known as the Treasury, and to another room which for a time was Francesco's bedroom; or alternatively there was a way down to a private entrance to the street: it was convenient either for research or amorous adventures.[16] The room was surrounded by cupboards in which were kept some of the choicest examples of the prince's collection of minerals. Borghini made the program for its decoration: on the ceiling was displayed Prometheus surrounded by the elements; below, on one wall, were aquatic activities, pearl fishing, whale hunting, the search for coral and amber, the

[15] *Lettere di Cosimo I de' Medici*, pp. 203–06.
[16] L. Berti, *Il principe dello Studiolo*, Florence, 1967.

209. Vasari, *Putti with Scroll*. Florence, Palazzo Vecchio, Sala dei Cinquecento

In the inscription Vasari calls himself Aretine painter and architect and "alumnus" of the duke, a word that has no exact English equivalent, but implies his debt to Cosimo's protection. He details all the work on the hall and apartments, raising the roof, adding windows and staircases, paintings and elaborate decorations.

crossing of the Red Sea, the washing of wool; opposite were the uses of fire, the making of gunpowder, the founding of cannon, the fusing of glass, alchemy, goldsmith work, the hot baths of Pozzuoli; at either end were scenes of diamond and gold mining. Then in a row beneath were mythical subjects appropriate to the main themes, while above from either end Cosimo and Eleonora, portrayed by Bronzino as youthful figures, looked down upon the scene. The ceiling was painted by Francesco Morandini, known as Poppi, a painter who as a young man (b. 1544) had been helped by Borghini and given lodging in the Ospedale.[17] Vasari was now making much use of him. The artists reacted vigorously to the competitive display of their talents. Alessandro Allori's *Pearl Fishers* is a competent work by a painter who was to stand high in the succession to Giorgio and Bronzino; Stradano's *Alchemy* [210] has suggestions of Flemish influences, and the Florentine critics, according to Borghini, found it unpleasing.[18] Jan van der Straet, called in Italy Giovanni Stradano, was born at Bruges in 1523. He came to Florence in 1546, and was known mainly as a designer of tapestries. From 1561 he became one of Vasari's assistants in the Palazzo Vecchio, and played a large part in the execution of the paintings there. He could handle a genre scene with a direct understanding that his Italian colleagues could not equal. Twenty-one painters were employed, some of whom had had few associations with Vasari. Carlo Portelli, for instance, is mentioned in the *Lives* as working on the decorations for Cosimo's wedding in 1539 and as a pupil of Ridolfo Ghirlandaio, best known for his *Martyrdom of St. Romuald* still in S. Maria Maddalena dei Pazzi. He must have been a near contemporary of Giorgio's. Jacopo Coppi was another senior artist. Mirabello Cavalori was a painter of independent status, probably much of an age with

[17] P. Barocchi, "Appunti su Francesco Morandi da Poppi," *MKIF*, x, 1961–63, pp. 117–48; Life by Baldinucci, Pecchiai, *Le vite*, iii, p. 1826. For Maso da S. Friano see P. Cannon Brookes in *Apollo*, xcii, 1970, pp. 346–49.

[18] Frey ii, p. 578.

Vasari. His *Wool Workers* shows him to have been capable of bold design and control of space.

Most remarkable was the influence of this undertaking on some of the younger artists. Maso Manzuoli, called Maso da S. Friano, "a man of about thirty or thirty-five years," had attracted attention by his *Visitation*, now in the Fitzwilliam Museum, Cambridge, which Vasari thought no practiced and old master could have done better. But neither this nor others of his earlier works suggest the imaginative grouping, sense of space and clarity of color of his *Diamond Mines* [211], which holds a place of honor on one of the end walls. Maso died soon afterwards in 1571 and his promise missed fulfillment. Girolamo Macchietti had a longer life, dying in 1592, but his later works do not equal the strange rhythms and originality of his *Baths of Pozzuoli* [212], where the large enveloping bath sheet swings across

210. Stradano, *Alchemy*. Florence, Palazzo Vecchio, Studiolo

On the right Francesco is busied with an experiment advised by a spectacled scientist.

Below

211. Maso da S. Friano, *Diamond Mines*. Florence, Palazzo Vecchio, Studiolo

"The diamonds lie in a heap, while the overseer bargains with eastern merchants. The rocks covered with pulleys are an extraordinary piece of fantasy."

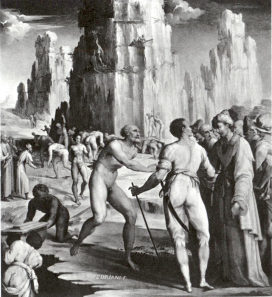

the space with an almost abstract quality; and in his *Medea and Jason*
Parmigianino's type of surrealism is pushed further into uneasy inten-
sity. Andrea del Minga's *Deucalion and Pirra* has a certain vigor, and
Alessandro Fei del Barbiere's *Goldsmiths* [213] is nicely competent.
Both men were still in their twenties, and in 1571 Fei for a time
assisted Vasari in his papal commissions in Rome. Battista Naldini, a
year or two older, was another of Borghini's protégés, brought up by
him in the hospital of the Innocents. As a boy he had worked in Pon-
tormo's studio, and for the last ten years he had played a steadily
increasing role as Vasari's assistant in the Palazzo Vecchio. Giorgio
obviously prized his services but in 1571 there was something of a
breach between them. "If Battista is not altogether in the right," Bor-
ghini wrote to Giorgio, "perhaps he is not altogether in the wrong."
Bishop Minerbetti, always ready with advice, also felt called upon to

212. Macchietti, *Baths of Pozzuoli*. Florence,
Palazzo Vecchio, Studiolo

Right

213. Fei, *Goldsmiths*. Florence, Palazzo Vecchio,
Studiolo

In the foreground Cellini works on the grand-
ducal crown. In the background Francesco walks
through the Uffizi gallery with one of his dogs.

intervene.[19] Naldini was one of the assistants to whom some of the large altarpieces of the altered churches of S. Maria Novella and S. Croce had been entrusted, but when working on his own, without Vasari's underlying cartoons, his heavy figures build up into unsatisfactory designs, and a naturalistic solidity replaces the *grazia* of the Manneristic tradition, without a new and appropriate *disegno* being invented. His *Allegory of Dreams* and *Whale Hunting* [214] in the Studiolo make a bold display of chiaroscuro, but remain clumsy pieces. They were, however, according to Borghini, perhaps partial to Naldini

[19] Frey II, pp. 568, 574.

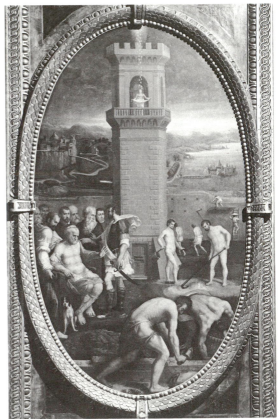

214. Naldini, *Whale Hunting*. Florence, Palazzo Vecchio, Studiolo

"In the background is a stranded whale. In the foreground amber is being collected on the shore."

Below

215. Traballesi, *Danaë*. Florence, Palazzo Vecchio, Studiolo

as a boy from the Ospedale, much admired. Bartolomeo Traballesi, Domenico Buti and Vittorio Casini were others of the younger men, artists whose exact dates are unknown and whose work elsewhere is hardly recorded; but they were capable here of paintings of some merit and Traballesi's *Danaë* [215], where the golden shower falls on a small figure at the top of a tower, is one of the strangest and most fanciful pieces of the whole collection. The challenge of unprecedented subjects and a new interpretation of old myths roused a response that makes this small room curiously idiosyncratic. It was a situation where competitive feelings must have been strongly felt, all the more that a free hand seems to have been given and it was no longer a matter of carrying out the old master's designs. "These your arts, or rather your artists," wrote Borghini to Vasari, "are full of envy, malice and quarrels. . . . Some say that you give a painting to be done by Jacopo [Zucchi] and then pass it under your name."[20] There was something of a revolt against a long domination. There were, too, elements of a return to naturalism, mixing with more Mannerist conventions. Macchietti's bather stretches up boldly for his great towel, but in the background is the familiar figure of Masaccio's shivering man, the key piece of quattrocento realism. Eventually the new ideas were to find a mouthpiece in Raffaelo Borghini, the great-nephew of Vincenzo, whose book *Il Riposo*, published in Florence in 1584, contains considerable criticism of Vasari, both for invention and execution, with the final judgment that he was a rapid and prolific painter, and well-skilled in architecture.

Vasari himself amongst these young enthusiasts seems to have found a stimulus for one of his most pleasing works, *Perseus and Andromeda* [216]. As he entered in his *Ricordanze*, the head of the Medusa bleeds into the sea and from this coral is created. Whatever the new strictness of the Counter-Reformation, it was possible in the prince's Studiolo to represent a highly attractive nude. Borghini thought it much the best of all the paintings.

The *Perseus* was painted in 1570. In December of that year Vasari left for Rome, summoned by Pope Pius V. He had already had contacts with Pius, and on a visit to Rome in 1567 had a two hours' session with him discussing a scheme for the church of Boscomarengo, the pope's birthplace in northern Italy, near Alessandria, where he wished to have his tomb. Vasari designed for him a high altar, inset with paintings, similar to his own memorial in the Pieve at Arezzo. The latter had been authorized by Pius, who had sent, Vasari characteristically notes, the bull gratis, and it was the model for this new undertaking. The frontal painting of the altar was a *Last Judgment*,

[20] Frey II, pp. 567–72, one of the most illuminating of all Borghini's letters.

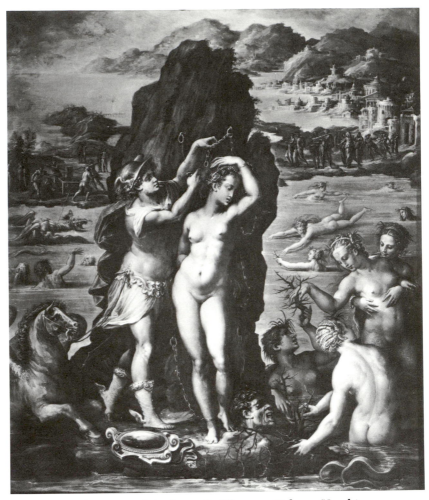

216. Vasari, *Perseus and Andromeda*. Florence, Palazzo Vecchio, Studiolo

and on the back was represented the murder of St. Peter Martyr, the great persecutor of heretics, a theme well suited to a Dominican pope who had been Inquisitor General in Rome. The paintings, designed by Vasari, were largely carried out by Poppi, with softer, more painterly outlines than those of his master. As earlier in the collaboration with Cristofano Gherardi, there is a studio style, wider than the master's own accomplishment.[21]

Pius was a new type of patron, very different in his requirements

[21] M. Viale, *La chiesa di S. Croce a Bosco Marengo*, Turin, 1959; for the Arezzo shrine see Frey III, pp. 120–32. There is a drawing for the Boscomarengo altar at Turin, Biblioteca Reale, no. 431. The altar has been dismantled, but the paintings are arranged along the side of the church.

from Cardinal Ippolito de' Medici or Cardinal Alessandro Farnese, very different, too, from the genial piety, blended with humanism, of Borghini or Miniato Pitti. Some of the prized ancient sculpture was removed from the Vatican, and the pope himself would have liked all of it to be transferred elsewhere. Giorgio, sincerely but conventionally devout, was more attuned to the easier-going religious practices of earlier days, when monks and priests could be laughed at, and deeper religious emotions were kept for times of crisis. The independent attitude of the Florence of Savonarola survived in him, and he saw nothing surprising in his identification (almost certainly wrong) of this condemned heretic amongst the fathers of the Church in Raphael's *Disputa*. It was again to Savonarola that he compared the preaching of Don Gabriel Fiamma in S. Lorenzo in writing of this new friend to Michelangelo, another devotee of the martyred friar. Don Gabriel became very intimate with the Vasari household, and exchanged sonnets as well as letters with Giorgio. These suggest a lively enthusiasm, rather than post-Tridentine severity, but we know nothing of the content of the sermons. He ended up in the not very distinguished post of bishop of Chioggia.[22]

But if the Rome of Pius V was not immediately congenial to Giorgio, he soon adapted himself to it, and found the pope a sympathetic master. Serious criticisms of popes were only made when, like Adrian VI or Paul IV, they failed altogether to encourage the arts. Pius had several claims on his allegiance, for it was he who conferred on Cosimo, despite imperial disapproval, the title of Archduke, solemnly crowning him in the Sistine Chapel on 5 March 1570. Relations between Cosimo and the papal see had been steadily improving, and in 1567, when Vasari was visiting Pius, Cosimo had at length allowed Archbishop Antonio Altoviti, son of Giorgio's old friend, to make his formal entry into Florence. There was, too, a more intimate bond for Giorgio in Rome. At several places in the *Vite* Vasari takes notice of the children in households that he visited, and, true Italian that he was, he had a ready affection for them. His own marriage being childless, he took great interest in his brother Pietro's sons, and he had obtained the freehold of his house in Borgo S. Croce in order to leave it to his nephews. For one of the boys, Marcantonio [217], he obtained in 1569 a place in the college in Rome where the pope's own nephews were being educated. Guglielmo Sangalletti, a Florentine whom Vasari had long known, was now an official much in the confidence of Pius V, and of the papal kinsman, Michele Bonello, who had been created cardinal in 1566, Cardinal Alessandrino as he was called. He and Sangalletti

[22] Frey I, pp. 508–15, 523, 531–34, 572, 576, 645, 651. The letters run from 1558 to 1571. For the sonnets see Scoti-Bertinelli, *Vasari scrittore*, pp. 266–67, 276–77.

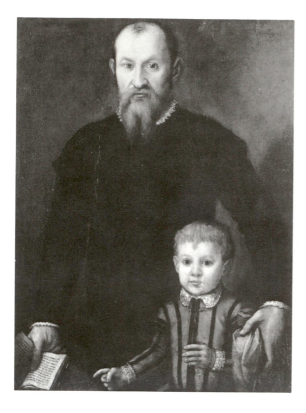

217. Vasari, *Self-portrait with his Nephew Marc-antonio*

This portrait, sold at Christie's on 5 December 1969, is probably not from Vasari's hand, but may be either a copy of a painting by him, or by one of the studio.

Opposite, above

218. Vasari, *Tobias and the Angel.* Vatican, Chapel of St. Michael

Opposite, below

219. Vasari, *The Preaching of St. Peter Martyr.* Vatican, Chapel of St. Peter Martyr

According to the legend the devil took the form of a horse to disturb the saint's discourse with its galloping.

were largely responsible for furthering Vasari's employment in the Vatican. There were many occasions on which the work required communications from Sangalletti in Rome to Giorgio in Florence, and in all of them there are messages about Marcantonio and what a promising boy he is. Another friend was interesting himself in Marcantonio, Alessandro de' Medici, son of Giorgio's Don Ottaviano, shortly to be archbishop of Florence and for a brief month in 1605 to be Pope Leo XI.[23]

In the Vatican in 1570 Vasari was given three chapels to decorate in the Torre Pio, part of the pope's new building activities. They were dedicated to St. Stephen, St. Peter Martyr and the Archangel Michael. On this occasion Vasari brought Zucchi with him, and he had a large part in converting Vasari's designs into fresco, though Giorgio found him "tiresome and touchy" ("malignuzzo e invidiosello").[24] The results are curiously uneven. In the chapel of St. Michael the small scenes round the drum, such as *Tobias and the Angel* [218], have charm and individuality, the charm of Zucchi rather than Vasari; but much of the work, particularly the scenes of the life of St. Peter Martyr, has a flatness of statement in line with other Roman work of the time. One

[23] A. del Vita in *Vasari*, VII, 1935, pp. 44–64.
[24] Frey II, p. 741; A. Calagno in *Vasari*, V, 1932, pp. 39–56.

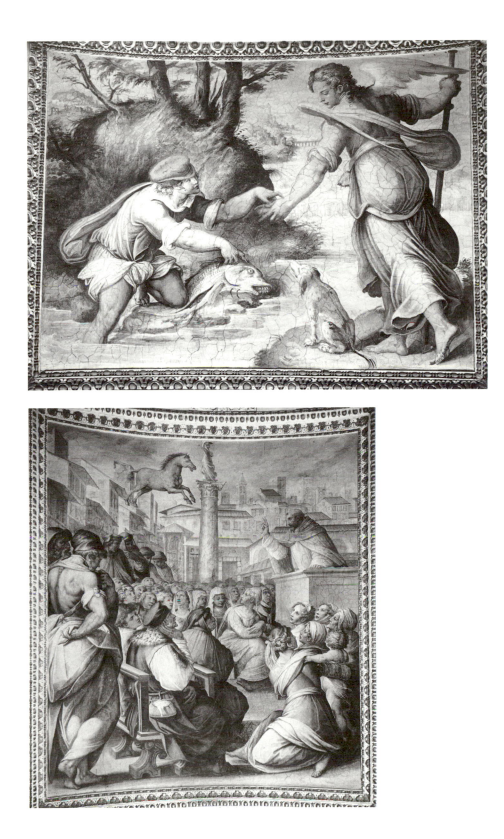

of the saint's miracles, when he stopped a galloping horse that was interrupting his preaching, becomes in Vasari's treatment a slightly ludicrous episode [219]. In the altarpiece for St. Stephen's chapel depicting the saint's martyrdom, a subject Vasari was also to paint for the Pisan church of the Knights of St. Stephen, some of the old rhythms are apparent. The three chapels were completed in eight months. Even for Giorgio, there had been little time for meditation on the work. The pope, however, was pleased with it and Vasari in June 1571 was created by him a knight of the Golden Spur of the Order of St. Peter. The knighting was accompanied by the gift of a pension, a white horse, one of the prestige symbols of the day, and a golden chain and badge, which Vasari shows around his neck in his self-portrait [220]. Marcantonio was not forgotten and he also seems to have received some papal grant.[25] Cosina, too, who had come to Rome, was allowed a special tour of all parts of the Vatican, an enviable privilege. Cosimo Bartoli wrote to him from Venice a warm letter of congratulations on the theme of merit being recognized. And to be working in the Vatican, on this triple tier of chapels in its very heart, must have been a great satisfaction. "To speak true," he wrote to Prince Francesco, "my thoughts are still in the Sala Grande, but for all that I will serve the pope to the best of my ability. It is only what I ought to do, for since Raphael and Michelangelo have painted here it is my duty to your Highness and myself not to fall behind them." Poor Giorgio! As the crowds pass rapidly through the chapel of St. Peter Martyr or that of St. Michael on their way to the Sistine Chapel or the Stanze, few glances are cast at his frescoes, and the lowest chapel, that of St. Stephen, is now a library office.

In Florence he was still full of commitments. In 1568 there had been the large *Assumption* for the Badia; for the new altarpieces in S. Croce there were the *Incredulity of St. Thomas* (1569) and the *Road to Calvary* (1570–71); and for S. Maria Novella the *Madonna of the Rosary* (1569–70), where the fashionable propaganda results in overcrowded confusion [138]; and the *Resurrection* [170], whose theological subtleties are by now a little out of date. Federico da Montaguto was hoping for an altarpiece for a monastery on his lands; he trusted

[25] Frey II, p. 592, III, pp. 155–58.

220. Vasari, *Self-portrait*. Florence, Uffizi

Vasari nowhere gives particulars of this painting, but the papal chain, unless this is a later addition, places it in the year 1571, when he was sixty years old.

that Vasari would not be hindered from painting it by other business, and in due course Vasari was at work on it.

In the Palazzo Vecchio the last paintings of the Sala dei Cinque-cento were being completed and on 9 January 1572 the whole series was formally unveiled. But on what for him must have been a great occasion, Vasari was not present. In the previous month he had returned to Rome where the pope was insistent that the Sala Regia, so long a contentious question, should be given its full decoration of frescoes [221]. When work had been renewed there under Pius IV, Vasari had been approached but replied that Rome did not lack men

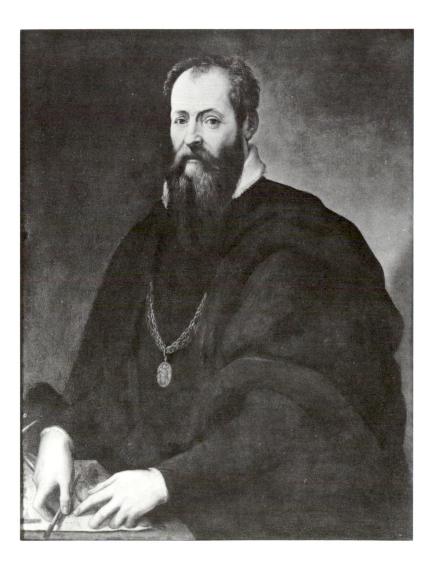

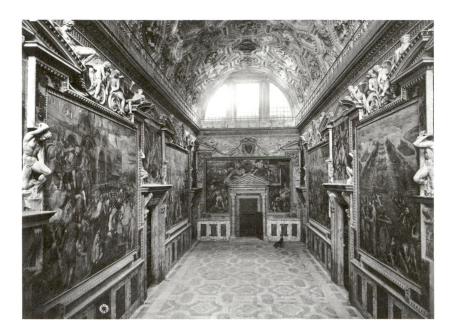

Opposite, above

221. Sala Regia, Vatican

If the paintings are on the whole undistin-
guished, the scheme of decoration is one of the
most splendid in the Vatican.

Opposite, below

222. Vasari, *Battle of Lepanto*. Vatican, Sala
Regia

Much of the work on this fresco was carried
out by Lorenzo Sabbatini, but the design is by
Vasari, and the allegorical figures are mainly by
his hand.

223. Vasari, *Return of Gregory XI from Avignon*.
Vatican, Sala Regia

The pope is a portrait of Gregory XIII, and the
scene is anachronistically set in the piazza of St.
Peter's as it was in Vasari's time. St. Catherine
of Siena, shown leading the procession, was not
in fact present, though she had advocated the re-
turn from Avignon.

for the task and that he could not leave his "much larger hall" in Florence. The papal official then turned to some younger men such as Livio Agresti of Forlì and Girolamo Siciolante of Sermoneta. Taddeo Zuccaro begged Cardinal Farnese to put his name forward, but the latter did not wish to delay the work at Caprarola. In the end, however, Taddeo received the wall with the entry into the Pauline Chapel, where he painted the Emperor Charlemagne confirming Pepin's donation, a subject in conformity with the general theme of papal power. Now Vasari was instructed to celebrate on the walls the great victory over the Turkish fleet at Lepanto on 7 October 1571. Pius had been much involved in the Holy League which had led to this success, and it was a subject that roused Vasari's own enthusiasm. Rumors of danger from the Turks are frequent in the *Vite* ever since Ippolito de' Medici had departed to fight them in Hungary. In his Pisan palace Giorgio had been working for an order created to combat them. His detailed *ragionamento* is clearly heartfelt, but the two large works devoted to the battle are records not inventions [222]. While he was working on them Pius V died on 7 May 1572, and Vasari returned to Florence.

He was not, however, to remain there, for the new pope, Gregory XIII, summoned him back to Rome. He was unwilling to go, but Cosimo insisted that this was an invitation that could not be refused. Gregory treated him in Rome as a distinguished guest, giving him rooms in the Belvedere, and turning out one of the cardinals so that he should have more space. It was the group of rooms now forming the first two apartments of the Etruscan Museum, and one of them had some years previously been given a painted frieze of the life of Moses by Federico Zuccaro. Fortunately, whatever his relations with Federico, Vasari thought them well done. Pleased with his quarters, Giorgio threw himself into the work with his usual enthusiasm, and perhaps more than his usual confidence. His subjects were the excommunication of Frederick II by Gregory IX and the return of Gregory XI from Avignon [223], both incidents that by similarity of name were compliments to Gregory XIII. Two other paintings followed, scenes of the Massacre of St. Bartholomew [224] in Paris in August of 1572, a sorry pendant to the triumph of the Holy League at Lepanto. The pope was delighted, so Vasari complacently wrote, with the work, and in particular promised he would do something for the much cherished Marcantonio.

By early June Vasari was back in Florence, coming by easy stages, riding twenty miles a day in the cool of the mornings and evenings. He stayed with Cardinal Farnese at Caprarola, and then went by Orvieto to Arezzo and his estate at Frassineto. En route to Florence he

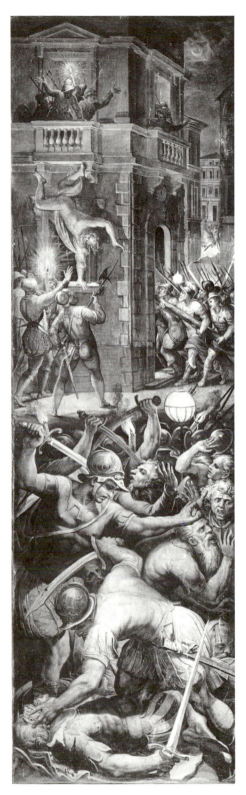

224. Vasari, *Massacre of St. Bartholomew*. Vatican, Sala Regia

Francesco de' Medici wrote to Vasari that he was glad to hear that His Holiness had decided to have painted "so holy and notable a deed as the retribution meted out to the Huguenots in France."

paid a last visit to Camaldoli, where Cosina had been given papal permission to enter the lower abbey.[26]

He had returned to undertake the frescoing of Brunelleschi's dome. It had been under discussion for some time, and Giorgio represents himself as talking it over with Francesco at the end of what must have been the final draft of the *Ragionamenti*, "this superb and marvelous fabric of the cupola . . . which, if there were nothing else, would render our city famous." He had seen Correggio's domes in Parma, "marvelously foreshortened as seen from below," but this great innovation was not realized by him as such, and receives no special tribute in his summing up of Correggio's work. He seems to have been more impressed by the semi-dome in SS. Apostoli at Rome painted by Melozzo da Forlì, "where the figure of Christ is so well foreshortened that he appears to make a hole through the vault." Melozzo, however, was not even given a *Life*, and occurs only as a sub-heading under Benozzo Gozzoli, because, Vasari states, there was much confusion between their names, a confusion shared by himself in the first edition where the SS. Apostoli frescoes are assigned to Benozzo. He came to the problem of the dome singularly little prepared for it, and the cupola itself was singularly unsuitable for painting. Its great scale and height meant that only the very boldest design would be visible, but Vasari and Borghini worked out a dense and complicated scheme. Instead of the upward thrust of Correggio or Melozzo this is arranged in a downward movement. The eight compartments are divided into descending rows of heavenly powers, with groups below illustrating various virtues and categories of men, and finally scenes of the Last Judgment. The central figure of Christ, with his downward glance, is closely based on that of Michelangelo.

His old patron Cosimo was rapidly failing. Giorgio went to visit him and found him able to see and hear, but little else. "I have been," he wrote to the cardinal of Como, "overjoyed to find him living, and much afflicted that when I spoke to him he could only reply with signs. . . . With what thoughts must I mount the stairs of the cupola."[27] Already earlier he had written to Francesco that "Giorgio is growing old, losing his memory, and his *virtù* consumes itself and death is the end of every story." "Now I am an outworn garment," he puts it in another letter, and begins: "la mia vita non gli puo più," "I can no more."[28] Dissolution of bodily force came on more painfully then than now, and more rapidly. The winter of 1572–73 had been a very hard one, difficult for these aging men. Old friends were disappearing. We have no record of the death of Miniato Pitti, but the name of this tried

[26] Frey II, p. 790. [27] Frey II, p. 792. [28] Frey II, pp. 446, 671, 754, 772.

friend does not recur in the correspondence after the summer of 1565, and he probably died shortly after that date. Benedetto Varchi died in 1565, Annibale Caro the following year. Cellini ended his stormy career in 1571, and in November 1572 Borghini wrote to Giorgio in Rome telling him of the death of "that good, pleasant and worthy man," Bronzino, a month earlier. Bishop Ricasoli had died a few days previously. In this same sad autumn Vasari lost a very close friend, to whom almost as much as Borghini he was indebted for assistance in his researches, Cosimo Bartoli; he had returned from Venice an ailing man, for whom the baths at Padua had done nothing, but he only reached his beloved Florence for the end to come. Mortality was much in mind. "Wield your brush," Bishop Minerbetti wrote to him, "which will live long after you, and lose no time, for we are of an age when hope of regaining any particle of it is vain." "Be prepared," wrote Borghini, "for everywhere I seem to perceive death in the weight of the world's affairs." And amongst others there had died in 1570 obscurely in Florence an old lady whom surely Giorgio had not seen for many a day, Lucrezia del Fede, the wife of his first master. Jacopo da Empoli was to record how as a boy copying the frescoes in the cloister of SS. Annunziata she had spoken with him "not without tears" and had pointed out the portraits in her husband's paintings, including one of herself in the *Nativity of the Virgin*.[29]

Now in his new task, Giorgio felt his years. He could not manage to clamber up the scaffolding to the dizzy height of the dome, and had to be pulled up in a basket. Did he remember chronicling how Barna fell to his death from scaffolding in S. Gimignano, and how Nanni di Baccio Bigio fell from a high scaffolding in St. Peter's but miraculously was preserved? Then on 21 April 1574 Cosimo died. He had been a man of many faults and weaknesses, but he had inspired great loyalty in Giorgio, whose spirit was broken by his master's death. He followed him two months later, dying on 27 June 1574. He had made many sketches for the dome, but had only begun painting the lower circles of the design [225]. Ironically the work was handed over to one of his bitterest critics, Federico Zuccaro. There is a painting by Federico, in the Palazzo he built for himself in Rome (now the Hertziana Library) which shows himself, a vigorous, handsome man, discussing with Vincenzo Borghini a model of the cupola. With them is a lady in a widow's dress. It can only be Cosina, still faithfully trying to aid her husband's work. She survived him for ten years, dying in 1584. In the cupola itself, in the circle that Vasari had allotted to "Christian people, poor, rich and all," Federico presides with his brother

[29] F. Baldinucci, *Notizie dei professori del disegno*, Florence, 1846, III, p. 6.

Opposite

225. Vasari and Federico Zuccaro, Frescoes (detail) in the cupola of the cathedral, Florence

In the lowest circle are the tortures of the damned; above, angels blow trumpets. In the right-hand group of the third row can be seen Zuccaro, Vasari, Borghini and Ammanati.

226. Federico Zuccaro, *Discussion of Frescoes for the Cupola of the Cathedral, Florence*, sketch. Florence, Uffizi

Zuccaro shows himself on the left discussing with Borghini the layout of the frescoes. Raffaele Borghini points to a model of the cupola, a sketch of which lies before them. The aged Vasari leans half asleep on the table; his wife, Cosina, stands in the background.

Taddeo at his shoulder. The aged Giorgio sits below him. It is perhaps as well that, except in unusually strong light, it is not decipherable from below.[30]

He had had many friends. He lives in his correspondence more vividly than in the *Vite*, and in the letters mutual affection speaks beyond mistake. He has the reputation of self-conceit, and there is an undeniable self-satisfaction in the achievement of his aims. "If I can," he had written as a young man to Niccolò Vespucci, "I hope to rise to be among the number of those who by their excellent works have honored rewards." He had fulfilled his desires. He had been able to provide for his family; he was prosperous and respected; in 1571, the last year of his *Ricordanze*, his earnings were 4,865 scudi, compared to the seventeen scudi he had received in 1530; he had always been careful: "If men realized that they might live till they could no longer work, many would not be forced to beg in their old age that which they had squandered in their youth."[31] The *Vite* had brought him international renown. He could as a result of it all be at times ponderous and pompous. The manners of his day required subservience to princes, and Giorgio was nothing if not conventional.

Since the Sienese war of 1554 Florence had enjoyed peace and prosperity. There was no doubt only a limited freedom, and men's lives and property were at the risk of their ruler's caprice, but compared to Rome Florentine rule had many tolerances. The Inquisition was kept in check: books rather than human beings were burned and even here Cosimo intervened in the interests of scientific study when the Dominicans of S. Marco sought over-enthusiastically to purge their library. A heretical thinker such as Pietro Carnesecchi might be surrendered to papal demands, but it was in Rome not Florence that in 1567 he was executed. Taxation might be heavy, but Tuscany had few famines, and Cosimo's scientific interests were applied to the encouragement of agriculture. Urban care seems to have reduced the incidence of plague, though malaria remained a scourge in the country districts. Trade was protected by measures against the Turkish pirates such as the fortification of Porto Ercole and Porto Ferraio on Isola d'Elba, and by the extension of harbor facilities at Livorno. At the end of his long study of Florentine history Vasari could conclude his *Ragionamenti* on the decorations of the Palazzo Vecchio with a passage where he compares present peace with past dissensions: "When I con-

[30] B. Heikamp, "Federico Zucchari a Firenze 1575–79," *Paragone*, XVIII, 1967, no. 205, pp. 44–61, no. 207, pp. 4–34; *Mostra di disegni degli Zuccari*, ed. J. Gere, Uffizi, 1966, p. 44. A sketch in the Uffizi for the Hertziana picture shows the aged Vasari half asleep in one corner [226]. In the actual painting he is omitted and the woman is more clearly characterized and given her widow's dress.

[31] *M*, II, p. 431.

sider the quiet, repose and peace that we enjoy at present and compare it with the wars, seditions and ancient troubles, and the famine and pestilence, suffered in this city, it seems to me that all these many labors of former citizens and of your ancestors have been as it were a ladder for the lord Duke Cosimo to come into the present glory and felicity." In remote England a young boy was learning similar thoughts:

> Now civil wounds are stopped, peace lives again:
> That she may live long here, God say amen![32]

To Vasari Cosimo had one great virtue, a decisive mind that knew what it wanted. Writing in the *Life* of the Rossellini brothers he states of Pope Nicholas V that he was "of great and resolute mind, and of such good understanding that he guided and controlled the artists no less than they did him, which makes for great undertakings being brought easily to an end, when the patron understands what is needed, and is capable of prompt decisions; whereas an irresolute and incapable man, hesitating between yes and no, between various designs and opinions, allows much time to pass uselessly without any work being done." This describes Giorgio's own relationship with his master. As Michelangelo often said to him, "Thank God for giving you a patron like Duke Cosimo." The artist on his side, as Vasari often notes, had his obligations. He knew that he undertook too much: "I am as I can, not as I ought to be," he once wrote, "and that comes from my being too much at the will of others,"[33] but he had little patience with those who failed to complete their contracts within a reasonable space of the appointed time. "Giorgio is most prompt."

In his religious thought as it appears throughout his writings he has, as has been said, a conventional piety, of which there is no reason to question the genuineness. In a striking passage in the *Life* of Bandinelli, he criticizes the latter's work on the tomb of Clement VII because he had made the figure of the pope larger than the supporting saints, the two St. Johns, thereby "showing either little religion or too much adulation, or the one and the other together, in that he made sanctified men, the first founders of our religion after Christ, and the most pleasing to God, inferior to the popes . . . for it seems to me that religion, meaning ours that is the true religion, ought to be placed by men above all other things and loyalties, and that the praise of any person must be kept within bounds." There is about these words the tone of Florence, when the preaching of Savonarola was

[32] Shakespeare, *Richard III*, v, iv, 53–54.
[33] Frey I, p. 133.

still remembered. In another place, writing of Lorenzo Lotto, he
reflects on his pious end, and how wise he was not to remain "too
deeply involved in the things of this world, which weigh down those
who place their trust in them, and never let them raise their minds to
the true good of the other life, and to the highest blessedness and
felicity."

In the Villa Albani there is a strange picture long attributed to
Vasari, though he makes no mention of it in the *Ricordanze* and, unless
a very late work which stylistically is possible, it should probably be
assigned to a follower. Its program is, however, pure Vasari. It is gen-
erally known as the *Allegory of the Redemption of the Human Race*
[227], from a scroll at the top of the painting: HUMANAE RECONCILIA-
TIONIS IMAGO. Beneath, on a cloud is God the Father supporting the
dead Christ, but this is not a Trinity and there is no dove. In the
earthly landscape there is on one side the Temptation of Eve and the
Expulsion; on the other the Crucifixion and the Return of the Prodigal
Son. The central group is composed of two cloaked female figures.
Justice holds a vast, drawn sword, of which the raised point seems
almost to touch Christ's wounded side. A naked putto stands beside
her holding the scales. Opposite, Mercy seizes the pointing hand of
Justice as though to avert the gesture from a small naked figure
crouching in the folds of her cloak. It is the many-breasted Diana of
the Ephesians kneeling with clasped hands raised in appeal. Between
the two chief figures is the globe of the world, and below is inscribed
MISERICORDIA SUPEREXALTATA JUDICIUM, "Mercy exalted above Justice."
Full of strange symbols, the exact *ragionamento* is hard to reconstruct.
Diana we know, represented in both his houses, had meant something
very personal to Vasari, possibly the admired pagan world against
whose art the Church at times could be merciless.[34]

These are obscure problems, whereas Giorgio's essential character-
istic is his normality. He led a busy, decent, prosperous, happily mar-
ried life amid all the turmoils and scandals that fill more strikingly
the narratives of the times. In his constant travels he met with no
adventures except bad weather. His home was friendly and hospitable.
Childless, he cared for his nephews, having discharged his family obli-
gations to his sisters. He avoided wars, and no hired assassins lurked
around his house in the Borgo S. Croce. It is the cinquecento at its
most domestic. Cosimo's daughter and daughter-in-law were to be
murdered by their husbands, providing thereby plots for English
Jacobean dramatists. It is good to remember that this great period as
well as its *causes célèbres* had its own sanities and homeliness. Gior-
gio's chief dislikes, slackness in work, overindulgence in pleasure, unre-

[34] P. Barocchi attributes the *Allegory* to Gherardi, "Complementi al Vasari pit-
tore," p. 273.

227. Vasari (?), *Allegory of the Redemption of the Human Race*. Rome, Villa Albani

liability, were not unreasonable objects of antipathy. In his apprecia-
tion of the work of others, he is eager to praise, and there is little
trace of the envy that he often characterized as the besetting sin of
his profession. The Florentine Academy of Design, in which with Bor-
ghini's aid he had been a prime mover, was an example followed else-
where, notably in Rome with the foundation in 1593 of the Accademia
di S. Luca, of which the inevitable Federico Zuccaro was the first
president. His own art, whether in painting or architecture, is too
studied, too theoretic to have life-enhancing qualities, but his writing
came from a generous and ceaselessly interested mind, whether in art
or life. His industry and application will always be things to wonder
at. The words he himself wrote of Filippo Brunelleschi could serve to
summarize his own career: "He never uselessly wasted time, but was
always busy with his own work or that of others who needed him, and
he was always calling in upon his friends and helping them."

Appendices

Appendix A: Silvano Razzi

The success of the *Vite* seems to have led to some claims as to participation in the work. The statement attributed to Miniato Pitti (Gaye, *Carteggio*, I, p. 50) that Vasari had neglected all his advice in the second edition can be disregarded, given the tone of their correspondence up to the last letter from him in 1563 (Frey II, p. 9). The Camaldoline friar, Silvano Razzi, certainly worked on the revision (Frey II, p. 24), but it is impossible to assess how much was due to him, or to give any great weight to the statement made by Giulio Negri (*Istoria degli scrittori fiorentini*, Ferrara, 1722) that "he wrote several lives of illustrious painters which were printed by his close friend Giorgio Vasari with his own in three volumes in Florence 1568."

Appendix B: Travel

Vasari gives little information about the problems of travel. It was certainly carried out on post horses. Bishop Minerbetti states in one letter (Frey I, p. 327) that he has been riding nine posts a day, and a post can hardly have been less than 10 miles; but 90 miles a day would certainly mean at least nine hours in the saddle, and must have been a forced journey. For shorter expeditions such as Florence to Pistoia (40 kilometers) one horse was sufficient (Miniato Pitti arranged for Vasari to have a horse to visit him in Pistoia: Frey I, p. 20). There is frequent complaint about rain and mud (1566 seems to have been a very wet summer), but nothing about dangers from brigands. Some old posting houses remain, particularly in the Montepulciano area, and seem to have been about 15 kilometers apart. The journey from Ferrara to Florence is approximately 153 kilometers and took four days. This means an average of about 40 kilometers a day. The crossing of the Apennines must have slowed down the rate of progress. In 1573, riding with Cosina by easy stages from Rome to Florence, Vasari made 20 miles a day.

Presumably in his later years Vasari owned some horses, including the white steed presented by the pope. They could have been stabled in the ground floor of the house in the Borgo S. Croce.

Appendix C: Vasari in Padua

On none of the journeys are there letters from Padua, and it is probable that Vasari never stayed there, but only visited it briefly. In the first edition, repeated with little change in the second, there is an account of Donatello's *Gattamelata* and the reliefs in Il Santo that is clearly based on personal knowledge. In the *Life* of Mantegna there is in the second edition a passage on the Eremitani frescoes, but this is closely based on Bernardino Scardeoni's *De antiquitate urbis Patavii*, which had been published in 1560. The very confused description does not suggest that Vasari had personal knowledge of them.

Select Bibliography

The Lives and Letters

References to the *Lives* are given to the edition by Gaetano Milanesi (*Le opere di Giorgio Vasari, con nuove annotazioni e commenti,* 9 vols., Florence, 1875–85). The edition by Pio Pecchiai (3 vols., Milan, 1928–30) is valuable for its lavish illustration. There is a useful account of the various editions and the textual history of the work by Paola Barocchi in Vol. I, *Commento,* in the edition of the *Vite* (Florence, 1966–) in course of publication under the joint editorship of herself and R. Bettarini. This gives the text of both Vasari's first and second editions, and the commentary contains extracts from a large number of critical works.

The portraits from the second edition were published separately by Giunti in 1568.

Many of the *Lives* have been published in separate editions. Of these the outstanding example is Paola Barocchi, *La vita di Michelangelo nelle redazioni del 1550 e del 1568,* 5 vols., Milan, 1962. There is a volume of *Vite scelte* with useful notes edited by A. M. Brizio, Turin, 1964.

Vasari's letters, over whose rediscovery and assignment there was something of an international incident, were published by Karl Frey in 1923 and 1930 in his two volumes *Der literarische Nachlass Giorgio Vasaris,* followed by a third volume in 1940, *Neue Briefe von Giorgio Vasari,* published by H. W. Frey. An Italian translation of the first volume was made by G. Tomassetti, 1923, and much of the second and third volumes was translated by A. del Vita in *Il Vasari* beginning in Vol. I, 1927, and completed in 1941. The letters and other documents are now deposited in the Archivio in Vasari's house in Arezzo.

English Translations

The first English translation of Vasari (eleven *Lives,* abridged), was made by William Aglionby in 1685, and republished in 1719 as *Choice Observations upon the Art of the Painters, together with Vasari's Lives of the most Eminent Painters from Cimabue to the Time of Raphael and Michel Angelo.* The *Lives* translated were, as termed by Aglionby:

Cimabue, Ghiotto, Lionardo da Vinci, Andrea del Sarto, Raphael d'Urbin, Giorgione, Michel Angelo, Giulio Romano, Perino del Vaga, Titian, Donato, a Sculptor. The vigorous, if sometimes free, translation catches the mood of Vasari better than many later versions. The first complete English translation was made by Mrs. J. Foster (5 vols.) in 1850. The standard English version is that of G. du C. de Vere, 10 vols., London and New York, 1912. The Temple Classics edition translated by A. B. Hinds in 1900 and reprinted, edited by William Gaunt, in the Everyman's Library, 4 vols., 1963, has the great advantage of portability, but the translation is not always reliable.

While indebted to various English texts, I have used my own translations of passages quoted, with the exception of those from L. S. Maclehose's *Vasari on Technique, being the Introduction to the Three Arts of Design*, where the translation cannot I think be bettered, and where G. B. Brown's commentary is also of great use (first published, London, 1907: reprinted Dover Publications Inc., New York, 1960). There is a lively translation of a short selection of *Lives* by George Bull (Penguin Classics, London, Baltimore and Ringwood, Australia, 1965).

Other Works by Vasari

Lo zibaldone, Rome, 1938; *Il libro delle ricordanze*, Arezzo, 1938 (also printed in Frey II); *Inventario e regesto dei manoscritti dell'Archivio Vasariano*, Rome, 1938: all published by Alessandro del Vita, first in his periodical *Vasari, Rivista d'Arte e di Studi Vasariani*, Arezzo, 1927–1943 and 1957– , then in separate editions.

The *Descrizione dell'apparato* for the marriage of Francesco to Joanna of Austria, written for Vasari by Domenico Mellina and Giovanni Battista Cini, and printed in 1556, was included by Vasari in the second edition, as was also his own *Ragionamenti* for the Palazzo Vecchio and for the cupola: all are included by Milanesi and Pecchiai in their editions.

Biographies

Accounts of Vasari's life preface almost all the editions of his book, notably that by Luigi Grassi in the Club del Libro edition, Milan, I, pp. 1–17. Wolfgang Kallab's biography would have been a magisterial work, but he had only reached Vasari's return to Florence in 1532 at his untimely death in 1906. The remainder exists in the form of a year-by-year register, an extremely valuable contribution, but one that he was unable to check (published in *Vasaristudien*, Vienna and Leipzig, 1908). Pecchiai's account, in the introduction to his edition, presents

one of the more unflattering portrayals of Vasari. M. Goering and P. Gazzola give careful details and bibliographical information in Thieme-Becker, *Allgemeines Lexikon der bildenden Künstler von der Antike bis zur Gegenwart*, xxxiv, 1940, pp. 119–28.

The only monographs, however, are those by R. W. Carden (*The Life of Giorgio Vasari, A Study of the Later Renaissance in Italy*, London, 1910), published before Frey's edition of the letters had made much new material available; Einar Rud (*Giorgio Vasari, Renaissancens Kunsthistoriker*, Copenhagen, 1961: English trs. 1963) is a pleasantly written book but too brief for the subject matter; a short life by A. Moschetti, *Giorgio Vasari, 1511–1574*, Turin, 1934; and a popular handling of the subject by W. J. C. Arondeus, *Schilderkunstige Avanturen; Leven en Werken van Giorgio Vasari*, Amsterdam, 1946. P. Barocchi's *Vasari pittore*, Club del Libro, 1964, is the essential discussion of Vasari as a painter, supported by various articles, listed in the bibliography under her name. In knowledge of the subject she has no rival.

Catalogues

Mostra documentaria e iconografica di Palazzo Vecchio, Florence, 1957.

P. Barocchi and others, *Mostra di disegni dei fondatori dell'Accademia delle arti del disegno nel IV centenario della fondazione*, Florence, Uffizi, 1963.

P. Barocchi, *Mostra di disegni del Vasari e della sua cerchia*, Florence, Uffizi, 1964.

C. Monbeig-Goguel, *Giorgio Vasari, dessinateur et collectionneur*, Paris, Cabinet des Dessins, Musée du Louvre, 1965.

The Age of Vasari, loan exhibition, University of Notre Dame, South Bend, Indiana, and State University of New York at Binghamton, 1970.

C. Monbeig-Goguel, *Inventaire général des dessins italiens: Vasari et son temps*, Paris, Musée du Louvre, 1972.

Contemporary Sources

Scipione Ammirato, *Gli opuscoli*, Florence, 1583.

——— *Istorie fiorentine*, iii, Florence, 1641.

Pietro Aretino, *Lettere sull'arte di Pietro Aretino*, ed. F. Pertile and E. Camesasca, 4 vols., Milan, 1957–60.

R. Borghini, *Il Riposo*, Florence, 1584. Reproduced Edizione Labor, Milan, 1967.

V. Borghini, *Carteggio artistico inedito*, ed. A. Lorenzoni, Florence, 1912.

G. Bottari and S. Ticozzi, *Raccolta di lettere sulla pittura, scultura ed architettura, scritte da' più celebri personaggi dei secoli XV, XVI, XVII pubblicata da M. Gio. Bottari e continuata fino ai nostri giorni da S. Ticozzi*, 8 vols., Milan, 1822–25.

Annibale Caro, *Lettere familiari*, ed. A. Greco, Florence, 1957–61.

C. Conti, *La prima reggia di Cosimo I de' Medici nel palazzo già della Signoria di Firenze, descritta ed illustrata coll'appoggio d'un inventario inedito del 1553 e coll'aggiunta di molti altri documenti*, Florence, 1893.

G. Conti, *L'apparato per le nozze di Francesco de' Medici e di Giovanna d'Austria nelle narrazioni del tempo e da lettere inedite di Vincenzo Borghini e di Giorgio Vasari*, Florence, 1936.

Cosimo I de' Medici, *Lettere di Cosimo I de' Medici*, ed. G. Spini, Florence, 1940.

Descrizione dell'apparato fatto nel Tempio di S. Giovanni di Fiorenza per lo Battesimo della Signora prima figliuola dell'illustrissimo Don Francesco de' Medici, Florence, 1568.

A. Emiliani, *Il Bronzino*, Busto Arsizio, 1960 (with a register of letters pp. 60–92).

Filarete, *Tractat über die Baukunst*, ed. W. von Oettingen, Vienna, 1890.

C. Frey, *Sammlung ausgewählter Biographien Vasaris*, 4 vols., Berlin, 1884–87.

G. Gaye, *Carteggio inedito d'artisti dei secoli XIV, XV, XVI*, 3 vols., Florence, 1839–40.

V. Golzio, *Raffaello nei documenti*, Vatican, 1936.

Michelangelo, *Il carteggio di Michelangelo*, ed. G. G. Poggi, P. Barocchi and R. Ristori, 2 vols., Florence, 1965–67.

—— *I ricordi di Michelangelo*, ed. L. Bardeschi Giulich and P. Barocchi, Florence, 1970.

E. H. Ramsden, *Letters of Michelangelo*, 2 vols., New York, 1963.

Secondary Sources

I have not attempted to list general works on the Renaissance or monographs on particular artists, though many of them contain comments on Vasari. This highly selective bibliography contains books and articles specifically related to Vasari or to some of the undertakings with which he was particularly concerned.

S. L. Alpers, "Ekphrasis and Aesthetic Attitudes in Vasari's Lives," *JWCI*, xxiii, 1960, pp. 190–215.

U. Baldini, *Palazzo Vecchio e i quartieri monumentali*, Florence, 1950.

————— "La Deposizione di Giorgio Vasari per il Cardinale Ippolito de' Medici," *Rivista d'Arte*, xxviii, 1952, pp. 195–97.

————— "Un disegno del Naldini per il salone dei Cinquecento," *Rivista d'Arte*, xxviii, 1953, pp. 157–60.

F. Baldinucci, *Notizie de' professori del disegno da Cimabue in qua*, Florence, 1681–1782; 2nd ed., ed. F. Ranalli, Florence, 1845–47.

P. Bargellini, *Scoperta di Palazzo Vecchio*, Florence, 1968.

P. Barocchi, "Il Vasari pittore," *Rinascimento*, vii, 1956, pp. 187–217.

————— "Schizzo di una storia della critica cinquecentesca sulla Sistina," *Accademia Toscana di Scienze e Lettere, La Colombaria*, 1956, pp. 177–212.

————— "Il mondo antico nel rinascimento," *Atti de V Convegno Internazionale di studi sul rinascimento*, Florence, 1957, pp. 1–20.

————— "Il Vasari architetto," *Atti dell'Accademia Pontaniana*, vi, 1956–57, Naples, 1958, pp. 113–36.

————— *Vasari pittore*, Club del Libro, 1964.

————— "Appunti su Francesco Morandi da Poppi," *MKIF*, x, 1961–63, pp. 117–48.

————— "Complementi al Vasari pittore," *Atti e Memorie dell'Accademia Toscana di Scienze e Lettere, La Colombaria*, xxviii, 1963–64, pp. 253–309.

M. Baxandall, *Giotto and the Orators*, Oxford, 1971.

L. Berti, *La Casa Vasari in Arezzo e il suo Museo*, Florence, 1955.

————— *Il principe dello Studiolo*, Florence, 1967.

A. F. Blunt, *Artistic Theory in Italy 1450–1600*, Oxford, 1956.

————— "Illusionist Decoration in Central Italian Painting of the Renaissance," *Journal of the Royal Society of Arts*, 1959, pp. 309–26.

————— *Studies in Renaissance and Baroque Art Presented to Anthony Blunt*, London, 1967.

F. Bologna, *Il Roviale Spagnuolo e la pittura napoletana del cinquecento*, Naples, 1959.

W. Bombe, "Giorgio Vasaris Häuser in Florenz und Arezzo," *Belvedere*, xiii, 1928, pp. 55–59.

C. Booth, *Cosimo I, Duke of Florence*, Cambridge, 1921.

E. A. Carroll, "Lappoli, Vasari and Rosso Fiorentino," *AB*, xlix, 1967, pp. 297–304.

A. Chastel, "A propos d'une étude récente: le problème de Vasari," *Revue des Études italiennes*, vii, 1960, pp. 59–68.

I. H. Cheney, "Francesco Salviati's North Italian Journey," *AB*, xlv, 1963, pp. 336–49.

————— "Notes on Jacopino del Conte," *AB*, lii, 1970, pp. 32–40.

S. J. A. Churchill, *Bibliografia Vasariana*, Florence, 1912.

K. Clark, "Michelangelo Pittore," *Apollo*, lxxx, 1964, pp. 437–45.

K. Clark, *A Failure of Nerve: Italian Painting 1520–1535*, Oxford, 1967.

R. J. Clements, *Michelangelo's Theory of Art*, New York, 1961.

D. R. Coffin, "Pirro Ligorio and the Decoration of the Late Sixteenth Century in Ferrara," *AB*, xxxvii, 1955, pp. 167–85.

———— "Pirro Ligorio on the Nobility of the Arts," *JWCI*, xxvii, 1964, pp. 191–210.

J. Coolidge, "The Villa Giulia," *AB*, xxv, 1943, pp. 177–225.

B. F. Davidson, "Vasari's *Deposition* in Arezzo," *AB*, xxxvi, 1954, pp. 228–29.

A. G. Dickens, *The Counter Reformation*, London, 1968.

C. Dumont, *Francesco Salviati au Palais Sacchetti de Rome et la décoration murale italienne*, Institut Suisse de Rome, 1973.

H. Egger, "Vasaris Darstellung des Einzuges Gregors XI in Rom," *Zeitschrift für Kunstwissenschaft*, ii, 1948, pp. 43–48.

E. Emanuel, *Van Eyck und Vasari in Lichte neuer Tatsachen*, Tel-Aviv, 1965.

P. Frankl, *The Gothic: Literary Sources and Interpretations through Eight Centuries*, Princeton, 1960.

L. A. Ferrai, *Cosimo I de' Medici, Duca di Firenze*, Bologna, 1882.

G. Folena, "Vincenzo Borghini," *Dizionario biografico degli italiani*, 1970, pp. 680–89.

K. W. Forster, "Metaphors of Rule: Political Ideology and History in the Portraits of Cosimo I de' Medici," *MKIF*, xv, 1971, pp. 65–104.

G. F. Gamurrini, *Le opere di Giorgio Vasari in Arezzo*, Arezzo, 1911.

M. L. Gentile, "Studi sulla storiografia fiorentina alla corte di Cosimo I, *Annali della R. Scuola Normale Superiore di Pisa; Filosofia e Filologia*, xix, Pisa, 1906.

J. A. Gere, *Taddeo Zuccaro: His Development Studied in His Drawings*, London, 1969.

M. Goering and P. Gazzola, "Giorgio Vasari" in Thieme-Becker, *Allgemeines Lexikon der bildenden Künstler von der Antike bis zur Gegenwart*, xxxiv, 1940, pp. 119–28.

E. H. Gombrich, "Vasari's *Lives* and Cicero's *Brutus*," *JWCI*, xxiii, 1960, pp. 309–11.

L. Grassi, "Pensiero e significato del Vasari scrittore d'arte e biografo," in the edition of Vasari's *Vite* published by the Club del Libro, Milan, 1962– , i, pp. 1–17.

J. R. Hale, *England and the Italian Renaissance*, London, 1954.

D. Heikamp, "In margine della vita di Baccio Bandinelli del Vasari," *Paragone*, xvii, 1966, no. 191, pp. 59–62.

M. Hirst, "Three Ceiling Decorations by Francesco Salviati," *ZfK*, xxvi, 1963, pp. 146–65.

———— "Francesco Salviati's *Visitation*," *BM*, ciii, 1961, pp. 236–40.

J. Hook, *The Sack of Rome, 1527*, London, 1972.

———— "The Fall of Siena," *History Today*, xxiii, 1973, pp. 105–15.

H. Huntley, "Portraits by Vasari," *Gazette des Beaux-Arts*, 1947, pp. 23–36.

C.-A. Isermeyer, "Die Cappella Vasari und der Hochaltar in der Pieve von Arezzo," *Festschrift für C. G. Heise*, Berlin, 1950, pp. 137–53.

———— "Il Vasari e il restauro delle chiese medioevali," *Studi Vasariani*, Florence, 1952, pp. 229–36.

W. Kallab, *Vasaristudien, Quellenschriften für Kunstgeschichte und Kunsttechnik des Mittelalters*, xv, Vienna and Leipzig, 1908.

W. Chandler Kirwin, "Vasari's Tondo of Cosimo I with his Architects, Engineers and Sculptors in the Palazzo Vecchio," *MKIF*, xv, 1971, pp. 105–22.

R. Klein and H. Zerner, *Italian Art 1500–1600: Sources and Documents*, Englewood Cliffs, N.J., 1966.

R. Krautheimer, "The Beginnings of Art Historical Writing in Italy," *Studies in Early Christian, Medieval and Renaissance Art*, London, 1971, pp. 257–74.

L. Lanzi, *Storia pittorica della Italia*, Bassano, 1795–96, 2nd ed., Milan, 1824–25.

J. Larner, "The Artist and the Intellectuals in Fourteenth-Century Italy," *History*, liv, 1969, pp. 13–30.

E. Lavagnino, *La chiesa di Santo Spirito in Sassia e il mutare del gusto a Roma al tempo del Concilio di Trento*, Turin, 1962.

A. Lensi, *Palazzo Vecchio*, Milan and Rome, 1929.

A. Lorenzoni, *Vincenzo Borghini, studio critico*, Udine, 1910.

A. Manucci, *Vita di Cosimo de' Medici Primo Gran Duca di Toscana*, Bologna, 1636.

Il Marzocco, xvi, no. 31 (special number dedicated to Vasari on the fourth centenary of his birth), Florence, 31 July 1911.

C. Monbeig-Goguel and W. Vitzthum, "Dessins inédits de Giorgio Vasari," *Revue de l'Art*, 1968, pp. 86–93.

———— *I disegni dei maestri: il manierismo fiorentino*, Milan, 1971.

P. Murray, "Notes on Some Early Giotto Sources," *JWCI*, xvi, 1953, pp. 58–80.

———— *An Index of Attributions before Vasari*, Florence, 1959.

E. Panofsky, *Meaning in the Visual Arts*, Anchor Books, Doubleday reprint, New York, 1955.

———— *Renaissance and Renascences in Western Art*, Stockholm, 1965; Paladin reprint, 1970.

L. von Pastor, *History of the Popes from the Close of the Middle Ages*, viii–xv, London, 1908–28. (The German edition, reprinted Freiburg im Breisgau, 1956, is based on Pastor's final revisions.)

N. Pevsner, *Academies of Art Past and Present*, Cambridge, 1940.

E. Pillsbury, "Drawings by Vasari and Vincenzo Borghini for the 'Apparato' in Florence in 1563," *Master Drawings*, v, 1967, pp. 281–83.

J. Pope-Hennessy, *Italian High Renaissance and Baroque Sculpture*, London, 1970.

A. E. Popham and J. Wilde, *The Italian Drawings of the XV and XVI Centuries in the Collection of His Majesty the King at Windsor Castle*, London, 1949.

W. Prinz, *Vasaris Sammlung von Künstlerbildnissen*, Beiheft zu Bd. xii, *MKIF*, 1966.

C. L. Ragghianti, "Il valore dell'opera di Giorgio Vasari," *Rendiconti della R. Accademia Nazionale dei Lincei*, ix, 1933, pp. 736–826.

M. W. Roskill, *Dolce's Aretino and Venetian Art Theory of the Cinquecento*, New York, 1968.

J. Rouchette, *La Renaissance que nous a léguée Vasari*, Paris, 1959.

F. Santi, "Gli affreschi di Lazzaro Vasari in S. Maria Nuova di Perugia," *Bollettino d'Arte*, iv, 1961, pp. 315–22.

J. Schlosser, *Die Kunstliteratur*, Vienna, 1924.

J. Schulz, "Vasari at Venice," *BM*, ciii, 1961, pp. 500–11.

———— *Venetian Painted Ceilings of the Renaissance*, Berkeley and Los Angeles, 1970.

U. Scoti-Bertinelli, *Giorgio Vasari scittore*, Pisa, 1905.

J. Shearman, *Mannerism*, London, 1967.

A. Smart, *The Assisi Problem and the Art of Giotto*, Oxford, 1971.

———— *The Renaissance and Mannerism in Italy*, London, 1971.

C. H. Smyth, "Mannerism and *Maniera*," *Studies in Western Art: Acts of the Twentieth International Congress of the History of Art*, Princeton, 1963, ii, pp. 174ff.

F. Stampfle, "A Ceiling Design by Vasari," *Master Drawings*, vi, 1968, pp. 226–71.

Studi Vasariani, Convegno internazionale, Florence, 1950, Florence, 1952.

Studies in Western Art: Acts of the Twentieth International Congress of the History of Art (1961), ii. *The Renaissance and Mannerism*, Princeton, 1963.

D. Summers, "Michelangelo on Architecture," *AB*, liv, 1972, pp. 146–57.

G. Thiem, "Studien zu Jan van der Straet," *MKIF*, viii, 1958, pp. 88–111.

———— "Vasaris Entwürfe für die Gemälde in der Sala Grande des Palazzo Vecchio zu Florenz," *ZfK*, xxiii, 1960, pp. 97–135.

———— "Neuentdeckte Zeichnungen Vasaris und Naldinis für die Sala Grande des Palazzo Vecchio," *ZfK*, xxxi, 1968, pp. 143–50.

Il Vasari, Rivista d'arte e di studi Vasariani, ed. A. del Vita, Arezzo, 1927–43, 1957–

A. Venturi, *Storia dell'arte italiana: La pittura del cinquecento*, IX, 6, Milan, 1933.

M. F. Viale, *La chiesa di S. Croce a Bosco Marengo*, Turin, 1959.

G. Viroli, "L'opere e il soggiorno di Giorgio Vasari in Rimini," *La Romagna*, V, 1908, pp. 511–41.

A. del Vita, "L'origine e l'albero genealogico della famiglia Vasari," *Il Vasari*, III, 1930, pp. 51–75.

D. Viviani, *Quando e come s'iniziò in Arezzo la costruzione della Fabbrica delle Logge sui disegni di Giorgio Vasari*, Arezzo, 1934.

U. Viviani, *Arezzo e gli Aretini*, Arezzo, 1921.

H. Voss, *Die Malerei der Spätrenaissance in Rom und Florenz*, Berlin, 1920.

P. Ward-Jackson, "Vasari the Biographer," *Apollo*, LXXVII, 1963, pp. 373–79.

Z. Waźbiński, *Vasari i jego dzieje "Sztuk Rysunku,"* Toruń, 1972 (in Polish, with summary in French: *Vasari et son histoire des "Arts du dessin"*).

B. H. Wiles, "Tribolo in his Michelangelesque Vein," *AB*, XIV, 1932, pp. 59–70.

R. Wittkower, "Patience and Chance: the Story of a Political Emblem," *JWCI*, I, pp. 171–77.

R. and M. Wittkower, *Born under Saturn*, London, 1963.

——— *The Divine Michelangelo*, London, 1964.

J. R. Woodhouse, "Vincenzo Borghini and the Continuity of the Tuscan Linguistic Tradition," *Italian Studies*, XXII, 1967, pp. 26–42.

F. Zeri, "Salviati e Jacopino del Conte," *Proporzioni*, II, 1948, pp. 180–83.

——— *Pittura e Controriforma: L'arte senza tempo di Scipione da Gaeta*, Turin, 1957.

Index

Library of Congress Cataloging in Publication Data

Boase, Thomas Sherrer Ross, 1898-1974.
 Giorgio Vasari: the man and the book.

 (The A. W. Mellon lectures in the fine arts; 20)
(Bollingen series; XXXV:20)
 Based on 6 lectures given at the National Gallery of
Art in Washington in Feb. and Mar. 1971.
 Bibliography: p.
 Includes index.
 1. Vasari, Giorgio, 1511-1574. 2. Art historians—
Italy—Biography. I. Title. II. Series. III. Series.
Bollingen series; 35.
N7483.V37B6 709'.2'4 [B] 77-4763
ISBN 0-691-09905-7

DATE DUE			
MY 30'91			
SE 15'91			
JA 10'92			

Boase 193771